Reflections of Reality in Japanese Art

Reflections of Reality

in Japanese Art

Text by Sherman E. Lee

Catalogue by Michael R. Cunningham
with James T. Ulak

Published by The Cleveland Museum of Art
in cooperation with Indiana University Press

This exhibition has been organized jointly by
 The Cleveland Museum of Art
 The Agency for Cultural Affairs of the Japanese Government
 The Japan Foundation

Additional support, for the exhibition or programs, comes from the Federal Council on the Arts and Humanities under the Arts and Artifacts Indemnity Act, the National Endowment for the Arts, the Ohio Arts Council, the Japan-United States Friendship Commission, and the Asian Cultural Council

The sketch on the cover is adapted from catalogue number 56, *Portrait of the Zen Priest Hakuun Egyō.*

Titlepage calligraphy by William E. Ward
Composition by Typesetting Service, Inc., Cleveland, Ohio 44115
Printed by The Meriden Gravure Company, Meriden, Connecticut 06450

Distributed by Indiana University Press, Bloomington, Indiana 47405

Library of Congress Catalogue Card Number: 82-45940
ISBN: 0-910386-70-6

Contents

Lenders to the Exhibition

Agency for Cultural Affairs, Tokyo
Art Institute of Chicago
Atago-Nembutsu-ji, Kyoto
Buttsū-ji, Hiroshima
Byakugō-ji, Nara
Chion-in, Kyoto
Chōfuku-ji, Kyoto
Chūson-ji, Iwate
Cleveland Museum of Art
Daihōon-ji, Kyoto
Daishōgun-hachi-jinja, Kyoto
Eisei Bunko, Tokyo
Emman-in, Shiga
Enryaku-ji, Shiga
Fukuoka Municipal Art Museum
Ganjō-ji, Kyoto
Hirosaki Municipal Museum, Aomori
Hirota Yutaka, Tokyo
Hōkoku-ji, Ehime
Hompō-ji, Kyoto
Hōshaku-ji, Kyoto
Idemitsu Art Museum, Tokyo
Ishiyama-dera, Shiga
Jingo-ji, Kyoto
Jōfuku-ji, Kyoto

Jōkei-in, Wakayama
Kakimori Bunko, Hyogo
Kangikō-ji, Kyoto
Kannon-ji, Kagawa
Kanzeon-ji, Fukuoka
Kenchō-ji, Kanagawa
Kokawa-dera, Wakayama
Kōkoku-ji, Wakayama
Kongōchō-ji, Kōchi
Kōzan-ji, Kyoto
Kyoto National Museum
Manno Hiroaki, Osaka
Masaki Art Museum, Osaka
Meigetsu-in, Kanagawa
Metropolitan Museum of Art, New York
Mikami-jinja, Shiga
MOA Art Museum, Shizuoka
Moriya Nobutaka, Kyoto
Murō-ji, Nara
Museum of Fine Arts, Boston
Myōchi-in, Kyoto
Myōhō-in, Kyoto
Nakamura Hideo, Kanagawa
Nakazawa Tatsuo, Tokyo
Namban Bunka-kan, Osaka

Nara National Museum
Ninna-ji, Kyoto
Osaka Prefecture
Kimiko and John Powers, New York
Rikkyoku-an, Kyoto
Saikyō-ji, Shiga
Seattle Art Museum
Seigan-ji, Kyoto
Setsu Iwao, Tokyo
Shindaibutsu-ji, Mie
Shingetsu-ji, Fukui
Shōgon-ji, Shiga-ken
Shōjōkō-ji, Kanagawa
Shōju-Raigō-ji, Shiga
Tahara-machi, Aichi
Takahashi Tarō, Tokyo
Takakura Kazuya, Fukuoka
Takeuchi Setsuko, Tokyo
Tamukeyama-jinja, Nara
Tōdai-ji, Nara
Tokyo National Museum
Tokyo National Museum of Modern Art
Tokyo University of Arts
Tōshōdai-ji, Nara
Yokose Fuji, Tokyo
Yokouchi Chūsaku, Aomori

Foreword

With a view to introducing to the people abroad some aspects of Japan's cultural heritage, the Agency for Cultural Affairs has annually organized an exhibition of Japanese art in one or another foreign country in cooperation with a major art museum that wishes to host it. To cite a recent example of such an exhibition held in the United States of America, the exhibition 'The Great Age of Japanese Buddhist Sculpture' will be still fresh in your memory, which we co-organized with the Kimbell Art Museum in Fort Worth and the Japan House Gallery in New York and was favorably received by the American public.

In succession to it, the Agency for Cultural Affairs, the Japan Foundation, and The Cleveland Museum of Art have joined their efforts to hold a major exhibition in Cleveland. The Cleveland Museum of Art has been an enthusiastic introducer and advocator of Asiatic art in America, and is highly esteemed also in Japan. To think of such prestige, it strikes us as rather strange that no full-scale exhibition of Japanese art has been brought there from Japan for decades. With due consideration for the circumstances, therefore, the exhibition 'Reflections of Reality in Japanese Art' was worked out by the Agency for Cultural Affairs in close cooperation with The Cleveland Museum of Art, in an ambitious scheme to show forth to the American audience special features of Japanese art, particularly Japanese paintings and sculptures.

Japanese art is often regarded as more decorative than graphic or realistic. But it is not necessarily the case. Art historians are keen enough to indicate in the history of Japanese art several periods in which the spirit of realism predominated. This exhibition is designed to present a systemized assemblage of such Japanese art treasures in which human figures, landscapes, fauna and flora are shown in vivid realistic representation, with our great hope that this unprecedented and unique exhibition may prove to be a great success.

It is a very large exhibition in scale as compared with our past overseas exhibitions. It includes such important items as *Ama no Hashidate* by Sesshū, *Kokawa-dera Engi Emaki* (legends about the origin of Kokawa-dera Temple) and *Portrait of Priest Myō-e Shōnin*, which are seldom allowed to go abroad on account of their irrplaceable status in the cultural heritage of Japan. You will readily understand from these facts how earnestly the Agency for Cultural Affairs has wished that this exhibition be instrumental in introducing the true features of Japan's cultural traditions to the American public as widely as possible and concurrently contribute to the further progress of cultural interchange between the two nations.

In closing my greetings I should like to extend my heartfelt thanks to the Japanese collectors who have willingly lent their treasures for this exhibition, to Director Sherman E. Lee and the staff of The Cleveland Museum of Art who contributed their best for the successful organization of the exhibition, and to the Japan Foundation, without whose united efforts and support this exhibition could not have been organized.

Bunichiro Sano, Commissioner-General January 1983
Agency for Cultural Affairs, Government of Japan

The expression of reality in representations of the human figure, in landscapes and depictions of animals and plants, has been a theme throughout the long history of painting and sculpture both Western and Oriental. The content of this "reality," however, obviously varies with the social, religious, and political values that define the cultures of different parts of the world. In the 2,000 years of Japanese art history, successive periods – Heian, Kamakura, Muromachi, Momoyama, and Edo – were each marked by unique cultural features, and pursued "reality" through different modes of expression. If there is any consistent attitude to be found in this pursuit, it is a concern for spiritual and psychological truths, rather than an attempt simply to render objects as they appear to the eye. Realism, in the sense of reproducing what the eye sees through the techniques of perspective and shading (chiaroscuro) and oil paint itself, did not appear in Japan until the late Edo Period. Soon after this, the French Impressionists discovered the spiritual realism of Japanese art, initiating a remarkable exchange of ideas about realism between East and West.

We have great admiration for The Cleveland Museum of Art for recognizing so perceptively this aspect of Japanese culture and undertaking this exhibition on the theme of realism in Japanese art. As co-sponsors, we believe that the exhibition will play an important role in the promotion of mutual understanding about Japanese and American cultural contrasts and similarities.

Many of the cultural properties in this exhibition are exhibited only for limited periods of time even in Japan; we hope they will bring enjoyment to many American viewers.

Kentaro Hayashi
President, The Japan Foundation

Preface

Many scholars argue that any catalogue of an exhibition should be produced *after* the exhibition closes. Unresolved questions, or those erroneously thought to have been solved, are never clearer than when the assembled works of art permit those direct confrontations that often present answers impossible to imagine through memory or study of the various kinds of available reproductions. The "posthumous" catalogue would benefit from the immediate study of just those juxtapositions and sequences provided by the exhibition. Furthermore, publishing deadlines could be ignored and perfection, or its likeness, attained—the catalogue free of error is the forbidden dream of almost all curators.

The argument is persuasive, but not completely so. It is strongest when offered in connection with a monograph exhibition—the display of works by one artist or of one artistic movement in a particular place or time. There, so much that was hitherto unknown or unclear can be learned that the insights made possible by the exhibition are best recorded after the event. The argument is less persuasive when one is dealing with the standard art-historical exhibition devoted to a period, a geographic area, or a whole new and relatively unknown culture. One needs an introduction to such broad and strange terrain; but, again, the subsequent interpretation made possible by the temporary exhibition may well be its most important by-product. Specific displays of newly discovered material, studied in depth by scholars but unknown to others, usually do provide the appropriate occasion for full and sometimes definitive treatment in the catalogue produced for the exhibition. One thinks of the recent splendid displays in Japan and the United States of Chinese archaelogical materials, and their catalogues, which have become basic tools for future study.

The present work rests uneasily outside any of these categories. It attempts to deal with a wide chronological range of art within one specific geographic area— Japan. But this reach in time has been complicated by an attempt to consider a peculiar and restricted category of works of art subsumed under related ideas of reality rather than under the more usual categories of time, place, creed, or subject matter. This effort follows by antithesis an earlier exhibition in Cleveland, *Japanese Decorative Style* (1961). *Reflections of Reality in Japanese Art* is an exhibition and catalogue about a way of looking at the world, thinking about it, and then depicting the resulting thoughts and emotions in visual images. The exhibition, if successful, should raise more questions than it answers and should suggest topics suitable for further research. It is a visual essay with an accompanying written essay directed to a varied readership. Our hope is that

viewers with different interests and levels of knowledge may be stimulated to look further and that they may be intrigued by what we take to be a significant Japanese achievement within the closely related cultures of East Asia.

No special exhibition known to me has ever included all of the works it might ideally contain. Requirements of both principle and expedience are sometimes inevitably in conflict with the necessarily limited purposes of the exhibition. Within these acknowledged perimeters we can only say that we are immensely grateful and beholden to The Agency for Cultural Affairs (Bunka-chō) of the Japanese Government, Sano Bunichirō, Commissioner-General, and Kuboniwa Shinichi, Director-General, Cultural Properties Protection Department, for its unfailing and sympathetic support in making the exhibition possible. Their personnel, notably Yamamoto Nobuyoshi, Director of the Fine Arts Division; his predecessor, Nishikawa Kiyotaro, now Councillor; Watanabe Akiyoshi; Miyajima Shinichi; Washizuka Yasumitsu; and Matsushima Ken, Senior Specialists for Cultural Properties, have been patient yet energetic in their cooperation and support. The Bunka-chō has been responsible for all arrangements in Japan, including negotiations for loans; initial catalogue information; gathering photographs of all the objects; and the collecting, packing, and shipping of the 101 precious loans. Not least, the Japanese Government, through the Bunka-chō, and The Japan Foundation have provided total financial subsidy to the exhibition for costs incurred in Japan. The Japan Foundation, especially through the kind support of Hayashi Kentaro, President; Tanaka Tetsuo, Executive Director; Nakagawa Keiji, Head of the Arts Department; Iseki Masaaki, Councillor of the Arts Department; and Watanabe Osuke, Director of the Washington D.C. office, has once again been most helpful to the cause of Japanese–United States cultural relations.

The United States indemnification of the Japanese loans to the exhibition was made possible through the affirmative decision of The Federal Council on the Arts and Humanities, Anne Hartzell, Acting Director. The exhibition was also supported by planning and later grants from The National Endowment for the Arts, Frank Hodsol, Chairman. Additional funding was provided by The Ohio Arts Council, John Henle, Chairman, and by The Asian Cultural Council, New York, Richard Lanier, Director.

The catalogue was a difficult and untimely work to produce, and its appearance is due to the dedication and just plain hard work of numerous individuals. I am particularly grateful to Naomi N. Richard, Yorktown Heights, New York, who performed nobly as editor. Her grasp of the subject combined with her concern for clarity has aided the author's presentations immensely. The Museum's Chief Editor of Publications Merald E. Wrolstad efficiently carried out the design of the book, and Sally W. Goodfellow, Associate Editor, coordinated production details. I must add at this point my thanks to Edward B. Henning, Chief Curator of Modern Art, and Adele Z. Silver, in charge of Public Information, for their reading and criticisms of the text. Michael R. Cunningham, Associate Curator of Japanese Art, and James T. Ulak, Ph. D. candidate, Case Western Reserve University, were responsible for catalogue entries and have been invaluable sources of instruction and correction in the preparation of both the exhibition and the catalogue. The members of the Department of Oriental

Art—Elinor Pearlstein, Assistant Curator; Jean K. Cassill, Assistant; and Jane Berger, Secretary—have done far more than is imaginable to insure accuracy, consistency, and completion of the endless details engendered by both the exhibition and the catalogue. Hiroko Aikawa of the Museum Library deserves special thanks for her indispensable assistance with translations and transcriptions of Japanese. June I. Barbish, Executive Secretary to the Director, and her assistant, Darlene Black, assisted in handling correspondence and typing the text. Our thanks as well to Janet L. Leonard and Judith De Vere for merciful help with typing.

Museum Designer William E. Ward was responsible for the splendid display of the exhibition. William S. Talbot, Assistant Director for Administration, was in charge of the various and complex grant and indemnification applications. Frederick L. Hollendonner, Chief Conservator, and Yuji Abe of Tokyo acted as advisors and inspectors for the condition and safeguarding of objects in the exhibition. Delbert R. Gutridge, Registrar, supervised the enormously complex matters of transportation, insurance, and registration. And Nicholas C. Hlobeczy, Museum photographer, was responsible for images of materials from The Cleveland Musuem of Art and other photography in connection with installation and public information.

Museum colleagues in the United States have been most helpful, notably: Jan Fontein, Director, Museum of Fine Arts, Boston; Phillipe de Montebello, Director, Metropolitan Museum of Art, New York City; James Wood, Director, Art Institute of Chicago; and Henry Trubner, Associate Director, Seattle Art Museum. We are also indebted to Kimiko and John Powers for their generous loans. Particular mention should be made of the private lenders from Japan who have so sympathetically responded to requests for loans: Hirota Yutaka, Manno Hiroaki, Moriya Nobutaka, Nakamura Tanio, Nakazawa Tatsuo, Setsu Iwao, Takahashi Tarō, Takakura Kazuya, Takeuchi Setsuko, Yokose Fuji, and Yokouchi Chūsaku.

The Trustees of the Museum have supported the entire undertaking from the beginning and many others have been helpful in making possible the exhibition, catalogue, and accompanying programs and activities. To all those mentioned and to many more not mentioned, thanks are offered most gratefully.

Sherman E. Lee, Director and Chief Curator of Oriental Art

Chronology

Jōmon Period ca. 7000 BC–ca. 200 BC
Yayoi Period ca. 200 BC–AD 250
Tumulus Period AD 250–552
Asuka (Suiko) Period AD 552–645
Nara Period AD 645–794
 Early Nara (Hakuhō) Period AD 645–710
 Late Nara (Tempyō) Period AD 710–794
Heian Period AD 794–1185
 Early Heian (Jogan) Period AD 794–897
 Late Heian (Fujiwara) Period AD 897–1185
Kamakura Period AD 1185–1333
Nambokuchō Period (Northern and Southern Courts) AD 1333-1392
Muromachi (Ashikaga) Period AD 1392-1573
Momoyama Period AD 1573-1615
Edo (Tokugawa) Period AD 1615–1868
Meiji Period AD 1868-1912

Notes to the Reader

Japanese personal names are written in traditional fashion with family name preceding the given name, except in the Notes and Literature, where all names occur Western style.

Numbers in brackets refer to catalogue entries.

The terms *-ji*, *-dera*, *-in*, and *-an* designate Buddhist temples. The term *jinja* indicates a Shintō shrine.

Romanization of names and titles is given as consistently as possible; accepted variations occur occasionally.

The abbreviations S., C., and J. following Buddhist names signify Sanskrit, Chinese, and Japanese equivalents.

Full bibliographic data for Japanese art serials and periodicals are listed following the catalogue entries.

INTRODUCTION # Kinds of Reality

The Japanese genius for decorative style in the visual arts is both evident and explicable—particularly by those Western art historians and critics who came to know Japanese art in the first half of the twentieth century during the high tide of "significant form" and aesthetic analysis. The influence of Japanese printmakers' bold, asymmetric, and heterodox compositions on Western painters and printmakers of the late nineteenth and early twentieth centuries is now familiar and well documented in the critical literature of art. Indeed, too often admiring recognition has been transformed into a pejorative cliché: that Japanese art is merely decorative.

But one of the great Postimpressionists, Vincent van Gogh, much preoccupied with and influenced by the Japanese art he knew, largely prints and sketch-drawings, wrote in 1888 a significant comment on what he saw in Japanese art:

> If we study Japanese art, you see a man who is undoubtedly wise, philosophic, and intelligent, who spends his time how? In studying the distance between the earth and the moon? No. In studying the policy of Bismarck? No. He studies a single blade of grass.
>
> But this blade of grass leads him to draw every plant and then the seasons, the wide aspects of the countryside, then animals, then the human figure. So he passes his life, and life is too short to do the whole....
>
> And you cannot study Japanese art, it seems to me, without becoming much gayer and happier, and we must return to nature in spite of our education and our work in a world of convention.[1]

Van Gogh saw in Japanese art a passionate attention to the microscosm in nature, a direct and keen observation of nature's smallest elements for their own sakes, and this he contrasted with the conventionalized perceptions,

thematic grandiosity, and moralistic freight embodied in the nineteenth-century European academic tradition. What held his attention was a vision of the Japanese artist grappling with the problem of representing the natural world, not that artist's decorative virtuosity.

It would seem at first a simple matter to find and characterize this Japanese realism, and so I thought some twenty years ago, during the preparation of the exhibition *Japanese Decorative Style,* when Japanese realism's equal claims to recognition began to assert themselves. Not so; for realism, whether in its Western, Eastern, or specifically Japanese usages, is a term of many definitions and many manifestations—hence the title of this exhibition: *Reflections of Reality in Japanese Art.*

Realism, in Western philosophy and art, is a term protean in its meanings. In the Platonist and Thomist definitions *real* applies to ideal archetypes or to patterns in the mind of God, respectively, and palpable, visible things are merely imperfect and approximate shadows of those realities. In the opposing nominalist view reality inheres in palpable and visible things, and patterns and archetypes—in other words, abstractions—are *un*real. Modern relativism also opposes the archaic and inapplicable Platonist-Thomist position but makes an exact definition, or even a description, of realism difficult if not impossible: "What is truth? said jesting Pilate; and would not stay for an answer" [Francis Bacon, *Of Truth*]. Among the many (and often conflicting) philosophical meanings assigned to the term *realism* is acceptance of the independent reality of matter. This approaches both the everyday use of the term and the realist aspects of Japanese art. The third definition in the *Oxford English Dictionary*—"close resemblance to what is real..., fidelity of representation..., precision

and vividness of detail"—also begins to characterize realism in Japanese art, which includes the attempt to represent the particular appearance of an individual thing rather than an idealized conception of its type. "To describe facts as they really are" was the literary aim of Chikamatsu Monzaemon (1653–1724), the greatest playwright of the early Edo period: "In writing *jōruri* (puppet plays), one attempts first to describe facts as they really are, but in so doing one writes things which are not true, in the interest of art."[2]

Realism encompasses not only style and method but subject matter as well. Six hundred years before Chikamatsu, Lady Murasaki (speaking as Prince Genji) observed of literary topics that the "good things and bad things alike…are things of this world and no other."[3] This realism of subject matter is particularly relevant to our thinking about Japanese painting, in which the realm of acceptable subject matter from the human world expanded in tandem with the realm of possible subject matter from the natural world, as the latter came to include landscape both tame and wild. For such expansion to occur, patrons as well as painters had to realize the aesthetic validity of lowly—even unpleasant—subjects.

The confusion between realism of subject and realism of style plagues the study of both Eastern and Occidental art. Such painters as Honoré Daumier, Gustave Courbet, Jules Breton, Edgar Degas, and Henri Toulouse-Lautrec differ enormously in artistic approach; it is their subject matter, largely drawn from the milieu of farmers, workers, the petite bourgeoisie, or the underworld, that makes them all "realists." This confusion is reflected in the *Oxford English Dictionary,* which defines realism in art and literature as "fidelity of representation" (method or style) and then adds that it may encompass "details of an unpleasant or sordid character" (subject).

Before the late nineteenth century truth to appearance usually meant, in the West, a "realistic" rendering of the visual image as if seen by an objective eye from a fixed observation point. This concept, difficult enough to apply within the complexities of the Western tradition, became even more unpersuasive when the widely different artistic assumptions of various cultures outside that tradition were recognized. The almost bewildering variety of methods by which the Western visual artist has presented images that seemed convincingly real to his contemporaries, however conventional they may have seemed to succeeding generations, has been given an original and synthesizing presentation by Ernst Gombrich. The astonishment of Giotto's audience at his apparent mastery of suggested volume, space, and emotion is now matched by our high esteem for his conventions as almost abstract vehicles of expressive power. Beside the works of Velásquez, the Florentine's pictures seem most unrealistic. The key role played by visual conventions acceptable to a given artistic milieu reveals the symbolic nature of any visual representation. The modern experimental psychologist or physiologist can arrange numerous "real" environments in which the eye perceives a carefully concocted lie—whether the ambiguous ink drawing that is both duck and rabbit, or the room that offers a convincing but gross falsehood from one specific viewpoint and a dismembered truth from all others.

Western artists, like Western philosophers, have been unable to agree upon what is really real. The cubists claimed to be more realistic than the academicians; certainly their works seem more palpable and concrete. The superreality in surrealism is in part created by the tension between phantasmal dream images and their precise and literal rendering; comparable tension exists in medieval European depictions of the unicorn or East Asian representations of powerful and believable dragons and phoenixes. In both East and West, medieval renderings of various hells offer the same taut balance between visionary subject and meticulously detailed description—proof enough that, at least in their imaginings of the supernatural, sometimes the twain do meet. Perhaps two literary descriptions from widely disparate sources contain similarities that help define an intuitively sensed necessary condition of realism in general and in Japanese art. The first is the well-known passage from James Joyce's *Portrait of the Artist as a Young Man* in which the preacher describes the tortures of the Christian hell to the young students in chapel; the other, on an early thirteenth-century Japanese handscroll, is from the text pertaining to a fire scene in one of the Buddhist hells. Thus Joyce:

But the sulphurous brimstone which burns in hell is a substance which is specially designed to burn for ever and ever with unspeakable fury. Moreover our earthly fire destroys at the same time as it burns so that the more intense it is the shorter is its duration: but the fire of hell has this property that it preserves that which it burns and though it rages with incredible intensity it rages forever.[4]

And the Buddhist text:

Within the Tetsueisen there is a place called the Shrieking Sound Hell. The inmates of this place are those who in the past accepted Buddhism and became monks. But failing to conduct themselves properly and having no kindness in their hearts, they beat and tortured beasts. Many monks for such cause arrive at the Western Gate of Hell where the horse-headed demons with iron rods in their hands bash the heads of the monks, whereupon the monks flee shrieking through the gate of Hell. There inside is a great fire raging fiercely, creating smoke and flames, and thus the bodies of the sinners become raw from burns and their agony is unbearable.

Joyce perhaps outdoes his Japanese counterpart by stressing the everlastingness of his fire; otherwise the descriptions are equally vivid, the realities they evoke equally present and ghastly. Like the Japanese realist painter, both writers try, with unnerving success, to convince the reader of the truth, the sensuous reality, of their subject. The images they create are immediate and palpable, not symbolic or metaphoric; one seems to experience these hellfires in the flesh, not in the mind. The images derive their power from the shared experiences of artist and observer [16].

The acceptance of diverse "realistic" conventions can be interpreted anthropologically as well as artistically. Frobenius's famous example of the two portraits of a Maori chief, one by a Western artist, the other by the chief himself, is a significant demonstration of cultural disparity in the achievement of a likeness.[5] The Western rendering shows a head and shoulders modelled in light and shade and conforming to the conventions of nineteenth-century European portraiture. The tattooed face is but a part, the skin, in the portrait. The self-portrait of Tupa Kupa shows the tattoo design alone, spread out as if the face had been split and flattened in a well-known convention familiar also in early Chinese

art and in American Indian art of the Northwest Coast. To the Maori the clan-rank tatoo *was* the man; it was the only way he could be represented so as to be recognized. Each convention, European and Maori, was successful because of the understanding between artist and beholder.

In Japanese art this shared cultural and visual experience expressed in persuasively "real" imagery takes a variety of forms and types, further complicating attempts to understand the manifold diversity of realism. Above all, reflections of reality in Japanese art are conditioned by a pervasive belief in the illusory nature of worldly reality, a belief dating from the earliest Buddhist ethos of the Nara and Heian periods. Tradition has it uttered by the Indian Buddhist saint Vimalakirti (J. Yuima) [5] in words recorded in the sutra that bears his name, the *Yuima Kyō:* "All the worlds are like flickering flame; they are like a shadow, an echo, a dream; they are like a magical creation." Centuries later the very name given the genre art of the Edo period—*ukiyo-e,* floating world pictures—suggests the transience and ultimate unreality of all human activity, even the pursuit of pleasure, which seems so real to the senses.

The early Japanese experience of Buddhism was embedded in a matrix of Chinese culture, principally that of China at its political and cultural apogee, the T'ang dynasty (618–906). Chinese figure painting and sculpture, both religious and secular, introduced to Nara Japan a totally new and sophisticated dimension of suggested reality. The new modes were accompanied by the Chinese emphasis on a rational, generalized and measured way of thinking and seeing. But, as Alexander Soper suggests, the Japanese predilection for "particulars" rather than "principles" as a means of visual evocation[6] succeeded in steadily moving them, rather than the Chinese, toward works that we associate with realism. The results of this historical process, both in Chinese-influenced and especially in native guises, make an important part of this exhibition.

Realism of subject matter acted as a spur to realism of technique or style. For example, the Buddhist *Rokudō,* or Six Realms of Reincarnation (heavenly beings, humans [19], beasts [18], demons, hungry ghosts, hell), although acknowledged to be illusory, stimulated observation and

3

depiction. It did so by directing attention to the visible world—human beings, animals, and their environment—and by requiring convincing images of the invisible ones—hells and paradises—in order to admonish and persuade.

A primary example of the intimate relations between subject matter and what we take to be realist style is the continuous narrative handscroll. This form was developed to illustrate the always complex and often pungent narratives derived from literary or folk accounts of the histories of temples, clans, wars, or individuals. The artist's need to make the story clear, believable, and engrossing to lettered and unlettered audiences alike encouraged an increasingly flexible use of brush, ink, and color. Furthermore, the typical Japanese desire to record the natural beauty of certain landscapes frequently led to modifications—such as softening colors and rhythmically repeating lines and forms—of the artistic means by which they were recorded.

In portraiture Japanese artists moved toward more particularized and "caught" likenesses by applying subtle shading, but using modified Chinese calligraphic (thick and thin) brushstrokes to vary linear definition, and by altering the Chinese conventions of placement, scale, and orientation to the beholder. Exaggeration of distinctive features, whether in caricature or satire, accompanied the individualization of portraiture.

Method, including materials, technique, and style, is a determinant of the kind and degree of realism possible in art. Traditional painting in East Asia was executed almost wholly with brush and ink, often supplemented by water-based colors, on paper or silk. The opaque pigments invented in the West, first tempera, then oil, permit a more solid and colorful depiction of objects in space; Chinese and Japanese mediums necessitated more conventional and symbolic representation. Although the beholder knew the conventions, recognition required a measure of sympathetic reconstruction beyond that necessary in the West. Hence the amazement and considerable emulation with which Chinese and Japanese artists and connoisseurs about the beginning of the seventeenth century greeted the first European paintings to be seen in East Asia. Until then the realistic modes in Japan had been confined within the technical and expressive limitations of the native brush tradition.

Even before any acquaintance with Western models, it was the pervasive practice in most Japanese schools of painting, however "unrealistic," to make both summary and careful sketches from nature, particularly renderings of individual flora and fauna. Many of these, in themselves exceptional works of art, served additionally as preliminary studies for more convincing images of reality in larger, more complex, and more finished works. This practice was reinforced by Western influence when it did arrive in the seventeenth century; sketches from nature were seen to be particularly advantageous in rendering the pictorial conventions of vanishing-point perspective and single-source illumination for modelling in light and shade. In the creation of convincing images of reality, no small ingredient was the traditional, often astonishing, dexterity of the Japanese artist, which allowed him successfully to project the image of the thing observed.

Broad and lively interest in the subject matter provided by the visible world; growing awareness of distinguishing particularities, first of types and then of individuals; and sure command of methods by which to translate observations into images: these, in conjunction, begin to define an area within which can be found the various reflections of reality in Japanese art.

Realistic art, however, remains art, not reality. Nor was it often confused with reality after the full development of realistic modes in the Kamakura period (1185–1333). But an anecdote from the preceding Heian period, antedating the appearance of styles we can reasonably define as realistic, identifies realism in painting with a kind of magical reality. The painter Kose no Kanaoka had depicted upon a palace screen a horse that was said to leave the screen every night to graze on flowers the artist had painted on another door; the horse ceased to stray only when Kanaoka painted a halter upon his neck.[7] Similar early anecdotes in the West, such as the bird pecking at the beguiling cherries painted by Zeuxis in ancient Greece, illustrate analogous connections between realism and magic. Later commentators on art and literature, both Eastern and Western, recognized the essential tension between art and reality. Chikamatsu's rejoinder in the following exchange is justly famous:

Someone said, "People nowadays will not accept plays unless they are realistic and well reasoned out....It is thus that such people as *kabuki* actors are considered skillful to the degree that their acting resembles reality.... People will not stand for the childish nonsense they did in the past.

Chikamatsu answered, "Your view seems like a plausible one, but it is a theory which does not take into account the real methods of art. Art is something which lies in the slender margin between the real and the unreal.... It is unreal, and yet it is not unreal; it is real, and yet it is not real. Entertainment lies between the two."[8]

How close this subtle Japanese definition comes to Schiller's aphorism in a letter written to Goethe in 1800:

Appearance should never attain reality,
And if nature conquers, then must art retire.

Of course this attitude opens the door to artistic convention (in Schiller's age, neoclassicism), but it recognizes, as did Chikamatsu, the undefined boundary between art and reality. Wallace Stevens's formulation, proceeding from a modern awareness of the world and therefore applicable to both East and West, is succinct, pragmatic, and ends in agreement with Lady Murasaki:

The subject matter of poetry is not that "collection of solid static objects extended in space" but the life that is lived in the scene that it composes; and so reality is not that external scene but the life that is lived in it. Reality is things as they are.[9]

"Things as they are" is a pragmatic acceptance of the varied and often conflicting evidence registered by the senses and confirmed by individual and group sensibilities. There is little place in this reaction to the world for systematic and rational structures like those formed in China or in the West, both ancient and modern. Hence the Japanese concentrated their intellectual energies and registered their great intellectual achievements not in philosophy but in the literary and visual arts, their achievements in material culture not in science but in craft technology. Hence, too, they persisted in the almost random intuitions of native Shintō beliefs as substratum and accompaniment to the received religion of Buddhism. Ethical questions were either avoided or unsystematically answered, and such answers as were given were based upon imported Buddhist and Chinese Confucian precepts, whose philosophical and logical assumptions and implications were understood only by a tiny minority of scholars and theologians. Loyalty transcended right thinking; extremes were more attractive than the middle path. Aesthetic need was served by a subtle and rich decorative style still capable of amazing the most experienced connoisseur. The need to record the appearances of the world knew no decorous suppression of the ugly or unpleasant. And especially there was no need to explain *why* one did as one needed to do.

The absence of philosophy and science in Japan was a major antecedent of the Tokugawa rulers' misgivings toward Western ideas and their increasing suppression of almost all manifestations of these ideas. The persecution and arrest of Watanabe Kazan [130] in 1838-39, while not occasioned by his masterly pioneering adaptation to portraiture of Western style modelling in light and shade, was caused by suspicion of his related interest in *Rangaku* ("Dutch" studies), including philosophy, politics, and economics. Ironically, the realism of Kazan's finest works was yet another manifestation of the long and characteristically Japanese realist tradition—an intuitive, empirical, and pragmatic attitude to infinitely varied aspects of reality, summed up in the still-common ancient expression *genjitsu*, "the way things are."

1. Robert J. Goldwater and Marco Treves, ed. and trans., *Artists on Art* (New York: Pantheon, 1945), p. 384.

2. Ryusaku Tsunoda, Wm. Theodore De Bary, and Donald Keene, *Sources of Japanese Tradition* (New York: Columbia U. P., 1958), p. 447.

3. Murasaki Shikibu, *The Tale of Genji*, trans. Edward G. Seidensticker, 2 vols. (New York: Knopf, 1976), 2:437.

4. (New York: Viking, 1968), p. 121.

5. Leo Frobenius, *The Childhood of Man* (Philadelphia: Lippincott; London: Seely, 1909), p. 35.

6. "The Rise of Yamato-e," *The Art Bulletin* 24 (December 1942): 375–76.

7. Soper, "Yamato-e," p. 363, n. 34.

8. Tsunoda, De Bary, and Keene, *Sources*, p. 448.

9. Wallace Stevens, *The Necessary Angel* (New York: Random House, 1965).

CHAPTER ONE

Realist Exceptions in Pre-Buddist Japan

The first Japanese art works convincing in their natural appearance are ceramic sculptures representing not humans but shells and animals. Thus, at the very beginning of any study of realism in Japanese art, we are confronted with a most subtle and salient question—why *them* and not *us*?

The dates of the Jōmon (cord-pattern) culture of Stone Age Japan, from which these ceramic sculptures come, are still subject to debate. Carbon-14 dates of 7000 BC are reported from some contexts in which cord-decorated pots have been found. A more conservative consensus maintains that artistically developed earthenware vessels were produced at least as early as 3000 BC. Archaeologists do agree on five evolutionary stages for the artifacts of this hunting-gathering culture. Kidder[1] dates the end of earliest Jōmon to about 4000 BC, that of early Jōmon to about 3000 BC, middle Jōmon to about 2000 BC, late Jōmon to 1100 BC, and latest Jōmon to the end of the fourth century BC.

The overwhelming majority of the justly famous Jōmon ceramics are heavily patterned and sculpturally dynamic functional vessels, some with motifs that may be derived from snakes, shells, or flora. Additionally, a small number of anthropomorphic clay images *(dogū)* have been found, as well as a much smaller number of naturalistic shell and animal sculptures modelled in the round. The humanoid figures are all distorted almost beyond recognition into more or less abstract or patterned images, often "fertility goddess" types; they clearly belong to the grammar of ornament on the richly sculptured vessels. Saucer eyes with slits (the so-called "snow-goggle" type), tiny extremities, and heavily patterned costumes characterize these fig-

ures, although at least two display an informal seated posture that reveals both direct observation and the technical skill to transmute observation into image.[2] A solitary fragment, a female torso, is unusual in its smooth and natural modelling of breasts and protruding stomach.[3]

The ceramic shells[4] whose naturalism appears so anomalous in the Jōmon context are modelled in careful imitation of the deep-sea conchs found off central Honshū. Presumably the paucity of the ceramic versions reflects the rarity of the shells themselves in Jōmon society.[5] Significant in these ceramics is their total representational realism, with the usual vigorously abstract or stylized Jōmon decoration largely suppressed. At least one sculpture may be a cast impression of an actual shell. Somewhat like the famous clay-coated skulls from Jericho of about 6000 BC, the cast conch represents the human desire to preserve a treasured object by using the actual object to make a replica.[6] The close connections between reality and replication for magical purposes are continuing themes in all realistic art and in Japanese art in particular. Later we will note the magical-religious implication of early Buddhist priest portraiture. In any case, the clay conch sculptures represent a direct and almost literal translation of an inanimate object, or still life, into an inanimate medium—clay.

The naturalistic late Jōmon animals represent a different facet of realism, for they are modelled in clay in imitation of living and moving forms. They also reveal a far greater technical command of translating a natural image into an artistic medium than do the more abstract or demonic humanoid images. The wild boar [1]—probably dating from latest Jōmon (fifth-fourth century BC), to judge from the curving ribbon-like cord

6

pattern and from the image's archaeological context at the Tokoshinai site—outstandingly combines subtle and penetrating observation and skill in modelling. These are apparent in the animal's shape and bulk, in its accurately placed and described features, and notably in the artist's use of the familiar Jōmon decorative pattern to delineate natural features—to outline the cheek-plates and suggest the upward-curving tusks. In its representational excellence this beast is an isolated "sport" in a surrounding world of abstract pattern. Still, together with a few less remarkable animal images and the naturalistic female torso described above, it gives evidence of a limited presence of objective observation and representational skill in Japan at the end of its long Stone Age.

In this the Japanese experience was not unique in East Asia. At least as early as the late Shang dynasty (eleventh century BC) a Chinese artist had produced, in a smooth, natural, and nonhieratic style, a still-unique bronze rhinoceros wine vessel *(tsun)*.[7] To this was added, by the end of the third century BC, a small but significant series of bronze animals, including another and even more realistic rhinoceros vessel,[8] marking the change from the hieratic and formal art of pre-Ch'in China (before 221 BC) to the often naturalistic and exuberant art of Ch'in (221-206 BC) and Han (206 BC-AD 220). The so-called Animal-style art of the Ordos-Mongolian steppe people provided some inspiration for this change in China, but the lonely Jōmon realistic animals seem to be indigenous to Japan.

The probability of local origin is reinforced by the lack of essays in realism during the subsequent Yayoi period (200 BC-AD 200) and early Tumulus period (AD 200-ca. 400), when Chinese

1 *Wild Boar.*

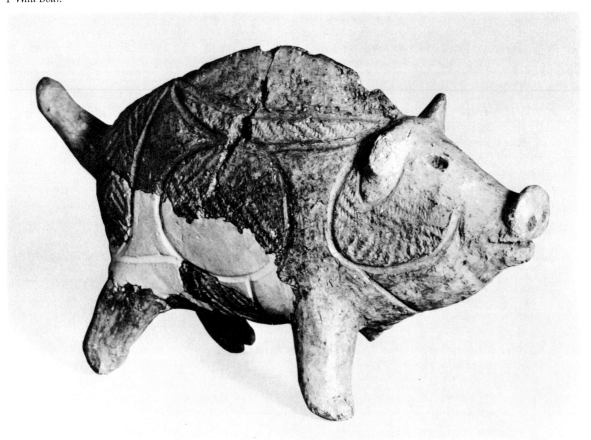

2 *Chicken.*

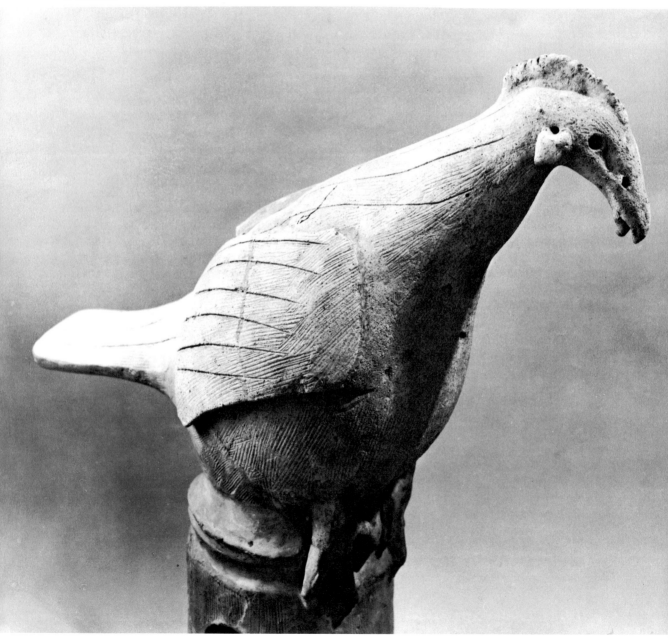

and Korean influences began to penetrate south-western and central Japan. Although the Japanese produced, during the sudden and virtually simultaneous development of their Bronze and Iron Ages, bronze mirrors in Han Chinese style decorated with recognizable but heraldic figures, animals and even silkworms, natural-looking sculptures or reliefs are conspicuous by their absence. It is significant that the next appearance of realism in Japanese art is found in the clay products of the later Tumulus period (AD 400–552), that these are unrelated to Chinese or Korean works, and that the most realistic of all these clay artifacts are representations of animals.

The new culture of the late Tumulus period was largely intrusive, introduced by successful mounted warriors entering southwestern Japan from the mainland, especially Korea. Agriculture remained the economic base, but the new warrior class brought centralization to the clan structure and developed, out of small local states, the concept of a unified nation under a sovereign. Luxury goods of gold, silver, gilt bronze, jasper, and jade were produced in some quantity by organized "guilds" and were deposited as grave offerings in vast burial tumuli. The Japanese adopted a modified version of the Chinese *ming ch'i*, clay figurines substituted for the humans and animals formerly sacrificed and buried to accompany deceased rulers and nobles in the afterlife. But these *haniwa* (circle of clay) figures look nothing like their mainland antecedents and differ also in not being deposited in the burial chambers but left partially exposed to view along the upper slopes and perimeters of the mounds. Since they survive today in the thousands, the production of *haniwa* must have been enormous. Many *haniwa* are simple cylinders, but others are sculptured representations. Some of these latter are architectural models; most are human figures—ladies, warriors, shaman types, singers, and musicians. A few are animals—horses, reflecting the might of the ruling class; numerous domestic animals such as pigs and chickens; and a very few wild animals such as deer and monkeys.

The human and horse *haniwa* are based on the form of the clay cylinder, and their appearance is dominated by its technical requirements. Bodies, arms, muzzles, and legs are tubular. Features and expression are achieved either by cutting through the clay to the void behind or by applying details of ornament on the curving surfaces. The doll-like, abstract character of the result has little to do with realism but can be enormously expressive—hence the great popularity of *haniwa* with modern collectors and the thriving contemporary industry dedicated to supplying them.

Very different are the barnyard and wild animals and birds. Though they may perch atop the basic cylinder, they appear quite natural and well observed. Their almost summary free modelling creates an impression of immediate reality rather than a sculptural realization of the shape of reality such as we see in the late Jōmon boar. The chicken [2] seems nervous, beady-eyed, and peckish, its nature realized in the detailing of the head and the simplification of form of the feathered body. The fragmentary remains of the monkey figure [3] provide one of the most sympathetic and striking renderings of this creature in early art. In the asymmetrical pose, the turned and tilted head, the sculptor has caught the animal's quicksilver movements; in the structure of brow and eye-socket, its penetrating look.

The informed and sensitive impressionism of these few animal sculptures seems heterodox compared with the almost heraldic literalism of the armor and fittings on *haniwa* warriors and horses. Like the Jōmon boar, these animal figures offer glimpses of keen observation that belie such East Asian rationalizations about the difficulty of representing animals as Han Fei-tzu's famous remark "that dogs and horses are difficult [to paint] and demons and divinities easy . . . because dogs and horses are things generally and commonly seen, and demons and divinities are deceptive and uncanny apparitions."[9] The contradiction between such axioms and the occasional early successes of Japanese (and Chinese) artists in rendering animals naturally may be explained by one of two related possibilities: either the critics considered an effectively natural rendition unsuccessful because it lacked formality and decorum; or, precisely because the animal world was other than the human world,

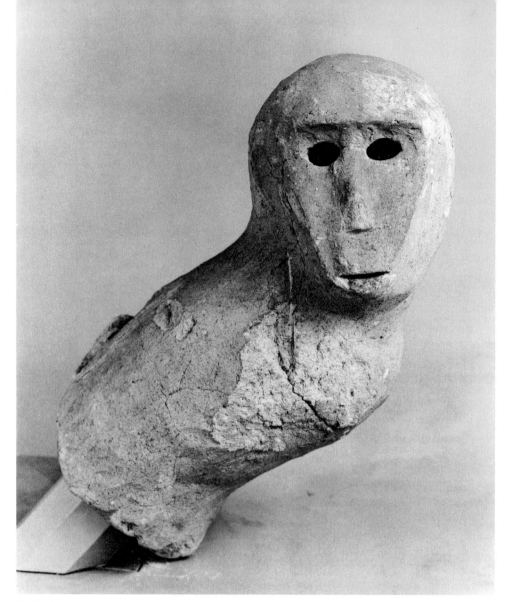

3 *Monkey.*

animals could be realistically rendered without offending against accepted formal ways of portraying one's fellow humans. In any case, the rare and intermittent appearance of realism in pre-Buddhist Japanese art remains confined to "the others"—the animal world.

1. J. Edward Kidder, *Prehistoric Japanese Arts: Jomon Pottery* (Tokyo and Palo Alto: Kodansha, 1968), pp. 286-88, chart of Jōmon chronology.

2. Namio Egami, *The Beginnings of Japanese Art* (New York: Weatherhill; Tokyo: Heibonsha, 1973), fig. 47; Tsuboi Kiyotari, gen. ed., *Nihon no Genshi Bijutsu* (Tokyo: Kodansha, 1977-1979), vol. 5: *Dogū*, by Masayoshi Mizuno, p. 55 and fig. 100.

3. Mizuno, *Dogū*, fig. 36.

4. Kidder, *Jomon Pottery*, p. 164, pl. XII.

5. An unpublished ceramic shell in the Archaeological Section of the Tokyo National Museum was exhibited in October 1981.

6. Ernst Gombrich, *Art and Illusion* (London: Phaidon; New York: Pantheon, 1960), p. 110.

7. In the Center of Asian Art and Culture, Avery Brundage Collection, San Francisco.

8. In the Historical Museum, Peking.

9. Quoted by Chang Yen-yüan in 847 and translated in William R. Acker, *Some T'ang and Pre-T'ang Texts on Chinese Painting* (Leiden: Brill, 1954), p. 151.

CHAPTER TWO

Chinese and Buddhist Beginnings

The rapidity and comprehensiveness with which the Japanese of the Asuka and Nara periods adopted Buddhism, and with it the advanced Chinese culture and technology, is one of the most remarkable of all historic achievements in acculturation. Besides the Buddhist faith and religious organization, architecture, city planning, governmental organization, courtly ritual, and advanced literature, which together transformed Japanese society, the mainland culture also provided an advanced and rich vocabulary and grammar of subject matter and technique in the visual arts. At first these were embodied largely in Buddhist images, either sculptures and paintings made in China or Korea and brought to Japan, or works made in Japan by Chinese and Korean artists accompanying the growing number of priestly visitors and emigrés.

From the beginnings of this influence in the Asuka and Early Nara periods the visual arts produced in Japan were to all intents and purposes indistinguishable from those produced on the continent, particularly from Korean sculpture and from Chinese painting and sculpture. The preeminence of the great Chinese empire and of Chinese Buddhism was so overwhelming that the art styles of the seventh through ninth centuries in East Asia were international, like the Gothic style in most of fourteenth-century Europe. Realism in Japanese art at this formative time, then, occurred within the ample boundaries of Chinese art.

Chinese landscape painting had not yet developed the believability and complexity that would characterize the classic works of Five Dynasties and Northern Sung in the tenth and eleventh centuries. The illusion of shallow space settings was created by rocks and trees sparsely used as staffage for figure compositions, and perspective was rendered by overlapping and by progressive reduction in size for more distant elements. Landscape color tended to be decorative, emphasizing green, particularly in the foreground, and blue, especially for far-off objects. But landscape itself was not a primary subject, existing rather to support narrative or religious themes. The delineation of architecture was already a specialized task, and Chinese painters had achieved remarkable accuracy through a form of isometric projection and firm, even drawing of the almost-geometric building structures. The customary red color (lead oxide) of buildings was duplicated in architectural painting.

Chinese figure painting had reached a highly developed stage in both rendition and composition. The sophisticated use of the brush in calligraphy was by now commonplace and provided a shared discipline for Chinese and Japanese artists once the island nation officially adopted the Chinese language and character system in the sixth century. The peculiarly Japanese phonetic modification and syllabaries (kana) did not evolve until the ninth and tenth centuries. The brush line, whether even and deliberate-seeming ("wire-like") or varied in thickness and apparently rapid of execution ("calligraphic"), was used to delineate the inner and outer boundaries of figures and draperies. Graded shading was schematic, used to describe volumes rather than to record their appearance in a directed source of light, and was common in both religious images and secular subjects.

Figures were based largely on types abstracted from tradition and general observation. But three-quarter front and back views, "lost profiles," and foreshortening of limbs and trunks

were normal practice. Grouping figures in a curving arc to create a shallow or medium stage-like space was practiced by the Chinese with ease; as in landscape painting, spatial depth and recession were commonly suggested by overlapping figures along the diagonal and by progressive reduction in size. Figures and the rare surviving portraits are, however, most often isolated against the empty, abstract background provided by wall, silk, or paper. The placement of figures in settings was developing, but conservative usage (as mentioned above) preferred denoting the setting by a few selected objects that indicated rather than fully defined a physical ambience.

By the early eighth century Chinese painters were producing rather elaborate compositions containing numerous figures and animals, often in military or hunting scenes, both as palace and tomb murals (Figure 1) and in the portable hanging scroll or handscroll formats. Temple representations of the Buddhist paradises were compositionally most intricate, presenting multiple palace-like architectural settings, garden environments, and hundreds of major and minor deities; the principal figures were shown in iconic stillness, with the secondary angels and musicians dancing, flying, or playing instruments. Disciples and priests were represented with features more individualized than the smoothly

Figure 1. *Hunting Party.* Section of wall painting, 154 x 190 cm. East wall of tomb passage, tomb of Li Hsien (Prince Chang-huai), Ch'ien-hsien, Shensi Province, China. T'ang dynasty, AD 711.

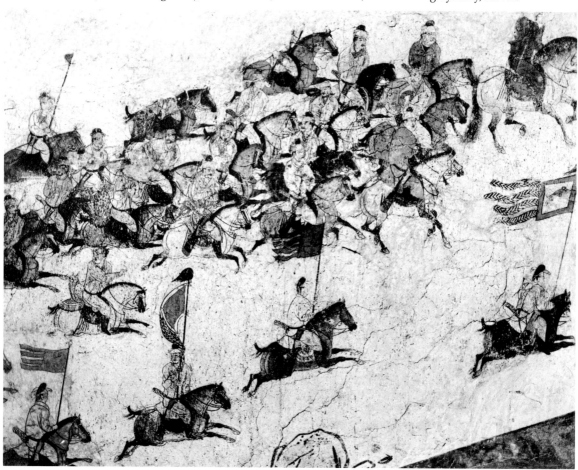

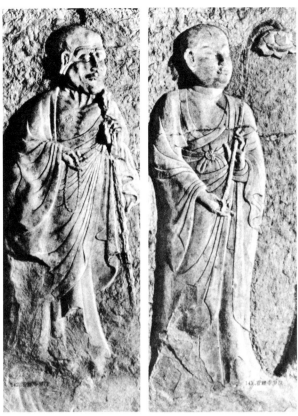

Figure 2. *Two Lohan.* From limestone frieze of twenty-nine *lohan.* K'an-ching-ssu cave, Lung-men (near Loyang), Honan Province, China. T'ang dynasty, late 7th–early 8th century.

Figure 3. *The Patriarch Amoghavajra.* Li Chen, Chinese, active ca. 780–804, T'ang dynasty. Hanging scroll, ink and color on silk, H. 110.8 cm. Tō-ji, Kyoto.

geometric contours of the major Buddhas and bodhisattvas. The wire-like line was used in all types, but calligraphic line crops up with increasing frequency in the saints, priests, and secular figures in narrative scenes. The suggestion of movement in noniconic, time-bound figures is particularly apparent in the military and hunting scenes. Large groups of horses and riders in the unrealistic but suggestive "flying-gallop" posture derived from Han Chinese, and ultimately from Scythian, art provided prototypes for a lively and convincing narrative style that would be developed further in medieval Japan (tenth–fourteenth centuries) than in China, where decorum rather than exuberance was the norm.

For all these techniques of representation there were artists' manuals, books or scrolls of

models that were as important in the process of transmission as the portable finished paintings. The ephemeral nature of these compendiums of sketches and patterns led to their almost total disappearance in China, but in Japan they have survived in some numbers, particularly those of the Heian period and after.

A major subdivision of figure painting in China was portraiture, not only of secular figures, usually emperors and officials, but especially of noteworthy Buddhist priests and founders of sects. For Japanese art the most significant prototypes are the representations of the Buddha's disciples (S. arhats; C. *lohan*; J. *rakan*), particularly Ananda and Kasyapa, who from early times are relatively individualized in both painting and sculpture, the former young and gently sensuous, the latter elderly and

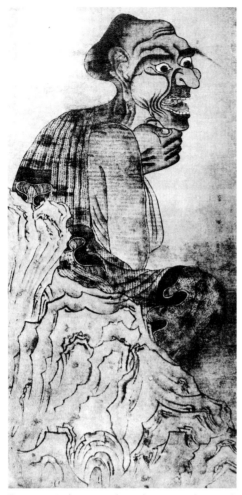

Figure 4. *Lohan*. Attributed to Kuan-hsiu, Chinese, 832–912. Five Dynasties period. Hanging scroll, ink and color on silk, H. 127 cm. Imperial Household Collection, Tokyo.

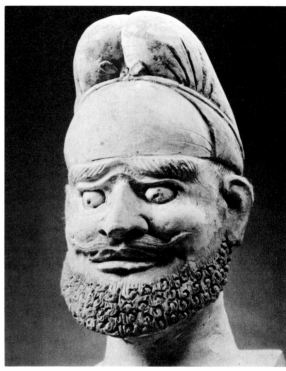

Figure 5. *Head of Tomb Figurine Depicting Foreigner.* Earthenware with traces of polychromy, H. 17.2 cm. Tomb of Li Hsien-hui (Princess Yung-t'ai), Ch'ien-hsien, Shensi Province, China. T'ang dynasty, AD 706. Shensi Provincial Museum, Hsian.

gnarled (Figure 2). As the T'ang dynasty progressed, the disciple type became increasingly the vehicle for observations of grotesque, even deformed, aspects of human appearance. The famous portraits of five patriarchs of the Shingon (C. Chen-yen) sect by the Chinese painter Li Chen at Tō-ji, Kyoto (Figure 3), or the Sixteen Lohan attributed to Kuan-hsiu in the Imperial Household Agency (Figure 4) were brought to Japan late in this first period of Chinese influence and dramatically illustrate some of the models available to the Japanese artist. The early eighth-century clay figures of disciples and mourners at the *Parinirvana* (death, or final annihilation) of the Buddha, from the ground floor of the pagoda

at Hōryū-ji, reveal the close connection between Japanese portraits and grotesques and the myriad glazed clay figures produced as tomb furnishings in T'ang China (Figure 5).

Still another category of figural representation in painting and sculpture comprises guardian figures and other supernatural beings and foreigners. Fewer outlanders were present in Japan than in China, where they were numerous, and it was principally the artists' manuals that provided prototypes of the Indians, aboriginals, and Central Asians who figured in representations of the transmission of Buddhism from India through Central Asia. Masks (*men*) of these foreign visages, being likewise portable, were also

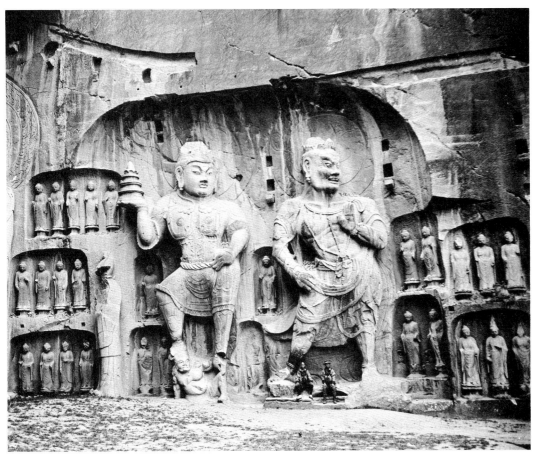

Figure 6. *Guardian Deities.* Side wall of Feng-hsien-ssu cave, Lung-men, Loyang, Honan Province, China. T'ang dynasty, AD 672–675.

available in Japan, and their use in ceremonial processions and dances, both courtly and Buddhist, afforded movement and secondhand verisimilitude for the artist to observe. Besides, there was surely the possibility, however infrequent, for direct observation of such foreign types as acrobats, jugglers, wrestlers, and swordsmen. Seeing the nude or nearly nude male figure gave the artist at least the muscular and proportional schematics for increasingly convincing depictions of the fierce and grotesque Buddhist guardians and demons. The study of armor and of armored figures was also essential in producing the guardian figures (Figure 6), and here the Japanese benefitted from the long *haniwa* tradition of schematically depicting the intricacies of armor.

By the end of the eighth century the Japanese had absorbed a new and complete figural art based on about a thousand years of development in China. This art was grounded in the observation of figures in a limited setting, whether natural or manufactured, but it was filtered through the Chinese predilection for idealized representation governed by a strong tradition of decorum. It had also been drastically enlarged and modified by the iconic tradition imported from India with Buddhism. Although the Chinese example engendered some secular figural art in Japan—such paintings as the screen panels (*ryuchu byōbu*) of court ladies in a simple tree-and-rock setting preserved in the Shōsō-in, and the hieratic image of Prince Shōtoku with two attendants in the Imperial Household Agency—

15

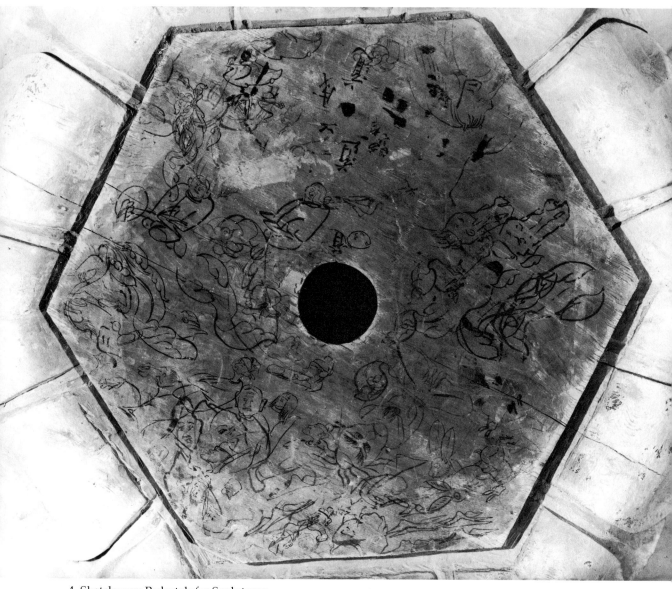

4 Sketches on Pedestals for Sculptures.

it was Buddhist art that had by far the greatest impact there.

The Japanese had embraced Buddhism with unparallelled fervor. In the art of this time secular subjects are far outnumbered by painted and sculptured images, icons, and paradise scenes whose appearance, of necessity, was dictated more by theology than by observation. Mastery of Buddhism's complex iconography and of the rational and balanced style necessary for clear presentation of abstract concepts and transcendent places was largely limited to artists attached to the swelling number of temples in and around Nara, the capital of ancient Yamato in the heart of the Kansai plain.

Once mastered, however, the style could be applied, sub rosa, to more worldly, even subversive, ends. Occasional impromptu sketches have been found in such out-of-the-way places as the ceiling boards of the golden hall (*Kondō*) of Hōryū-ji, Prince Shōtoku's own temple, or the unexposed parts of the sculpture bases from Tōshōdai-ji [4] on the outskirts of Nara. These reveal the artists at leisure, using the new brush techniques to record, quickly and sometimes irreverently, their own observations. There are faces, some heightened into caricature; a few pornographic sketches; and at least one direct and accurate impression of the walking gait of the deer even then common around Nara. These ephemera, probably only a fraction of those actually executed, are significant because they witness the artists' ever-present and irresistible will to record what they saw, whether for self-education or amusement. These surreptitious exercises apart, a primary impetus in the direction of realism was provided by two officially sanctioned and important categories of Buddhist art: portraits of priests, and masks.

Early Portraiture and Masks

The new Chinese and Buddhist subject matter of Japanese art for the most part provided a necessary foundation from which new directions in painting and sculpture, including realistic ones, might emerge. But in priestly portraiture some of the most basic problems posed by the relations among appearance, reality, and the artistic image arose at the very beginning, occasioned by the nature of Buddhism itself and by the Japanese adoption of Chinese artistic disciplines.

The historic Buddha, Sakyamuni (J. Shaka; died ca. 483 BC), was not represented as an icon in human form for at least half a millennium after his *Parinirvana*. With the growing tendency in northern and northwestern India to personify the Buddhist ideal and make it the object of adoration (*bhakti*), the Buddha image became a necessary alternative to the previous symbolic representations, but a true portrait was obviously impossible. An ideal image type was introduced, based on Mediterranean Apollo figures and Indian *yaksha* (virile forest deity) prototypes, looking not at all like any previous image of deity but closely embodying descriptions of the Buddha as they evolved in holy literature. By the fifth century AD a classic Buddha-image type emerged in northern India and was disseminated to Southeast, Central and East Asia. Local variation notwithstanding, the Buddha image became a distinctive and readily recognizable ideal portrait of the holiest of men.

Such classic idealization was applied less abstractly and rigidly to the early portraits of holy men and priests. The immediate disciples of the Buddha became types—young, old, foreign—of wise and saintly men, but each type was recognizable by traditional physical attributes as this or that disciple. The Buddha's two favorite disciples in particular, young Ananda and old Kasyapa, have a long tradition of representation and, like the Buddha, are easily identified in most Buddhist art. But as Buddhism became secularized and individualized, particularly in East Asia, theologians and artists had to resolve the problem of representing individuals—living or recently dead holy men and important priests.

The Chinese tradition contained a peculiarly useful example of a primeval form of effigy making easily adapted to the special purposes of the Buddhist priest portrait. The Taoist tradition of "terminal incorruptibility"[1] recognized the superhuman power of particularly holy adepts to maintain the physical self undecayed after death. This was accomplished by self-starvation almost to the point of death, followed after death by drying and coating the body with lacquer or smoking it with incense. Such preserved "self-mummified" bodies have a long and documented history in China and, however distorted the literary or actual remains may have been, the existence of such bodily remains is uncontested. Needham provides rational explanations of the phenomenon, which requires certain climatic conditions and/or a pragmatic chemical (or alchemical) technology found only in China. Since Buddhist holy men were the new sages of the imported and triumphant religion, what would have been more natural than to continue the already ancient tradition with the variations required by the history of the transmission of Buddhism?

Two types of priest image embodying the concept of terminal incorruptibility appeared,[2] both significant in the origins and development of the later sculptured or painted priest portrait. One

was the *shin shin zo*, derived directly from the Taoist self-mummification tradition. The earliest and most influential *shin shin zo* is the portrait-mummy of the Sixth Patriarch of the Ch'an (Zen) sect, Hui-neng (639–716), preserved in the Liu-tsu-tien at the Nan-hua Temple, near Canton in Kuangtung Province, southern China.[3] Now black with repeated coatings of incense and lacquer over added segments of cloth and iron sheeting, Hui-neng's remains are still an impressive sculptural image of an ancient and emaciated sage. This desiccated appearance is significant, for emaciation, natural enough in the preserved corpse, also signified one of the stages in the Buddha's spiritual development, his attempt to achieve Enlightenment by extreme, prolonged fasting. A special category of seated stone Buddha images from the Gandhara region of India-Pakistan exemplified this phase of the Buddha's life, and a related representation was to emerge later in Ch'an and Zen art as *Sakyamuni Coming Down from the Mountain [Shussan no Shaka]* [65]. The mummified image of Hui-neng was an object of pilgrimage and greatly influenced later sculptured images, especially that of Ganjin (C. Chien-chen; 688–763), the blind Chinese priest who founded Tōshōdai-ji in 754 and whose dry lacquer portrait is one of the treasures of early Japanese art.

The second portrait-sculpture type incorporating the physical remains of the subject is the *kotsu hai zo*, an image made, at least in part, of the ashes of the deceased. Obviously the *shin shin zo* developed out of the Chinese practice of post-mortem interment and the *kotsu hai zo* from the Buddhist (and Indian) tradition of cremation. The earliest *kotsu hai zo* was probably that of Wu-hsiang (d. 756), made of clay and ash and no longer in existence.[4] No portrait-sculptures of this clay-ash type are presently known, but Inoue[5] mentions two variations: the wood mask of Ennin (d. 864) placed with his ashes in his coffin at Risshaku-ji, Yamagata Prefecture; and the more pertinent wood effigy of Enchin at Onjō-ji (Mii-dera), Shiga Prefecture, whose inner cavity contains the priest's ashes.

Those few Japanese clay sculptures known from the Nara period are standing figures of deities, such as the Twelve Generals of Yakushi at Shin Yakushi-ji, or the Bonten, Taishakuten,

Nikkō, and Gakkō in the Sangatsu-dō of Tōdai-ji. The numerous smaller clay figures in the pagoda of Hōryū-ji include representations of disciples and mourners but, perhaps only because of their relatively small size, seem more related to T'ang tomb figurines than to the portrait type now being considered.

Portrait-sculptures incorporating or containing ashes of the deceased partake of the fetish concept, which is found throughout the world and in ancient China was embodied in small talismanic figures that could be used as substitutes for specific persons in both beneficent and maleficent magic. The clay-ash portrait was a survival of these magical practices and at the same time, containing as it did the ashes of the deceased, a kind of reliquary. Between this fetish-reliquary and the more usual wooden sculpture whose cavity contains a bone or personal possession or *painted* portrait of the deceased the connection is unclear, but the use of the portrait-sculpture as a reliquary is yet another confirmation of its magical nature. Of course, images of deities were used as reliquaries as well, but with holy texts and/or precious relics associated with the deity's local tradition replacing the ashes, bones, hair, or possessions of the portrait-sculpture's subject.

Who qualified for memorialization in the extraordinary portrait-sculptures of this early time? The subjects are of two types: temple or sect founders (*soshi*) and revered high priests (*kōsō*). Most portraits of the former were necessarily based not on direct observation but on literary or artistic tradition, having been made long after the subject's death. High priests, like Ganjin (who was also the founder of Tōshōdai-ji), were more likely to have been seen and remembered by persons available to the artists and priests responsible for the production and efficacy of the required portrait, and in such case at least some individualization was possible within the generally idealistic Chinese figure style of the time. The tension between idealization and particularization was resolved to different degrees in different images. The blind Ganjin seems both a knowable though exceptional individual and an ideal holy sage.

In part, it is the dry lacquer medium that stiffens his representation and makes it seem

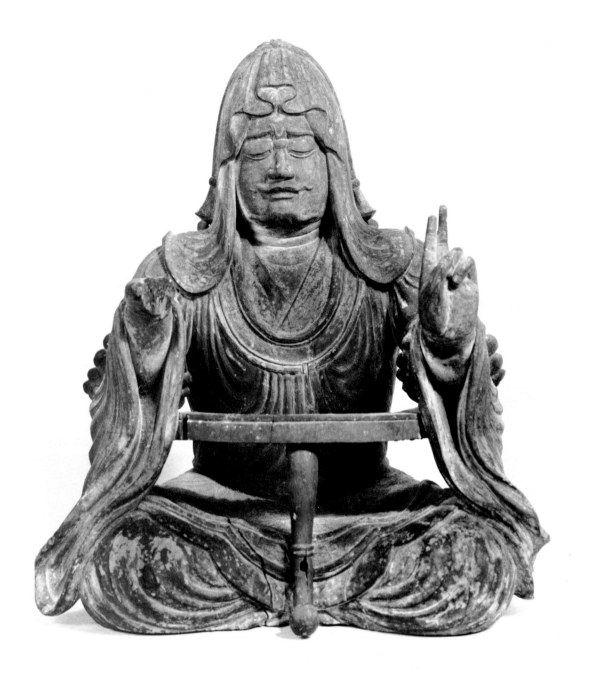

5 *Yuima Koji.*

somewhat abstract. The same cause and effect are visible in the other two priest portraits surviving from the Nara period—that of Gyōshin, abbot of Hōryū-ji (d. 750), and that of Gien (d. 728), abbot of Oka-dera, the monastery he founded in Nara Prefecture.[6] The hardened layers of lacquer-soaked cloth that create the basic shape of a dry lacquer sculpture make of the torso a static surface of drapery folds that barely indicate depth or movement. Characterization is concentrated in the rendering of the head, but it is a type rather than an individual that is characterized, the biography and accomplishments rather than the physical appearance that are portrayed: Ganjin is all blind and patient benevolence; Gyōshin, willful power and ambi-

20

tion; Gien, a *rakan* type, is wrinkled with good-humored concern.

On the other hand, a semimythical personage like the lay sage Yuima (S. Vimalakirti) [5], a contemporary of the historical Buddha, is particularized only within the conventional Chinese representation of the scholar-sage, venerable and seated with the armrest customary for old teachers and scholars.[7] The beard or moustache was traditional in the representation of Indians, hirsute compared with East Asians.

All of the figures discussed above are posed in meditation, and in this respect all resemble a Buddha image. The costumes too are generalized but were not, in this, much different from real monks' robes, which were modelled on the traditional undifferentiated garments of the Buddha and more especially of the members of his order. Priests, whether sculptured or painted, were represented in the same style that was used for deities. The carefully contained and evenly modulated line derived from the early T'ang tradition of China continued dominant until the late Heian period.[8] Sculptured portraits, rare in the Nara period, were almost nonexistent in the succeeding Heian period, in which the more numerous idealized painted portraits of founders and patriarchs (rather than contemporary priests) continued the T'ang brush style.

A very few of the early Heian representations of secondary deities do reveal some efforts at differentiation based on direct observation rather than pattern-book tradition. One of these, the life-sized wooden guardian figure of Daikokuten [6] from Kanzeon-ji, Fukuoka Prefecture, is particularly striking, not for its scowling visage, resembling those of the Nara guardians and generals, but because its costume seems to be a carefully studied rendering of a well-to-do farmer's garment. This earliest known realistic rendition of Daikoku provides the prototype for the evolution of later and increasingly popular renditions of this agricultural deity of plenty. Compared with the numerous other icons of Heian Buddhism, the Kanzeon-ji image appears especially innovative, though it may derive its sculptural simplicity in part from the Shintō image tradition, in which the *kami* (numinous spirits of heroes, ancestors, natural sites, or objects) are commonly represented in contemporary court costumes.

Masks (*men*) are far commoner than portraits in early Japanese art. Some 251 *gigaku* masks are known,[9] almost all of them in Japan and 171 of these in the Shōsō-in, the imperial storehouse within the grounds of Tōdai-ji, the largest temple in Nara.[10] Most of these, along with the twenty-three remaining in Tōdai-ji itself, are associated with the elaborate ceremonies for the consecration of the great bronze Buddha in the main hall of that temple in 752. The 494 *bugaku* masks known to be extant are later in date, the earliest dated to 1042, the latest to 1845.[11]

Gigaku, imported from China and Korea during the Nara period, was a religious dance-drama and processional performed to the accompaniment of flutes, gongs, and drums and was associated with the court and the Buddhist faith. The masks were large, covering the entire head, and made of either paulownia (*kiri*) wood or dry lacquer (*kanshitsu*), both by nature light in weight. *Bugaku*, similar to *gigaku* and likewise introduced from China and Korea, replaced *gigaku* during the Heian period, becoming *the* court music-and-dance ceremony, performed in secular surroundings as well as religious by both professionals and accomplished courtiers. *Bugaku* masks were smaller than their prototypes, covering only the face and sometimes the top of the head. The numerous facial types of the later *bugaku* masks generally reflect the numerically more limited types of the earlier and larger *gigaku* masks. They share two factors significant in the development of realism in Japanese art: the exaggeration of facial features that often spilled over into caricature, and the techniques by which they were made.

Gigaku masks are classifed by Mori[12] into fourteen subjects, including a lion and its keepers, a prince and his daughter, two Buddhist guardians of temple gateways (*niō*, or "two kings," also called *shūkongōjin* or *kongō rikishi*), a giant bird, a grotesque barbarian, a monk, a widower and his sons, a drunken foreign king and his drunken attendants. The widower (*taikofu*) [7, 8] is wrinkled with age and hirsute, with real hair attached to the mask. The drunken attendants are usually smiling tipsily. Masks of guardians and "barbarians" lent themselves especially to caricature and grotesquerie. These qualities are found also in certain *bugaku* masks, notably the

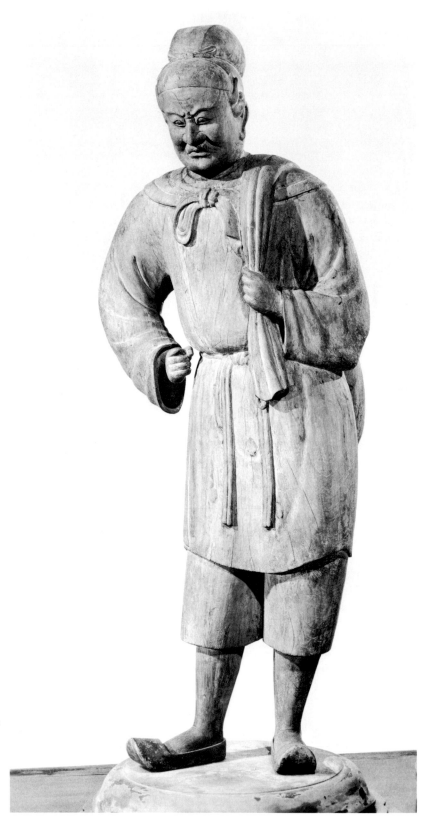

6 *Daikokuten.*

Opposite
7 *Gigaku Mask:*
 Bearded Old Man.

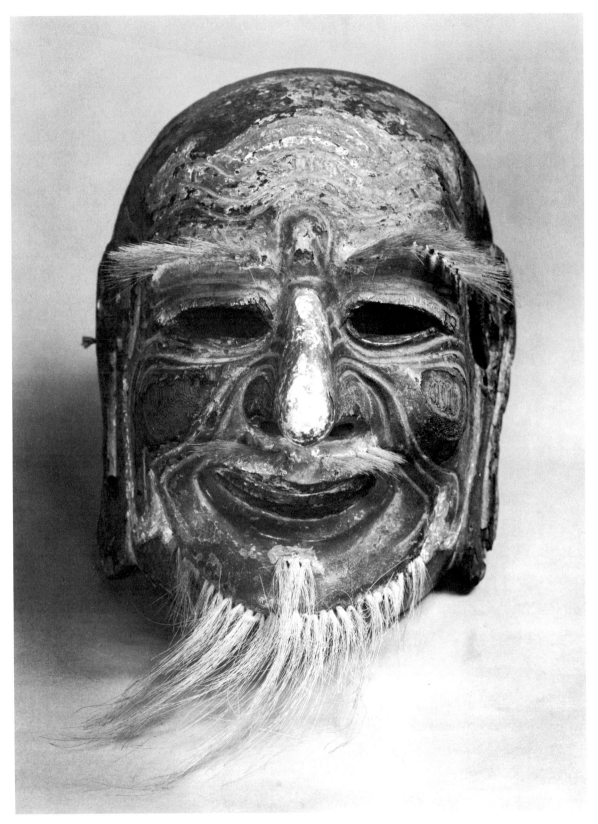

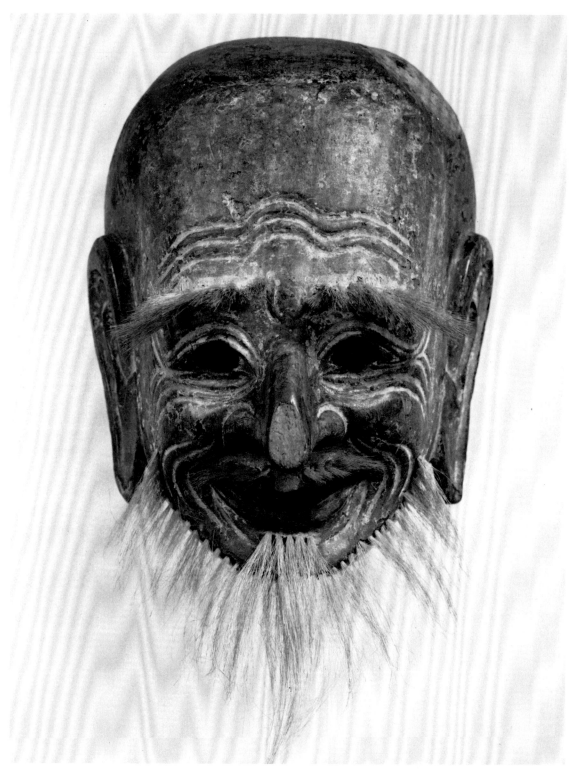

8 *Gigaku Mask: Bearded Old Man.*

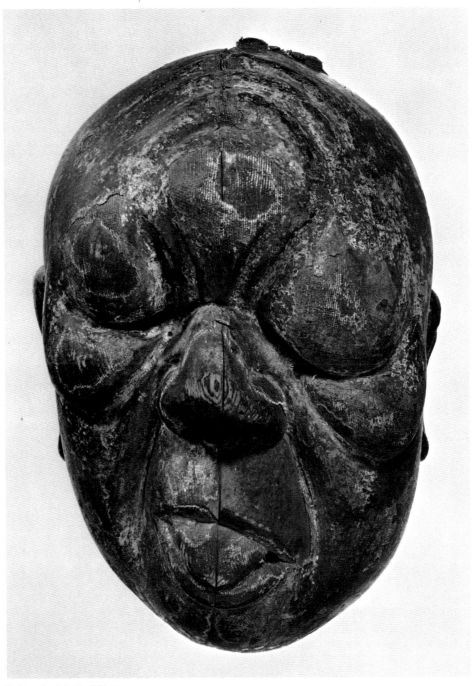

9 *Bugaku Mask: Old Woman.*

hare men, a leprous woman [9] who appears in the *Ni no Mai*, and the *heishitori*, a giddy cup-bearer [10] from the *Kotokuraku*. Their comical crudeness reflects the carver's satiric intent. Since *gigaku* and *bugaku* masks were intended to

be seen in movement, from a considerable distance, and within a theatrical context rich in competing spectacle, exaggeration and a technically broad and summary treatment were especially necessary to create the emphatically ex-

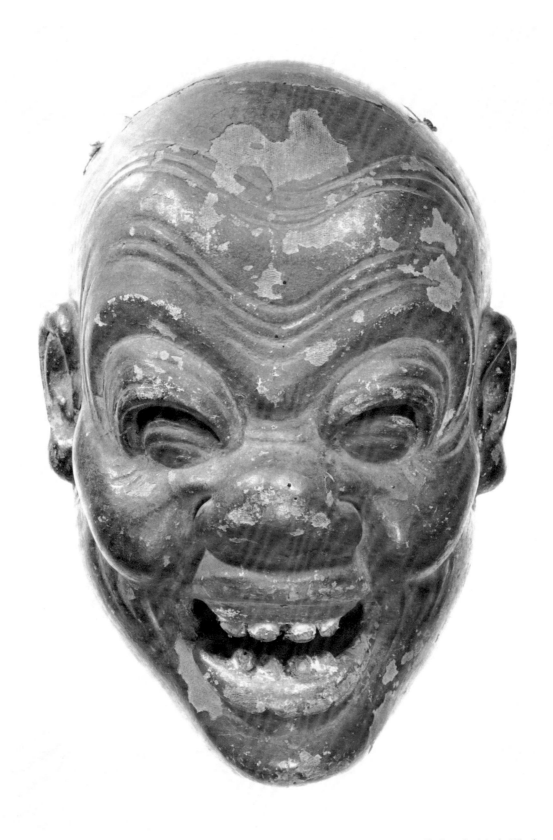

10 *Bugaku Mask: Winebearer.*

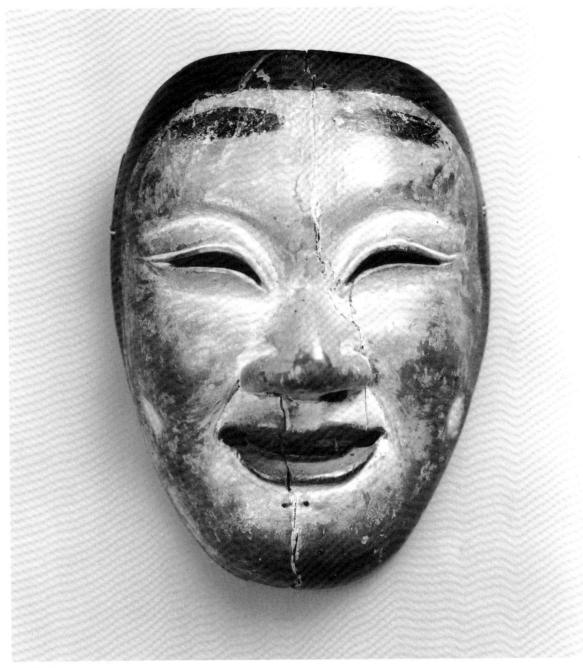

11 *Nō Mask: Man.*

pressive lineaments that alone could command attention and recognition. The aggressive nature of caricature and its reliance upon exaggeration of typical or individual characteristics is common to East and West.[13] Although many of the exaggerated features in the masks were traditional, taken from pattern books and sketches handed down in the studio, without some direct observation the caricatures would have become so generalized as to be meaningless even to the most knowledgeable beholder.

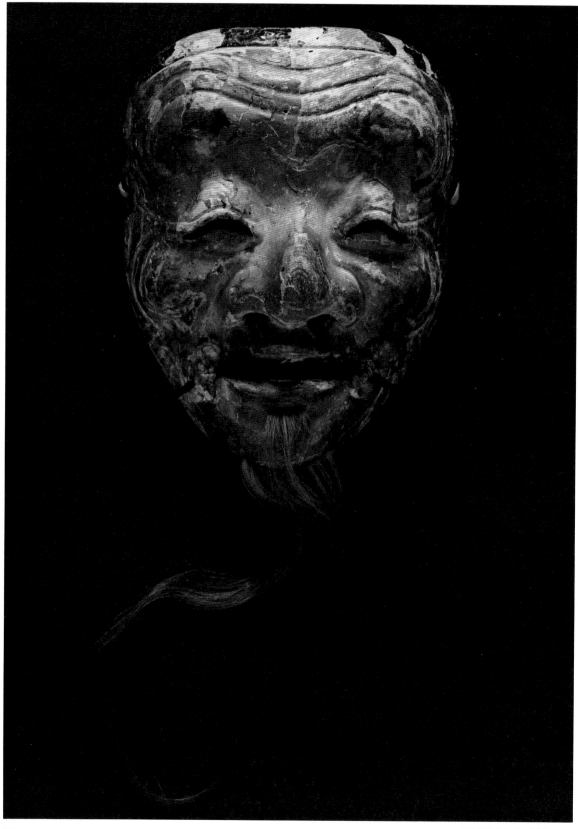

12 *Nō Mask: Old Man.*

Color Plate I. *An Albino,* from *Yamai no Sōshi* [15].

Color Plate III. *Transcription of a Sutra on a Folding Fan,* section of a handscroll [20].

Color Plate II. *The Realm of Humans* [19].

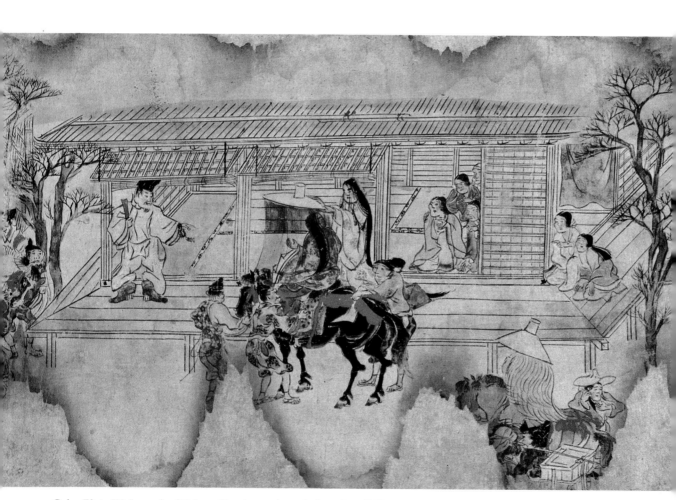

Color Plate IV. *Legends of Kokawa Temple,* section of a handscroll [24].

The second significant contribution of *gigaku* and *bugaku* masks to the development of realism proceeds from their materials, tools, and method of manufacture. Paulownia wood is soft and does not permit much refinement of detail; and masks, unlike large figural sculptures, can be hand-held and manipulated at various angles, thus enabling the carver more easily to check both internal consistency and truth to reality while the work is in progress. Surviving casual sketches left by sculptors and painters confirm the usefulness of this method—studies of mouths, ears, and noses, at different angles and with varied degrees of exaggeration as tests of effectiveness. Mask making sharpened the sculptor's acuity in rendering appearance; it is no coincidence that famous sculptors made masks.[14] The realistic emphasis commonly recognized in much late Fujiwara (897–1185) and Kamakura (1185–1333) sculpture was certainly promoted by the multipart joined wood construction, which permitted the carver to hold in his hands the "mask" of the uncompleted figure.

Gigaku and *bugaku* masks were also a potent source of imagery and attitudes for the development of forms of realism, satire, and caricature in Japanese art. Masks, as Keene has observed in connection with the later *nō* examples, "may actually have been intended to promote realism rather than stylized beauty.... Obviously the mask of a young woman would make an actor more believable in that part than if he played with unadorned face"[15] [11]. A *nō* mask of the earliest type, *Okina* [12], represents an old man whose specific appearance recalls, on a smaller scale, that of the widower in the *gigaku* repertory. Even though the masks were surrogates for reality, they were more than a secondary source of inspiration for the artist. They redirected the attention of both creator and observer to the inspiration of the caricatures: *genjitsu*, "the way things are."

1. For the following discussion I am indebted to Joseph Needham, *Science and Civilization in China*, vol. 5: *Chemistry and Chemical Technology* (Cambridge: Cambridge U. P., 1974), pt. 2, pp. 294–304 on "terminal incorruptibility"; and to *Shozō Bijutsu no Shomondai: Kōsōzō o Chūshin ni Kenkyū Happyō to Zadankai* [*Problems of Portrait Art: Concerning Portrait Sculpture and Paintings of High Priests*], Report V, Committee on Research, Ueno Memorial Foundation for the Study of Buddhist Art, Kyoto National Museum, 25 October 1977 (Kyoto: Kenkyukai, 1978). English summary. Referred to hereafter as *Symposium*.

2. Tadashi Inoue, "The Origin and Development of Priestly Portrait Sculpture in the East," *Symposium*, pp. 2–3.

3. Needham, *Science and Civilization*, vol. 5, pt. 2, fig. 1330.

4. *Sung Kao Seng Chuan* [*Sung Lives of Eminent Monks*], c. 19.

5. *Symposium*, p. iii.

6. Gyōshin's portrait is in the Yumedono, which he built in the east precinct of Hōryū-ji in 739 as a memorial chapel to Prince Shōtoku; Gien's is in Oka-dera.

7. Cf.: (1) Figure of Wang Jung in a Six Dynasties representation of the Seven Sages of the Bamboo Grove, impressed on clay bricks in a tomb at Nanking (reproduced in Ellen Laing, "Neo-Taoism and the 'Seven Sages of the Bamboo Grove' in Chinese Painting," *Artibus Asiae* 36 [1/2, 1974]: 5–54); (2) depiction of Vimalakirti in Pin-yang cave at Lung-men, ca. 520 (reproduced *ibid.*).

8. Genzo Nakano, "Comments," *Symposium*.

9. Peter Kleinschmidt, *Die Masken der Gigaku des ältesten Theaterform Japans*, Asiatische Forschungen, vol. 21 (Wiesbaden: Harassowitz, 1966).

10. For a detailed study, see Hisashi Mori and Kenzō Hayashi, *Shōsō-in no Gigaku Men* [*Gigaku Masks in the Shōsō-in*] (Nara: Imperial Household Agency, 1972). English summaries.

11. Kiyotaro Nishikawa, *Bugaku Masks*, trans. and adapted Monica Bethe, Japan Arts Library, vol. 5 (New York and Tokyo: Kodansha and Shibundo, 1978) p. 168ff.

12. Mori and Hayashi, *Gigaku Men*, p. v.

13. Ernst Kris, *Psychoanalytic Explorations in Art* (New York: Schocken, 1972), pp. 173–203; and the related essay in Ernst Gombrich, *Meditations on a Hobby Horse* (London: Phaidon, 1963), pp. 127–42.

14. Nishikawa, *Bugaku Masks*, mentions works by Jōkei and others attributed to Unkei, both major sculptors of the Kamakura period, as well as masks by six other known masters.

15. Donald Keene, *Landscapes and Portraits: Appreciations of Japanese Culture* (Tokyo and Palo Alto: Kodansha, 1971), p. 53.

CHAPTER FOUR

Rokudō and Transient Reality

The transfer of the Japanese capital from Nara to Heian (Kyoto) in 794 and the discontinuance of official relations with a deteriorating China by the end of the ninth century foretokened and promoted a thoroughgoing transformation in Japanese life. One aspect of this change is that subsequent generations became more distinctively—in fact, self-consciously—Japanese in thought and taste. In *The Tale of Genji* a provincial lady described as painfully unfashionable by Lady Murasaki writes in Chinese characters and has garlic on her breath; a retired governor of Hitachi is odd because he fingers his lute in the old-fashioned, Chinese way. The immense debt to Chinese culture was neither forgotten nor repudiated, but to be fashionable was now to recognize "things as they are in the modern world" (i.e., *Japanese* style) rather than in the old Chinese manner.[1]

The greater part of the first two hundred years of the Heian period was dominated by the emperor and his court at Kyoto and by the Tendai (C. T'ien-t'ai) and Shingon (C. Chen-yen) sects of Esoteric Buddhism. Thereafter, however, the imperial organization and the mystery doctrines, both borrowed from China, increasingly failed to serve the changing conditions and temper of the times, and their power and influence dwindled as new and very different forces created unprecedented and characteristically Japanese institutions and styles. Tax-free manors outside the capital (*shōen*) proliferated. These originated in grants by the crown to members of the imperial family, to the great nobles, to the Buddhist establishment, and to lesser aristocrats in reward for civil or military service, or in the legal appropriation by private persons of unreclaimed land. They were progressively enlarged by plots "commended" by their fearfully over-

taxed cultivators to the protection of these tax-exempt landowners, who became the de facto lords of their lands. The central government, helpless to prevent, usually confirmed the subversion by appointing the landowners to the provincial government. Power followed wealth and authority, and the lords of the manors rapidly became leaders of a rising warrior class accustomed to fighting among themselves and flouting central Heian authority. In 1028, in the region of modern Tokyo, the largest-scale revolt to that time was begun by Taira no Tadatsune; after several ineffective moves by the throne it was suppressed by a general of the Minamoto clan deputed by the emperor.[2] This initial confrontation between Taira and Minamoto presaged their final and total conflict, which ended the Heian period in 1185.

As in the provinces the manor lords supplanted the authority of central government without seceding, so at court the Fujiwara clan usurped the imperial prerogative but not the throne itself, and the rational but inapplicable Chinese administrative scheme was replaced by a series of ad hoc regulations and decrees. The Fujiwara monopoly of power, based on generations of remarkably adroit marriage politics, was unquestioned by 899 and reached its apogee when Michinaga (966–1027) was clan chief. In the arts the period of their dominance saw the culmination of certain important trends and the birth or seed-time of others.

In AD 1000 the Heian court, comprising the emperor's entourage and Fujiwara Michinaga's retainers, was the center of a complex, sophisticated, and self-absorbed culture whose consciously aesthetic and formal concerns differed sharply from those of the provincial landowners beginning their move toward power. The inter-

ests and values of Kyoto are beautifully summed up in Lady Murasaki's lines about the former governor of Hitachi:

The governor could not have been called a man of low estate. He numbered among his relatives several high courtiers. Being a man of considerable private wealth, he indulged himself as his status allowed, and presided over an orderly and not at all vulgar household. A strangely coarse and rustic manner, however, belied these tasteful surroundings. Probably because he had long been buried in the remote East Country, he was incapable of uttering a syllable that struck cultivated ears as correct. Aware of this defect, he kept his distance from higher circles at court, and in general maintained a watchful aloofness. He cared little for the flute and koto, but he was an expert archer. Numbers of well-favored women, indeed women rather too good for such a household, had been pulled into its service by the power of money. In dress they were excessively modish, and they wrote bad poetry and fiction and otherwise sought to cultivate the skills that see one through the Koshin vigil.[3]

Discipline and rigor, both intellectual and physical, were inherent in the dominant Tendai and Shingon sects of early Heian Buddhism. Both are Esoteric doctrines, Japanese manifestations of Tantric tendencies in the Mahayana Buddhism imported from India through China, though Tantrism was originally more prominent in Shingon than in Tendai. (A few Esoteric centers remain in Japan, including the original Shingon foundation at Mt. Kōya in Wakayama Prefecture.) Tendai and Shingon both preached the way of *jiriki*, salvation "by one's own strength," but this path, in addition to rigorous discipline, required devotion to complicated rituals and icons expressing a secret and mystical vision. Multiplied deities and subtle interconnections of magic, tradition, and doctrine paralleled the courtly preoccupation with minutiae of rank, protocol, and good taste.

Mandalas (J. *mandara*)—geometric cosmic diagrams, usually painted, expressing spatially the precise interrelationships of myriad hierarchies of Buddhas, bodhisattvas, *myōō* (fierce manifestations of the Buddha), guardians, and generals—were one principal manifestation of Eso-

teric Buddhism. Another comprised the painted or carved representations of the austere or terrible aspects of deity (the *myōō*) [13]. These in turn were unfailingly arranged in mandala conformations on the large raised altars of the temples of the new sects.

Some of these temples, such as Tō-ji, were built within the capital; others, in a deliberate (though unsuccessful) attempt to avoid the secular involvements that had corrupted the Nara clergy, were situated in the mountains above Kyoto, and of these perhaps the most famous is Enryaku-ji; still others were even farther removed from worldliness in distant mountain fastnesses—Murō-ji in Nara Prefecture, and the original Shingon complex founded by Kōbō Daishi (Kūkai) on Mt. Kōya. This physical expression of the secret and remote nature of Esoteric ritual lent yet another impulse to the growing decentralization of society. It failed, however, to preserve the purity of the sects. Since all people, including the rulers, were devout believers, many of the temples became rich and powerful, and their growing rivalries led to the creation of still another divisive force, private temple armies of "bad monks" (*akuso*),[4] given to intimidating and attacking each other and even the central government. The dominance of Esoteric Buddhism, like that of the emperor, was by AD 1000 seriously compromised by its own deficiencies.

By the end of the tenth century, a new evangelism was stirring in Buddhism. Nature had always been capricious, and now the political order was increasingly unstable. To ordinary people, enduring precariousness, the Esoteric sects were offering unintelligible and comfortless precepts and deplorable examples of conduct, while their armed mobs exacerbated public danger. Popular anxiety, and the inability of the government to cope with it or the Esoteric sects to allay it, brought to the fore a new emphasis in Buddhism: the worship of Amida (S. Amitabha; C. O-mi-t'o-fo), the Buddha of Compassion, began to spread. Amidism, preaching the soul's rebirth in Amida's Pure Land (Jōdo), or Western Paradise, was no new doctrine but part of the cosmic scheme of Esoteric Buddhism, which had inherited it from the older Nara sects.

What was new was the emphasis given to it by

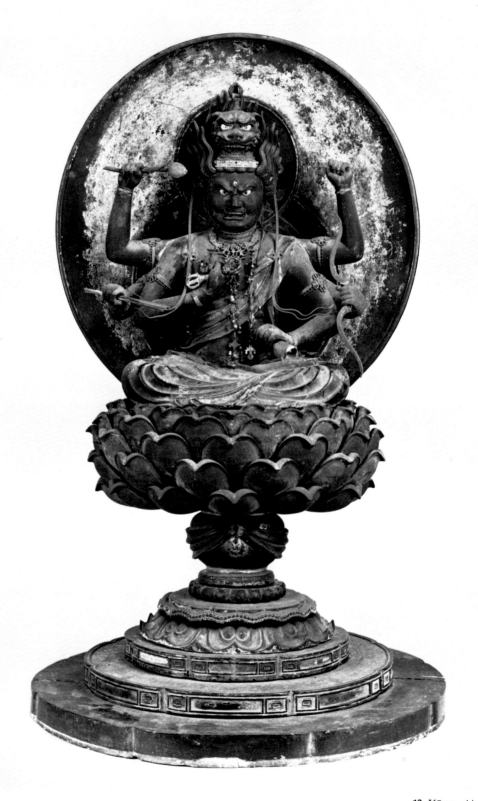

32 13 Kōen, *Aizen Myōō*.

two priests particularly sensitive to contemporary ills and longings. Kūya (903–72) [49] simply focussed attention on the loving kindness of Amida, in contrast with the wrathful manifestations of deity abounding in Esoteric worship. Genshin (942–1017), himself a learned Tendai monk, principally clarified the doctrine of Amidism. In place of *jiriki* (salvation "by one's own strength"), Genshin offered *tariki* (salvation "by the strength of another"), that is, salvation through the divine intercession of the merciful Amida. No longer were arduous spiritual exercises, strict austerities, or rarefied intellectual understanding necessary—only faith in Amida. That faith was simply manifested by the practice of *nembutsu*, repetitions of the phrase "Homage to Amida Buddha." No wonder Amidism surged over Japan like a river in flood. Nor was its appeal limited to the wretched or powerless: the splendid Fujiwara, the modish court aristocrats, were equally drawn to it.

Genshin propounded his new teaching of salvation by faith in the *Ojō Yōshū* [*Essentials of Salvation*], written in 984–85.[5] While most of it recounts the pleasures of the Western Paradise, more often quoted are the earlier passages depicting the terrible and endless tortures of the hells. These have a particular significance for our exploration of the development of realism in Late Heian and Kamakura art.

The opening words of the *Ojō Yōshū* set a new tone for the end of the first millennium:

> The teaching and practice which leads to birth in Paradise is the most important thing in this impure world during these degenerate times. Monks and laymen, men of high or low station, who will not turn to it? But the literature of the exoteric and the esoteric teachings of the Buddha are not one in text and the practices of one's work in this life in its ritualistic and philosophical aspects are many. These are not difficult for men of keen wisdom and great diligence, but how can a stupid person such as I achieve this knowledge? Because of this I have chosen the one gate to salvation of *nembutsu*. I have made selections from the important sūtras and shāstras and have set them forth so that they may be readily understood and their disciplines easily practiced.[6]

The reference to "degenerate times" is to *mappō*, the last of the three historical stages of the law in traditional Buddhist belief, when the Noble Eightfold Path of the Buddha would become inaccessible to all men. It was a period of ultimate degeneration and destruction, widely expected by the Japanese to begin in 1052. This millennarian concept recalls that prevalent in Christian Europe, where the year 1000 was thought to signal the end of the world and the Last Judgment. Toward the end of the tenth century in Japan symptoms of *mappō* were not far to seek, and the concept could only have reinforced a growing feeling of despair among all classes of society. Even aside from *mappō*, in Buddhist teaching suffering is inherent in this world, into which one is reborn according to one's karma (J. *inga*, cause and effect) until one has achieved Enlightenment. A recurring refrain, over and above references to the evanescence and transience (*mujōkuan*) of life, was, "To what *inga* do I owe this suffering?"[7] The scrolls representing the sufferings of this world—the *Kūsō Zukan E-maki* [*Scroll of the Nine Aspects of Decay*] [14], known also as *Ono no Komachi*, and the *Yamai no Sōshi* [*Scroll of Diseases and Deformities*] [15; Color Plate I]—and the far worse retributions in hells—the *Jigoku Zōshi* [*Scroll of Hells*] [16]—project this terror and despair with hallucinatory zeal and powerful, descriptive realism.

The embodiment of the *inga* was *Rokudō*, the Six Realms of sentient and recurring existence enumerated by Genshin: hell (with eight sections), hungry ghosts, animals [18], fighting demons, humans [19; Color Plate II], and *devas*, or still-unenlightened deities. These realms were often the subject of literary, pictorial, and sometimes sculptural description, increasing in number at the end of Heian and into the Kamakura period.[8] Though four of the six realms were imaginary, they were populated with images of violence and decay that could all too easily be drawn from life. The images of deities, on the other hand, became increasingly attractive and compassionate under the influence of Amidism, in contrast with the forbidding, or at best impassive, divinities created in the Early Heian period, when the influence of Esoteric Buddhism was

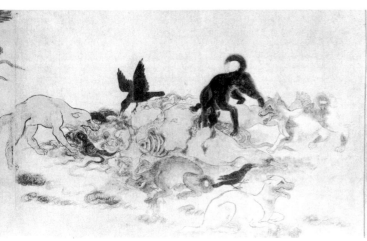

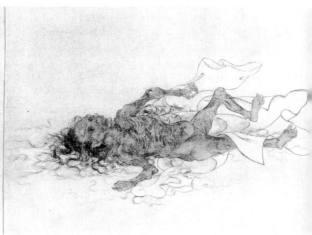

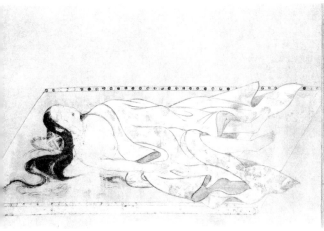
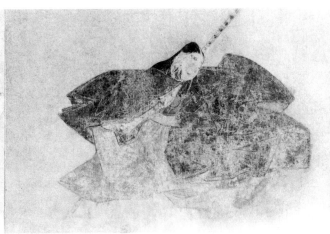

14 *Scroll of the Nine Aspects of Decay,* handscroll.

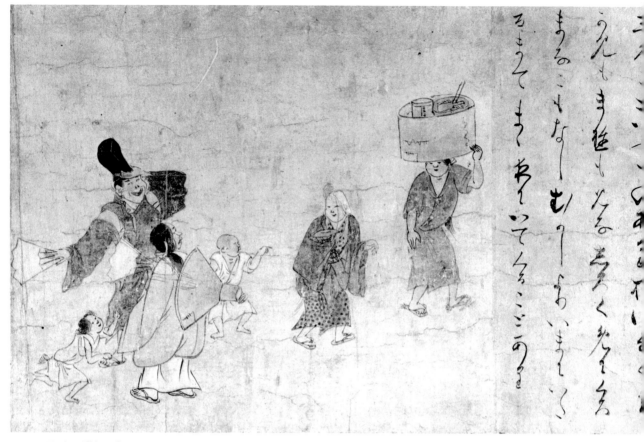

15 *An Albino,* from *Yamai no Sōshi.*

paramount. Fujiwara sentiment, like that of the Italian baroque or of French romanticism, carried with it a strong undercurrent of realism, both to convince the beholder of the truth of the sentiment and to reveal the conditions of life that made compassion and sentiment necessary.

All of these elements, however explicit or vague, came together about the year 1000. Millennarian ideas, Jōdo and the *Rokudō* concept, political decentralization, increasing internecine violence, and the decline of the fashion for things Chinese were major components of a new social tone. They made possible an unabashed examination of the world as it was and laid a foundation for artistic creation during the next

two centuries, beginning with literature and rapidly spreading to the visual arts.

Late Heian painting was, at least in motive, essentially an art of illustration. It visualized contemporary courtly literature of almost suffocating hyperaestheticism but keen psychological insight; the idealized Esoteric and Amidist divinities, the former remote and lofty, the latter approachable and gracious; the scarifying religious visions of *mappō*; religious narratives; and noncourtly secular narratives that tended to be harshly picaresque in tone. Each of these categories made its own stylistic demands. The principal, even the sole, patrons of all of them, however, were the court and the Buddhist temples, and

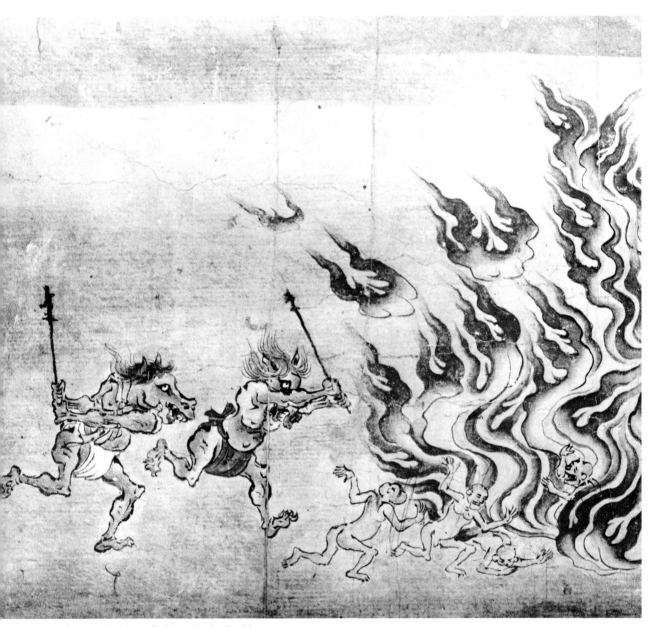

16 *Monks Punished in Hell*, from *Jigoku Zōshi*.

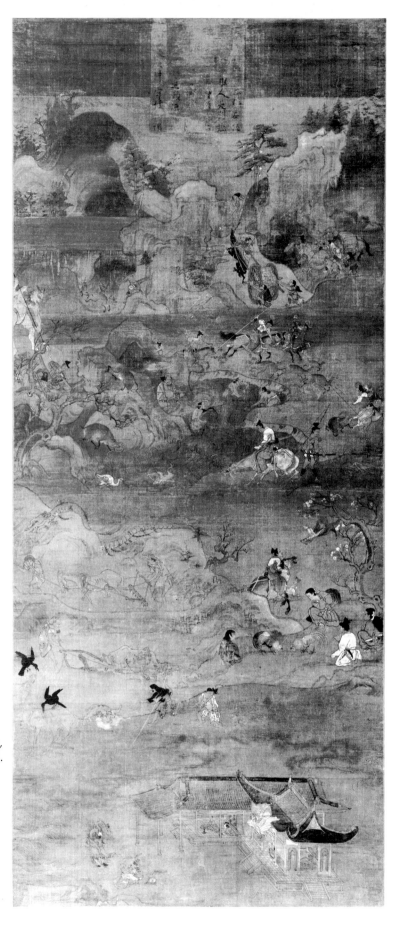

18 *The Realm of Animals,*
 hanging scroll.

x

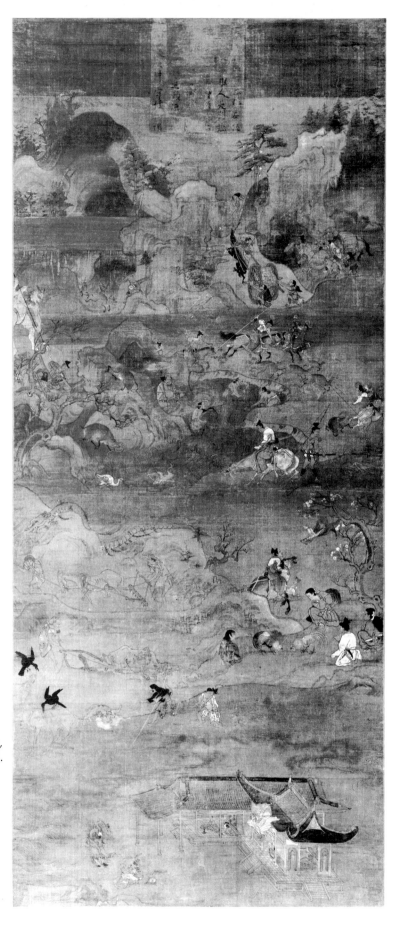

18 *The Realm of Animals,*
 hanging scroll.

38

19 *The Realm of Humans,*
 hanging scroll.

the artists were primarily attached to the imperial atelier (*e-dokoro*) or the temple workshops (*e-busshi*; although court painters of Buddhist subjects were in the Heian period also called *e-busshi*).

The most progressive literature of the time is the work of educated court ladies writing about the life they know. Sei Shōnagon's *Pillow Book* [*Makura no Sōshi*]—half diary, half commonplace book—was begun by this most fashionable of ladies-in-waiting before 994 and ended sometime after 1000 and must just antedate the more famous *Tale of Genji* [*Genji Monogatari*], completed about 1030 by her equally up-to-date rival Murasaki Shikibu (ca. 980–ca. 1030).

> Just then the escorts passed close by my carriage—remarkably close, in fact, considering the vastness of the Palace grounds—and I could actually see the texture of their faces. Some of them were not properly powdered; here and there their skin showed through unpleasantly like the dark patches of earth in a garden where the snow has begun to melt.
>
> The young girls who are to take part in the procession have had their hair washed and arranged; but they are still wearing their everyday clothes, which sometimes are in a great mess, wrinkled and coming apart at the seams.
>
> An elderly person warms the palms of his hands over a brazier and stretches out the wrinkles. No young man would dream of behaving in such a fashion; old people can really be quite shameless. I have seen some dreary old creatures actually resting their feet on the brazier and rubbing them against the edge while they speak.
>
> Indeed, one's attachment to a man depends largely on the elegance of his leave-taking. When he jumps out of bed, scurries about the room, tightly fastens his trouser-sash, rolls up the sleeves of his court cloak, over-robe or hunting costume, stuffs his belongings into the breast of his robe and then briskly secures the outer sash—one really begins to hate him.
>
> If the robe is scarlet, however, it looks better, even though it is just as transparent. I suppose one of the reasons I do not like ugly women to wear unlined robes is that one can see their navels.[9]

Not only the approach but the subject matter is new here. Sei Shōnagon knew, like Blake, that beauty and art rested in minute particulars—but she knew as well that hers was a new iconography.

> If the story teller wishes to speak well, then hechooses the good things; and if he wishes to hold the reader's attention he chooses bad things, extraordinarily bad things. Good things and bad things alike, they are things of this world and no other.[10]

Murasaki feels a greater need than Shōnagon to justify her expanded subject matter, and does so by reference to the existence of both good and bad in *this* world. The *Pillow Book* is anecdotal and discursive, lacking the sustained plot and character development of *Genji*, the world's first novel, but it is sharper in observation and more pungent in comment. Both books have been the source of abundant pictorial illustration: the earliest extant *Genji* illustrations form the extraordinary and famous early twelfth-century scroll traditionally attributed to the court painter Fujiwara Takayoshi;[11] the earliest surviving *Pillow Book*, formerly in the Asano Collection, is dated two centuries later.[12] Both scrolls epitomize the decorative and antirealistic tendencies of Late Heian court painting—the *yamato-e* style. In this they run counter to the direct visual observation of surroundings and the psychological penetration so abundantly present in the writings they purportedly illustrate.

Uneasiness with the new realistic subject matter surfaces again in the Shitennō-ji sutras, where it finds yet a different solution. In this fan-shaped book [20; Color Plate III] inelegent scenes of this world are half-hidden beneath a superimposed printing of the *Lotus Sutra* (J. *Hokke Kyō*), a pious acknowledgement of the superiority of the Buddha's realm over the imperfect here and now.

The expansion of subject matter, of what could be written about and represented, was the first manifestation of the new attention to this world. *Rokudō* provided scriptural justification, and

20 *Transcription of a Sutra on a Folding Fan,* hanging scroll.

many works in the new mode are directly associated with the miseries inherent in the Six Realms of Reincarnation. A work by the perhaps-legendary court painter Kawanari (trad. 783–853), known only through literary reference, may have foretold the later Heian preoccupation with *Rokudō.* Kawanari is said to have startled people with his realistic painting of a "black and bloated" corpse which he placed in a darkened room.[13] This is a standard motif in *Rokudō* works, of which the most complete surviving examples date from the Kamakura period [18, 19]. Most of the extant scrolls are *kakemono* (hanging scroll) sets representing the Six Worlds, those of men and of beasts evoking the sharpest and most extensive examination of the visible world. Such scenes were also to be found in the foregrounds of Amidist representations [21] based on the writings of Shan-tao (613–81), a Chinese patriarch of the Pure Land sect. In his parable of the White Path Crossing Two Rivers (J. *Niga Byakudō*), thieves, monks, decomposed corpses, and elegant courtiers together constitute a believable world from which the devotee may flee to the realm of Amida beyond the rivers of fire and water. The Kamakura style of

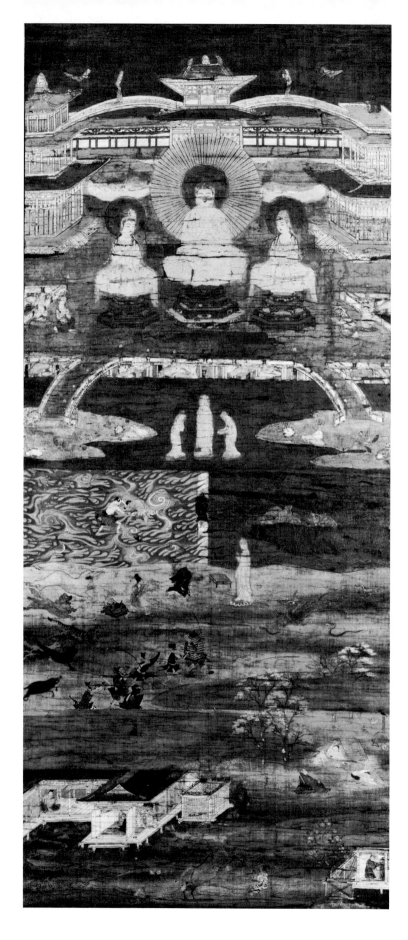

21 *Niga Byakudō,*
hanging scroll.

the visible world in *Rokudō* and *Niga Byaku-dō* paintings derives from earlier works we are now to consider.

No greater contrast exists than that between the decorative style of the *Genji* scrolls and the style seen in the handscrolls of *Rokudō* and narrative subjects produced in the second half of the twelfth century.

Traditional usage describes the new Japanese painting styles of Late Heian as *yamato-e* (Japanese pictures) and distinguishes between a woman's style (*onna-e*), represented by the *Genji* scrolls, and a man's style (*otoko-e*), epitomized by such handscrolls as the *Kokawa-dera Engi* [*Legends of Kokawa Temple*] [24], *Shigisan Engi E-maki* [*Legends of Mt. Shigi*], *Yamai no Sōshi* [15], and *Jigoku Zōshi* [16]. The *onna-e* are decorative, highly and opaquely colored, carefully composed within a strong geometrical framework; outlines are fine and even and faces schematized, with a simple L for the nose and tiny dashes for eyes and mouth; blocks of text and illustrations of individual scenes alternate, each clearly marked and limited in width, allowing no continuous development of representation along the full length of the handscroll.[14] The contrasting *otoko-e* style is narrative and cursive, slightly and transparently colored, loosely composed in a flowing and informal way; outlines are calligraphic and faces well observed and individualized, often caricatured; the picture is usually extended over long sections of the handscroll (*e-maki*)—hence the designation "*e-maki* style."

Where do we find the *e-maki* style? Not in paintings from the court atelier, but in works associated with temples, either in representations of *Rokudō* or in various continuations of the cursory notation or impromptu sketch traditions. These latter are found on sculpture bases [4], boxes, and auxiliary Tantric implements [22]. Another, slightly later, example of *e-maki* style comes from the Kamakura period, when eighth-century scrolls of the *Kako Genzai-e Inga Kyō* [*Illustrated Sutra of Cause and Effect*] were copied several times, once by the well-known painter Sumiyoshi Keinin. The *Inga Kyō* was a continuous narrative, rendered with continuous pictorial representation on the upper half of the

scroll and continuous sutra text below. Closely derived from T'ang and earlier Chinese examples, the *Inga Kyō* illustrations are informal and notational, with elementary landscape settings that are even more cursive and transparently colored in the Kamakura than in the Nara versions. A more complex and free work in the Late Heian sketch manner is the rendering of the *Kegon Gojūgosho E-maki* of Tōdai-ji (Figure 7), the story of Zenzai Dōji's (S. Sudhana) pilgrimage to abodes of fifty-five saints, a basic text of Kegon Buddhism in the Nara period.

Jigoku Zōshi [*Scroll of Hells*] is a direct illustration of *Rokudō* and of the first part of Genshin's famous text describing the tortures and unbearable pains of the punishments in the eight hells. Three rolls are known: one of four hells in the Tokyo National Museum (from the Anju-in, Okayama Prefecture); one of seven hells formerly in the Masuda Collection and now divided, with one section in the Seattle Art Museum [16]; and a third with seven hells in the Nara National Museum (formerly in the Hara Collection, Yokohama). All combine illustration and text in alternation. All owe something to Chinese hanging-scroll sets representing the Ten Judges of Hell, in which the lower parts of each painting are devoted to gruesome depictions of the tortures endured by the miscreants condemned by the judges above. But the Japanese *Jigoku Zōshi* suggest more movement and the victims seem more frail and human, plebeian types individualized, or at least more variously typified. These plebes are related in appearance and style to figures in the other *Rokudō* handscrolls we will consider. The *Jigoku Zōshi* scroll reveals several different hands at work: an accomplished calligraphic style marks the roll of which one section is now in Seattle; a more static but heraldic and grand effect dominates the Nara roll; the Tokyo painting is closer to the one in Seattle but has a less calligraphic touch. There must have been many more such handscrolls, of considerable effectiveness in restraining evil-doing. Hearing or reading Genshin's text while looking at the graphic renditions of awful punishment must have been as persuasive as the unreal could possibly be.

22 *Wooden Cylinder for Tantric Ritual.*

Figure 7. *Kegon Gojūgosho E-maki*. Section of the handscroll, ink and color on paper, 30.3 x 373.9 cm. (overall). Japan, Kamakura period (1185–1333). Fujita Art Museum, Osaka. Important Cultural Property.

The hell of repeated misery is one thousand [marches] beneath the Southern Continent.... Sinners here are always possessed of the desire to do each other harm.... With iron claws they slash each other's bodies until blood and flesh are dissipated and the bones alone remain. Or else the hell-wardens, taking in their hands iron sticks and poles, beat the sinners' bodies from head to foot until they are pulverized like grains of sand.... And then a cool wind arises, and blowing returns the sinners to the same state in which they were at the outset. Thereupon they immediately arise and undergo torment identical to that which they had previously suffered.... In this hell there are a trillion different numberless tortures....

Those who at sometime in the past bound men with rope, beat men with sticks, drove men and forced them to make long journeys, threw men down steep places, tortured men with smoke, frightened small children, and in many other ways brought suffering to their fellow man, fall into this hell.[15]

In the poignant last sentence, reading like a catalogue of peasant grievances in the midst of more grandiose sadistic visions, we see the close connection of text and pictures with observed reality. The depicted flames may derive in part from traditional representations of fire-edged *mandorlas* and halos of wrathful Buddhist deities such as Fudō (S. Acala) [84] or Daitoku Myōō (S. Yamantaka), but they must also have been based

45

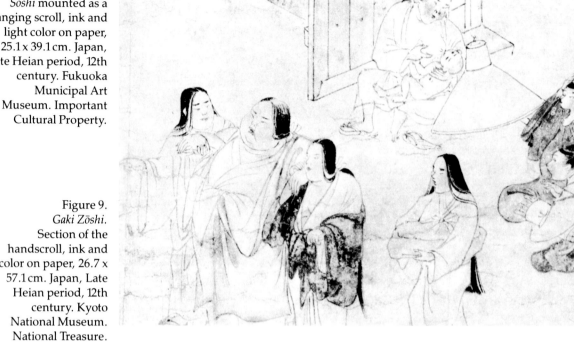

Figure 8.
A Fat Woman.
Detached section of the
handscroll *Yamai no
Sōshi* mounted as a
hanging scroll, ink and
light color on paper,
25.1 x 39.1 cm. Japan,
Late Heian period, 12th
century. Fukuoka
Municipal Art
Museum. Important
Cultural Property.

Figure 9.
Gaki Zōshi.
Section of the
handscroll, ink and
color on paper, 26.7 x
57.1 cm. Japan, Late
Heian period, 12th
century. Kyoto
National Museum.
National Treasure.

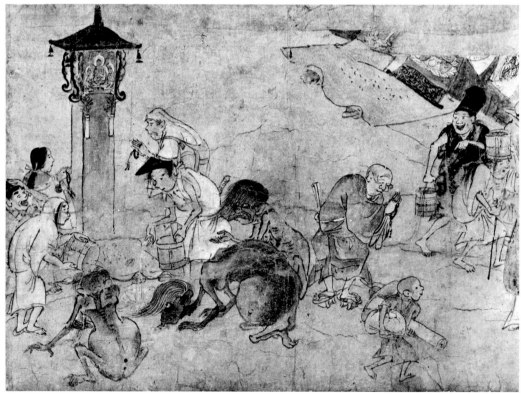

on bitter memories of wooden temples and villages burning. And the demons' zestful grip on their iron clubs is convincing because genuinely observed, either at the execution ground or on the battlefield. Note, too, the contrast between the thin, wirelike lines defining the pathetic gestures of the naked victims and the firm, dark, calligraphic lines outlining the ample musculature of the demons. Nevertheless the artist continued to rely on types, perhaps even on handed-down studio patterns; the screaming figure emerging from the flames at the extreme right could be substituted for the laughing figure at the far right of the Fukuoka Municipal Art Museum's fragment of *Yamai no Sōshi* (Figure 8). *Rokudō* scenes, whether they were, strictly speaking, works of observation or imagination, were vessels in which Japanese artists forged a convincing vocabulary for a more realistic art.

Among the most compelling scrolls in the realistic *Rokudō* tradition is the *Gaki Zōshi* [*Scroll of Hungry Ghosts*] (Figure 9), which exists in two versions, one now in the Kyoto National Museum, the other in the Tokyo National Museum. Although they are closely related and both date from the late twelfth century, the Kyoto example is the more freely drawn and is close to the famous *Shigisan Engi E-maki* in style. The hungry ghosts are the grotesque unfortunates of reincarnation, with bony extremities, distended bellies, leonine or canine faces, and dishevelled hair. Forever famished, they eat and drink what they can get—leavings from shrine offerings, slops, excrement, cadavers. Though invisible to the living among whom they go, they are not so to the viewers of the painting, for whom their misery serves as grim admonition. The human beings around them are shown poorly dressed, carrying wooden pails, shopping for food, praying or making offerings. They are considerably individualized—handsome or ugly, laughing or intent, erect or with an "old woman's back." Deft, rapidly drawn lines sketch their figures and imply their movements. Their gestures are emphatic and ungainly, and their grins show more of malice than of shared enjoyment. They are vulgar and coarse, true likenesses of the plebes and rustics described by Sei Shōnagon and Murasaki—but they are neither effete nor

effeminate like the stylized inhabitants of *onna-e*. Settings for the plebes are minimal but effective: a curving stream may imply a receding landscape, or the entrance to a hovel may suggest a poor village street. Figures are grouped and overlapped, sometimes complexly—the small crowd at the right of the offering scene numbers fifteen. The same direct observation and unsparing depiction used to portray the mundane plebes has gone to compose the extramundane ghosts.

The third of the *Rokudō* handscroll subjects is the dispersed *Yamai no Sōshi* [*Scroll of Diseases and Deformities*], originally one roll of twenty pictures alternating with text. The subject is not merely physical ills but the innate imperfection of the world of mankind in *Rokudō*. The illnesses and defects that bedevil people in this world are pitilessly shown, the horror accentuated by the new means of pictorial depiction. As in the *Gaki Zōshi*, the sufferers are shown in context, not a complete setting but an indication of place. Onlookers smirk or gape in pointed derision. Though their dress identifies many of them as courtiers, and therefore, presumably, people of the most refined aesthetic sensibilities, they appear here as deficient in courtesy and compassion as the plebes and peasants of the *Gaki Zōshi*: other people's defects are not pitiful but diverting. It is a view that society at large, including the artist, seems to have shared, and one that a crass understanding of Buddhism did not refute: bad karma brings suffering. *Genjitsu!* This is the way things are in this transient and painful existence.

Still another handscroll, related to *Rokudō* in theme and also revealing connections between the new *e-maki*, or *otoko-e*, style and the *yamato-e*, or *onna-e*, style is *Kūsō Zukan E-maki* [*Scroll of the Nine Aspects of Decay*], popularly called *Ono no Komachi* [14], now in the Nakamura Collection. While probably dating from the end of the Kamakura period, it continues a tradition we have already found attributed in literary sources to Kawanari, the Heian court painter. Komachi begins as an elegant court lady but ends as a bloated corpse and finally a skeleton. The motif is well known in Western art—the memento mori, the Dance of Death, Hamlet's soliloquy at

Ophelia's grave: "Now get you to my lady's chamber and tell her, let her paint an inch thick, to this favour she must come; make her laugh at that."

The painter of the *Ono no Komachi* scroll divides the progressive deterioration of the lady into stages, each a self-contained composition with only a minimal setting barely suggested—the brocaded edge of receding *tatami* in the scene of her courtly glory, a single *tatami* on her deathbed. Swathed in robes at the scroll's beginning, she lies partially exposed in death, and finally her very flesh is stripped away as her corpse falls prey to a pack of hungry dogs and a single raven, all convincingly shown and not unlike those in the *Rokudō* hanging scrolls depicting the world of animals. At least a passing acquaintance with the structure of rib cage and skull are evident in the representation of extreme stages of decay.

Although the lines depicting the figures are not all thin and even, they are less free, calligraphic, and descriptive of the movement of silhouette edges than the brushstrokes used in the *Gaki Zōshi* or *Yamai no Sōshi*. Just as the theme encompasses the high artificiality of court life and the grim realism of *Rokudō*, so also the style betrays an unresolved tension between the courtly *yamato-e* method and the only-too-physical nature of Ono no Komachi's end. This same tension can be sensed in a scene from the famous and unsurpassed *Ban Dainagon* scroll: the family of the unprincipled Tomo Yoshio (the Ban Dainagon), learning of his disgrace, is represented in *onna-e* fashion but with the distorted, lamenting faces more often seen in *otoko-e*. The discrepancy between subject and style is even less resolved in one section of the Tokyo National Museum's *Gaki Zōshi*, in which little ghosts crawl over the bodies of carousing aristocrats: apparitions and nobles are executed with the same courtly refinement and garment-bound immobility.

Clearly the syntax of the *onna-e* style is neither adequate nor appropriate to earthy or grotesque subject matter. The Late Heian essays in the various subject matters associated with *Rokudō* used both *onna-e* and *otoko-e*; but the forging of an apt artistic style for the representation of this world in all of its manifestations, pleasant and unpleasant, was achieved by the end of the Late Heian and continued in Kamakura, producing a body of narrative *e-maki* that is one of the most creative and distinctive contributions of Japanese art.

1. These corroborative details are cited in Soper, "Yamato-e," pp. 369–70.

2. Ivan Morris, *The World of the Shining Prince* (London: Penguin, 1964), p. 94.

3. Murasaki, *Genji*, 2: 937. For a description of the Koshin vigil, see Joseph M. Goedertier, *A Dictionary of Japanese History* (New York and Tokyo: Walker/Weatherhill, 1968), p. 160.

4. George Sansom, *A History of Japan to 1334* (Stanford: Stanford U. P., 1958), p. 222.

5. See A. Andrews, *The Teachings Essential for Rebirth* (Tokyo: Sophia University, 1973), for a full discussion, and Tsunoda et al., *Sources*, pp. 198–203, for translations of essential excerpts.

6. Tsunoda et al., *Sources*, pp. 198–99.

7. Sansom, *Japan to 1334*, p. 220.

8. For excellent reproductions of many of these works, see Tōru Shimbo, *Rokudō-e* [*Pictures of Rokudō*] (Tokyo: Mainichi, 1977).

9. Ivan Morris, trans., *The Pillow Book of Sei Shonagon* (New York: Columbia U. P., 1967). The above excerpts occur, respectively, on pp. 2, 5, 25, 30, and 267.

10. Murasaki, *Genji*, 1: 437.

11. Alexander C. Soper, "The Illustrative Method of the Tokugawa 'Genji' Pictures," *The Art Bulletin* 37, no. 1 (March 1955): 1–16. Ivan Morris, ed., *The Tale of Genji Scroll* (Tokyo: Kodansha, 1971) is a facsimile reproduction, with commentary, of the surviving parts of this scroll.

12. Shigemi Komatsu, ed., *Nihon E-maki Taisei* [*Collection of Japanese Scroll Paintings*], vol. 10: *Hatsuki Monogatari E-maki, Makura no Sōshi E-kotoba, Takafusa Kyō Tsuya-kotoba E-maki* [*Love Romances, Scenes from the Pillow Book, Love Romance of Takafusa and the Lady Kogō*], by Yoshinobu Tokugawa et al. (Tokyo: Chuokoronsha, 1978), pp. 25–65.

13. Soper, "Yamato-e," p. 359, n. 22.

14. I have preferred to call this style *yamato-e*, and the contrasting *otoko-e* style *e-maki*, since most representative works of the *otoko-e* type utilize the handscroll format to fullest advantage. See *Japanese Decorative Style* (Cleveland: Cleveland Museum of Art, 1961), p. 27ff.

15. Tsunoda et al., *Sources*, pp. 200–201.

CHAPTER FIVE

E-maki: Tales Well Told

Handscrolls (C. *shou-chuan*; J. *makimono*) are made by joining successive lengths of paper or silk to produce an extended horizontal ground for writing or painting. They are stored rolled up, to be displayed from time to time at their owners' pleasure. The Roman *rotulus*, made of vellum, was similar, but it was abandoned in the West.

In China and then in Japan the handscroll developed independently into an amazingly flexible instrument for recording ideas and images. Averaging perhaps a foot in height and often exceeding forty feet in length, the format offered challenge and scope to the artist's imagination and was relatively easy to store, transport, and preserve. Since Chinese and Japanese writing was composed vertically and from right to left, handscroll paintings were similarly oriented to be viewed from right to left. A handscroll is not to be perceived in one sweeping, comprehensive glance, like a framed picture, but sequentially. The hands must unroll the scroll and the eyes travel over it to reveal the successive contents of the work, and so a kinetic sensibility is essential for full realization of the format's possibilities. It offers the viewer a linear, historical process rather than a total image grasped as a *gestalt*, or configuration. Memory, too, is called into play: to appreciate the whole, one must bear in mind (or turn back to) what has been seen already. Development over time as well as space, physical movement, recapitulation, all in a potentially continuous flow, were possible, even mandatory, in this flexible device.

Handscrolls were undoubtedly first used for literary purposes, ranging from philosophy through history and literature in prose or verse to the most mundane inventories and records.

Adaptation to pictorial use was certainly achieved in China by the Eastern Han dynasty (AD 25–220); one of the most beautiful representational handscrolls, the *Admonitions of the Instructress to the Ladies of the Palace*, now preserved in the British Museum, is at least a reflection, if not a copy, of a work by Ku K'ai-chih (ca. 344–ca. 406). Although visually the paintings dominate, the *Admonitions* scroll is an illustrated text, and in this it epitomizes the relationship between writing and image in the later *e-maki*: in the beginning was the word and the visual image followed.

In China handscroll painting reached its summit, beginning in the tenth and eleventh centuries, in landscapes. In these, the almost musical organization of the manifold elements of nature reflects the Chinese artists' strong intellectual and philosophic predispositions, but it does not illustrate a text. Complex figural compositions, which developed earlier than landscape, display a degree of restraint, or better, decorum, that reflects Confucian ideas of right conduct and of the didactic function of art. In Late Heian and Kamakura Japan the progress of *e-maki* was quite different: pictorial narration was the thing, and the active life of this world, whether religious or secular and however transient, became an accepted subject.

It would be hard to imagine a stronger impetus to pictorial imagery and imagination than the literary style and technique of *The Tale of Genji* and *The Pillow Book*, which abound in telling details of glance and gesture and in extended descriptions of dress and scenery. The *Genji* characters, in fact, are often to be found looking at what their author calls *e-maki* (literally, pictorial handscrolls).[1] But the scrolls mentioned *in*

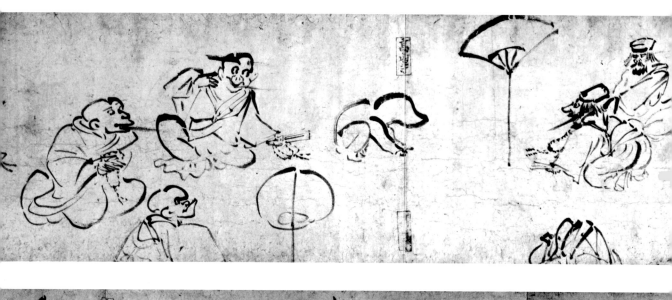

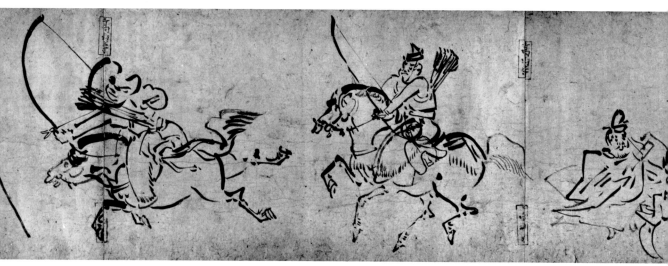

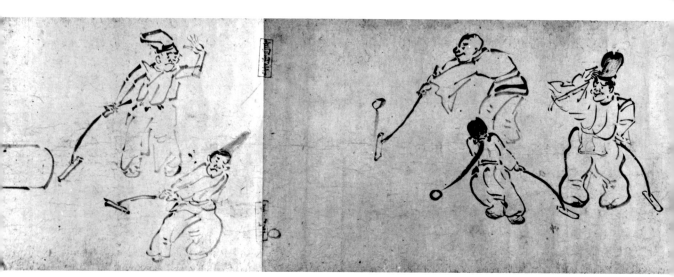

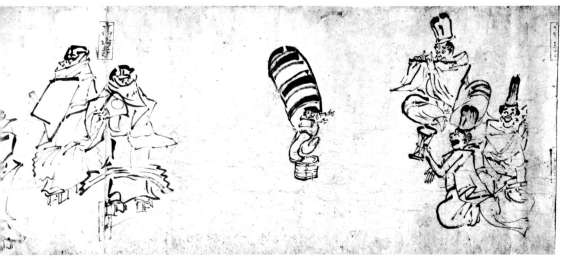

23 *Caricatures of Animals and People,* handscroll.

51

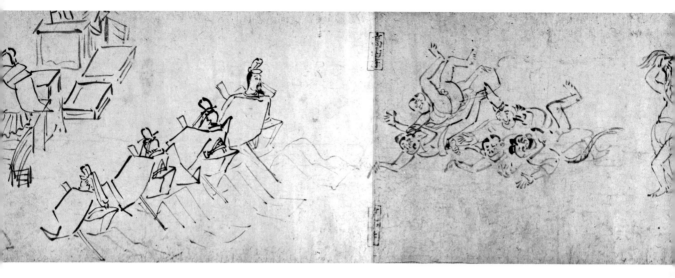

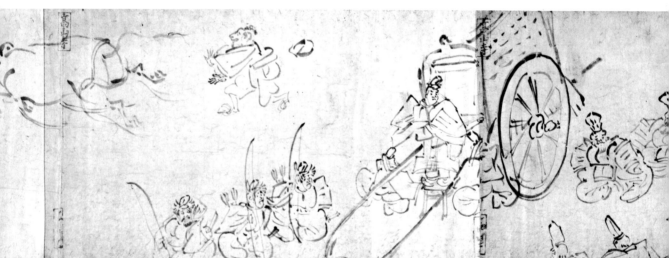

the novel, like the scroll *of* the novel painted about a century later, seem to have been what we have called *onna-e*, or *yamato-e*: discrete and static scenes illustrating and alternating strictly with blocks of text. Further, Murasaki describes such *e-maki* as "dazzling to the eyes," implying the kind of opaque color and decorative emphasis familiar from that twelfth-century *Genji* scroll and later works of the *onna-e* tradition. Convincingly to portray "the active life of this world" required a pictorial narrative instrument more flexible than that which served to illustrate the sophisticated literature of a subtle and ceremonious court.[2]

One scroll may serve as symbolic introduction to the new art of *e-maki*, the dominant pictorial form for the two hundred years beginning about 1150. This satirical work comprises four rolls of monochrome ink *e-maki*, *Chōjū Jinbutsu Giga* [*Caricatures of Animals and People*], assembled as a set in the possession of Kōzan-ji in Kyoto, one of the medieval centers of the Buddhist sketch tradition. The first two rolls, executed in a free sketch style, are among the most treasured and famous of all Japanese paintings and represent frolicking animals; the third roll depicts both animals and people in a relatively tight and fine-line sketch style; the fourth satirizes people in a particularly bold and shorthand sketch manner.

52

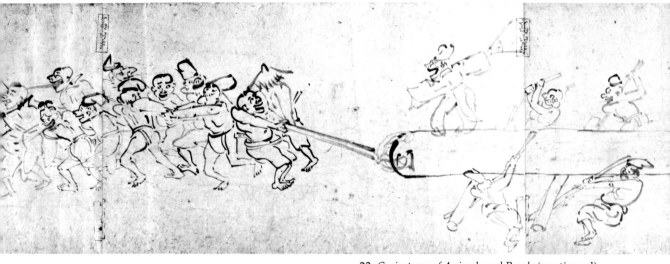

23 *Caricatures of Animals and People* (continued).

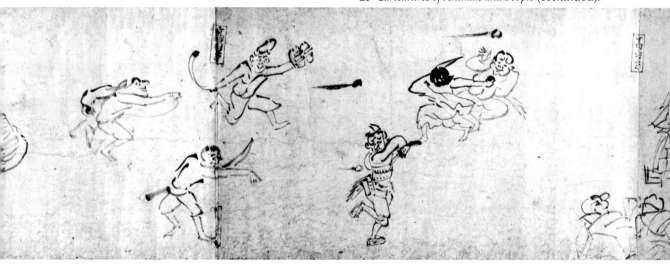

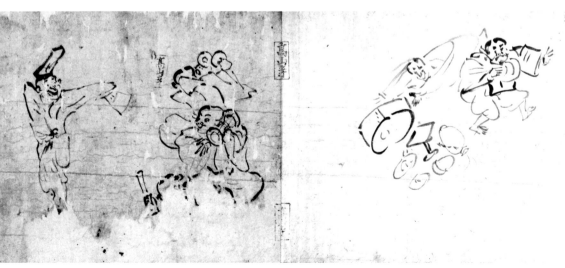

The first two are generally dated to the last quarter of the twelfth century, while the remaining two are usually considered to be works of the thirteenth century. As telling documents of the development of *e-maki* and of satire in medieval Japanese art, they can be considered together.[3]

In contrast with the careful contours and solid color of the *onna-e*, the *Chōjū Jinbutsu Giga* rolls are playfully calligraphic and entirely ink monochrome. The "nail-head" and "rat-tail" strokes are sometimes carefully disciplined, especially in rolls 1 and 2, but often reveal gay, even drunken, abandon, particularly in the fourth roll [23]. The word *abandon* applies with even greater force to the content of the rolls, especially the fourth, which is wholly irreverent and occasionally blasphemous. None of the rolls has a text. The first and second in particular, the fourth to a lesser degree, employ a continuous flowing composition unfolding in varying rhythms from right to left—moving quickly or slowly or pausing, approaching the viewer or receding—all with a brilliant combination of ease and bravura. The beguiling subject matter of the first two rolls— rabbits, frogs, monkeys, deer, mice, horses, and oxen, among others—has so entranced modern viewers that the enormously sophisticated use of *e-maki* format may have been overlooked somewhat.

Roll 4 begins with three grotesque court musicians with flute, drum, and clapper facing left into the scroll and conjuring up a miniature dancer who bursts forth (attired in court hat and long baggy trousers) from a covered wooden pail. A well-cloaked nun (?) appears, looking to the right, signalling her awareness of the first episode despite her position in the second. Her two companions look left to the next incident, a "wind-blowing" contest between two bearded mountain priests (*gyōja*) [48] and three seated monks, one most prognathous and intense. The monks' wind is so powerful that it blows the shirt of the squatting figure in the center of the group over his head toward the *gyōja*. The movement of the composition ascends to the first folding fan at the top of the scroll (presumably one of the targets in this windy contest), then descends to a second, oblate fan of Chinese type. Now comes a sudden shift to the next group— four monks in starched habits, three laymen,

and one figure concealed under a wide-brimmed travelling hat. The last and largest of the monks is conducting a prayer service before embellished altar tables, two candlesticks, and a hanging-scroll icon representing not a Buddha or bodhisattva but a fully splayed schematic frog. A stream of air, probably representing incantations, issues from the presiding monk's grotesque mouth toward the icon. This blasphemy is aggravated by the courtier in customary high hat who lifts the lady's hat to peer at her, oblivious to the caricatured holy ceremony. Occasional nail-head and rat-tail strokes, like those so deftly employed in the first two rolls, attest the confidence of the rough brushwork. Two seated courtiers end the scene, facing inward to the right. They are notably sedate and uncaricatured compared with the other participants in this first satirical segment.

Next, we move sharply to the left, following two mounted archers, the one in the lead aiming at one of three fan-shaped targets fixed in the ground. This scene gives way abruptly to a second dance musicale with three musicians and two dancers, one wearing a "laugher" mask [10]. The first two musicians form a rigid vertical, which is immediately modified by the slant of the two dancers. The lone figure of the prancing drummer ends the tableau, but not before the drummer's stick has summoned up another scene involving sticks: four courtiers and a young boy, all wielding mallets and vigorously playing a kind of dismounted polo.

The mallet of the last and somewhat puzzled-looking courtier is closely juxtaposed with yet another, enormous, "stick," a cylindrical wooden column for a large structure. This is being levered forward by four grotesquely straining workers, and pulled from the left by another team of thirteen. Originally the haulers numbered eighteen, but the rope has snapped and the five in the lead have tumbled in a heap, laughing. One of them, in falling, exposes his genitals and buttocks. The sixth man in the line is still on his feet, holding the frayed rope-end, laughing and relaxed. A single foreman-courtier stands on the pillar shouting exhortations to the crew, a motif that often recurs in construction scenes in later scrolls [29]. The workmen nearest him continue to pull strenuously.

What happens next reveals again the narrative mastery of these early *e-maki* artists. A solemn reading of holy text by an abbot on a raised dais is attended by two caricatured monks seated below and by four courtiers solemnly sitting in echelon on the right. The last of these, the nearest to the preceding boisterous scene, swivels his head to observe the randy work crew, and his goateed face expresses both annoyance and disdain. But the direction of his glance, backward against the movement of the scroll, provides a psychological bridge between the two incongruous scenes.

From the two monks seated along the lower border of the scroll we move up to two plebes who introduce a new and active scene: they and four others, including a warrior in half-armor, are playing a game with slings and balls. One plebe, remarkably well observed, is running, wielding a sling in one hand and shielding his face with two *geta* (wooden clogs). This horseplay is followed by a stock scene from courtly-historical narrative: nine kneeling warriors and attendants watch or assist a noble in his august descent from a large carriage. The stock character of the bearded old retainer on the ground at the right of the carriage wheel is played off against the descending figure of the arrogant, youthful noble supported by two attendants seen from the rear. The last of the military retainers on the left turns in that direction and with his archer's bow points the transition to the next animated scene. Note that the two "serious" scenes, the abbot's reading and the aristocrat's descent from his carriage, are enmeshed in the vulgar, ludicrous, or satirized events that dominate the roll. Church and state are both at risk here.

The succeeding scene is again one of fast and dramatic action: a man, presumably the driver, chases the carriage-bullock as it tears off to the left, the speed of its passage indicated by the most summary of flying brush lines. Two figures face the charging bullock coming from the right. One has fallen, spilling a large wooden tub of food containers on the ground, but the other stands his ground, hands raised as if to stop the runaway bullock. The scroll ends as it began, with a musicale—two musicians tapping handdrums while a fan-dancer performs, his fully

vertical figure abruptly closing the scroll's movement to the left.

The purpose of this long description of the representation is to suggest as fully as possible the skill and complexity to be found in a relatively simple pictorial handscroll. That the tone is predominantly satirical is evident. Whether the artist's temper was malicious or simply highspirited irreverent seems impossible to determine. In any case, the sheer quantity of observation involved in the presentation of this *new* subject matter derived from the mundane world is both impressive and significant. If we subtract some of the satire and caricature and add elements of color, setting, and continuous, selective narrative, we arrive at the fully developed *e-maki* of Late Heian and Kamakura.

Not unexpectedly, a large majority of these later *e-maki* deal with the history of a Buddhist temple or of a famous Buddhist priest. In the comprehensive exhibition of early (pre-1500) narrative scrolls at the Tokyo National Museum in 1974, eight scrolls recounted military histories, five were devoted to secular legends, and three to the history of Shintō shrines, but twenty-two depicted Buddhist subjects, in addition to four scrolls dealing directly with *Rokudō*. As one might expect, the fourteen scrolls illustrating courtly literary romances were almost all in the decorative *onna-e* style. While competition among the now-numerous popularizing Buddhist sects may in part account for the great abundance of religious narrative scrolls, their number primarily attests to the continuing dominance of Buddhism in Japan's medieval feudal society.

One of the earliest and most beautiful of the *e-maki* is the somewhat damaged National Treasure *Kokawa-dera Engi* [*Legends of Kokawa Temple*] [24; Color Plate IV]. It incorporates the old and new elements that became standard constituents of subsequent *e-maki*. To the Buddhist sketch tradition of free, informal, and notational brushwork and the examination of the mundane world prompted by *Rokudō* and by secular literature, the *Kokawa-dera Engi* and three works comparable with it in style and date[4] added color and narrative complexity, including the introduction of man-made and natural settings for depicted action.

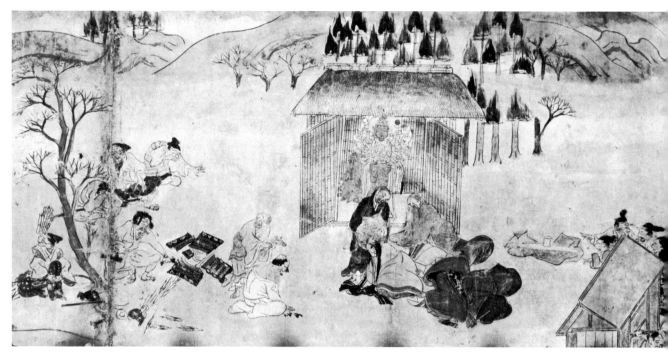

24a *Legends of Kokawa Temple,* handscroll (section).

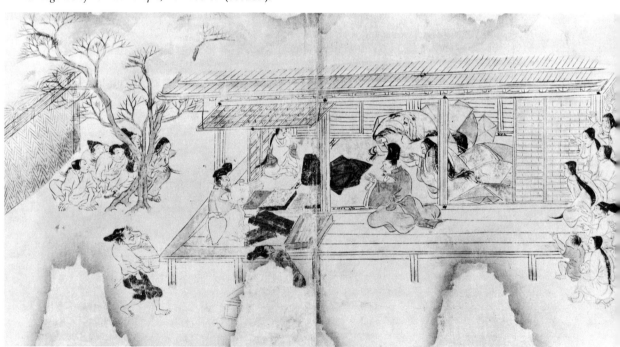

24b *Legends of Kokawa Temple,* handscroll (section).

The color in these late twelfth-century scrolls resembles that found occasionally in Heian Buddhist iconographic sketches. Most of it is transparent wash, although (except in the *Shigisan Engi E-maki*) the lapis blue, malachite green, and cinnabar red are in places saturated and opaque. Most likely this opacity reflects not artistic choice but the mechanical difficulty of making transparent pigments from materials largely composed of solid particles. Even so, the effect against the bare paper is lively, quite unlike that of the precisely and thickly applied colors of the *onna-e*. Illustrated Nara scrolls of the *Sutra of Cause and Effect* [*Kako Genzai Inga Kyō*], copied in the Kamakura period, suggest that these early Chinese style Buddhist narrative scrolls may well have influenced the Late Heian *e-maki*. Certainly the technique of using gemstone pigments in a loose wash derives from such Chinese prototypes, both Buddhist and secular.

Action in the *Kokawa-dera Engi* and its contemporaries occurs in relatively developed settings. These include houses, streets, temples, and pavilions, usually in the isolated or fragmentary forms we have already observed in such *Rokudō* works as *Yamai no Sōshi*. But now landscape settings play a far more important role in the unfolding of narrative. The low, rolling hills, grass-tufted rocks, and spare trees, briefly sketched in ink and colored in malachite green and lapis or azurite blue, look like Japan but are Chinese in aesthetic vocabulary. This seeming paradox is simply explained. In its beginnings Chinese landscape painting created intimate, miniature environments, not the awesome peaks, beetling crags, and deep valleys characteristic of its tenth- and eleventh-century monumental style. The characteristics of the T'ang landscapes imported to Japan at the height of Chinese influence in the eighth century—sweetly colored, gentle, garden-like—were precisely those of the Japanese heartland, the Yamato area encompassing Nara, Kyoto, and their environs. On the wooden doors of the Byōdō-in (dated to 1052), and at Tō-ji, in Kyoto, on the famous eleventh-century screen paintings of the Chinese poet Po Chü-i, are Japanese landscape settings reflecting the T'ang idiom. To the eager, inventive twelfth-century court and temple artists of the Kyoto area they offered a ready-made landscape vocabulary. We shall see fragments of these hills, bands of mist, pines, and rocks adapted to the needs of the early *e-maki* masterpieces.

Narrative techniques, however, were not adapted but invented by these remarkable artists. In *Rokudō* handscrolls text alternates with illustration. The *Chōjū Jinbutsu Giga* rolls contain no text but present continuous scenes of different activities with different participants. In the *Kokawa-dera Engi* (and its three contemporaries are in essence the same) four brief segments of text tell the story, but the scrolls are essentially pictorial and the writing does not interrupt the continuous graphic narrative. One unrolls the handscroll from right to left, rolling up the portion already viewed so as to expose only one episode at a time: thus the action progresses, with the same characters and settings reappearing as often as the story calls for them. The viewer remembers what has happened and anticipates what may happen. The Japanese describe this as *iji dōzu* (different time–same illustration), or as *hampuku byōsha* (repetition picture),[5] but without making explicit that this is the way we actually see and experience the world. It is also the method of literary and—even more immediately—of cinematic narration, and a variant of it appears in the so-called continuous narration of early Western art, in which successive episodes of an event or story are represented within the same frame. In sum, then, the *e-maki*, of which *Kokawa-dera Engi* is one example, incorporate tradition and innovation: subject matter derived from the visible world and rendered as a continuous story sketched against softly colored natural or architectural backgrounds.

Kokawa-dera Engi presents two stories in sequence. The first relates the miraculous founding of Kokawa-dera in the eighth century. Its cast includes only a poor hunter, his family, and the golden image of Thousand-Armed Kannon (Senju Kannon) [24a]. The second tale demonstrates the healing efficacy of Senju Kannon and involves a wealthy family, their sick daughter, and the conversion of the whole family to monastic life. Both stories are proselytizing in intent. They are straightforwardly told in an abbreviated pictorial technique showing the new mastery of *e-maki* style.

We can see the resemblance in brush technique between the Senju Kannon images and many iconographic sketches of the Heian period, represented here by sixteen deities swiftly drawn in black ink around the exterior of a wooden cylinder [22]. (The latter, which held wishes written on paper in its hollow interior, is a particularly esoteric example of Esoteric Buddhist ritual articles.) There are a few complete narrative rolls in this sketch manner, the earliest known being the early Kamakura period *Kegon Gojūgosho E-maki* [*Fifty-five Pilgrimages of Zenzai Dōji*] (Figure 7), whose Esoteric persuasion and didactic intent are attested by the repetitive scenes and the cartouches with explanatory text above each one. Some Chinese characteristics derived from T'ang religious scrolls are also present, but are modified by the informal brushwork and the particularly light and transparent color washes in the now rapidly developing Japanese *e-maki* techniques.

The color in *Kokawa-dera Engi* is beautiful and, despite fire damage to edges of the paper, well preserved. Its evidently rapid application bespeaks its notational character. Settings are abbreviated and include humble architecture—sheds, country houses, sections of fences—in the foreground and miniature clumps of trees and vegetation in the distance. These segments of reality are not placed discontinuously on the blank paper but appear, naturalistically and convincingly, out of horizontal bands of mist. This by-now-omnipresent device originated in the cloud bands characteristic of T'ang Chinese landscape painting; it appeared in Heian Japan in such grand decorative and didactic schemes as the panel paintings of the life of Shōtoku Taishi from the *e-dono* (picture hall) of Hōryū-ji.[6] In the *Kokawa-dera Engi* these bands are subtly and lightly indicated, recalling the thin ribbons of morning mist ubiquitous in the Yamato region. They drift above and below buildings, figures, and landscape and make the abbreviated forms into believable settings.

The rendering of houses is particularly noteworthy: we see not only their exteriors but the action taking place within [24b; Color Plate IV]. This is accomplished by showing us the interiors from slightly above and to one side of the structures, in sharp contrast with the "roofless" convention used in such courtly *onna-e* paintings as the *Genji* scroll. The perspective in which we see the *Genji* interiors is arbitrary, decorative, highly original, and most "unnatural," requiring a disciplined aesthetic knowledge for acceptance even today. The more realistic look into the interiors of the *Kokawa-dera Engi* and *Shigisan Engi* is in harmony with other elements of their *e-maki* style and, like their sketchy and calligraphic brushwork, indicates an origin in temple rather than court workshops. Likewise the omnipresent *pentimenti*—lines that casually pass through one element of the composition while defining some other element—are characteristic of the sketch style.[7]

The figures in *Kokawa-dera Engi* are related to those we have already observed in the *Rokudō-e* hanging scrolls and handscrolls. Facial distortion and caricature are common and appropriate, since the cast of characters comprises plebes and country folk. Only the ladies of the wealthy farmer's household make any pretense at courtly attire, and while they are depicted with a nod to *onna-e* conventions, their robes billow and swell as they move, unlike the more decorative but static garments of the court ladies in *The Tale of Genji*.

Compared even with the *Shigisan Engi* and *Kibi* scrolls, the brushwork in *Kokawa-dera Engi* is remarkably free and summary but also somewhat rustic. Perhaps this reflects the relatively modest position of Kokawa-dera in the contemporary hierarchy of Buddhist temples. We do not find here the supreme sophistication of the three *Ban Dainagon* rolls, which represent the best artistry available to noble patronage. But this very lack permits *Kokawa-dera Engi* a fresh and unspoiled directness, an evident delight in a simple country story well told.

The exemplary lives of Buddhist saints, especially of the founders of important sects or temples, were illustrated in particularly lengthy and detailed narrative scrolls. The longest of these scrolls is the *Hōnen Shōnin E-den*, a pictorial biography of the monk Hōnen (1133–1212), founder of the Pure Land (Jōdo) sect of Japanese Buddhism. It consists of forty-eight rolls painted between 1307 and 1317 and preserved today at the Chion-in, Kyoto. The many artists undoubtedly necessary to produce this mammoth biography of the founder of the Jōdo sect must have influ-

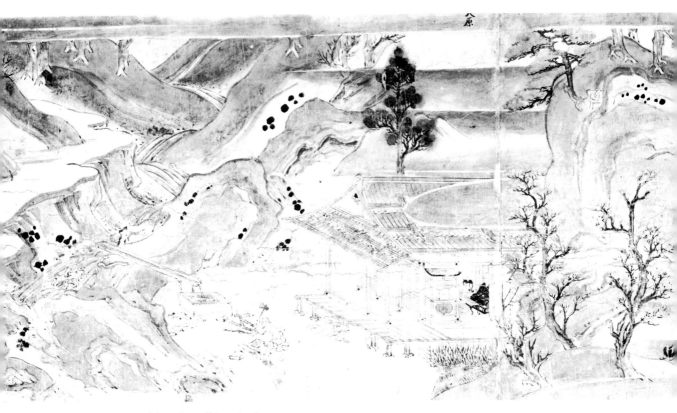

25 *Yūzū Nembutsu Engi,* handscroll (section).

enced the style of other scrolls painted in the early fourteenth century for the Jōdo or related Jōdo Nembutsu sects. The two rolls of the earliest surviving version of the *Yūzū Nembutsu Engi* [25, 26],[8] recounting the story of Priest Ryōnin, founder of the Amidist Yūzū Nembutsu sect, are in much the same style as the *Hōnen Shōnin* scroll. The figures are reduced in scale relative to the settings, a progressive tendency already evident in the late thirteenth century. The text has increased in importance, with the narrative scenes correspondingly abbreviated. Significantly, the most successful settings are those portraying humble villages and rustic retreats. The scene around a village well [26] harks back a century or more to a precursor in the *Shigisan Engi E-maki,* even repeating the by-now stock figure of the bare-breasted woman ladling water from a wooden bucket as she treads her laundry against a stepping-stone. The sleeping dog, bent old woman, and gossiping ladies have also become traditional characters.

The Chicago roll of the *Yūzū Nembutsu Engi* is more colorful than the Cleveland roll, more decorative. In this it resembles some late Kamakura *e-maki,* notably the brilliant and gorgeous *Kasuga Gongen Reigen Ki E-maki* [*Illustrated Scroll of the Kasuga Gongen Miracles*], a Shintō scroll of twenty rolls executed under the direction of the chief court painter, Takashina Takakane, and dedicated in 1309. The more traditional *e-maki* style of the Cleveland roll of *Yūzū Nembutsu Engi* appears to be the work of several artists, including the master responsible for the first roll. The demand for this exceptionally popular religious tract prompted numerous and varied copies and finally, in 1390, a large woodblock-printed edition. This was an early harbinger of the subsequent flood of religious and, later, secular woodblock prints.

The increasing importance of environment relative to figures is symptomatic of a growing interest in landscape during the thirteenth century. But this secular enthusiasm was subordi-

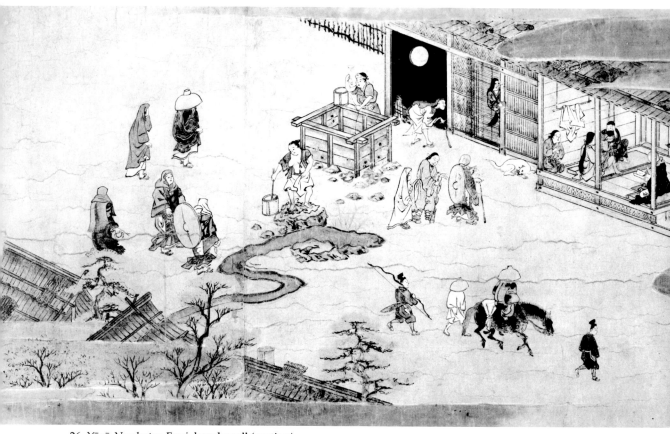

26 *Yūzū Nembutsu Engi,* handscroll (section).

nate to the primarily religious purposes of the
patrons of *e-maki.* Two beautiful and famous sets
epitomize the mounting fascination with nature:
Saigyō Monogatari E-kotoba [*Illustrated Biography of
the Monk Saigyō*] [27; Color Plate v], probably
from the second half of the thirteenth century,
and *Ippen Shōnin E-den* [*Illustrated Biography of the
Monk Ippen*] [28; Color Plate vi], dated to 1299.[9]

The *Saigyō Monogatari E-kotoba* presents land-
scapes with figures, not figures against land-
scape backgrounds. It is both a culmination of
native landscape traditions in the *e-maki* format
and a rare example of the full integration of
landscape, almost as a persona, into a narrative
of religious salvation.[10] Monk Saigyō's social
context was the world of Heian aristocrats, and
his illustrated biography reflects their peculiarly
immediate but thoroughly secular association of
landscape with human sensibilities. At the same
time the scroll suggests that "cherry blossoms
and the moon" can reveal Buddha-nature. Zen,

which was a growing force in Japanese Buddhism
in the thirteenth century, even held that the
making of pictorial images of bamboo, orchid, or
ideal landscape could be a spiritual exercise. The
Saigyō Monogatari's fusion of spiritual biography
with landscape perceived for its own sake and
also as emotional and religious metaphor is a
rare phenomenon in the classic age of *e-maki* and
requires further consideration.

Like the *onna-e* paintings of Late Heian, the
Saigyō Monogatari precedes each scene with a
block of text, often ending with a poem, that
establishes the mood.[11] It resembles *onna-e* also
in its choice of subjects—the beauties of the four
seasons and of sites famed for their loveliness.
This aristocratic orientation is to be expected, for
the man who became the monk Saigyō was Satō
Norikiyo (1118–90), a military courtier-poet of
Late Heian. The first roll, which tells of
Norikiyo's aristocratic origins and his abrupt re-
nunciation of family and court, presents the pal-

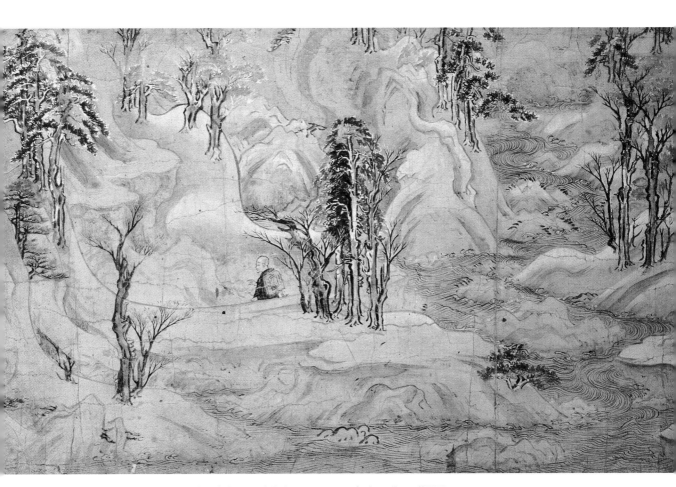

Color Plate V. *Illustrated Biography of the Monk Saigyō,* section of a handscroll [27].

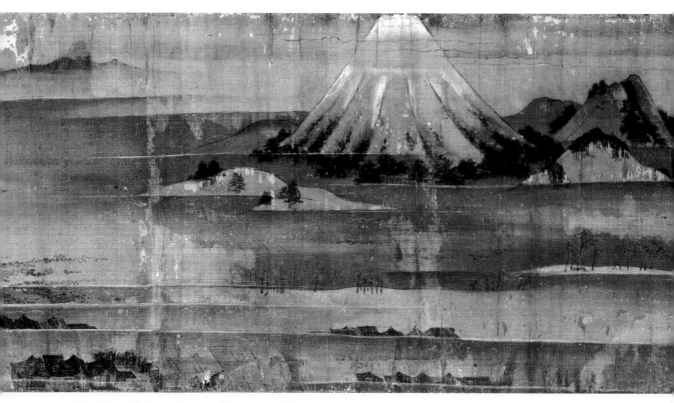

Color Plate VI. En-i, *Illustrated Biography of the Monk Ippen,* section of a handscroll [28].

Color Plate VII. *Gushōjin* [42].

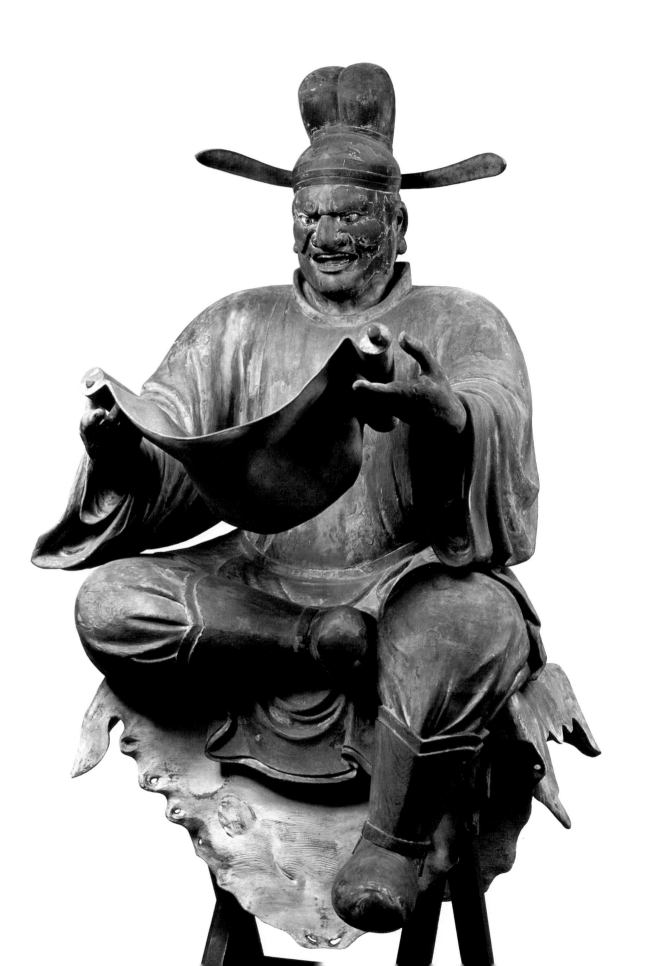

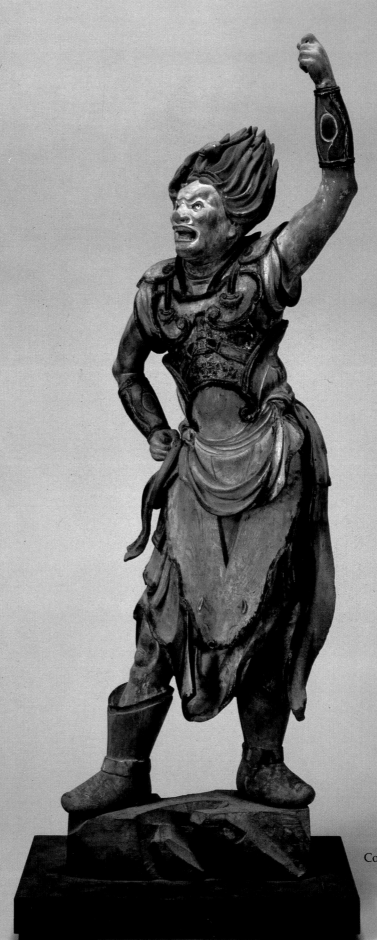

Color Plate VIII. *Uma* [44]

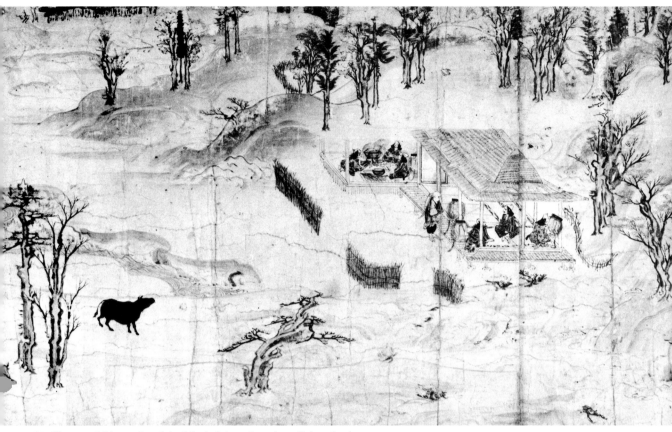

27 *Illustrated Biography of the Monk Saigyō,* handscroll (section).

ace environment in refined detail, emphasizing the strict geometricism of the architecture; the second shows Saigyō, now a monk, still contemplating nature's beauty and writing nature poetry in the courtly tradition [27a], and this roll revels in freely drawn landscape. Saigyō's renunciation of family responsibilities and career advancement has gained him the best of two worlds—religious salvation and aesthetic contemplation. A century later the former court lady Nijō, now a nun, writes of viewing a version of the *Saigyō Monogatari E-kotoba*:

> I remember looking at a scroll when I was only nine years old called "Records of the Travels of Saigyō." It contained a particular scene where Saigyō, standing amid scattering cherry blossoms, with deep mountains off to one side and a river in front of him composed this poem:
>> Winds scatter white blossoms,
>> Whitecaps break on rocks;
>> How difficult to cross
>> The mountain stream.

I have envied Saigyō's life ever since and although I could never endure a life of ascetic hardship, I wished that I could at least renounce this life and wander wherever my feet might lead me, learning to empathize with the dew under the blossoms and to express the resentment of the scattering autumn leaves, and make out of this a record of my travels that might live on after my death.[12]

"Crossing the stream" is a Buddhist allusion to salvation, but the tone and content of Lady Nijō's comment expresses typical courtly susceptibility to the loveliness of nature.

Roll 2 opens with a genre scene of village life [27b], already one of the mainstays of realism in the narrative scroll. The small figures of villagers scurrying about with fuel, food, and the wrapped pine boughs used for celebrating the arrival of the new year are dominated by the environment, a pictorial relationship typical of the second half of Kamakura and indicating a

61

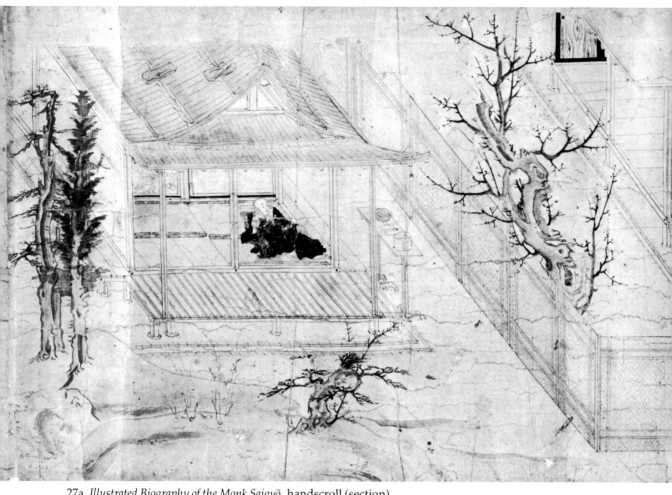

27a *Illustrated Biography of the Monk Saigyō,* handscroll (section).

date in the second half of the thirteenth century, somewhat later than that usually assigned to this work. The third illustration in this roll, the one described by Lady Nijō, is the most famous part of the *Saigyō Monogatari*: the priest is shown searching alone through the winter landscape of Mt. Yoshino for the famous cherry blossoms of the region [Color Plate v]. The next two illustrations, one short, the other long, continue Saigyō's immersion in nature. We see him first before the small Yagami Oji Shintō shrine, where he thanks the gods for his view of the blossoms, and then at the end of an extensive view of Chisato beach with its arc of rough pines. There the priest is shown asleep in a fisherman's hut, his dream of two monk friends made manifest by their figures outside the hut. Despite the

dominance of the landscape, we are prepared for the next episode by the appearance on the beach at the lower edge of the scroll of small figures of the Shugendō (an ascetic Buddhist order of mountain priests) monks whose discipline and company will occupy Saigyō for the next long scene. The contrast between the more delicate features of the shaven Saigyō and the long hair, beards, and rough-hewn appearance of the Shugendō priests is marked, given the small scale of the figures in the rustic landscape.

Remarkably, the landscapes in the second roll of the *Saigyō Monogatari* manage to convey the ruggedness and rankness of untended nature by means of the old *yamato-e* techniques—wriggling ink brushstrokes; deftly applied color; rolling, rhythmic curves for hills and hummocks; and

62

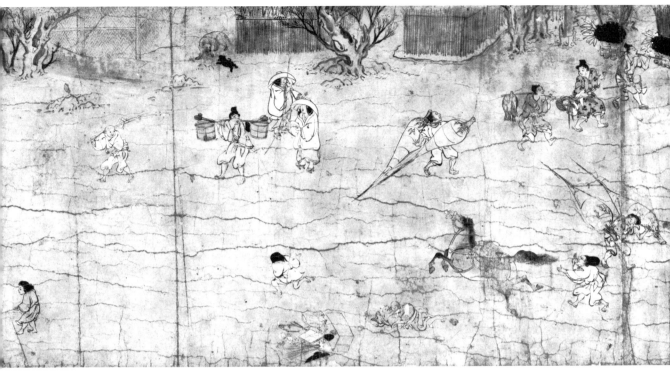

27b *Illustrated Biography of the Monk Saigyō,* handscroll (section).

delicate, closely placed, swirling lines for flow-
ing stream or windswept bay. They bear no trace
of the influence of Sung Chinese landscape art,
already becoming important in Japan by the end
of the thirteenth century. The native manner had
almost always been appropriate for the depiction
of gardens or of nature well swept and pruned,
but here it rises to the challenge of depicting raw
nature. In the *Shigisan Engi* the old *yamato-e* style
had served effectively for sketchy notation of
fragmentary, generalized landscape *backgrounds*,
but in the *Saigyō* pictures landscape has moved
into the foreground and become more complete,
more unified, and more recognizably regional.

The twelve rolls of the *Ippen Shōnin E-den* [28],
dated to 1299, also present narrative within de-
veloped environmental settings but are unusual
among Kamakura *e-maki* in other respects: land-
scape is rendered with increased verisimilitude,
and some scenes reveal Sung Chinese influence;
and the material of the scroll is silk, not paper,
perhaps also in emulation of common Chinese
practice in the Southern Sung dynasty
(1127–1279).

Completed only ten years after the death of
Ippen (1239–89), founder of the Amidist Ji (Time)
sect, by an otherwise unknown priest-scholar
named En-i,[13] the scrolls give an unprecedent-
edly detailed and faithful view of the places,
people, and activities of the period. The en-
cyclopedically long *Honen Shōnin E-den* seems
stereotyped and repetitive compared with the
inventiveness and variety of the *Ippen Shōnin
E-den.*

The vigor and originality of this work is not to
be found mainly in details of brushwork or delin-
eation. In its drawing and characterization the
Ippen Shōnin E-den is not as lively or incisive as
earlier narrative scrolls, nor does it equal even
such contemporary and later works as the *Eshi
Zōshi* [*Story of a Painter*], the *Gosannen Kassen
E-maki* [*Illustrated History of the Later Three Years'
War*], or the *Ishiyama-dera Engi E-maki* [*Illustrated
Legends of Ishiyama Temple*] [29].[14] But the overall
visual unity in many sections of the *Ippen Shōnin
E-den* is new. Earlier narrative scrolls, even the
Saigyō Monogatari, dwelt more on story line and
characterization. Here concentration is on the

63

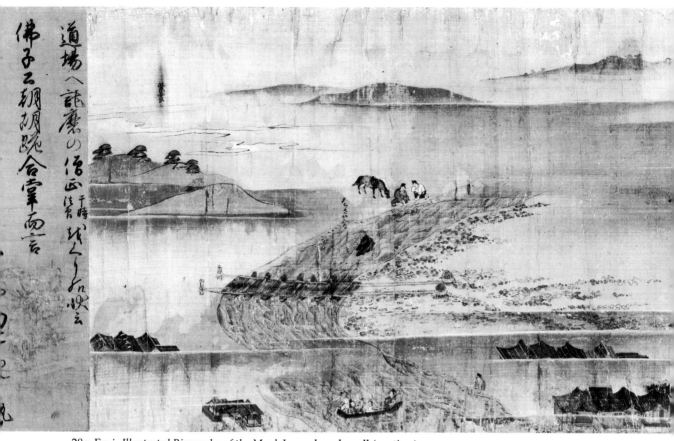

28a En-i, *Illustrated Biography of the Monk Ippen,* handscroll (section).

total context of the narrative—what life looked like along the course of Ippen's long mission. So great is the emphasis on the environment, whether landscape or crowded village, that Ippen himself seems somewhat submerged, as though artist and author-compiler (Priest Shōkai, Ippen's younger brother) preferred to confirm the saint's achievements by the reality of their context.

Some of the unity of space and place is achieved by tonal means, a softening and blending analogous to the style of the Chinese Southern Sung masters, though this may be in part the effect of aging, which darkens silk and abrades ink and color. Further unity and naturalness is accomplished in some scenes by an apparent lowering of the horizon and a flattening of the ground plane, devices also used in the "level distance" category of Chinese landscape painting. Softly mist-banded bamboo groves are indi-

cated in middle and far distance, and this adds to the atmospheric unity of the pictures. The first roll contains an often-reproduced scene that recalls the "one-cornered" compositions of the Ma-Hsia school of Chinese landscape painting; but this, along with the occasional use of "axe-hewn" ink texture strokes (C. *ts'un*) and a few conventionally delineated leaves on deciduous trees, is one of the few specific instances of borrowing. The *Ippen Shōnin E-den's* representational devices are in the main only somewhat less traditional than those in the *Saigyō Monogatari*, but they are used to render a more complete, varied, and particularized picture of Japan's regions and seasons.

The abundant sense of specific place, whether temple, shrine, village, mountain, beach, or waterfall, is peculiar to this scroll, and several writers speculate that En-i or Shōkai, or both, must have visited many of the sites, either together

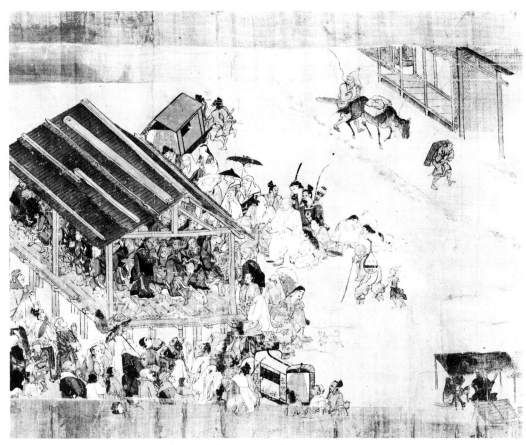

28b En-i, *Illustrated Biography of the Monk Ippen*, handscroll (section).

with Ippen as his disciples or afterward to ensure the authenticity of the scroll.[15]

The scroll opens with Ippen's journey to Kyūshū in 1251, crisscrosses Japan from one clearly identifiable landmark to another for ten rolls, and ends at the Kannon-dō Temple in Hyōgo, where Ippen died on 23 August 1289. In this veritable Baedeker the historic sites are mostly recognizable but not what we would call realistic: landscapes are laid out almost topographically and temples and shrines are represented in traditional *yamato-e* manner. Snow-covered Mt. Fuji [Color Plate VI], wooded at its base, is well shaped but distorted in scale. The same is true of that most famous of all Japanese waterfalls, Nachi. Only the muddy, shallow, swift-flowing Fuji River [28a], surely painted from direct observation, injects an almost jarringly realistic, "life-sketch" note into the unnaturally smooth lay of the land below the great mountain.

The thousands of figures represented in the twelve scrolls—there were over 362 in roll 6 when it was intact—come from all walks of life. They are smaller in scale and more uniform in characterization compared with those in earlier scrolls or in later scrolls of secular and satirical subjects. Most of the figures—the blind lute player, the mountain warrior, the ascetic priest (Ippen is always thin, dark-skinned, plainly dressed, intent), the straining boatman, and others—are familiar types in the vast Kamakura *e-maki* repertory. Some reveal earlier origins, notably the unfortunates huddled in their pathetic sheds just before the dance-praying scene at the Jizo-dō at Katase [28b], who recall *Rokudō* figures. Representations of courtiers resemble *onna-e* types but are few and far between, and the total absence of "roofless" interiors in itself attests the predominance by this date of the popular *e-maki* tradition.

Remarkable sophistication is apparent in the representation of groups and crowds. The artists working under En-i's direction knew not only something of recent Chinese landscape painting methods but also how to suggest large numbers of people by representing a relatively small number. This bit of realistic legerdemain they shared with the painters of military histories, which necessarily involve large numbers of characters. Thus in the scene of dance-praying at Katase beach the dense crowd of participants hidden by the roof of the open platform is expressed by a mere eighteen people visible (or partly visible) at the platform's perimeter. Figures partially seen behind doorjambs, roof rafters, sheds, pillars, and other impediments occur throughout the narrative. Although individually the figures pale by comparison with most earlier representations, the ensemble is convincing. Only one other East Asian handscroll conveys an equally persuasive view of its time and place—the much copied *Going Up-River for the Ch'ing-ming Festival* [*Ch'ing-ming Shang-ho T'u*], now in the Palace Museum, Peking. It is a lengthy view of the city of Kaifeng and its environs, painted in the early twelfth century, probably by Chang Tse-tuan, and one of the few masterpieces of Chinese painting in this genre. Close comparison of the dispassionate, objective complexity displayed in the earlier work with the more lyrical and touching Japanese endeavor is a revealing study in the different sensibilities of the two traditions.

Legendary histories of Shintō shrines were also the subject of *e-maki*, but they are few compared with those of Buddhist inspiration. By far the most famous of these is the *Kitano Tenjin Engi E-maki* [*Illustrated Legends of Kitano Tenjin Shrine*], of which numerous illustrated versions are known. The earliest of these versions, dated to about 1219, comprises eight oversized (52 cm. high) rolls attributed to Fujiwara Nobuzane and still in the possession of the Kitano Tenman-gu Treasure Hall in Kyoto. As one might expect of a work closely associated with the court—the introductory text stresses that emperors have worshipped at Kitano Shrine continuously for over two centuries—the paintings are richly colored, tightly controlled, highly decorative, and self-conscious. Elements from the more informal tradition occur only occasionally here. Even the extensive scenes of hell seem fantastically decorative beside the earlier *Jigoku Zōshi*. The story of the rise and unjust fall of the noble Sugawara Michizane (845–903) and of the building of Kitano Shrine to appease his vengeful spirit is above all a capital entertainment—the court talking about itself and employing the best available talent to tell its story in an unusually large format.

A second *Kitano Tenjin* scroll, the *Kōan bon*, or Kōan era edition, of 1278, survives only in three rolls and some fragments. Evidently it was a subtle and delicate work in a small-scale *e-maki* style analogous to that of the *Saigyō Monogatari*. Along with the other Kōan fragments,[16] the scene in the Seattle Art Museum [30] showing Michizane being taken by boat into exile at Tsukushi, on Kyūshū, indicates a work of quiet refinement in contrast with the grand decorative manner of the 1219 set. The emphasis is on fine linear representation of bodily strain and movement and delicate linear patterning of the gently moving waves.

A third early version of the *Kitano Tenjin Engi* comprises five rolls preserved at the Metropolitan Museum of Art in New York [31]. It follows the 1219 version rather closely except for the expansion of the *Rokudō* scenes of Priest Nichizō's journey through the Six Realms of Reincarnation, a subplot within the overall narrative of the Michizane story. The depiction of Nichizō as a mountain priest (*shugenja*) of the Shugendō sect is not unlike the representations of such monks in the Saigyō and Ippen scrolls, and a date about 1300 seems appropriate for this scroll.

Of special interest is one section common to the various versions of the tale, showing the building of Kitano Shrine [31a]. Descriptive line drawing renders a believably earthy lot of construction workers, in sharp contrast with the more colorful and decorative rendering of subjects in other parts of the scroll. The one courtier present, with his expressionless *onna-e* face, and his stiff coat and baggy trousers depicted by mass instead of line, looks stylistically as well as socially out of place among the half-nude, straining laborers and intent architects and foremen. Such construction scenes occur in many later scrolls illustrating legendary temple origins: the

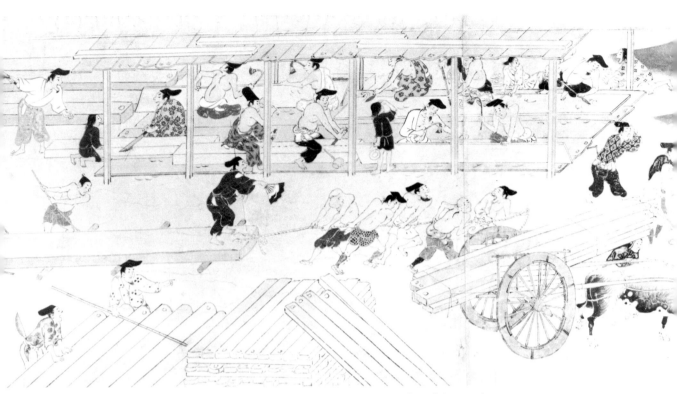

29 Takashina Takakane (attrib.) *Illustrated Legends of Ishiyama Temple,* handscroll (section).

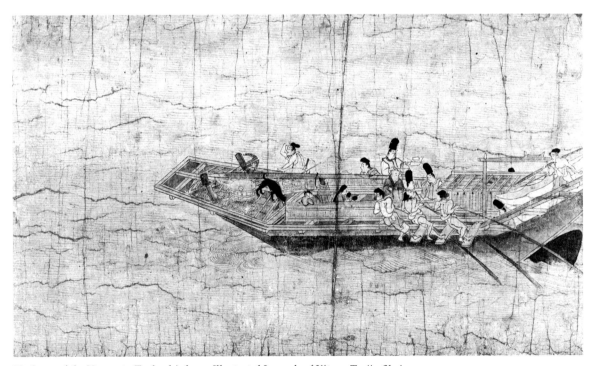

30 *Scene of the Voyage to Tsukushi,* from *Illustrated Legends of Kitano Tenjin Shrine.*

Ishiyama-dera Engi E-maki [*Illustrated Legends of Ishiyama Temple*] [29][17] contains a particularly lively one that provides much information on contemporary building technology. The officious foreman with his fan standing on the huge beam being pulled by straining workmen is well observed, and the contrast between his lively exhortations and the bent and weary shoulders of the workman immediately before him is an effective visual comment on early relationships between management and labor.

The Metropolitan Museum's *Kitano Tenjin Engi E-maki* shares one advanced visual detail with the somewhat earlier *Heiji Monogatari* roll in Boston. Both show rapidly moving, even careening, bullock-drawn carts with the spokes of their wheels represented as stroboscopic blurs of concentric lines and shading [31b]. Rather than giving a conceptual representation of the wheel as they knew it to *be*, both artists chose to show the wheel as it *looked* in fast motion. The two scrolls are among the earliest works known in which a purely visual phenomenon is recognized and described.

Yet another major category of *e-maki* embodying the narrative interests of Kamakura society comprises secular history, principally recent and contemporary military history. Beginning in 1274 the Mongol invasions brought to Japan a decade of higher danger and high deeds. A participant's view of that stern and stirring time is recorded in the seldom seen two rolls of the *Mōko Shūrai E-kotoba* [*Illustrated History of the Mongol Invasion*], commissioned by General Takezaki Suenaga to demonstrate to the High Command his prowess in the field and his just claim to a reward.[18] The scroll, dated approximately to 1293 (just twelve years after the major invasion attempt), is a detailed and telling, if self-serving, record of a decisive contemporary battle.

But the Mongol invasions, though as fraught with peril and heroism as any time in Japan's history, lacked the bitter poignance of civil strife. At any rate, they failed to kindle the Japanese imagination like the escalating struggle for power between the Taira and Minamoto clans, which in the second half of the twelfth century became war to the death. Out of this ferocious conflict came three tautly constructed, tersely written narratives, something between military

history and epic novel: the *Hōgen Monogatari*, relating the events of the insurrection of 1156; the *Heiji Monogatari*, recounting the series of battles in 1159–60 that made the Taira masters of Japan for two decades; and the *Heike Monogatari*, which begins with the struggle renewed in 1180 and ends in 1185 with total Minamoto triumph and the establishment of the first shogunate under Minamoto no Yoritomo.[19]

The ebb and flow of these stirring and bloody narratives is apparent even in translation, and their story-telling method is readily adaptable to pictorial narrative in handscroll form. In about the mid-thirteenth century all three narratives were illustrated. Four early (mid-Kamakura) rolls of the *Heiji Monogatari* survive, and their pictorial brilliance is clearly grounded in the literary qualities of the narrative.

When Toshitsuna hastened up and delivered this message, [Yoshihira] said, "I have heard. Advance, men." And the seventeen horsemen, without flinching, dashed out of the Palace grounds and smashed their way straight into the midst of the over five hundred

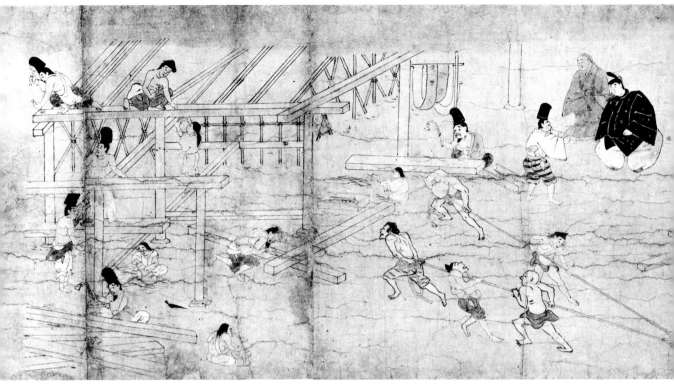

31a *Illustrated Legends of Kitano Tenjin Shrine,* handscroll (section).

31b *Illustrated Legends of Kitano Tenjin Shrine,* handscroll (section).

horsemen. Since it was a force which had started to withdraw, there was no stopping the horses' legs, and they fled down the Omiya [thoroughfare] and eastward along the Nijō [thoroughfare]. "Though he is my son," said [Yoshitomo] in praise, "Yoshihira did charge well indeed. Ah, how he did charge!"[20]

The seventeen against five hundred, the momentum of the horses' legs, and the clear indication by cardinal directions and street names of the flight of the larger force are grist for the painter's mill, capable as he was of representing believable groups in convincing action.

At the head of thirty horsemen, he rode down the cliff. The rest of his men and horses followed. The stirrups of the men behind almost struck the helmets and armor of those before. Since the cliff was sandy, they slid down about two chō and landed on level ground halfway. There they rested. From there downward, however, plunged a great mossy, craggy bluff, a sheer fifteen-jō drop to the bottom. It seemed that they could go no further, nor retrace their steps upward. All of them halted there and thought that the end had come.

Yoshitsune then turned to his men and said: "Back in our native place of Miura we ride down slopes like this even in pursuit of a single bird. This is nothing but a race course for me!"

Shouting these words over his shoulder, Yoshitsune led the way down. All followed him. They grunted under the strain, as they steadied their horses. The sight below was so horrible that the riders closed their eyes. Their actions seemed more those of demons than of men. They shouted their war cries even before they reached bottom. Their cries echoed among the cliffs like those of a hundred thousand.

The soldiers under the command of Yasuyuki set torches to the huts and houses of the Heike. Just then strong winds arose, instantly turning the huts and houses to cinders. Wrapped in black smoke, the men of the Heike rushed toward the sea in search of escape. Many vessels had been drawn up on the beach. But there was such confusion that four or five hundred or even a thousand men in full armor jumped into one; and when it was

rowed some three chō offshore it capsized. In this way two more large craft sank before their eyes. Then it was commanded that only men of high rank get on board. When men of low rank tried to embark, they were threatened by swords and halberds. Even so, they clung to the vessels and strove to drag themselves aboard. Their hands and arms cut off, their blood reddened the sea and beach."[21]

The military *e-maki* abound in such scenes, which lend themselves magnificently to pictorial representation. Repeatedly warriors cry out their pedigrees, ranks, and official positions before joining battle. At times enemies even demand them of each other. This was not mere bravado, still less a purely literary convention. Even the greatest battles were mostly individual combats between mounted knights, and rewards of land, rank, or treasure awaited the winners who could prove that they had dispatched a redoubtable foe. It was, in fact, rather a disgrace to kill or be killed by a nobody. For the same reason the tale introduces every high-ranking warrior with a lovingly detailed description of his armor.

"Aim not at the common soldiers," he ordered. "Close with their great general and smite him. The one [wearing] armor decorated with metal butterflies and orange-tinted [braids] and mounted on a cream-colored horse splashed with yellow is Shigemori. Push abreast of him and close with him and seize him." But Yozō Saemon, and others, some hundred horsemen of the Heike, came between [the Genji and Shigemori], protecting their general so that they could not come to grips with him."[22]

In real life such carefully chosen panoplies served to identify the champions in the field; in the narrative they delighted the audience, like the descriptions of court apparel in which *Genji* abounds. To the *e-maki* artists these set pieces, no less than the graphically described fights that invariably followed, virtually cried out to be painted.

In the fragment of a scene from the *Heiji Monogatari*[23] in the Seattle Art Museum [32] this consuming interest in the representation of armor is extended even to the foot soldiers. The emphasis on nail-head brushstrokes to define

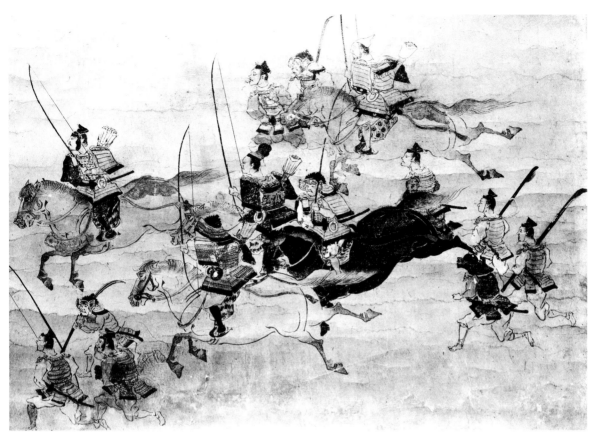

32 *Battle Scene,* from *Tales of Heike Insurrection.*

the horses' contours and interior musculature harks back to the iconographic sketch tradition. The horses at the "flying gallop" convey the speed and urgency expressed in the narrative, while at the same time recalling Chinese hunting murals of the eighth century, whose style persisted in the vocabulary of *yamato-e*. But the intent and somewhat particularized faces belong to the new narrative mode already accepted by the second half of the thirteenth century, the probable date of the Seattle fragment.

The *Heiji Monogatari* is particularly famous in the West because of the superb *e-maki* in the Museum of Fine Arts, Boston. This roll, usually referred to as *The Burning of the Sanjō Palace*, illustrates chapter 3 of the tale. Two other rolls by the same hand or hands (so complex an under-

taking must have involved a workshop) are extant: one in the Seikado Foundation, Toyko, illustrating chapters 4–6; another in the Tokyo National Museum illustrating chapter 13 and the beginning of chapter 14. Another complete roll [33] by a different workshop was rediscovered in 1978. This roll shows us the end of the tale—the story of Lady Tokiwa, widow of the murdered Minamoto hero Yoshitomo, and of his son Yoritomo's gratitude to the nun (mother of his principal enemy) who successfully interceded for his life.

It is not surprising that the *Heiji Monogatari* should have been illustrated more than once. Probably composed about 1220, it celebrated the triumph of the Taira (Heike) and at the same time memorialized the exemplary heroes on both

sides. Told and retold, with and without musical accompaniment, the *Heiji Monogatari*, along with several other epics of the Taira-Minamoto conflict, became perennial popular favorites as well as classics. The Boston–Seikado–Tokyo National Museum rolls, three survivors from a set of perhaps fifteen, emphasize daring compositions with dramatic effect. The Tokiwa roll, from what must have been another equally large set, tends to concentrate on narrative detail. The nature of the story allows for particularly effective contrast between scenes of Lady Tokiwa's piteous journey [33a] to save Yoshitomo's three children (including the future Minamoto hero Yoshitsune) and scenes of violent military combat [33b]. The rough garb of the gentle lady setting out on horseback on her journey provides a well-observed foil to her more formal court dress when she appears as suppliant to the emperor.

Indeed, we find in the Tokiwa roll a combination of military subject matter with more formal and decorative court scenes as well as such sim-

33a *Lady Tokiwa and Her Sons,* handscroll (detail).

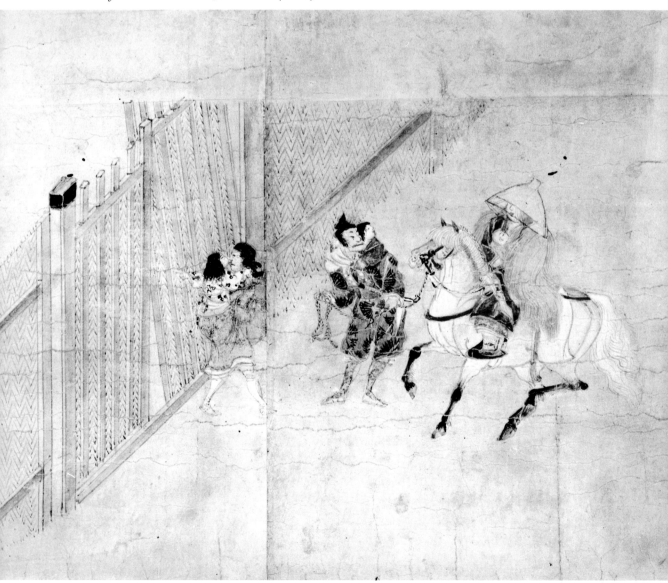

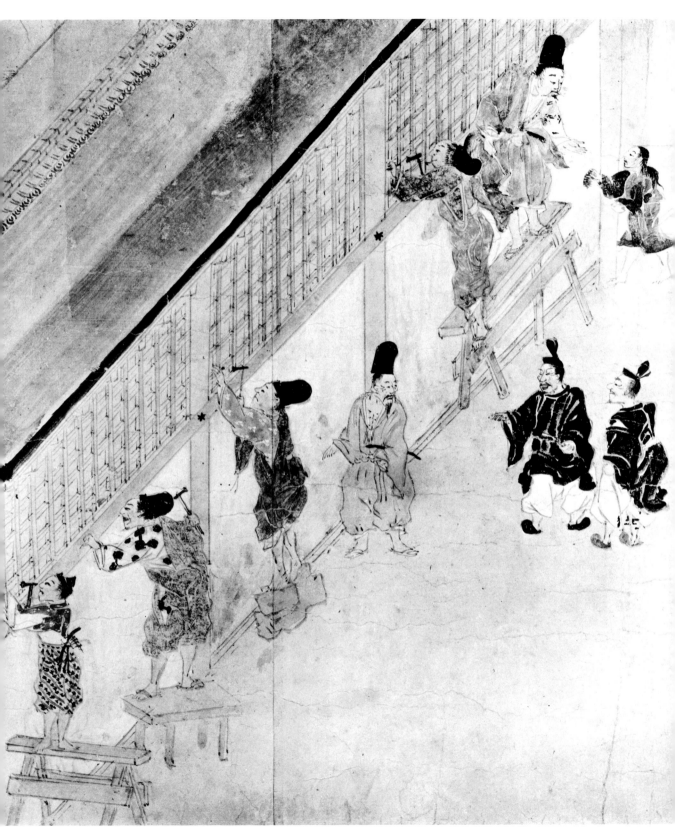

33c *Lady Tokiwa and Her Sons,* handscroll (detail).

73

ple genre representations as that of the carpenters repairing the palace [33c]. The mixture is clear evidence that by mid-Kamakura the *e-maki* artists were able to employ decorative or narrative manners at will, according to the nature of the subjects represented. By loosening the drawing of figures in court costumes and settings, by reducing the opacity and saturation of color in costumes, and by making architectural settings more transparent and sketchy, the artists could present setting and events as a continuous flow, anticipating cinematic methods. The bloody scenes of close combat between archers and armored foot-soldiers are unflinching and objectively observed. This objectivity, the habit of showing things as they are, has not been lost on modern Japanese cinema directors, whose battle scenes in medieval sagas indulge in no partiality for heroes over villains. Both are shown caught

in the universal flow of a world in which all fulfill their inevitable karma.

The *Zen Kunen Kassen E-maki* [*Illustrated History of the Zen Kunen Civil War*] [34], of the early fourteenth century, is a relatively late example of the military *e-maki*, and somewhat stiff in drawing. Nevertheless it conveys something of the complex representational and aesthetic orchestration necessary for successful pictorial narration of episodes involving both battalions and individual heroes.

As we saw in the *e-maki* of Lady Tokiwa's story, much of the ordinary business of daily living crops up in *e-maki* with religious, courtly, or military subjects. Amid the miracles, ceremonies, and battles people make cloth and pots and paper, while dinner cooks and babies suckle. Certain activities, such as the building or rebuilding of shrines [31a], were particular favor-

33b *Lady Tokiwa and Her Sons*, handscroll (detail).

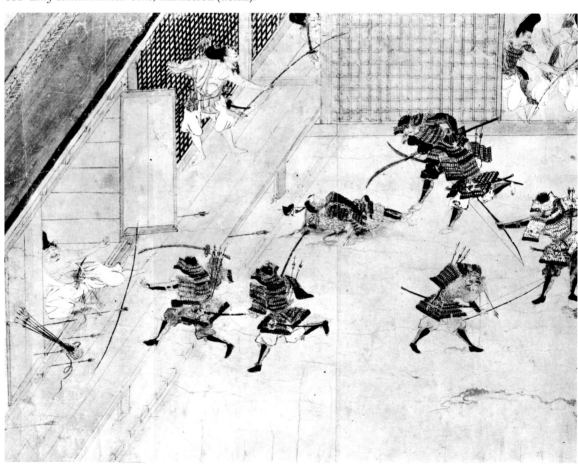

ites, often repeated; these became, in the Muromachi period (1392–1573) and later, a separate genre—the representation of the various crafts (*shokunin zukushi*). But very few *e-maki* earlier than the mid-fifteenth century were completely devoted to the activities of the working class. I know of only three: the *Tōhoku-in Shokunin Uta Awase* [*Tōhoku-in Poetry Contest Among Members of Various Professions*] in the Tokyo National Museum [88], the *Eshi Zōshi* [*Story of a Painter*] in the Imperial Household Agency; and the *Fukutomi Zōshi* [*Story of Fukutomi*], a two-roll set executed about 1400, whose second roll is in the Cleveland Museum of Art [35]. A complete but slightly later *Fukutomi Zōshi* is in the Shunpō-in, Kyoto. These exemplify the most interesting development in the final phase of medieval *e-maki* painting: the *otogi zōshi e-maki* (picture scrolls of popular tales).[24]

These genre scrolls of the Nambokuchō and early Muromachi periods are both an ending and a beginning—an ending because their successors deteriorate in quality to become folk art pictures (*nara-e*), a beginning because their earthy humor and ungenteel subjects inform later genres, especially *ukiyo-e* (pictures of the floating world). The tales (*otogi zōshi*),[25] ranging in length from short story to short novel, are of bourgeois or even low life. In their irreverent tone and unrefined themes they resemble *kyōgen*, the comic interludes in solemn *nō* performances. They began, like *kyōgen*, as entertainments by and for the upper classes, and were illustrated by court and temple painters, but before the end of Muromachi, authors and illustrators as well as a rapidly enlarging audience were also emerging

34 *Illustrated History of Zen Kunen Civil War,* handscroll (section).

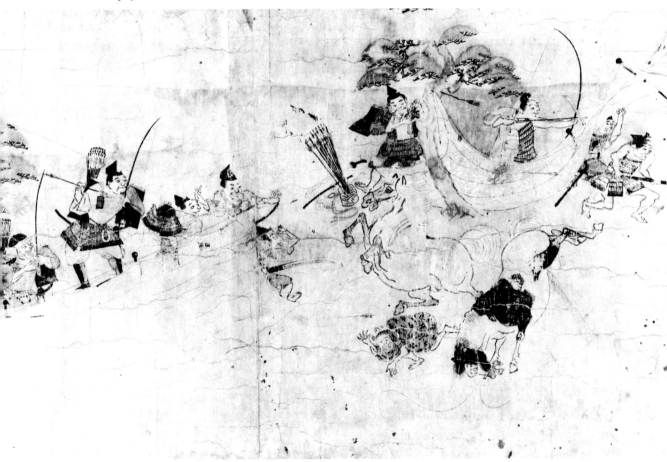

35a *Story of Fukutomi,* handscroll (section).

35b *Story of Fukutomi,* handscroll (section).

35c *Story of Fukutomi,* handscroll (section).

from the rising middle and lower classes.[26]

Fukutomi Zōshi epitomizes these developments in subject matter, narrative method, and aesthetic means. Roll 1 tells of Hidetake, a poor old man, thin, beak-nosed, and slightly hirsute, who prays to a Shintō deity for relief from poverty. His subsequent dream of a golden bell is interpreted by a medium to mean that his fortune will come from inside—an introduction of the widespread theme that gold and excrement are interchangeable.[27] Hidetake learns to perform an amusing dance punctuated by his musical farts, leading to his patronage and support by the local nobility. Roll 2 begins with Hidetake and his wife at ease in bed with their newly acquired wealth about them [35a]. Their fat neighbor, Fukutomi, persuaded by his wife, requests and seems to obtain Hidetake's secret. But the now-wealthy man has added morningglory seeds, a laxative, to the recipe for success, and the resulting performance by Fukutomi before the aristocrats is a stinking disaster [35b]. He returns home soundly beaten, to be nursed by his wife. The poor man loses even his clothes, which must be burned. His wife prays to Shintō gods and then falls upon Hidetake, biting him [35c]. This last scene ends with a representation of a blind itinerant priest, perhaps a reference to a moralizing conclusion. This, the material of farce and satire, is played to the hilt by the professional painter of the scroll.

The manner of telling is pungent, and different from what we have seen in earlier *e-maki.* The artist returns to the much older method of providing only a bare essential setting for each scene. Attention is concentrated on the protagonists. But now the text is totally integrated with the pictorial narrative by a device derived from theatrical performance and analogous to the modern comic strip. The dialogue, expertly written in cursive Japanese *kana,* is placed close to the person or persons speaking. Thus we find the

77

37 *Legends of Seigan Temple*, hanging scrolls.

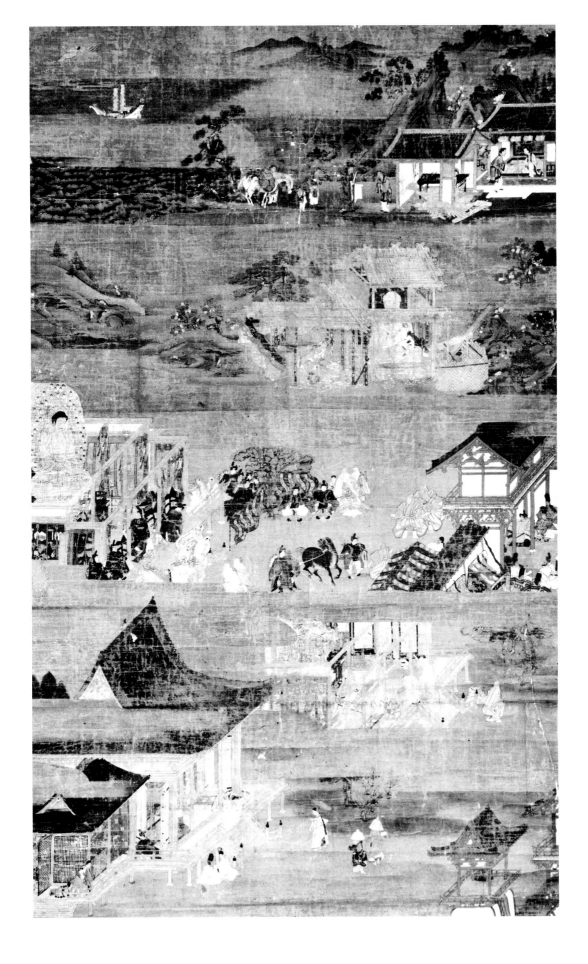

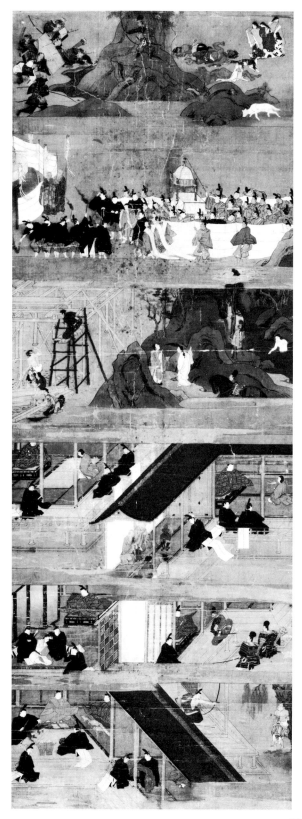
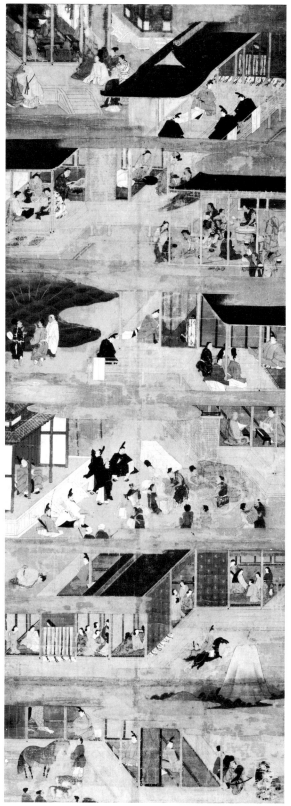

36 *Illustrated Biography of Prince Shōtoku,* hanging scrolls.

dialogue in the disastrous dance scene written immediately about the speakers:

A LADY-IN-WAITING (*serving Chujo*). Oh terrible! Drive him away, my lord.

A NUN (*serving Chujo*). I have never.... [illegible]

THE LORD (*to his servants*). Beat him and drive him away. Everything about him, even his face, is disgusting. Trample him down on his ugly backside until he feels almost like dying. How nasty. Do it till he has had a good lesson!

THE LORD'S SERVANTS. What a fool he is! Is he not the Fukutomi who lives at Shichigo?

THE LORD'S WIFE[?]. Have pity on an old man, just drive him away.

THE LORD'S SERVANT. He must have come here with loose bowels. What nerve to come to my master's house to do this! Give him a good lesson.

THE LORD'S SERVANT (*to the Lady*). Why does your Ladyship have mercy on him? Such a thief should be punished heavily.

FUKUTOMI. Please pardon me. Have patience to see more. I have learned more to show you.

THE LORD'S SERVANT (*to Fukutomi*) What nonsense you are talking. Take this for a good lesson!

BYSTANDERS. Look. He is being punished for his defecations.

This method, frequent in the *otogi zōshi e-maki*, succeeds in integrating written and depicted narrative even more effectively than the alternating text and pictures of Late Heian *onna-e* or the combination of poem with the name and identification of the poet in the ideal portraits [87] of famous poets.[28] An increase in the scale of the figures in these scroll paintings accompanies the curtailment of the settings—a direct reversal of the small-scale figures and complete settings of the late Kamakura biographical and religious *e-maki*. This increase in figure scale may have been stimulated by a rising interest, in the fourteenth and fifteenth centuries, in various kinds of high and low theatrical performances. These were dominated by the often masked actors rather than by settings, for then as now stage props were minimal. A convincing realism was sought for in the protagonists of the genre

scrolls, and it is not surprising that the characterization and movement of the figures in *Fukutomi Zōshi* are of a higher order than those in contemporary religious or military *e-maki*.

The dominance of narrative painting in the handscroll format led Kamakura artists to adapt hanging scrolls (*kakemono*) for storytelling as well. Numerous sets were painted, illustrating biographies and the histories of temples and shrines. The *Shōtoku Taishi E-den* [*Illustrated Biography of Prince Shōtoku*] [36] and the *Seigan-ji Engi* [*Legends of Seigan Temple*] [37][29] reveal the influence of *makimono* on these *kakemono* compositions. Instead of showing a single scene framed by brocade mounting, the ground of the hanging scroll is divided horizontally into registers, with the story progressing from the top to the bottom register and from right to left within each register. These regular and clearly delimited registers are unrelated in purpose and appearance to the cloud bands of earlier (Heian) screens and *kakemono*. The latter divide the picture area into irregular spaces and do not dictate the narrative progression. Overall, the late Kamakura hanging scrolls are decorative enough, but the conflict of vertical and horizontal in their format remains inappropriate to their purpose. Their existence alone, however, attests the cardinal importance of *e-maki* in the medieval Japanese achievement of an effective means of portraying the real world in space and over time.

1. *E* means picture; *maki* is an abbreviation of *makimono*, meaning handscroll.

2. Hideo Okudaira, *Narrative Picture Scrolls*, trans. and adapted with Introduction by Elizabeth ten Grotenhuis, Arts of Japan, vol. 5 (New York and Tokyo: Weatherhill/Shibundo, 1973), p. 23. This small volume and Dietrich Seckel, *Emakimono: the Art of the Japanese Painted Handscroll*, trans. J. Maxwell Brownjohn (London: Cape; New York: Pantheon, 1959) are the best available introductions to the subject, along with Soper's pioneering article "Yamato-e."

3. The third scroll is clearly by a different hand or workshop than the other three. In my opinion, the very abbreviated style of the fourth roll could well have been done by the same artist(s) that drew the first two—only working faster and perhaps a little drunk.

4. These are *Shigisan Engi E-maki* [*Legends of Chōgosonshi-ji on Mt. Shigi*], still in the possession of that

temple; *Ban Dainagon E-kotoba* [*Illustrated History of Ban Dainagon's Conspiracy*] in the Tokyo National Museum; and *Kibi no Daijin Nittō E-kotoba* [*Illustrated History of Minister Kibi's Visit to China*], in the Museum of Fine Arts, Boston. All of these late twelfth-century works are reproduced in toto in *Nippon E-makimono Zenshu* [*Japanese Scroll Paintings*] (Toyko: Kadokawa, 1958–), vols. 2, 4, and 5, respectively. *Kokawa-dera Engi* is reproduced in vol. 5.

5. Okudaira, *Narrative Picture Scrolls,* p. 67.

6. Soper, "Yamato-e," p. 364 and figs. 4–7. These panels have been much repainted.

7. The term *sumi-gaki* (Chinese ink drawing or calligraphy) was commonly used to describe the layout of the basic composition of a painting, the responsibility of the chief artist in a workshop. The application of color could be left to other artists, hence the occasional accidental presence of *pentimenti*. A sure grasp of the essentials of representing character and movement is characteristic of the *e-maki* tradition and demanded a particular mastery of what we would call expressive drawing. See Terukazu Akiyama, "Sumi-gaki [Ink Drawing] in the Heian Period," *Bijutsu Kenkyu*, no. 208 (January 1960).

8. The first roll is in the Art Institute of Chicago, the second in the Cleveland Museum of Art.

9. Only two rolls of the *Saigyō Monogatari E-kotoba* survive—one in the Tokugawa Art Museum, Nagoya, the second in the Hiroaki Manno Collection, Osaka. The *Ippen Shōnin E-den* is in twelve rolls—eleven at Kankikō-ji in Kyoto and one at the Tokyo National Museum.

10. Penelope E. Mason, "The Wilderness Journey: the Soteric Value of Nature in Japanese Narrative Painting," in *Art the Ape of Nature*, ed. Moshe Barasch and Lucy F. Sandler (New York: Abrams, 1981), pp. 67–90. Mason's emphasis on Saigyō's salvation through nature is correct but not the whole story.

11. Yoshi Shirahata, *Nippon E-makimono Zenshu* [*Japanese Scroll Paintings*], vol. 11: *Saigyō Monogatari E-maki, Taima Mandara Engi* (Tokyo: Kadokawa, 1958), English summary p. 2.

12. Karen Brazell, *Confessions of Lady Nijō,* p. 52, as quoted in Mason, "Wilderness Journey," p. 76.

13. Attempts to identify this En-i with a high priest who came to court from Onjō-ji in Shiga Prefecture have not been accepted. See Tsugio Miya, "The Ippen Hijiri-e and the Artist En-i," *Bijutsu Kenkyu*, no. 205 (July 1959), pp. 51–75. English summary.

14. In the Imperial Household Agency, Tokyo National Museum, and Kyoto National Museum, respectively.

15. Tsugio Miya, *Nippon E-makimono Zenshu* [*Japanese Scroll Paintings*], vol. 10: *Ippen Shōnin E-den* [*Pictorial Biography of the Monk Ippen*] (Tokyo: Kadokawa, 1960), p. 2; Terukazu Akiyama, *Japanese Painting* (Geneva: Skira, 1961), p. 99.

16. Three rolls in Kitano Tenman-gū, Kyoto; two fragmentary rolls in the Tokyo National Museum; three fragments at the Daitōkyū Kinen Bunko (Gotō Art Museum), Tokyo; one fragment in the Seattle Art Museum. See Komatsu, ed., *Nihon E-maki Taisei* (Tokyo: Chuokoronsha, 1977–79), 21: 46–83.

17. In the Kyoto National Museum.

18. The *Mōko Shūrai E-kotoba* is in the Imperial Household Agency.

19. Edwin O. Reischauer, "The Heiji Monogatori," in Reischauer and Joseph K. Yamagiwa, *Translations from Early Japanese Literature* (Cambridge, Mass.: Harvard U. P., 1951), pp. 377–95, gives an excellent account of these tales in their contemporary context.

20. Reischauer, "Heiji Monogatari," p. 443.

21. *The Tale of the Heike,* Hiroshi Kitagawa and Bruce T. Tsuchida, trans. (Tokyo: Univ. of Tokyo Pr., 1975), pp. 552–53.

22. Reischauer, "Heiji Monogatari," p. 442.

23. Sections of a previously unknown version of the *Heiji Monogatari* have recently been published, and the Seattle fragment may be another remainder of the same set. See Tōru Shimbo, "Newly Found Version of the Illustrated Handscrolls of the Heiji War," *Bijutsu Kenkyu*, no. 307 (September 1978), pp. 1–16. English summary.

24. See especially Hideo Okudaira, *Otogi Zōshi E-maki* [*Illustrated Narrative Scrolls of Late Medieval Japan*] (Tokyo: Kadokawa, 1982). English summary by Ann Herring.

25. See Keene, *Landscapes and Portraits,* pp. 53–54.

26. Okudaira, *Otogi Zōshi E-maki.*

27. See Steven Greenblatt, "Filthy Rites," *Daedalus: Representations and Realities* 3, no. 3 (Summer 1982): 1–16, especially pp. 10–11; and the equation of excrement in Rabelais, Thomas More's *Utopia,* and More's scatological reply to Luther.

28. See especially the Satake set and that called Agedatami, both dating from early Kamakura, in *E-maki Tokubetsuten* [*Special Exhibition of Illustrated Handscrolls*] (Tokyo: Tokyo National Museum, 1974), nos. 61–66 (Satake), nos. 67–69 (Agedatami).

29. The *Shōtoku Taishi E-den* consists of three rolls in the Tokyo National Museum; the *Seigan-ji Engi,* also three rolls, is in the Kyoto National Museum.

CHAPTER SIX

Portraiture in Medieval Japan

Still life and portraiture of living individuals have been the archetypal expressions of realism in Western art. In the Japanese visual arts still life, even including monochrome ink idealizations of the Buddhist vegetarian repertory or, later, stylized combinations of auspicious foods, was never significant. We have already seen the origins of Japanese Buddhist portraiture in the fetish or reliquary effigies of Chinese holy men (see chap. III). The value of the early portraits, especially the sculptures, lay in their magical identification with their subjects and in their degree of social and psychological verisimilitude. It may have been assumed that the portrait *looked like* the person depicted, but likeness was

neither demonstrable nor essential. By the Kamakura period, however, the purposes of portraiture were changing, and styles and techniques changed with them.

Ideal painted and sculpted portraits of the long-ago founders of various sects continued to be made and probably provided the starting point for new developments. Sketch-studies for portraits of these notables are found in numerous Kyoto temples, notably Kōzan-ji [60] with its potent sketch tradition, Ninna-ji [38], Jingo-ji, and Daigo-ji. Their subjects are revealed as formidable, sometimes awesome, types but not as individuals. The painted portrait of Sōō Kashō [39] in Enryaku-ji is ultimately derived from

38 *Portraits of Priests,* handscroll (section).

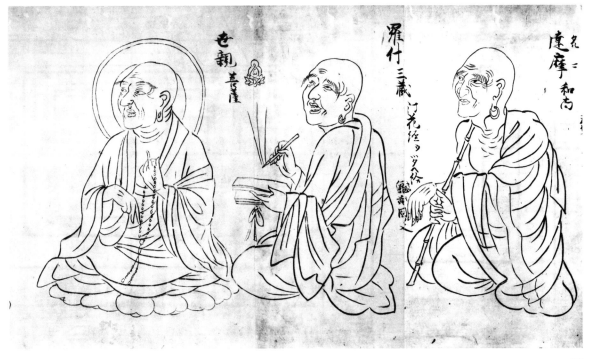

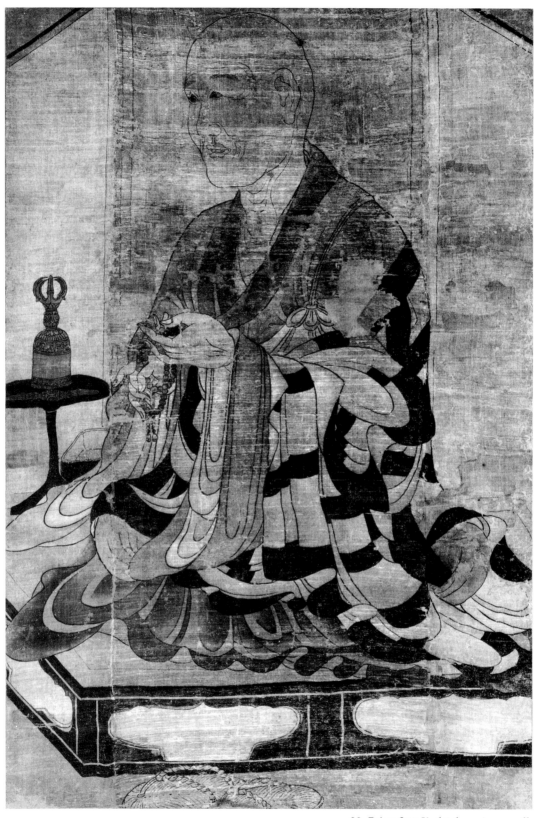

39 *Priest Sō-ō Kashō,* hanging scroll.

Chinese imports of the eighth and ninth centuries and their early Japanese counterparts. It makes an impressive icon, but as a "portrait" its principal subject is costume and setting, with the accompanying strongly drawn but generalized head secondary. For a satisfactory portrait Kamakura period viewers required greater individualization and intimacy.

Conscious revival of Nara period art styles was a most significant element of early Kamakura art. Rebuilding or restoring the old Nara temples after their destruction in the Late Heian wars gave powerful impetus to a Nara revival, and the new rulers at Kamakura consciously emulated their Nara predecessors. The several Kamakura copies of the Nara *Kako Genzai-e Inga Kyō* (see chap. V) are but one instance of this archaism. The same spirit pervaded sculpture, in which we find obvious elements of Kamakura literalism, such as crystal-inlaid eyes *(gyokugan)*, added to an underlying generalized appearance derived from surviving Nara period sculptures. Kaikei's *Mokkenren* [40], one of Buddha's ten disciples, is a highly convincing example of this new and more individualized realism evolving from Nara models. Even as late as the early fourteenth century preoccupation with the past could produce such striking ideal portraits as the polychromed wood bas-relief representing Keika, one of the five founders of the Shingon sect [41]. This sculpture relies heavily on painted icons of earlier date, such as the now sadly damaged scrolls by the T'ang Chinese master Li Chen, belonging to Tō-ji in Kyoto. The costume of Keika's young attendant, as well as the dais and the ancient shape of the carefully carved bronze *kundika* (container for dispensing holy water), reveals its derivation.

The efficacy of any Esoteric image, and therefore of the ritual addressed to it, was thought to depend at least in part on its resemblance to a prototype of known potency. Kongōcho-ji, which houses Keika's portrait, is in the farthest reaches of Shikoku. In this remote provincial outpost of Shingon Buddhism the only models for new icons would have been paintings, which are readily portable. The priority of the painted icon is clear. Why, then, a simulation of painting

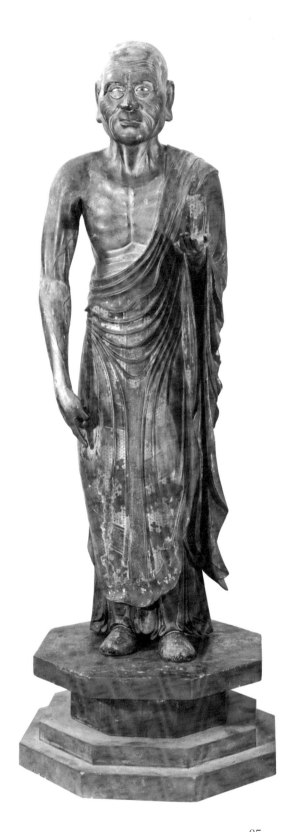

40 Kaikei, *Mokkenren.*

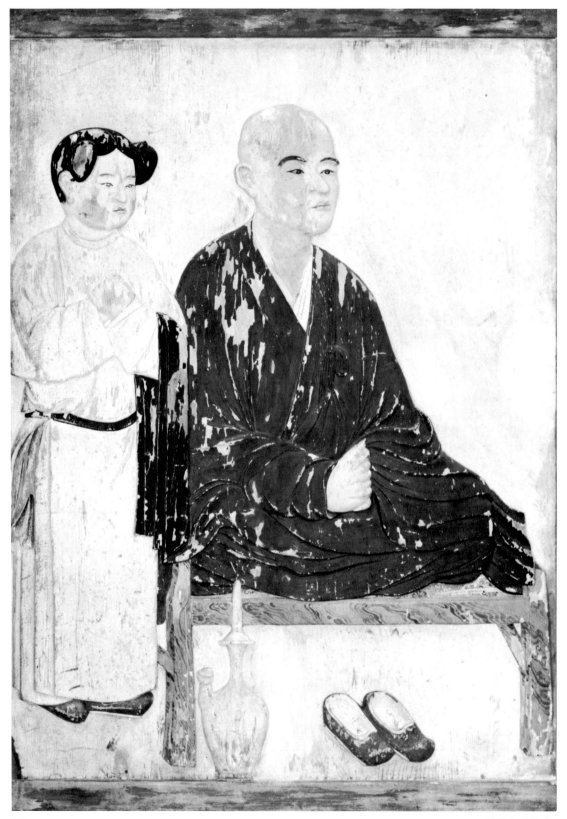

41 *Priest Keika.*

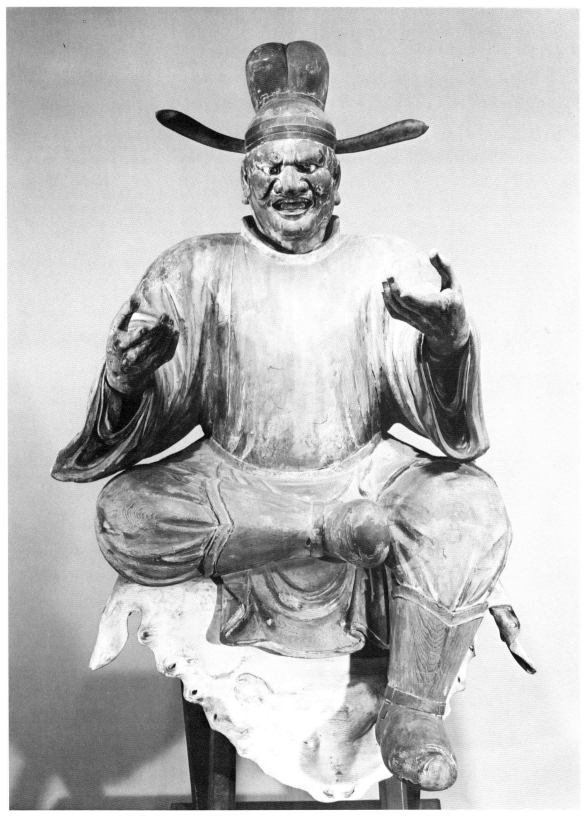

42 *Gushōjin.*

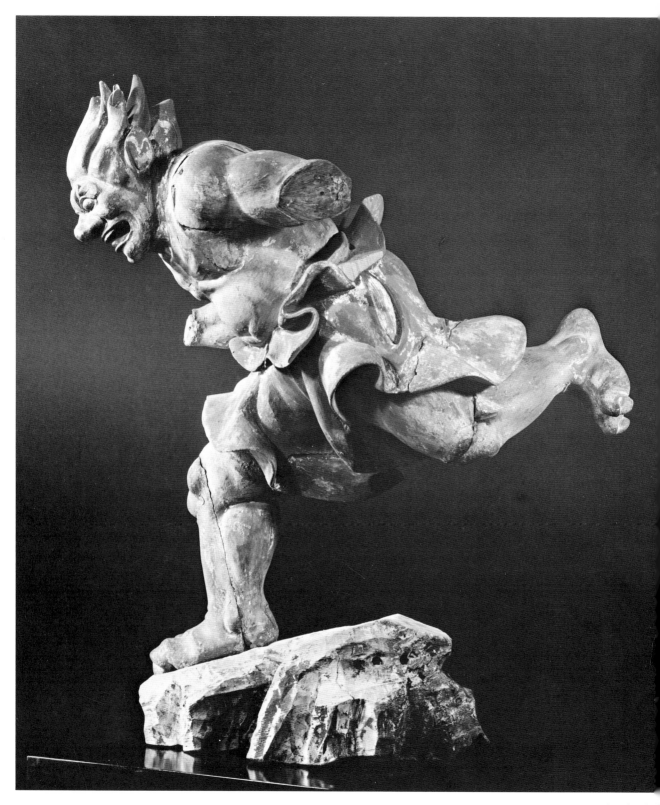

43 *Thunder Go*

in low-relief wood sculpture? And why do the few sculpted portraits of the older sects so closely resemble the more numerous contemporary and earlier paintings?

The twofold response to this question anticipates a similar pattern in the development of Zen portraiture. Among imported Chinese prototype images and early Japanese imitations, painted Buddhist portraits and icons in general outnumber and antedate sculpted ones. Despite a limited family of Japanese sculptures based on *small-scale* imported Chinese works in the round,[1] the prime sources of Buddhist imagery were paintings. Portrait sculptures, whether idealized or individualized, are mostly traceable to pictorial origins. This in turn came about because in China painting dominated the visual arts, particularly once the persecution of Buddhism and the mass destruction of temples and monasteries in 845 had ended the heyday of monumental sculpture. Chinese painters enjoyed artistic recognition, social esteem, and historical renown, while sculptors were anonymous artisans whose works were relegated to mention in local gazetteers.

In Japan the sculptor occupied an artistically more prominent and socially more acceptable position. Many Heian and even more Kamakura period artists in wood are known, their names fully recorded and in many cases exalted.[2] The native predilection for artistry in wood is commonly recognized and is represented by a far more numerous progeny than that surviving from China. Though paintings came first, in Japan sculptural images rapidly achieved parity with them.

Sculptural techniques and styles developed that made possible, or even inevitable, more persuasive renditions of reality, especially in categories to which realism closely pertained—the grotesque and portraiture. Heavenly guardians and generals, demons, and deities in their "terrible" aspects afforded sculptural opportunities far more varied than, and at least as challenging as, those presented by icons of beatific or compassionate divinity. By the Kamakura period the virtuosity of the Japanese sculptor in wood was unmatched. The *yosegi* technique[3] of assembling a statue out of several separately carved blocks had developed gradually during the

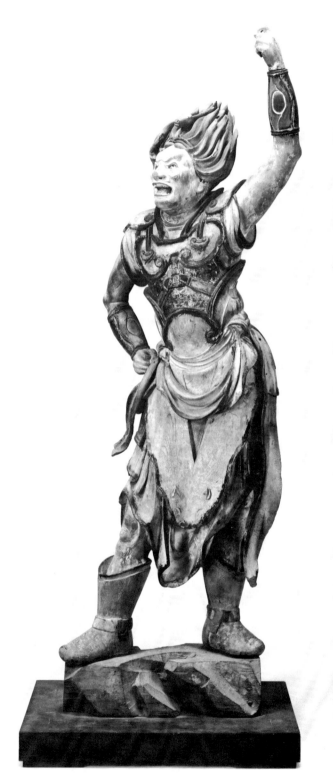

44 *Uma.*

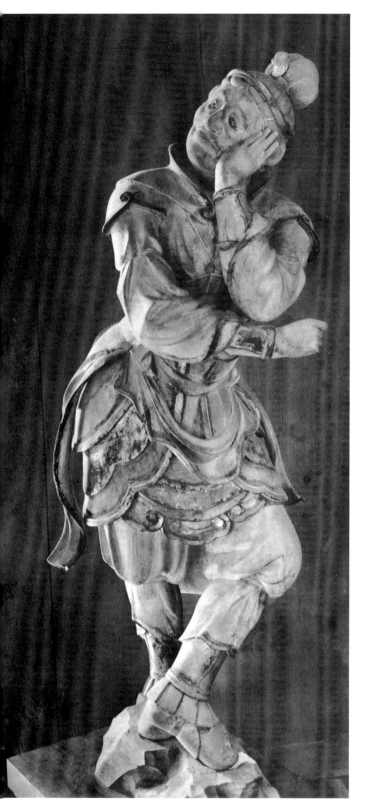

45 *Hitsuji.*

Figure 10. *Group of Seven Horses* (detail). Hans Baldung (called Grien), German, ca. 1484/5–1545. Woodcut, 21.6 x 32 cm., 1534.

Heian period. It enabled the sculptor of figures contorted in violent action [42; Color Plate VII] to suit the grain of the wood to each plane of his carving. Once images were no longer confined to single large columns of wood, the sculptor could indulge in more daring explorations of the volumes, voids, and movement of drapery [43]. Limbs and hands became more active and expressive. Tensions in muscle and sinew were translated more believably into wood [44, Color Plate VIII; 45]. The observed actions of living bodies in turbulent motion were persuasively represented, though without the anatomical accuracy achieved by classical and Renaissance masters in the West—and this despite the ample opportunity provided by medieval Japanese warfare to observe cadavers, flayed bodies, and skeletons. In representing musculature, for example, Kamakura sculptors fall short of a Dürer or Leonardo, rather equalling such transitional northern Gothic-Renaissance masters as Hans Baldung (called Grien), in whose woodcut of wild horses (Figure 10) the equine anatomy appears generally convincing but is in fact twisted and knotted past verisimilitude in order to express strain and violence.

Sculptors of the Unkei school of the late twelfth and early thirteenth centuries achieved virtuoso effects of expressive facial distortion, all based on increased knowledge of the bony and muscular structure of the head [46]. In Unkei's famous imaginary portrait-sculptures of the Indian priests Seshin and Muchaku, and in the two guardian figures (*niō*) from his atelier [47] (the former in the Kōfuku-ji, Nara, the latter in the Cleveland Museum of Art), the heads and faces are more persuasively real than those of their Nara period prototypes. We have earlier commented that the experience gained in mask making (see chap. III) sharpened the sculptors' powers of observation and technical skills. Likewise, the great volume of commissions at the beginning of the Kamakura shogunate, entailed by restoration of war-devastated temples in the Nara-Kyoto region, promoted rapid innovation and refinement in the portrait sculptor's art.

The relationship of the grotesque and daimonic to the emergence of more realistic portraiture can be observed in a rare category of ideal portraiture first seen in the Kamakura peri-

46 *Priest Sengan Naigu.*

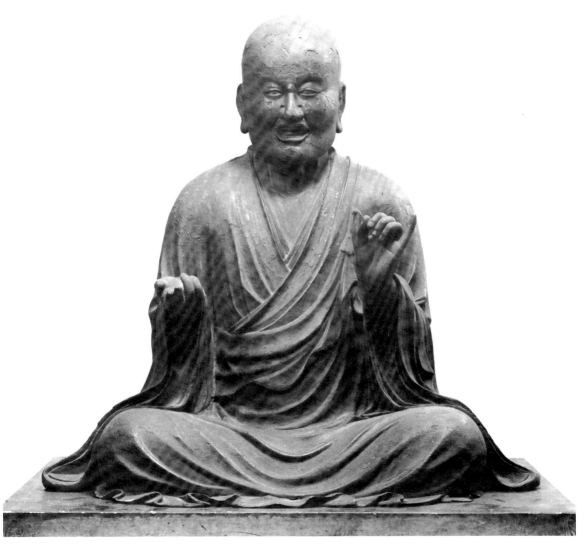

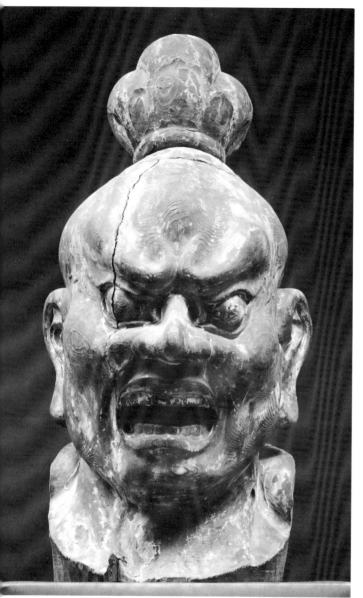
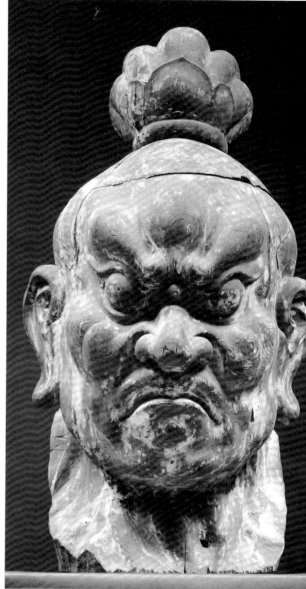

47 *Heads of Niō.*

od—sculptures of *En no Gyōja*, the archetypal mountain priest and legendary founder of the Shugendō sect whose monks we have encountered in the *Saigyō Monogatari* [27]. *En no Gyōja* (also called Shōkaku, Austere Man; d. 701) is usually shown bearded and always clothed in the heavy cloak and hood of the mountain man. The Cleveland sculpture [48], considered to be one of the oldest surviving portrayals,[4] is unusual in showing the priest clean-shaven. Most

striking in this ruggedly ascetic representation are the sinewy, bony character of the bared legs and hands and the hypnotically concentrated grimace of the powerful square face. The expression, at once startled and exalted, recalls that of the open-mouthed temple guardian (one of the *niō* [47], but En no Gyōja's visage displays human ecstasy rather than supernatural wrath. The image maker has presented him in the moment of seeing Zaō Gongen, the Buddhist-

92

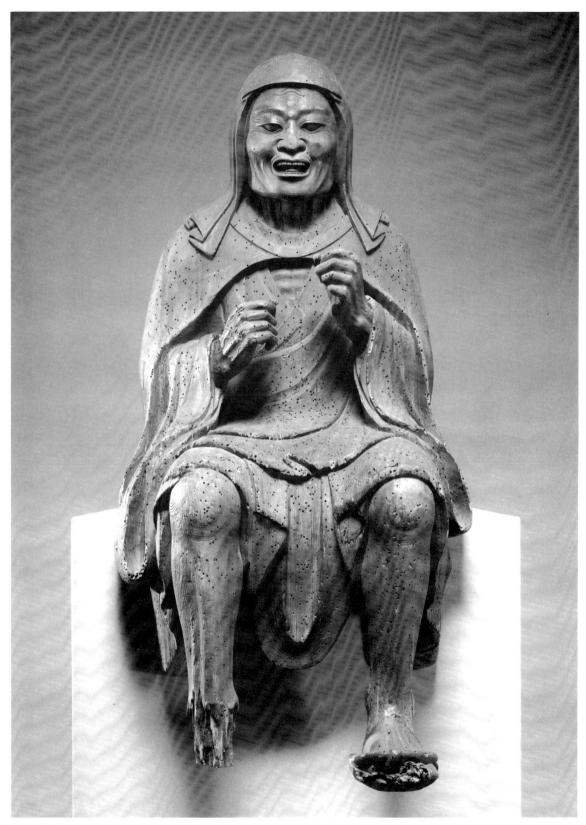

48 *En no Gyōja.*

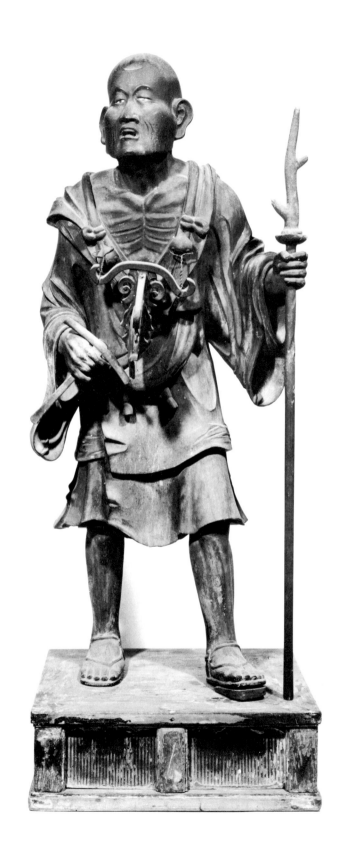

49 *Priest Kūya.*

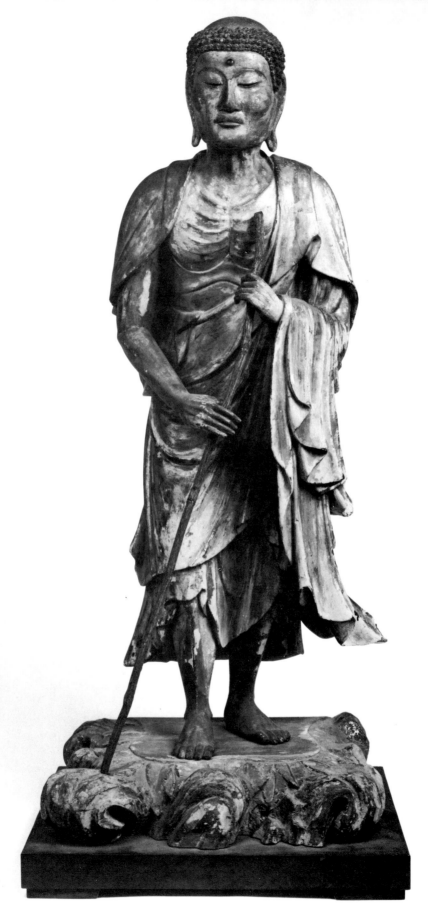

*Sakyamuni
Coming Down
from the Mountain.*

Shintō tutelary deity of Kimpu, south of Nara—simultaneously a beatific and ferocious apparition.

This image of transformed humanity, portrait-like in its particularity but based on half a millennium of tradition regarding En no Gyōja's appearance, introduced a number of Kamakura priest effigies that depart from previous essays in ideal portraiture. Sculptures of Kūya (903–72), Chōgen (1120–1206), and Ippen (1239–89) are each in turn closer in time to the life of its subject. One might expect a progressively more individualized and realistic image; instead the three portraits reveal a comparable immediacy, proceeding from the Kamakura sculptors' integration of fully understood Nara style with new techniques and habits of observation. This common foundation is projected by all three images, irrespective of their temporal distance from the living subject.

Kūya was the evangelical Tendai monk who first preached and popularized pietistic Amidism, offering salvation through rhythmical recitation of the *nembutsu* (see chap. IV). The sculpture from Shōgon-ji, Shiga Prefecture [49], is not as accomplished in detail as its more famous and better-preserved mates from Rokuharamitsu-ji in Kyoto and Jōdo-ji, Ehime Prefecture, on Shikoku. All show the saint singing as he walks, shod with sandals and using a deer-horn-tipped staff as a walking stick. He holds a beater and wears a gong for accompanying the *nembutsu* recitation. In the other two images this recitation is literally represented by a stream of six miniature standing images of Amida Buddha issuing from the priest's mouth, each image representing one character of the *nembutsu* formula: *Na-mu Ami-da Bu-tsu*. These were present in the Shōgon-ji work as well but have been lost. In all three images the stance is noniconic and informal, the body convincingly worn and weary looking. The unknown Kamakura sculptors succeeded in particularizing the long-dead Kūya: seeing the image, we feel the presence of the man.

The unusual sculpture of *Shussan no Shaka* [*Sakyamuni Coming Down from the Mountain*] [50], is treated in very much the same manner as the priest portraits—after all Shaka, before becoming the Buddha, was an itinerant holy man, a

parallel not lost on the sculptor. Compared with the almost ethereal lightness of the ink painting of the same subject in the Seattle Art Museum [65], the sculpted image seems more mundane and more Japanese.

The seated image of Shunjōbō Chōgen, or Shunjō Shōnin (Priest Shunjō), from Shindaibutsu-ji in Mie Prefecture [51], has at least two counterparts—the more famous image at Tōdai-ji showing the priest slightly older, and one more resembling the Mie sculpture, kept at the Amida-ji in Yamaguchi Prefecture. Each of the images is posthumous but made not long after his death. Chōgen was a sinologist as well as a theologian, enormously influential, and famous in his own lifetime. In 1181 he was charged by the first shōgun, Minamoto no Yoritomo, with full administrative responsibility for reconstructing the almost destroyed Tōdai-ji complex in Nara, including above all the huge Nara period bronze Daibutsu (Vairocana Buddha), its hall, and the Great South Gate, to which he added the remarkable colossal wood *niō* by Unkei. The scale and originality of this reconstruction required strength and purposefulness. Chōgen was also the founder of Shindaibutsu-ji, probably built about 1203, and this accounts for the presence there of this remarkable sculpture. Although it represents Chōgen at the advanced age of about eighty, it breathes no hint of frailty: the cross-legged figure sits uncompromisingly erect; the big, capable hands are folded together in a gesture not of relaxation but of power held in check; the expression of the large face is dourly commanding, with stubbornness in the down-turned mouth and a grim glint in the narrowed crystal-inlaid eyes. The Tōdai-ji image, by contrast, gives us a man fragile with years, much withered and a little bowed. His eyes are wider and not inlaid, his head thrusts forward as if in anticipation, his hands hold a rosary. The whole form conveys a poignant, albeit alert, eagerness in place of the stern determination of the Mie image. Both images portray a singularly compelling individual with powerful immediacy.

The fragile, bent figure of Ippen Shōnin is already familiar to us from the *e-maki* scroll relating his life and travels in Japan [28]. An almost life-sized late Kamakura or early Muromachi wood figure of the saint is the only nearly con-

51 *Priest Chōgen.*

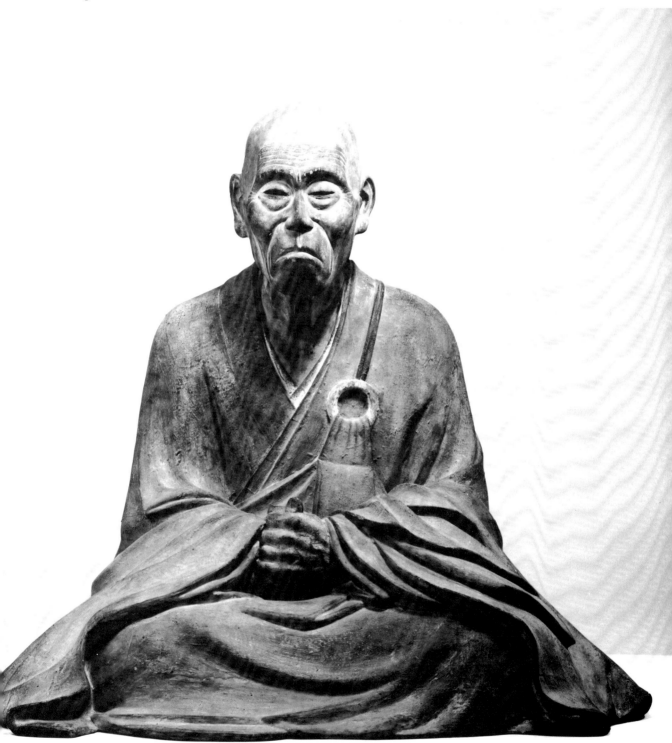

52 *Priest Ippen*,
hanging scroll.

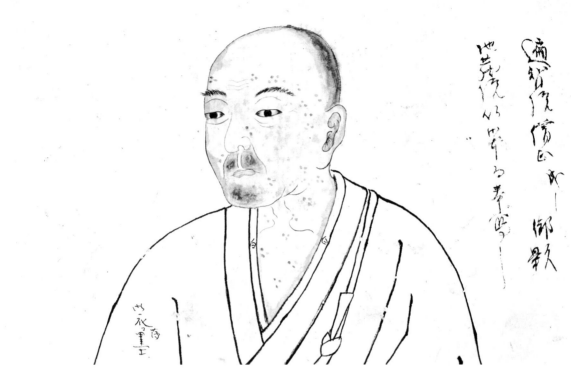

53 *Priest Seigen,* hanging scroll.

temporary sculpture of him.[5] It embodies the new tendencies in Kamakura portraiture that are visible in Chōgen's image and even more in Kūya's. Ippen, intently worshipping, seems caught in a momentary attitude—a striking characteristic of painted images of the saint as well. The scroll from Shōjokō-ji, Kanagawa Prefecture [52], dates close to Ippen's later years; while the Nishi Hongan-ji sketch is considered by his followers to be the most authentic representation of the saint, the Shōjokō-ji work is far more individual and impressive, echoing the small portraits in the *Ippen Shōnin E-den.* Even such amateur portrait-drawings as *Seigen Kokushi* [53] possess a touching immediacy. But professional intervention succeeded in codifying the pertinent characteristics of Ippen to the satisfaction of his followers. The hanging scroll from Shōjokō-ji[6] may well be the representation that set the standard for portraits of Ippen.

Two remarkable painted portraits illustrate the variety possible to inventive Kamakura artists within the traditional Buddhist visual repertory. The portrait of Shinran Shōnin (1173– 1262) [54]

achieves originality by combining old formulas with newly keen observation and unvarnished description: the triangular mass of the draped, cross-legged figure and the graded shading used to describe it date from Nara and Early Heian, while the shrewd, reptilian face is distinctively Kamakura. Intellectual, ethical, and physical rigors were not for Priest Shinran. He preached, instead, salvation by a faith so extremely passive and simplistic that it resembles Buddhism only in reverence for Amida. Nevertheless, Shinran's denigration of monasticism and good works— even of the *nembutsu*—was finely attuned to contemporary conditions of burgeoning populism and pragmatic power struggles, and it evoked enthusiastic response. The communities of Jōdo Shin (True Jōdo) believers became a major force in the Kamakura period and remained so for three centuries.

The other painting, *Myōe Shonin,* from Kōzan-ji, Kyoto [55; Color Plate IX], is one of the most unusual of all Kamakura works. Myōe (1173– 1232) revived Kegon Buddhism, which had fallen into desuetude since the Nara period, and

99

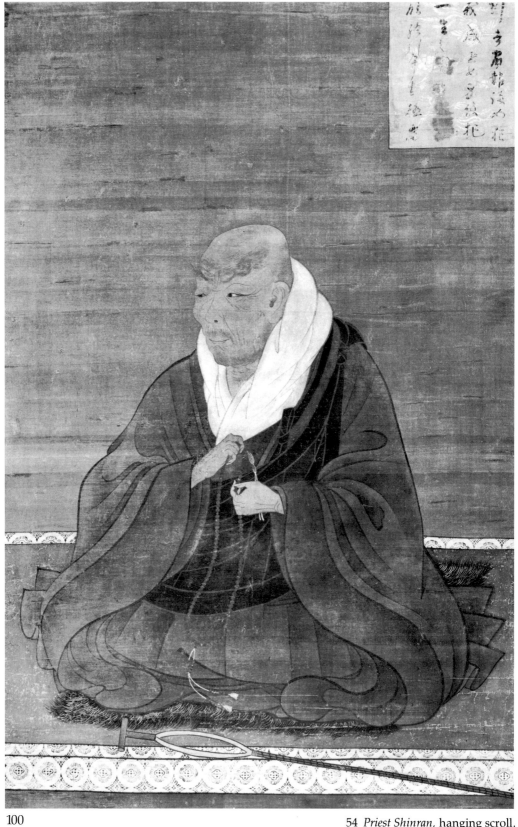

54 *Priest Shinran,* hanging scroll.

established Kōzan-ji as an independent Kegon temple in the mountains just north of Kyoto. Kōzan-ji, it will be remembered, had an important sketch tradition, including ownership of the satirical *Chōjū Jinbutsu Giga* scroll [23] as well as the early Zen representation of *Sakyamuni Coming Down from the Mountain* [65]. The portrait-landscape of Myōe seated in contemplation in a tree is traditionally attributed to Enichibō Jōnin, a priest-painter reputed to have been Myōe's friend and disciple. The picture, like many great works of art, has numerous reverberations, echoing the past and heralding the future. The subject of the monk in the tree can be traced back to early Chinese Buddhism,[7] and in Japan there is at least one rare precedent—the frontispiece to a gold-on-blue sutra roll of Late Heian, a National Treasure at Zentsu-ji on Shikoku, with a representation of Kōbō Daishi seated in a rather carefully displayed and barbered tree. But the rough, sketchily unkempt landscape in the portrait of Myōe seems most closely related to the nearly contemporaneous *Saigyō Monogatari* [27] with its equally unkempt landscape settings for the travels of Saigyō. Myōe's asceticism and composure contrast effectively with the exuberant natural setting. The concept may be traditional but the representation is based on Kōzan-ji's pine forest environs and Abbot Myōe's reputed habits of meditation. Again we find that combination of tradition and innovative observation which makes Kamakura realism so effective.

Somewhat different qualities are to be found in the painted and sculptured secular portraits of the period. The most famous of all such works are the three hanging scrolls of the late twelfth century remaining at Jingo-ji, just northwest of Kyoto. They represent Minamoto no Yoritomo, Taira no Shigemori, and Fujiwara no Mitsuyoshi (the companion scroll of Taira no Narifusa is lost), all principals in the struggle that ended with Yoritomo's triumph in 1185.[8] They are shown wearing stiff court robes arranged in highly decorative silhouettes, their faces somewhat differentiated and executed with thin, tense boundary lines. Pictorially they agree well with the carefully executed, "built-up" (*tsukuri-*

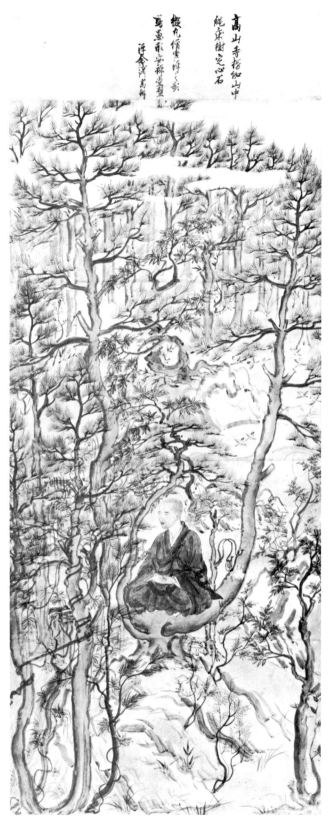

55 *Priest Myōe*, hanging scroll.

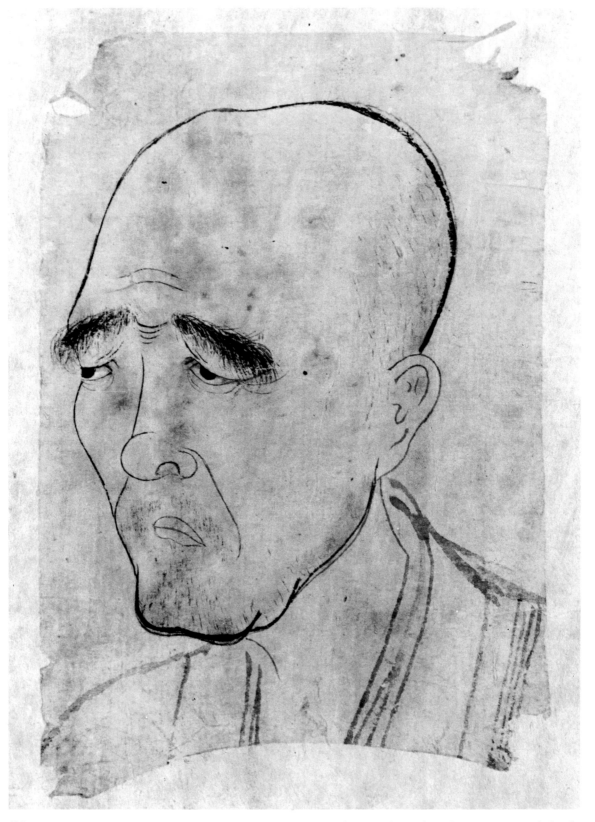

56 *The Zen Priest Hakuun Egyō,* unmounted sketch.

e) pictures of the court tradition related to *onna-e* and the style we have already characterized as *yamato-e*. They are plausibly attributed to a painter who was also a courtier and poet, Fujiwara no Takanobu (1142–1205), the progenitor of five generations of artists associated with the court and its style.[9] The realism and varied brushwork we have seen in Buddhist portraiture seem to be of a different order.

There has been much discussion and continuing disagreement about an important Japanese term used at this time—*nise-e* (likeness picture).[10] Suggested translations range from the simplistic—a portrait—to the convoluted—groups in a setting. In any case it seems reasonable to differentiate *nise-e* from the traditional court style of formal and decorative works, the *tsukuri-e* or "built-up" colored paintings, represented by the Late Heian *Tale of Genji*. Rather *nise-e* are the other side of the coin, life-like, fresh, even sketch-like representations, related to *a-a-e* (caricatures) and executed largely in ink instead of color.[11] In short, *nise-e* are more closely related to the *e-maki* tradition and represent a progressive rather than a traditional or regressive development—hence the need for a new definition. In their simplest form *nise-e* are represented by surviving freely sketched likenesses based on observation.[12] These range from penetrating small-scale studies, such as that of Hakuun from Tōfuku-ji, Kyoto [56], with its wholly individualized subject searchingly rendered in ink lines of slightly varied thickness, through the subtle, delicate portrait of Retired Emperor Hanazono (1297–1348) [57; Color Plate x], to the later Muromachi study of the nun Myōhō Ama at the Kyoto National Museum [59].[13] The larger likeness of Fujiwara Kanetsune in monastic garb [60], a preliminary study for a full-scale painting on silk, seems closer to the conservative religious and court portrait traditions.

The formal secular painted portrait is represented at its highest level in the damaged *kakemono* of the retired emperor Go-Shirakawa (d. 1192) from the Myōhō-in, Kyoto [61]. The bulky, domineering presence of the ex-emperor, who played a vacillating but important role in the Taira - Minamoto struggle, dominates a pictorial surface whose background consists of sliding screens (*fusuma*) delicately painted with birds and grasses in the new Chinese fashion. Again we are aware of aesthetic tensions generated by the disparate sources of the painting's artistic assumptions—the old court tradition, the old priest-portrait tradition of the professional temple painters, and the new attention to likeness.

57 Gōshin, *Emperor Hanazono,* hanging scroll.

59 Hasegawa Tohaku (attrib.), *The Nun Myōhō,* hanging scroll.

60 *Fujiwara Kanetsune,* hanging scroll.

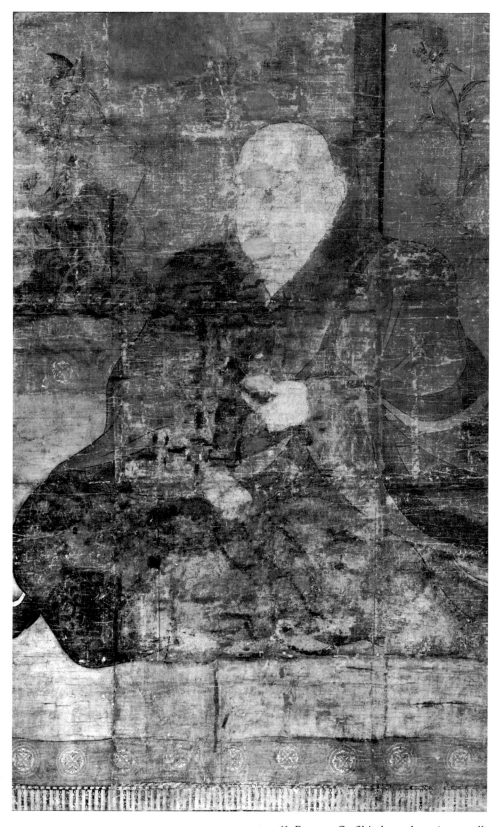

61 *Emperor Go-Shirakawa,* hanging scroll.

The large scale and powerful presence of the portrait are characteristic of Kamakura art.

The new *nise-e* type was not confined to painting but can be seen also in three rare sculptured secular portraits, all from the Kamakura region and all of powerful military rulers or officials—Minamoto no Yoritomo, the first shōgun, now in the Tokyo National Museum, Uesugi Shigefusa, at the Meigetsu-in, Kamakura; and Hōjō

Tokiyori (1227–63), a powerful regent of the Hōjō family which effectively controlled both shōgun and emperor after the death of Yoritomo, whose sculptured portrait is kept at Kenchō-ji near Kamakura [62]. All three figures wear the stiff cloak, puffy pants, and high leather hat of the official court costume. All have inlaid crystal eyes and sit frontally and cross-legged on the floor. Their hands are formally placed, the left

62 *Hōjō Tokiyori.*

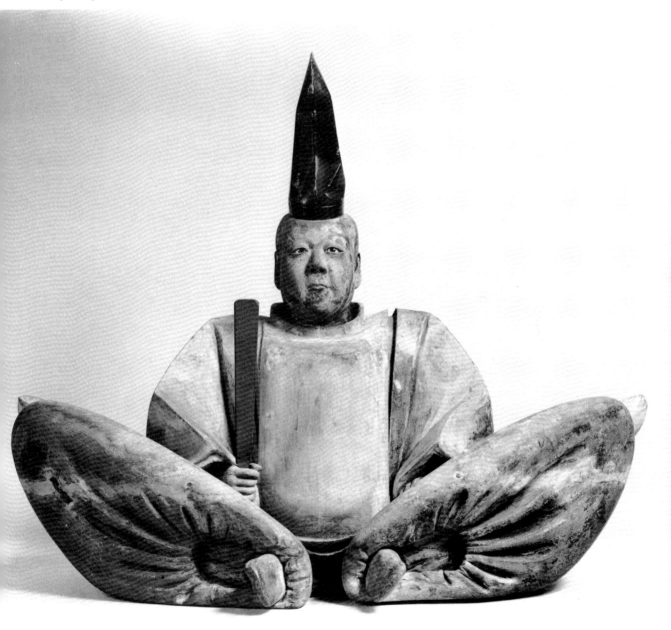

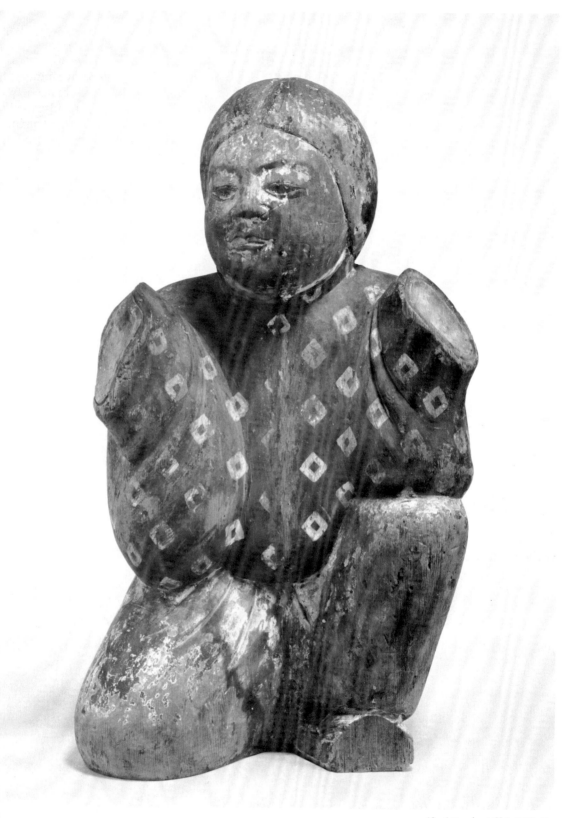

63 *Attendant Shintō Deity.*

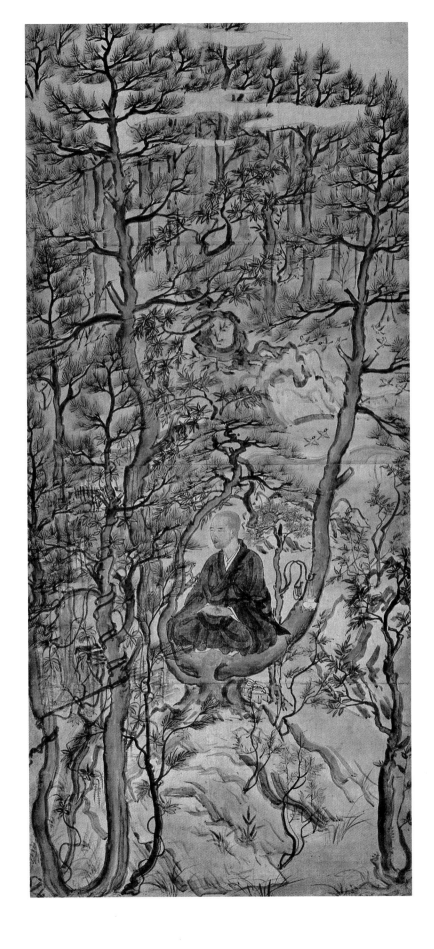

Color Plate IX.
Priest Myōe [55].

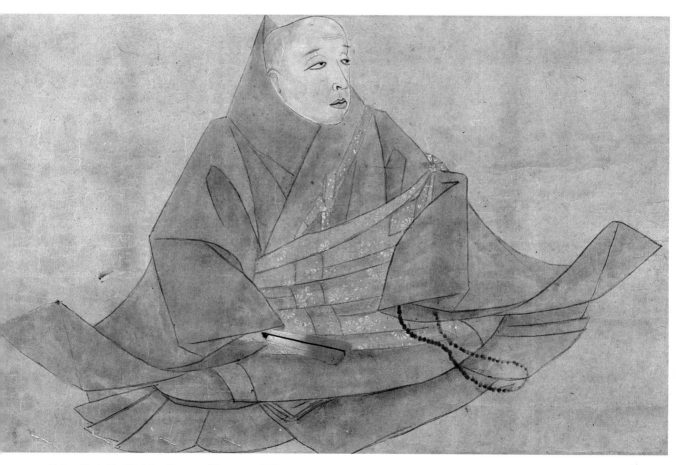

Color Plate X. Gōshin, *Emperor Hanazono* [57].

Color Plate XI. Mutō Shūi, *The Zen Priest Musō Kokushi* [72].

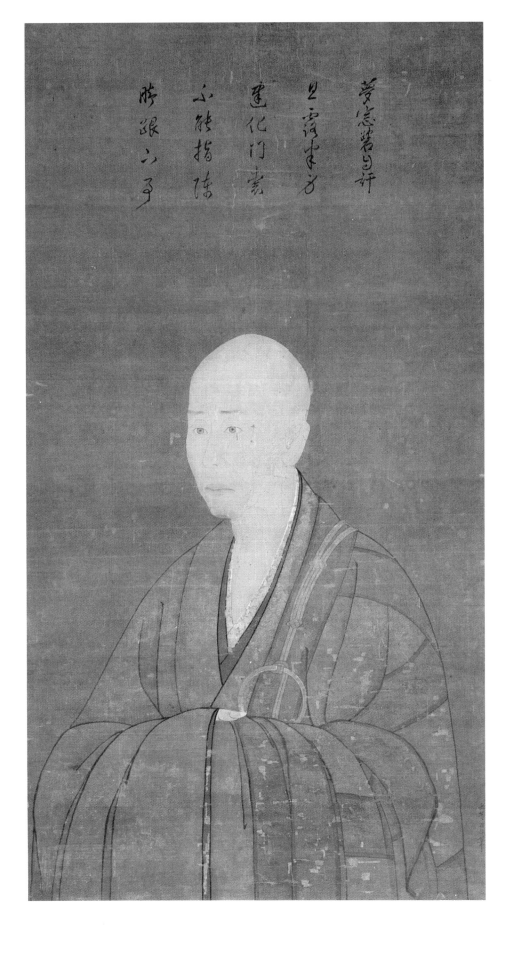

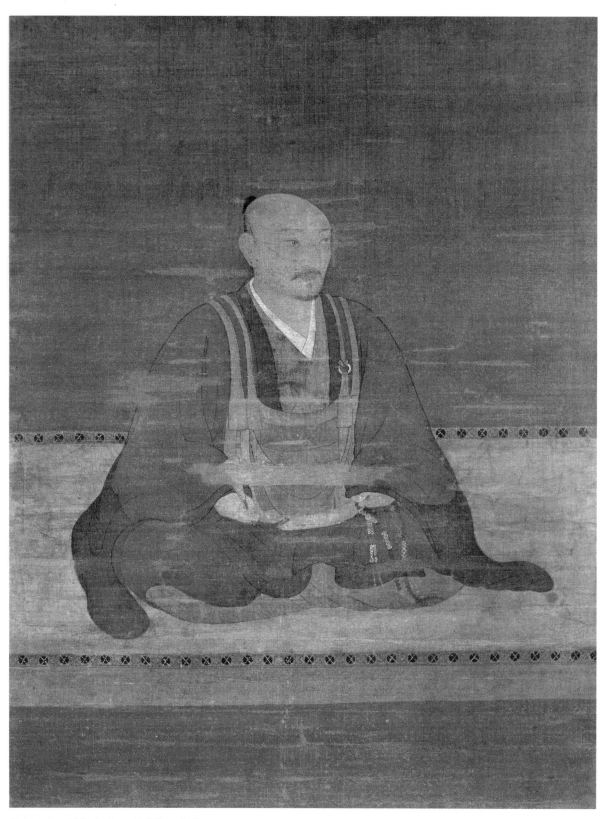

Color Plate XII. *Asakura Toshikage* [76].

resting on the thigh, the right holding a tablet of rank. In their identical formal postures the three figures seem to have stepped out of *onna-e* style handscrolls of courtiers[14] or representations of the *Thirty-six Immortal Poets* [*Sanjūrokkasen*] [87, 90]. Their faces, however, are markedly individual likenesses. Their only female counterpart is a unique image of the Shintō goddess Tamayori Hime,[15] dated to 1251 and still preserved at Yoshino Mikumari Shrine, Nara. Like the three

men, she wears court costume, has inlaid crystal eyes, and is formally posed. It may be significant that the sculpturally similar image of Yoritomo is said to have come originally from another Shintō shrine, Shirahata in Kamakura. Political, social, and religious tendencies in the thirteenth and fourteenth centuries increasingly fostered a systematic amalgamation of Shintō and Buddhism, with the major Shintō *kami* (deities) identified as local incarnations of the universal Buddhist

64 *Sumō Wrestlers and Referee.*

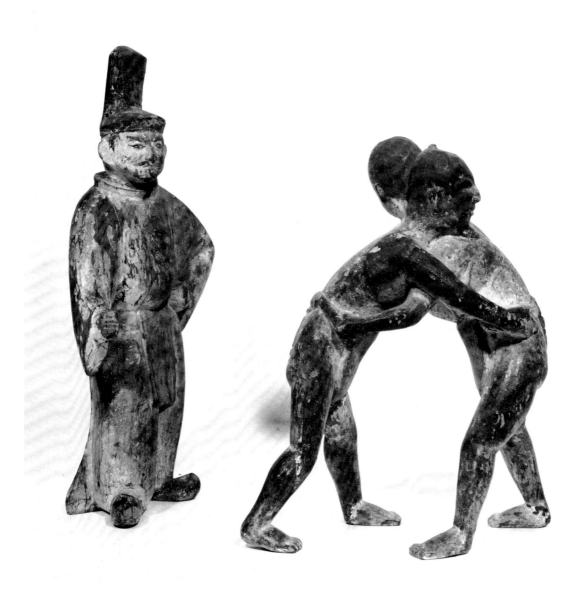

divinities. The Heian custom of representing Shintō *kami* in court costume may have influenced the choice of costume for the representations of the three warrior-rulers.

A brief digression is in order here concerning those few Shintō sculptures that depict secular themes or activities, for these too reflect the varied realist interests of this remarkably fertile period and undoubtedly involved many of the painters and sculptors who also worked on Buddhist and purely secular subjects. In the *Shintō Deity* from Daishōgun Hachi Shrine, Kyoto [63], a particularly observant sculptor translated the cold-weather habit of keeping one's hands in one's sleeves into a block-like sculptural unity. And what of the amusing genre group of two sumō wrestlers and a referee from Mikami Shrine in Shiga Prefecture [64]? It is the earliest work of art representing that traditional athletic contest, which is still vigorously alive today. The contrast between the composed courtier-referee and the straining wrestlers in this small-scale group recalls the juxtaposition of foreman and workers in the *e-maki* illustrating the building of Kitano Shrine [31] and Ishiyama-dera [29]. Most of these Shintō sculptures, except for Tamayori Hime, are technically conservative, using the single-block (*ichiboku*) technique of Heian times.[16]

Zen (Meditation) Buddhism, already half a millennium old in China, first took root in Japan in 1191 in its Rinzai (C. Lin-chi) form, followed near 1228 by the Sōtō (C. Ts'ao-tung) school.[17] Though arousing opposition among the older sects, it appealed powerfully to the warrior class, becoming increasingly popular during the Kamakura period and dominating cultural as well as intellectual life in Muromachi Japan.

Paralleling and reflecting the rapid flourishing of that sect among the new warrior-rulers of Japan, Zen portraiture became a major innovation in the arts of the Kamakura period.[18] Hōjō Tokiyori, regent and able ruler of Japan from 1246 to 1256, was also a founder of Kenchō-ji, a Zen temple near Kamakura, and sufficiently adept at Zen discipline, or at least diplomacy, to have his enlightenment certified (*inka*) by a Chinese Ch'an monk-teacher, Wu-an P'u-ning. A posthumous painted portrait at Kenchō-ji shows Tokiyori seated on a cloth-covered abbot's chair, garbed not in court costume but in a Zen priest's robe.[19]

The meanings and discipline of Zen have been much written about, silence and ineffability inspiring extensive speculation and explanation. Zen's essence would seem to be ascetic discipline and intuitive enlightenment following prolonged intensive study or meditation under the tutelage of a personal master. The idea of "transmission outside the scriptures"—direct devolution of the Zen experience from one individual to another—was central, and this idea conferred critical importance on portraiture at the same time that it greatly influenced the nature of Zen portraits.

Zen inspired a two-way traffic, with Chinese monks coming to Japan in considerable numbers to teach and many Japanese priests going to China to study and be certified.[20] Often certification entailed bestowal upon the now enlightened pupil of an inscribed painted portrait of the master. The superb Southern Sung portrait (dated to 1238) of the Ch'an master Wu-chun Shih-fan (1177–1249) was just such a parting gift to Wu-chun's disciple Ikkoku. It is still kept at Tōfuku-ji, the Zen temple founded by Ikkoku on his return to Kyoto, and is one of the earliest of such Chinese portraits still preserved in Japan. These portraits were simultaneously mementos of the master and reminders of the experience he had transmitted; as such, they were required to be accurately descriptive and keenly evocative of their subjects. The fulfillment of this need set high standards of realism for the Zen portrait tradition in Japan and made that tradition seminally important in any consideration of kinds of realism in Japanese art.

At first Zen nonportrait subjects, such as the *Shussan no Shaka* [*Sakyamuni Coming Down from the Mountain*] [65], were accomplished in a mixed Japanese–Chinese technique owing much to the Buddhist sketch tradition [66], a tradition notably prominent at Kōzan-ji, whose seal is found on the *Shussan no Shaka* in Seattle. Here "nail-head" and "rat-tail" strokes are more in evidence than the broader strokes and washes imported from Southern Sung China, which became the staple manner for figure and landscape subjects in the Zen ink painting of Muromachi Japan. Chinese Zen portraits, on the other hand, were painted with even ink lines and solidly applied colors, a manner familiar to the tradi-

110

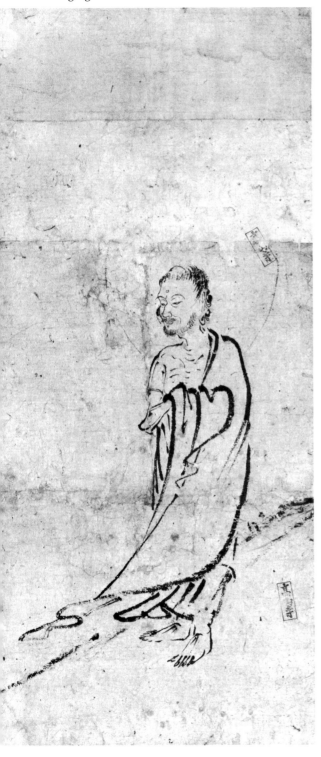

65 *Sakyamuni Coming Down from the Mountain,* hanging scroll.

tionalist Japanese icon painters, members of the temple *busshi* guilds. Thus the Zen portraits painted by Japanese artists are often indistinguishable from those done in China.[21] The style and iconography is uniformly Zen rather than distinguishably national in character, at least in the earlier examples from both countries. Although some painted Zen portraits might be posthumous, most were executed during the life of the subject, not at set times but whenever a portrait was needed as one of the documents of transmission for a newly enlightened pupil.

Oddly enough, the sculptured Zen portrait seems to have been unknown in China; at least, none have survived. In Japan, on the contrary, such sculptures rank among the greatest achievements in realism. We have already noted that painted works often preceded and served as models for sculptured portraits associated with other sects. A numerous and active body of accomplished and socially esteemed sculptors existed in Japan, and it was not long after the introduction of the painted Zen portrait that sculptured likenesses were produced. The earliest dated example is the image (datable to 1275–76) of Priest Kakushin (Hottō Kokushi, 1207–98) at Ankoku-ji, Hiroshima; another of the same priest (dated to 1286) is at Kōkoku-ji, Wakayama Prefecture. A third example, probably derived from the Kōkoku-ji portrait and approximately of the same date, was made for a nearby temple and is now in the Cleveland Museum [67]. The dates and appearance of these sculptures attest the practice of making sculptured portraits of leading priests—*kokushi* means "national teacher" and was a title bestowed by the court—at ages seventy, seventy-five, and eighty.

Portraits of *living* Zen masters, whether painted or sculpted, are called *jūzō*. The more general term, *chinsō*, refers to any commemorative portrait of a Zen master, whether given by him to a "graduating" disciple or commissioned in his honor by disciples; practicality dictated that the former be almost invariably paintings, while the latter might equally well be sculptures.

Sculptured *chinsō* are clearly indebted to the painted ones [68]. The subject is seated, usually on an abbot's chair, which in the painting is shown draped with a rich brocade. The pose is frontal, with hands clasped in meditation or

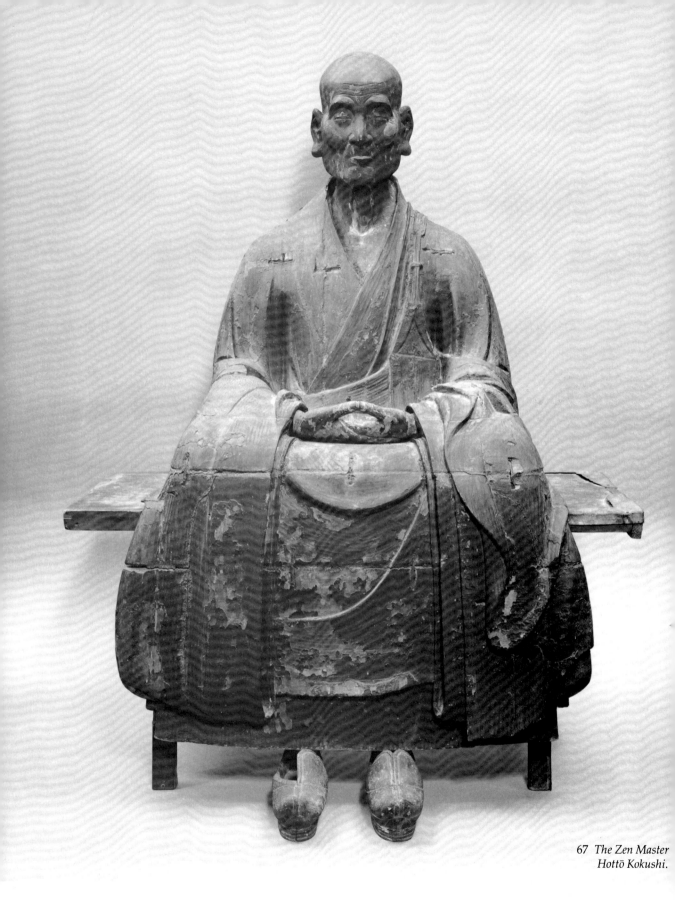

67 *The Zen Master*
Hottō Kokushi.

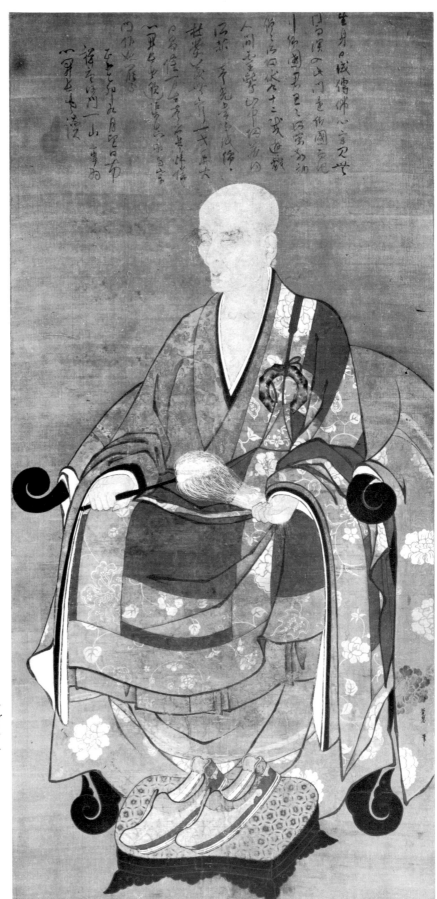

68 Kaku-e,
*The Zen Master
Hottō Kokushi,*
hanging scroll.

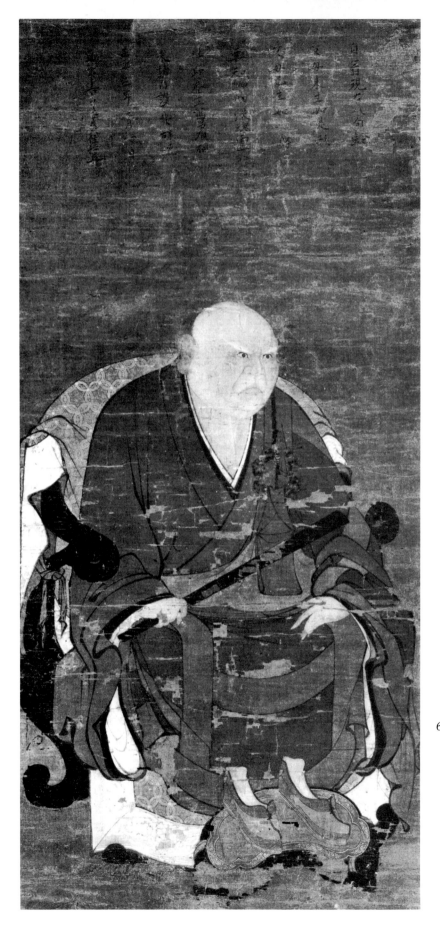

69 *The Zen Priest Buttsū Zenji,* hanging scroll.

114

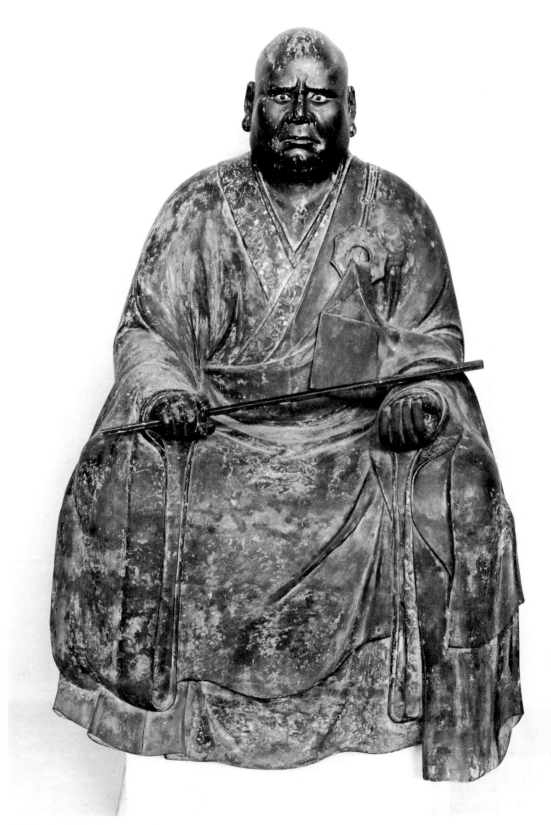

70 *The Zen Priest Buttsū Zenji.*

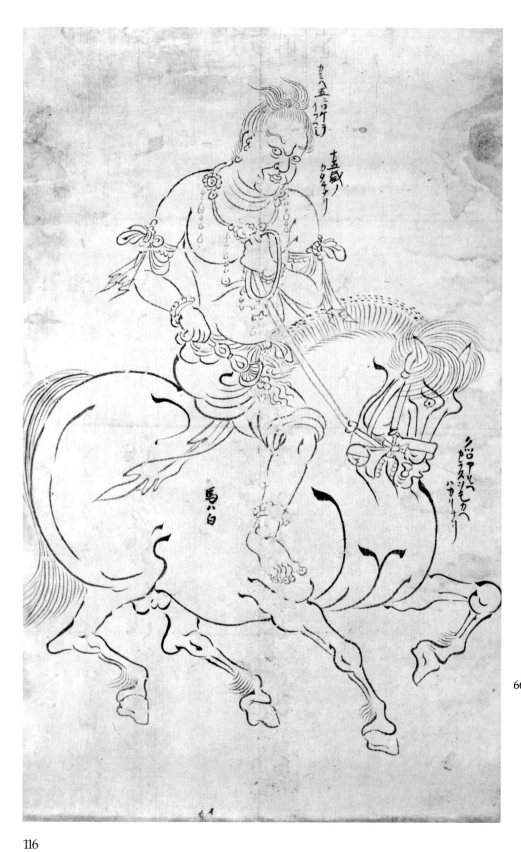

66 *Seitaka Dōji,*
hanging scroll.

with one hand holding a baton of office while the other rests on the knee. The master may sit on the chair (i.e., cross-legged) but sometimes sits in it with legs hanging down (i.e., Western style); in either pose the skirt of the undergarment hangs freely down, barely indicating the legs, and the monk's slippers, separately carved, are placed at the foot of the chair. In sculptural shape the composition differs from the usual Japanese portrait-sculpture in which the figure is seated on the floor. The height and monumentality conferred by the abbot's chair demands that the head be arresting and impressive, and this in turn requires a vigorous and expressive likeness, one that emphasizes the individuality of the features sometimes even to the edge of caricature. Thus both the painted and sculptured portraits of Buttsū Zenji [69, 70] show a powerful physical and psychological specimen, but one suspects a degree of exaggeration for effect, totally successful but still pushed to limits well beyond Chinese ideas of decorum.

Some of the surviving painted *chinsō* are half-length [71], and one of these contains an indication that perhaps choice of format lay with the subject. One of at least four such half-length portraits, the *Musō Kokushi* painted in 1349 by Mutō Shūi and kept at the Myōchi-in, Kyoto [72; Color Plate XI], bears an inscription by Musō indicating how well he knew the value of a concentrated image:

> The lower extremities from hips to heels cannot expound a theme,
> So only half a torso is visible within the Kenka gate.[22]

A comparison of the sculptured and painted portraits of Hottō Kokushi [67, 68] can suggest differences and similarities of purpose and style in the two works. Unlike the sculpture, the painting is posthumous (dated to 1315). It exaggerates the cranium, small mouth, and chin of the "National Teacher," who is nevertheless identifiable not as a type but as an individual. In both images the priest wears his robes of office. The sculpture has lost most of its original surface, revealing the marks of the grooving chisel used on the robes, but the painting remains richly colored; indeed, it is probably the most colorful of all well-known painted Zen portraits. Furthermore, it is very large—if anything, Ka-

kushin is shown slightly larger than life, befitting a major icon painted for Kōkoku-ji, the temple that he founded. The sculpture may be slightly smaller than life, possibly because it was made for a smaller, hence less wealthy temple. The sculpture is frontal; the painted figure is three-quarters view and looking to the figure's own right. This asymmetry is not casual, for such *kakemono* were hung together on special ritual occasions, and the central image—almost certainly an icon representing the First Patriarch of Zen, Daruma (S. Bodhidharma; C. Ta-mo)—would have been the focus of all attention, including that of the painted portraits. It will be seen that the differences in size and orientation resulted from nonaesthetic considerations: the wealth of the patron and the ritual use of the portrait.

Not all *chinsō* are products of the Zen sect. Some historians give priority for the type to a few portraits associated with the Ritsu (Risshu)[23] sect. Ritsu first flourished during the Nara period and was strongly revived in the Kamakura period, largely due to the evangelism of Priest Eison (1201–90), also known as Kōshō Bosatsu. Ritsu, like Zen, emphasized contemplation; it was patronized by the Hōjō regents before they turned to Zen. The most famous of all Ritsu portraits is the sculpture of Eison preserved at Saidai-ji, Nara, which inspired the image from Byakugō-ji, Nara [73]. It is unlike Zen *chinsō*: Eison is shown seated on the floor, and the disposition of his robes recalls Shintō and secular portrait-sculptures. The head has the individual, sharply focussed quality seen also in Zen portraits. The radically different pose, however, suggests that the *chinsō* formula was not habitual for Ritsu and that these remarkable works of realist art are properly considered Zen, or rather Ch'an, in inspiration.

Later portraiture until the Edo period (1615–1868) owed everything to the Japanese art traditions we have examined. They may have been modified or combined but their substance was not violated. Military leaders, portrayed alone in action on horseback, appeared in the aesthetic lineaments and solid color of the *yamato-e* style [74]. Even Kanō school painters, masters of the Chinese academic manner, tended to revert to more decorative Japanese conventions when painting portraits [75]. This Tosa

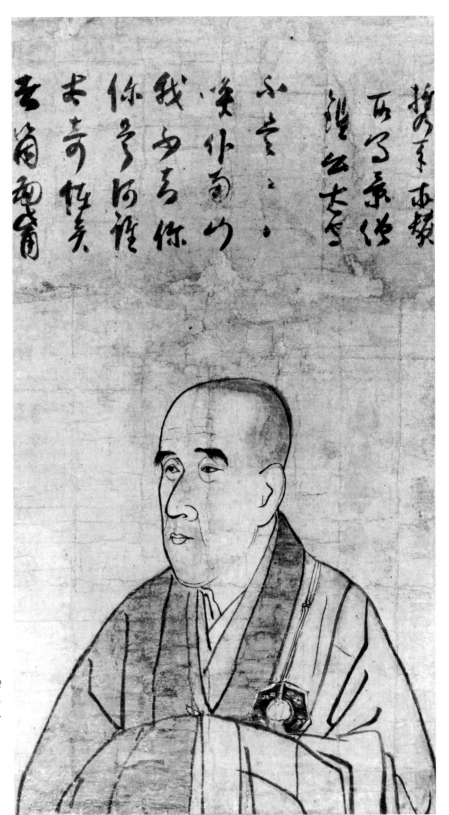

71 *The Zen Priest Nanzan Shiun,* hanging scroll.

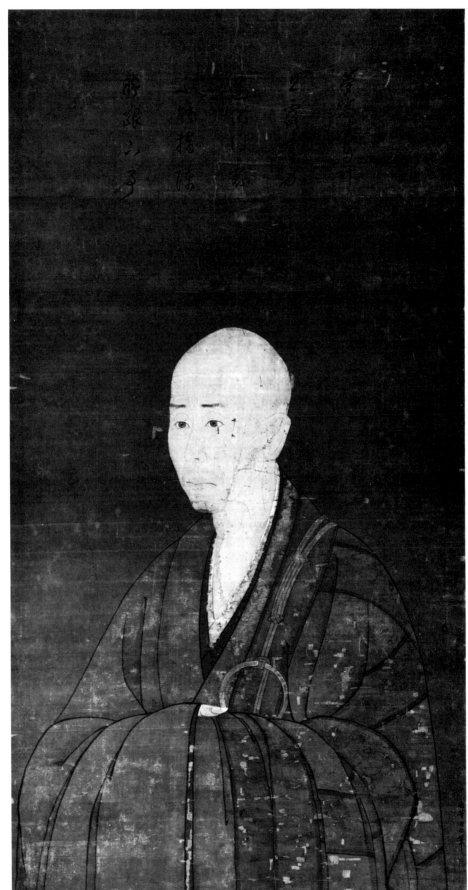

72 Mutō Shūi,
*The Zen Priest
Musō Kokushi,*
hanging scroll.

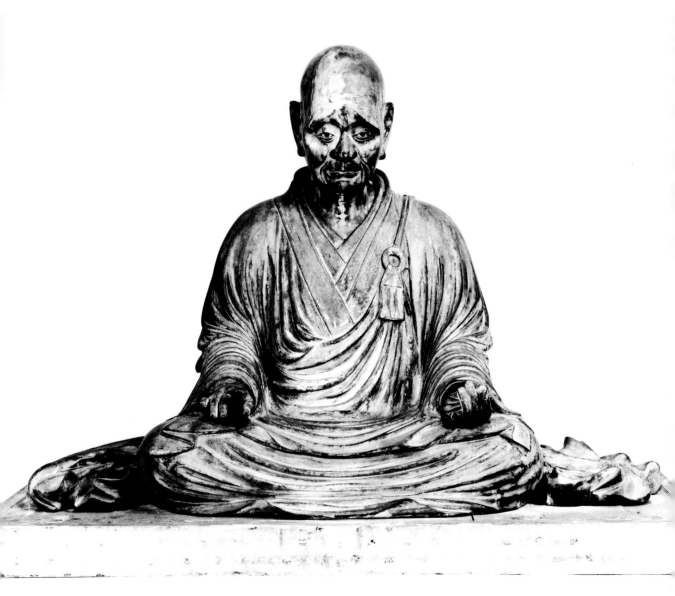

73 *Priest Eison.*

120

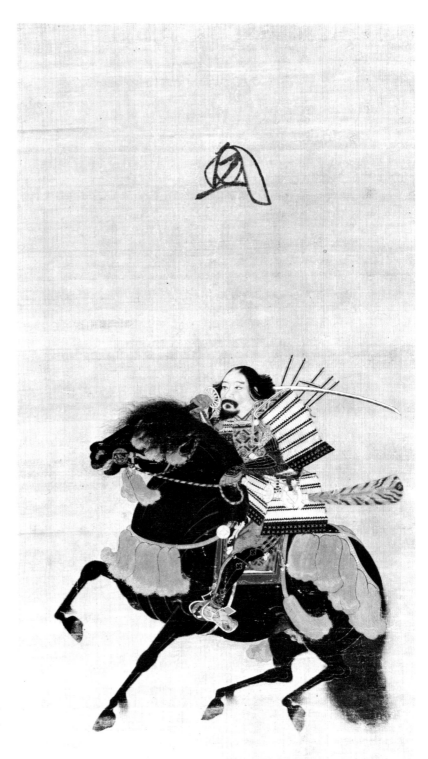

74 *Warrior on a Horse,*
hanging scroll.

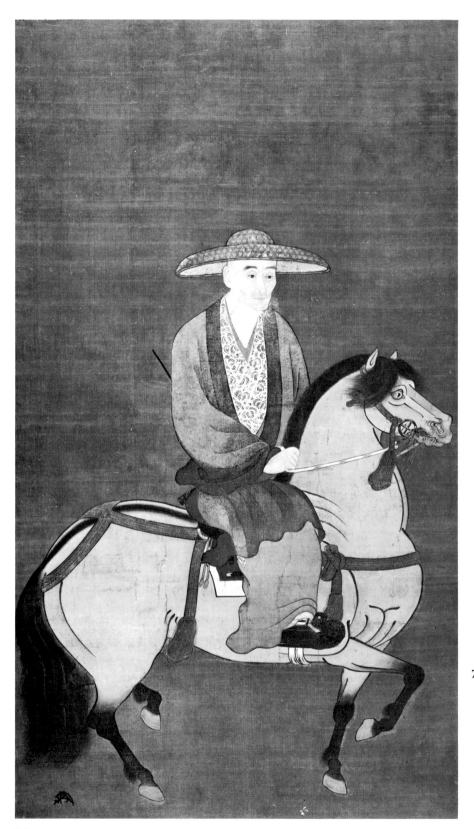

75 Kano Motonobu,
*The Poet Sōgi
on Horseback,*
hanging scroll.

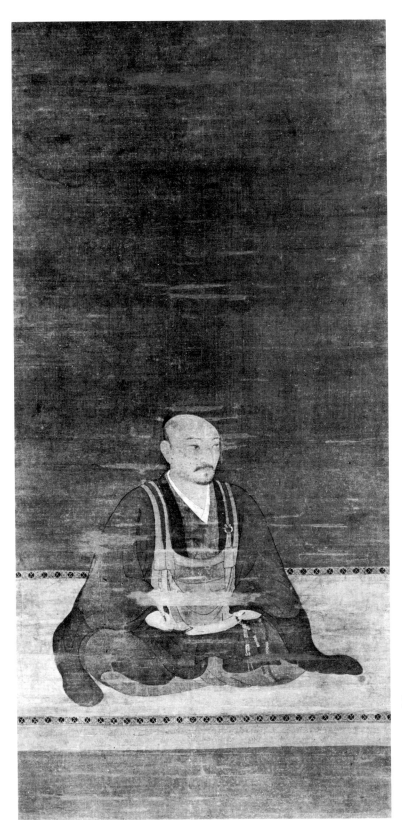

76 *Asakura Toshikage,*
hanging scroll.

123

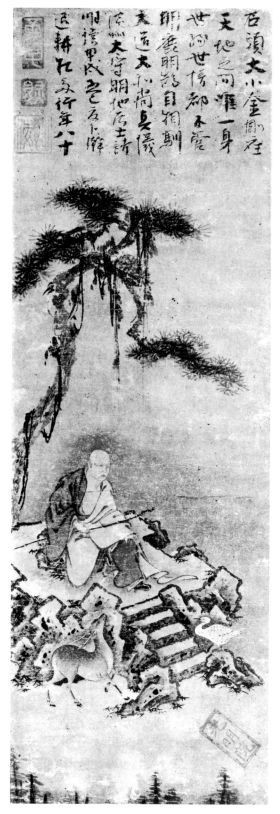

style, as the later court manner was called, could be put on by the skillful Muromachi artists as easily as a change of garments when they felt the subject matter, in this case portraiture, required it. The formal seated secular portrait tended to combine the configurations of early religious and *yamato-e* portraiture with heads more realistically observed in the Zen manner [76; Color Plate XII]. These portraits, produced in considerable number, were always competent but rarely inspired.

A few essays in combining the Chinese ink landscape idiom with portraiture succeeded in creating a convincing, integrated image of the individual in an ideal landscape; notably successful are Sesson's *Self-Portrait* in the Yamato Bunka-kan, Nara, and Minchō's (1352–1431) posthumous portrait (dated to 1394) of his Zen master, Daidō Oshō (1292–1370), belonging to the Nara National Museum [77]. These quiet portrait-landscapes attain a Zen ideal of revealing the universal Buddha-nature in man and nature but are hardly in the mainstream of Japanese realism.

A very great master of the Momoyama period (1573–1615), perhaps Hasegawa Tōhaku (1539–1610), painted one of the most striking of these later eclectic portraits, that of Takeda Shingen (1521–73) in the Jokei-in, Wakayama Prefecture [78]. Now made famous in the West by Kurosawa's film *Kagemusha*, the warlord is portrayed as massive, stolid, and menacing. The visual equation of armed warrior with falcon is extremely effective, accentuating their fierce natures and decorative plumages. Objective analysis finds Tosa dominance in the figure seated on *tatami* and a strong secondary note of Chinese ink style in the freer handling of rock and bamboo.

We may illuminate the achievements of early Zen by confronting the most remarkable of all Muromachi portraits, that of the famous Zen abbot Ikkyū (1394–1481), from the Tokyo National Museum [79], with a much later Obaku Zen portrait (dated to 1671) of the Chinese priest Dokuryū (C. Tai Li, 1596–1672), in the Cleveland Museum of Art [80]. The portrait of Ikkyū is probably a sketch, and while it may well have

77 Minchō, *The Zen Priest Daidō,* hanging scroll.

been made from life by his disciple Bokusai, whose separate inscription is placed above the portrait, this attribution is uncertain and thoroughly beside the point. Monk Ikkyū—brilliant scholar, poet, calligrapher, abbot of Daitoku-ji, son of the emperor though excluded from succession—was eccentric even to madness. He careened between the licentious pleasures of Kyoto's stews, the sober responsibilities of religious administration, and the most abstruse life of the Zen mind, transcending all accepted norms of behavior.[24] Numerous portraits of him exist: a sculptured one has real hair inserted for hair, eyebrows, and beard (recalling the Nara period *gigaku* mask [7, 8]), and a carefully executed traditional half-length painting is enclosed in a circle above a Tosa style rendition of his mistress, the blind musician Mori [81]. The variety of Ikkyū's portraits matches the extreme range of his existence, from spiritual searchings and exaltations, through the worldly intrigues of the corrupt Muromachi Zen hierarchy, to wallowings in drunkenness and debauchery.

One of the pithiest of Zen poems, encapsulating in four lines physical passion, spiritual passion, and the fusion of immanence and transcendence, is a stanza of Ikkyū's on his mistress:

> Blind Mori every night accompanies my
> songs;
> Deep under the covers mandarin ducks whisper anew.
> Her mouth promises Miroku's [the Buddha of
> the Future] dawn of deliverance,
> Her dwelling is the full spring of the ancient
> Buddhas.[25]

78 Hasegawa Tohaku, *Takeda Shingen,* hanging scroll.

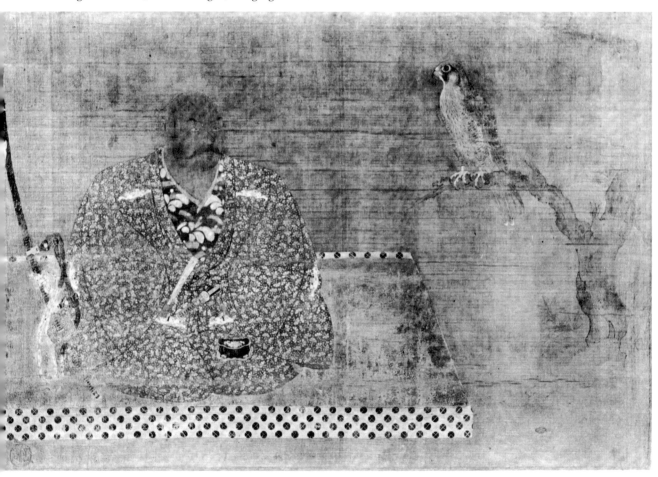

79 *The Zen Priest Ikkyū*, hanging scroll.

The man in the sketch-portrait lives up to our expectations. Hair short-cropped and unkempt, he gazes directly at the beholder, a rarity in all early Japanese portraiture.[26] The free, rough execution of the sketch suits his contemplative, anxious expression. In its psychological acuity the portrait is thoroughly modern, without precursors or immediate inheritors or compeers in its own time. One could as well imagine it appearing in post-Freudian Europe as in Muromachi Japan. In this universality, whether accidental or not, it differs from and surpasses the portrait of Dokuryū made some two hundred years later.

Obaku was the last version of Zen to reach Japan, brought there by refugees from the Manchu conquest of Ming China. In China Rinzai Zen (C. Lin-chi Ch'an) had acquired, by the seventeenth century, substantial admixtures of Esoteric and Jōdo doctrines. To Japanese Rinzai masters, inheritors of a tradition more or less unchanged since the Kamakura period, this newly arrived, highly syncretic teaching was unorthodox and unwelcome. With the support of

the Tokugawa shōguns it was soon constituted a separate sect, named for the Japanese pronunciation of Mt. Huang-po, site of the original Rinzai monastery in China. By the late eighteenth century more than five hundred Obaku temples existed in Japan. The principal contribution of Obaku to Japanese life was cultural, not doctrinal: in a country virtually closed by government fiat to foreign contacts Obaku monasteries became centers of late Ming Chinese language, learning, and culture. In addition, with their principal center in Nagasaki, to which Dutch traders had limited access, Obaku priests became a conduit and refracting lens for such Western influence as could trickle into Japan at that time.

Pictures of Obaku Zen masters constitute a cohesive, if small, entity in the history of Japanese portraiture. The portrait of Priest Dokuryū, by Kita Genki (act. 1664–98), seems at first glance a more realistic work than even the portrait of Ikkyū. The frontally observed head is carefully shaded to suggest structure and volume, while the sober visage conveys the emigré

80 Kita Genki,
The Chinese Priest Dokuryū,
hanging scroll.

priest's essential seriousness. Assertions of Western influence on Genki's technique have been both direct and subtle but remain controversial.[27] Genki's shading is really a soft variation of the brushstrokes that define wrinkles, noses, and other parts of the topography of portraiture and in this respect certainly derives from Chinese seventeenth-century practice,[28] wherever those origins may be determined to be.

But despite naturalistic modelling, the portrait of Dokuryū is no match for that of Ikkyū in individuality, realism, or modernity. The raw, compelling frankness of *Priest Ikkyū* is timeless, while the later and superficially more Western likeness appears time-bound. The sketch-portrait of Ikkyū seems a more creative summation of the past, a debt paid to the *nise-e* portrait-sketch, to Zen concentration on the countenance, and to the brush habits of the *e-maki* artists. To this list of antecedents Ikkyū would have added the inspiration of *Rokudō*. He was named Ikkyū (Rest) by his Zen master, Kasō Sōdon (1352–1428), in 1418, to which he responded with a poem:

From the world of passions
I return to the world beyond passions,
A moment of pause.
If the rain is to fall, let it fall;
If the wind is to blow, let it blow.[29]

1. Hardwood images of the Esoteric Eleven-Headed Kannon (Juichimen Kannon) and small portable shrines or reliquaries.

2. Takeshi Kuno, *A Guide to Japanese Sculpture* (Tokyo: Mayuyama, 1963), p. xlv.

3. See Langdon Warner, *The Enduring Art of Japan* (Cambridge, Mass.: Harvard U.P., 1952), pp. 45–46, for an excellent description of the new techniques and their significance.

4. Bunsaku Kurata, *Nihon no Bukkyō o Kizuita Hitobito: Sono Shōzo to Shō* [*Special Exhibition of Japanese Buddhist Portraiture: Portraits and Calligraphy*] (Nara: National Museum, 1981), p. 25, no. 20.

5. In the Hōgan-ji, Ehime Prefecture, Shikoku.

6. See also the monochrome ink painting on paper in the Kanagawa Prefectural Museum, in Kurata, *Nihon no Bukkyō o Kizuita Hitobito*, p. 135, no. 132.

81 *The Zen Priest Ikkyū and Lady Mori,* hanging scroll.

7. The legend (?) goes back to the monk Tao-lin (741–824) of the T'ang dynasty, who fled the court for a tree nest in the forest outside Hang-chou and was known thereafter as the Zen Master of the Bird's Nest. I owe this reference to Wai-kam Ho, who found it in Shinkō Mochizuki, ed., *Bukkyō Daijiten* [*Encyclopedia of Buddhism*] (Kyoto: Seikai Seiten Kankō Kyōkai, 1958), vol. 4, p. 3922. See also the fiercely disturbing late work by K'un-ts'an (1612–ca. 1674) in my *History of Far Eastern Art* (New York: Abrams and Prentice-Hall, 1982), fig. 608.

8. The portrait of the retired emperor Go-Shirakawa, from the Myōhō-in, Kyoto [61], is traditionally thought to be from the Jingo-ji group, but this is by no means certain.

9. Robert Paine and Alexander C. Soper, *The Art and Architecture of Japan* (Harmondsworth: Penguin, 1975), p. 144.

10. *Symposium* contains the current and widely differing opinions of numerous scholars.

11. This position is expressed by Kisaku Tanaka, "Nise-e Kō" ["Thoughts on *Nise-e*"], *Gasetsu*, no. 29 (May 1939), pp. 391–402, and by Hidetarō Wakita, "Nise-e mankō" ["Random Thoughts on *Nise-e*"], *Gasetsu*, no. 36 (December 1939), pp. 1083–88.

12. Keene, *Landscapes and Portraits*, p. 231, notes that "the only grounds for rejecting sketches ever mentioned in contemporary accounts are insufficient resemblance to the subject."

13. Nakano, *Symposium*, notes that *nise-e* sketches are found inside wood portrait-sculptures, a symbolic practice related to the use of ashes or relics in the earliest religious portrait images. The painted likeness serves to confirm the more formal sculptured portraits, including those of Go-Shirakawa (1311) at Joju-ji, Kūkai (1426) at Daigo-ji, and Shinran at Nishi Hongan-ji.

14. See *E-maki Tokubetsuten*, nos. 53 and 54.

15. Yukio Yashiro, ed., *Art Treasures of Japan* (Tokyo: Kokusai Bunka Shinkokai, 1960), vol. 2, pl. 226.

16. Haruki Kageyama, *The Arts of Shinto*, trans. Christine Guth, Arts of Japan, no. 4 (New York and Tokyo: Weatherhill/Shibundo, 1973), p. 19.

17. An excellent introduction to Zen and Zen art can be readily found in Jan Fontein and Money L. Hickman, *Zen Painting and Calligraphy* (Boston: Museum of Fine Arts, 1970).

18. See Keene, *Landscapes and Portraits*, chap. 5, esp. pp. 226–30 for a general discussion of Japanese portraiture, and pp. 230–41 for specific consideration of the portrait of Ikkyū [79].

19. Martin Collcutt, *Five Mountains: The Rinzai Zen Monastic Institution in Medieval Japan* (Cambridge, Mass.: Council on East Asian Studies, Harvard Univ., 1981), fig. 7, p. 60.

20. These expeditions, sponsored on the Japanese side by other sects as well as Zen, also carried on considerable commerce with China, with the blessing of, and sometimes as agents for, the government. See Collcutt, *Five Mountains*, pp. 101, 283–85.

21. Takaaki Matsushita, in "Ikkyū Oshō no Gazō," *Museum* (Tokyo), no. 53 (August 1955), pp. 9–13, notes the difficulties inherent in distinguishing Chinese portraits from Japanese portraits sent to China for inscription.

22. Fontein and Hickman, *Zen Painting and Calligraphy*, p. 60.

23. Keene, *Landscapes and Portraits*, p. 230.

24. See the excellent essay on Ikkyū's life and on the "Bokusai" portrait by Keene, *Landscapes and Portraits*, pp. 226–41.

25. Keene, *Landscapes and Portraits*, p. 239.

26. Keene, *Landscapes and Portraits*, and Shun Etoh, *Symposium*, both remark that this work and the portrait of Daitō Kokushi (dated to 1334) at Daitoku-ji, Kyoto, are the only early portraits that look out at the spectator.

27. Nakano, *Symposium*, derives the shading from either Chinese or Western practice. Kei Kawakami derives it from Chinese works under Western influence. This suggestion is still a sensitive subject under present study, especially by James Cahill and Michael Sullivan in *Proceedings of the International Symposium on Chinese Painting* (Taipei: National Palace Museum, 1970).

28. See the portrait of An Ch'i, a joint work by Wang Hui, T'u Lo, and Yang Chin, in *Eight Dynasties of Chinese Painting* (Cleveland: Cleveland Museum of Art, 1980), no. 259.

29. Keene, *Landscapes and Portraits*, p. 233.

Interlude: The Bending Icon and the Thirty-six Poets

Some idea of the potency and pervasiveness of realistic tendencies in medieval Japanese art can be gained by examining two contemporary subjects whose treatment was most persistently conservative and unrealistic: Buddhist icons and the Thirty-six Immortal Poets.

The first of these categories comprises the numerous representations of deities as aids to worship—symbolic, formal, and relatively abstract frontal images, standing or seated, often accompanied by appropriate subsidiary deities. Of these icons the most extremely unrealistic are the mandalas, diagrams of the realms of the Buddhas, in which divinities are anthropomorphically represented but placed within a conceptual geometric grid according to their stations in a complicated theological hierarchy.

Although most icons represented deities in the abstract, without a setting, at least one popular icon, the *Nehan* (S. *Parinirvana*, death or extinction of the Buddha) [82], traditionally required realism in the adjunct figures surrounding the golden reclining Buddha. The expressions of attending deities such as Kannon (S. Avalokitesvara; C. Kuan-yin) and Seishi (S. Mahasthamaprapta), usually pure god-like benignity and compassion, are shadowed here by all-too-human sorrow, while in Buddha's disciples grief shows more unreservedly, even grotesquely, their expressions recalling the pain and anger often seen in *Rokudō* subjects. Animals, too, attend the Buddha's passing, many of them crying and writhing in an abandon of anguish. Grief in the *Nehan* paintings is hierarchical, becoming more real and less hieratic as one moves down the ladder of being.

Still another type of icon is the *raigō*, the descent of Amida Buddha, flanked by the bodhi-

sattvas Kannon and Seishi, to welcome each dying person's soul to the Western Paradise. The very concept of *raigō* expresses the yearning for a personally solicitous god that found voice in the popular (i.e., pietist, salvationist) sects of Buddhism.[1] By its nature the *raigō* image tends to realism, "for Mercy has a human heart/Pity a human face" (William Blake). In almost all *raigō* the typical iconic expression, contemplative and withdrawn, gives way to a direct, compassionate gaze at the viewer. Other elements of realism were added, including setting and the suggestion of actual motion. In the original pictorial vision Amida and his attendant bodhisattvas and angel-musicians are golden figures without a setting. Soon, however, the earthly landscape into which they descend appears; though peripheral and small, and nearly eclipsed by the divine effulgence, it is a lovely glimpse of Japanese scenery, realistically rendered. In the *yamagoshi* (mountain-crossing) *raigō* the landscape has become foreground, with Amida rising in frontal splendor behind low, wooded hills. The so-called swift *raigō* (*haya raigō*) (Figure 11) were perhaps the most emotionally compelling: the heavenly entourage is shown in three-quarters view, descending along the diagonal on spiraling, comet-like clouds. Often the divinities are not seated on the clouds but standing and leaning forward in their haste to reach the dying devotee. Every element of these "swift *raigō*" contributes to the effect of a sweeping rush through the heavens. In the *yamagoshi raigō* of Konkaikōmyō-ji, Kyoto, one small detail dramatically illustrates the literal motive of the new realism. Amida's hands still hold the remains of actual silken cords whereby the dying believer, clinging to their other ends, was drawn to para-

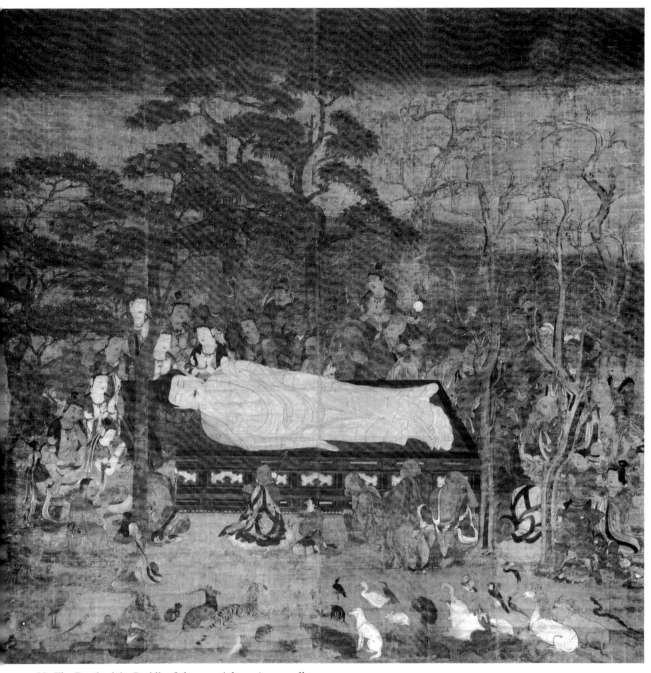

82 *The Death of the Buddha Sakyamuni*, hanging scroll.

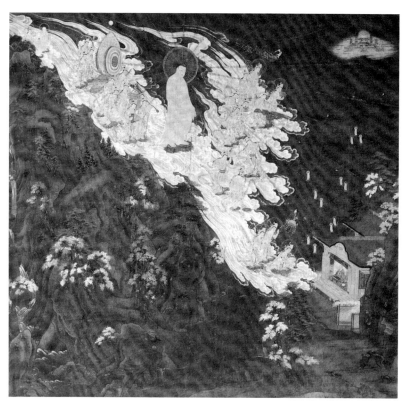

Figure 11.
*Descent of Amida and
Twenty-five Bodhisattvas* (detail.)
Hanging scroll, color on silk, 145
x 155.5 cm. Japan, Kamakura
period, 13th century. Chion-in,
Kyoto. National Treasure.

dise. Visual metaphor has been translated into physical reality.

Even in those images whose iconographical requirements indicated a more formal approach, one finds evidence of the new realist tendencies. Examples are rare, but this makes the deviation even more surprising and, it must be confessed, aesthetically and representationally disturbing. Thus the hanging scroll from Saikyō-ji, Shiga Prefecture [83], displays a golden Shaka holding a traditional Buddhist alms bowl and framed by an elaborate *mandorla* (body halo) with nine small Buddhas and ten angel-musicians (*S. apsaras*) on its flame-shaped border. But this Shaka, unlike most, does not face the worshipper frontally and bolt upright. We see him in three-quarters profile, his body—and with it the *mandorla*—bent toward the beholder. The new pose occurs also in sculpture, where it seems even more incongruous.

In a particularly rare and striking case we can understand the heterodox realism of an icon presumably created as a response to a specific historical event. Fudō Myōō, flaming manifesta-tion of Dainichi's (S. Mahavairocana) wrath against evil, is usually shown seated motionless upon a rock, the personification of his attribute "the Immovable." But the famous *Hashiri Fudō* [*Running Fudō*] [84; Color Plate XIII][2] depicts this adamantine Shingon deity as running, his sword not held before him like a scepter but swung back over his shoulder ready to strike—an awesome spectacle of deity moving to the attack. His two youthful attendants, Kongara and Seitaka, run before him, weapons also at the ready. Fudō was customarily supplicated in times of national crisis or disaster, and tradition has it that this unusual image was called on by the emperor Kameyama for divine aid against the Mongol invasions of 1274–75 and 1281. Fudō was moved and the invasions were repulsed, the last one put to rout by a fierce typhoon.

By the fourteenth century greater informality and realism were relatively common and occasionally carried to suprising extremes. One of the most popular of Zen icons was the representation of Kannon in flowing white robes, in different contexts variously called the *Byaku-e Kan-*

non [*White-Robed Kannon*], *Suigetsu Kannon* [*Water and Moon Kannon*], or *Ryūgetsu Kannon* [*Kannon of the Willow Moon*]. The figure might be standing in a hip-shot pose or seated, often informally with one leg pendent or the torso supported on one arm. But the *kakemono* from Kenchō-ji, near Kamakura [85], portrays the deity washing its feet at a small waterfall! If the intention was to humanize Kannon, to make the compassionate one more accessible to the worshipper, it has succeeded only too well, for the bodhisattva looks like a village woman washing herself. The painting might almost be a Chinese ink style detail of a genre scene in a narrative scroll.

Even the Zen *chinsō* portrait—generally individualized as to face but formally posed—occasionally admitted an astonishingly homely realism of gesture. In the portrait from Buttsu-ji, Hiroshima [86], Priest Guchushukyu, like most such subjects, is seated in an abbot's chair with his slippers placed below and his left hand on his left knee, but his right arm and hand are raised to scratch his shaven head. Again, the realistic gesture seems an almost shocking anomaly, even in a Zen context. Zeus may nod but is not expected to scratch himself in full view of the beholder.

The second, i.e., secular, category of unrealistic painting developed out of the Heian court's unparalleled addiction to poetry. Every event of aristocratic Heian life was adorned by poetry, and the ability to versify, to quote aptly, and to recognize and respond to quotations with equal facility was an essential of upper-class deportment. As Murasaki's *Tale of Genji* and Sei Shōnagon's *Pillow Book* make clear, poetry was indispensable at birth, death, and all rites of passage between; courtships and seductions were conducted largely in verse; genteel diversions were incomplete until memorialized in verse; government memorandums might well be in allusive verse instead of explicit prose; and the formal aesthetic contests that filled remaining idle hours included poetry contests (*uta awase*) on set themes between rival teams of courtiers. The anthologizing of poetry had begun even

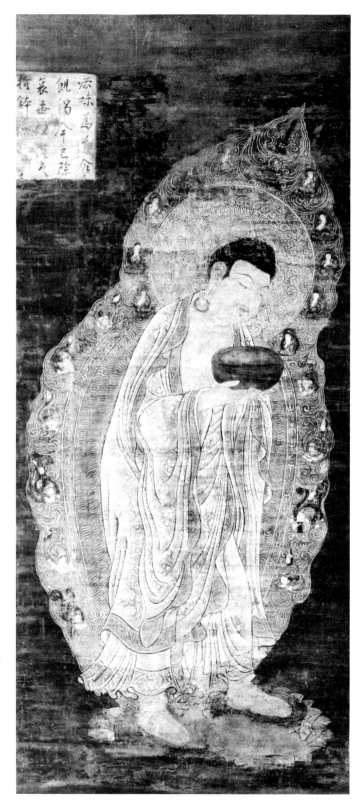

83 *Bending Shaka*, hanging scroll.

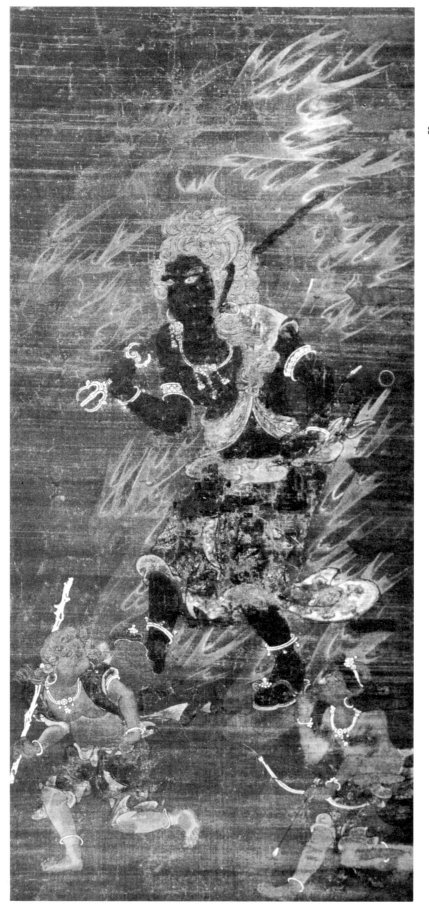

84 *Running Fudō,*
hanging scroll.

Right
85 Shōkei (attrib.),
Kannon,
hanging scroll.
Far right
86 *The Zen Priest
Guchūshūkyū,*
hanging scroll.

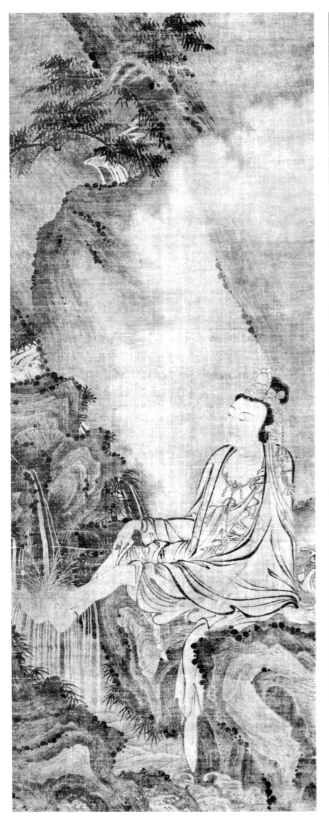

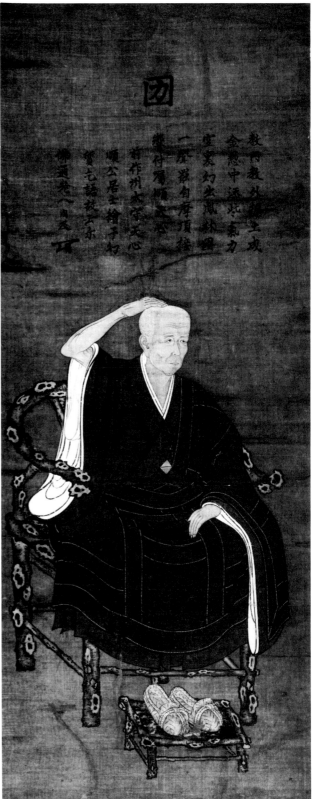

教化教外旨三成
金粟中流水氣力
蓮索幻出嵐煙暉
一座嵓岫摩頂接
薬付獨順應此
前作州如紫天心
順公居士撐于幻
賀元話裝予示
禪道卷八日又

earlier, with the inclusion of poems in the *Kojiki* [*Record of Ancient Matters*] of 712, followed by the first extant poetry anthology, the *Manyōshū* of the mid-eighth century, and the *Kokinshū* [*Ancient and Modern Anthology*] of about 922. These record only a portion of the vast body of poetry, both enduring and ephemeral, produced mainly by men and women of the aristocracy. The late tenth-century *Sanjūrokuninshū* [*Anthology of the Thirty-six Poets*] set an enduring fashion for compilations of the best works of Japan's thirty-six finest poets, a list whose elite membership varied somewhat according to the compiler.

By early Kamakura these anthologies of the Thirty-six Immortal Poets (*Sanjūrokkasen*) had become the inspiration for imaginary "portraits" of the immortalized poets, each accompanied by the text of one of his poems. The representations adhere to the rules of courtly decorum and to the conventions of *onna-e*, or *yamato-e*, style. However pensive or witty, reserved or ingratiating the personalities revealed in their works, the pictures of these poets all show formally clad courtiers or monks, ladies or nuns, but not distinctive individuals. They are masterpieces of the decorative treatment of single figures rather than portraits in any true sense. Taira no Kanemori's poem, for example, expresses a weary ennui, but his figure, in a detached section from a *Sanjūrokkasen* handscroll [87], seems only non-specifically contemplative.

> As I count, the years and months have piled on me.
> Why should anyone prepare for bidding farewell to one year and welcoming another?
>
> trans. Kojiro Tomita

Numerous other sets of the *Thirty-six Immortal Poets*, in both handscroll and album formats, were produced in the Kamakura period, a few showing some tendencies to particularization. But toward the end of the Kamakura period, in the early fourteenth century, a remarkable hand-

87 *The Poet Taira no Kanemori,* hanging scroll.

scroll was produced that, in effect, turned the decorous world of the poets upside down. The *Tōhoku-in Shokunin Uta Awase E-Maki* [*Tōhoku-in Poetry Contest Among Members of Various Professions*], from the Tokyo National Museum [88], is a rendition after-the-event of a *waka* (Japanese poetry) contest among the lower orders that was said to have occurred in 1215 at the Tōhoku-in, Kyoto. The set theme of the contest was that immemorial combination—the moon and love. The poems are not remarkably different from those by aristocratic authors, but the representations of the competing poets are heterodox, sketchy renditions that verge on caricature. The division of the competitors into two teams of the right and left was customary and mirrored the organization of the court, but these characters are far from courtly. They include, in alternate representations, a doctor, blacksmith, swordsmith, a medium or sorceress, and a pearl-diver on the team of the left; and, for the right, a fortune-teller, carpenter, metalworker, gambler, and tradesman. The judge, shown at the end of the scroll, is a picture mounter. The depictions are summary and pointed, recalling the rough, sketchy quality of the fourth roll of *Chōjū Jinbutsu Giga* [23]. The seated foundryman, wearing a robe tie-dyed in squares, resembles depictions of the weather-beaten mountain priests (*gyōja*) in that roll. The medium, a gray-haired, half-toothless harridan, is seated holding a hand-drum. To judge by her coiffure, she was intended as a caricature of a court lady. Her heavily drawn, badly placed eyebrows recall comical stories involving badly applied cosmetics, the most celebrated being the "Haizumi" (Blackening) section of the *Tsutsumi Chūnagon Monogatari*,[3] probably a compilation of works composed between 1050 and 1235 by several authors. But the most plebeian and well-realized figure is the unkempt nude male gambler, stripped bare save for a dilapidated court hat but still throwing his dice on the gaming block. The nail-head brushstrokes, the shorthand indication of the spinal column, his hairy legs, exposed genitals, and stupid expression, all hark back to the merciless observations of the human condition found in *Rokudō* handscrolls such as *Yamai no Sōshi* [15]. The idealization seen in the *Sanjūrokkasen* paintings has here been transformed into satire,

though it is hard to say whether the aristocratic poets or the vulgar commoners were the intended butt of the joke. Whichever the case, the handscroll attests a growing interest in the appearance and activities of the urban working class.

The Thirty-six Poets continued, especially in the Edo period, to be a favorite subject, first of the courtly Tosa school and second of the quintessentially decorative *rimpa* school derived from the great masters Tawaraya Sōtatsu (act. late sixteenth–early seventeenth century) and Ogata Kōrin (1658–1716).[4] In the hands of *rimpa* artists the theme of the Thirty-six Poets became a pretext to combine daring and colorful composition, emphasizing the patterns and asymmetric outlines of the poets' garments, with comical-satirical depictions of the thirty-six faces. This fresh new combination incorporated both the high and the low from traditions of representing the poets inherited and adapted by the artists of the *rimpa* school. Realism as caricature left a permanent mark on the aristocratic and poetic subject.

This tendency even extended into the later ideal world of *nanga*, the "southern painting" school which emulated the free, scholarly brush manners of Ming and Ch'ing China's *wen-jen-hua* (gentlemen-scholars' painting). Some among the *nanga* masters produced a specialized shorthand combination of haiku poetry, often composed by the artist, and a summary image, called *haiga*. The seventeen syllables of a haiku offer a terse, lightning-like glimpse into the heart of its subject, usually nature. In "capturing the moment," haiku and *haiga* usually succeeded in making the selected detail concrete and discrete, more real than reality. Though the form was new in the seventeenth century, Bashō (1644–94), its great master, proclaimed his debt to Saigyō (1118–90), the courtier-poet-monk immersed in landscape whom we have already met in chapter v. Bashō, in turn, was virtually deified by later generations, including Yosa Buson (1716–83), the important *nanga* painter who was both haiku poet and *haiga* artist and adept at the rapid caricature sketch. In emulation of Tosa representations of court poets of the past, Buson painted groups of no-longer-living haiku poets; produced one woodblock series of the *Thirty-six Haiku Poets*; and executed an especially interest-

一番
左
もろともに月のつきまさむ
宿れるつち池をへにけ
まりうつにつけつつ宿病
あらわれきふ沼にもとな

判者
経師

二番
左
月星はぬ宝きしやく人とむれん
河にきまさむいつらつち
めつれやそきねれけとま
こそはとをいきもせん

右
すつれれのさまをきゆらす
つらつれて

右
もうにかなそうされにこみとうくらしや
へ

88 *Tōhoku-in Poetry Contest Among Members of Various Professions,* handscroll.

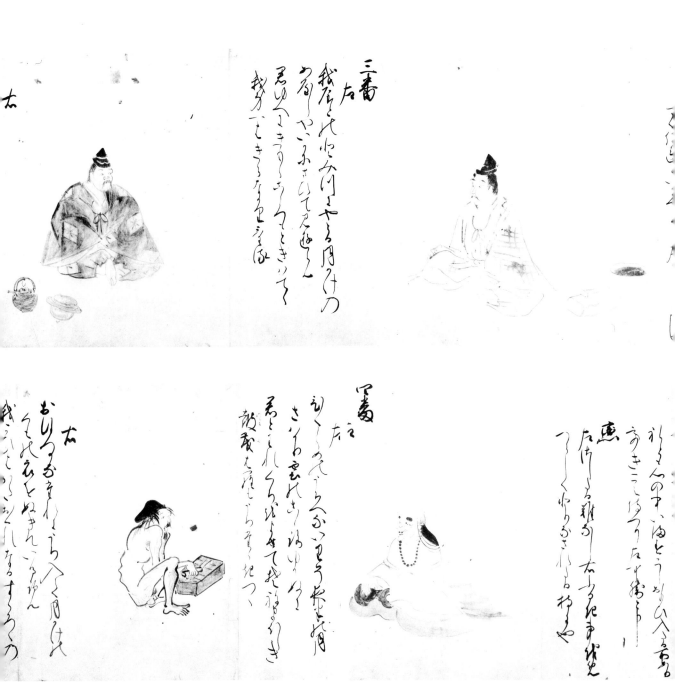

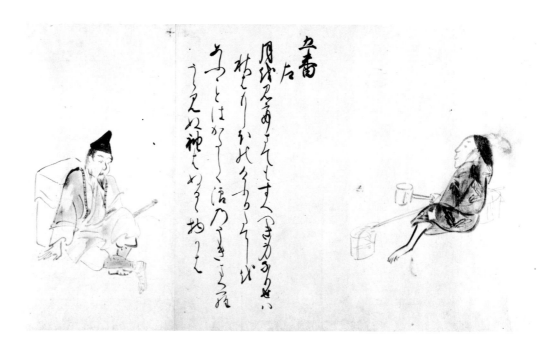

ing hanging scroll, *Haisen Gunkai* [*Gathering of Haiku Poets*] [89], showing twelve male poets and one female, plus a female attendant.[5] Bashō appears unobtrusively at the upper left, a grotesque elderly figure with his head wrapped in a cloth.

The picture is more carefully painted and composed than the usual *haiga*, and obviously Buson had such *rimpa* productions as Tatebayashi Kagei's (act. 1740–50) two-fold screen painting of the *Sanjūrokkasen* [90] in mind when he produced *Haisen Gunkai*. But Buson's coloring is somber rather than sparkling or gorgeous, and the painting elicits a pleasure comparable with that afforded by earthy and humble tea ceremony wares. It also embodies the haiku principle of revealing universals through deliberately commonplace images. The calculated overlapping of the figures rivals the decorative order of *rimpa* compositions, but in the individualized portrait heads, each carefully labelled with the poet's name, the more obviously satirical and humorous qualities of Buson's *rimpa* sources are absent and individual character is emphasized instead. The combination of these disparate elements in a unified work is a measure of Buson's artistic genius.

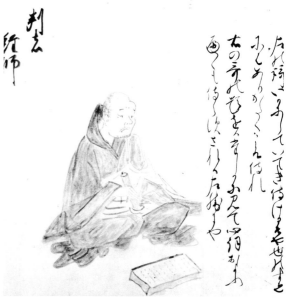

88 *Tōhoku-in Poetry Contest Among Members of Various Professions* (continued).

Buddhist icons and the Thirty-six Poets are subjects inimical to realism, existing as they do in the realms of faith and idealism. Yet they too could be bent or accented by the pressures of a continuing Japanese interest in the real world.

1. Fully demonstrated in Joji Okazaki, *Pure Land Buddhist Painting*, trans. and adapted Elizabeth Ten Grotenhuis (Tokyo: Kodansha, 1977), p. 94ff.

2. Formerly in the Inoue Collection, now in the Heisando Collection.

3. Reischauer and Yamagiwa, *Early Japanese Literature*, pp. 256–57.

4. No such composition by Sōtatsu survives, but extant close versions begin with Kōrin and were done by Kagei (act. ca. 1740–50), Saiki Hōitsu (1761–1828), and lesser followers.

5. For material on this and related subjects, see Cleopatra Papavlou, "The Haiga Figure as a Vehicle of Buson's Ideals" (Ph.D. diss., Univ. of California, Berkeley; Ann Arbor, Mich.: University Microfilms, 1982), pp. 15, 46, 48, 151.

89 Yosa Buson, *Gathering of Haiku Poets,* hanging scroll.

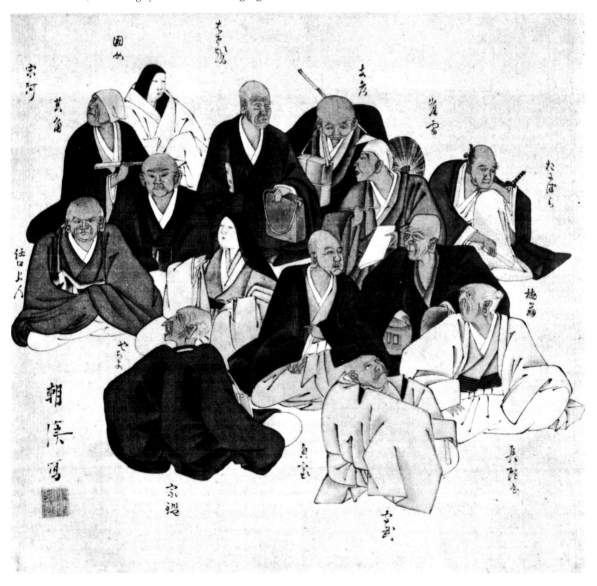

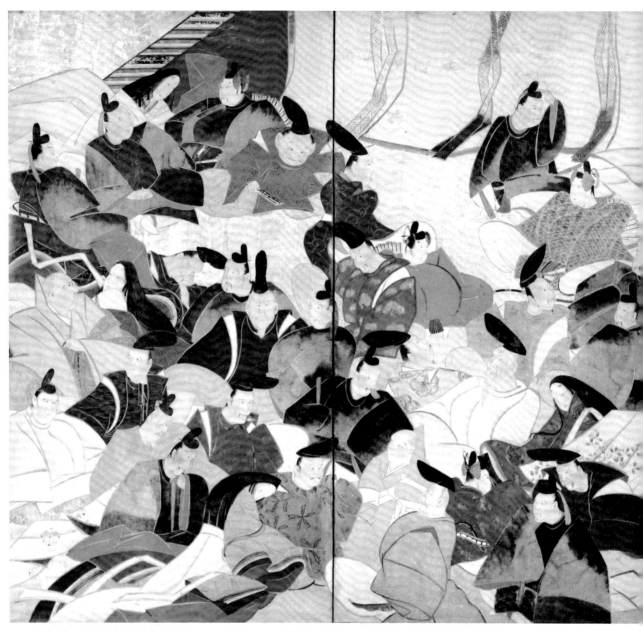

90 Kagei (attrib.), *Thirty-six Immortal Poets*, two-fold screen.

142

Early Sites and Views: Landscape as Subject

Countless are the mountains in Yamato,
But perfect is the heavenly hill of Kagu;
When I climb it and survey my realm,
Over the wide plain the smoke-wreaths rise
 and rise,
Over the wide lake the gulls are on the wing:
A beautiful land it is, the land of Yamato![1]

Emperor Jomei's (593–641) famous poem epitomizes a Japanese approach to landscape that was dominant for almost a thousand years. The opening line acknowledges the vastness of nature, the closing line extols its undifferentiated beauty, but the four lines between are devoted to the perfection of the particular, and images of Kaguyama, smoke-wreaths, and flying gulls are presented with intuitive and emotional pride. Where the great early Chinese landscapists searched nature analytically for principle and rational order, which they embodied in the patient accumulation of explicit monochrome detail, the Japanese artist relied on suggestive and emotive detail, the intimacy of a garden-like environment, and the immediate appeal of decorative color. This is not to say that the origins of this *yamato-e* are to be found in Japan.[2] We have already indicated that they were borrowed from early Chinese landscape style, the decoratively colored works produced before the rise of monumental ink landscape styles in the tenth century. This colored manner was, fortuitously and fortunately, perfectly suited to the medieval Japanese appreciation of landscape—a palette basically blue and green with grace notes of yellow and red for autumn foliage, and a picture composed of broad areas of relatively flat shapes with little interior structure. The comparatively steep and angular Chinese mountains and rocks were translated into the ubiquitous low, rolling contours of Yamato.

This gentle, gracious, lyrical manner was attuned to the landscape itself and to the Japanese perception of it, which was rooted not only in aesthetic predilections but also in the strong Shintō foundation beneath adopted Chinese and Buddhist overlays. An omnipresent feature of the Japanese landscape is the sanctified rock, tree, hill, or mountain marked by various offerings or by the presence of Shintō shrines ranging from miniatures to elaborate complexes [91, 92]. Sacred rocks and trees might also have a rope twisted around them. This recognition and worship of the numinous particular, in addition to the appreciation of unique sights—the beach at Hamamatsu, the waves at Matsushima, the autumn foliage at Mt. Arashi—provided the inspiration for shrine- or landscape-mandala, pictorial diagrams showing both the layout and the appearance of Shintō shrines in their natural settings. The thirteenth-century *Kotobiki Miya Engi* [91] seems almost an illustration of Emperor Jomei's poem in its balanced orchestration of mountains, trees, mist, water, and shrine. It is also remarkably like a T'ang dynasty (618–907) Chinese landscape and is in fact an extremely conservative work harking back to now lost Heian paintings that show T'ang influence.

The *Kumano Mandala* [92] may well be only a few decades later than the *Kotobiki Miya Engi*, but its concentration on the precise location and hierarchical relationships of the three most famous pilgrimage shrines of Kumano (in present-day southern Wakayama Prefecture) betrays other interests and other influences. One of these is a strong Buddhist tincture in the Shintō character of the landscape-mandala. By the Kamakura period a vigorous and systematic effort was being made to connect, or even combine, Shintōism

and Buddhism within the Japanese ethos. A syncretic Buddhism (*honji suijaku*) embraced Shintō spirits and gods as local manifestations of the almost equally numerous deities of Esoteric Buddhism. In the *Kumano Mandala* the rows of haloed Buddhist deities above the ranks of Shintō shrines impose elements of geometric order on the flowering landscape. The natural features, such as Nachi Waterfall at the upper right, are reduced to supporting a geometric, almost topographical, report on the three

shrines, miles apart in actuality but united here in a single pictorial setting. The immediate loveliness and specificity of the *yamato-e* approach to nature is modified in accordance with iconic and abstract interests.[3]

An extreme representation of nature as icon is exemplified by a Muromachi mandala of Mt. Fuji [93], admittedly a semifolk production but one of considerable force. The mountain's cone, whose separation into small subsidiary peaks is barely discernible from the south near Hamamatsu,

91 *Legends of Kotobiki Shrine,* hanging scroll.

92 *Kumano Mandala,*
hanging scroll.

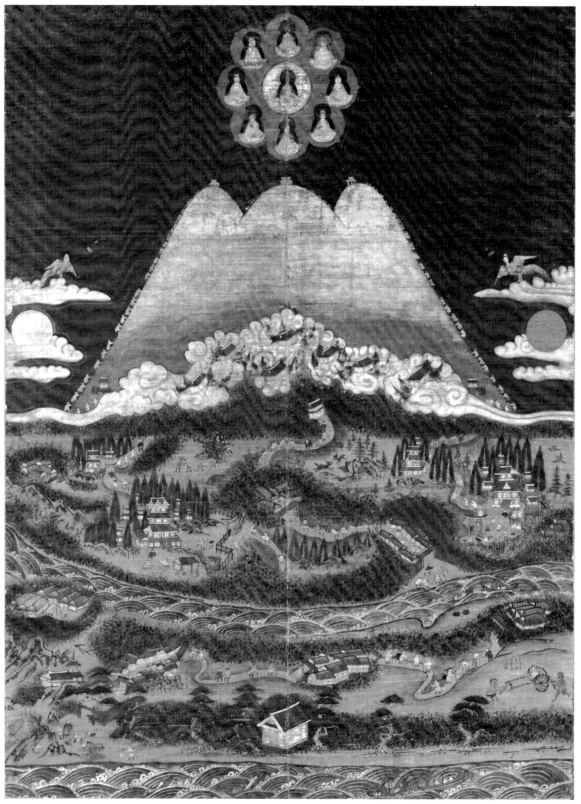

93 *Mandala of Pilgrimage to Mt. Fuji,* hanging scroll.

94 *Picture-Map of Meigetsu Temple,* hanging scroll.

appears here as three quite distinct elevations, each topped by a shrine. The rigid iconic balance of the picture is patent: over the central peak appears Dainichi Nyorai, the supreme Buddha of Esoteric Buddhism, with the sun and moon, each accompanied by a *kinnari*,[4] over the flanking peaks. Only the foreground, with its naive landscape and architectural elements, recalls the viewer to the emotive *yamato-e* elements of specific place and time, and these are given in a folkish shorthand at once decorative and diagrammatic. Compared with the episodic representation of Fuji in the *Ippen Shōnin* scroll [Color Plate VI], the Fuji mandala seems dogma-bound in the effort to achieve a timeless image rather than a seasonal impression.

The *Ippen Shōnin* detail points up the dilemma posed by the medieval Japanese understanding of nature. Its emphasis on the emotive detail, the intimate loveliness of landscape, was appropri-ate for the convincingly real glimpses of landscape found in settings of extended narratives or in the periphery of Shintō mandalas. The all-encompassing, organized view of nature common to early Sung Chinese landscape painting was foreign to the Japanese. When confronted with the need for rational composition, whether schematic or visual, the Japanese response was intuitive and piecemeal, practically effective but illogical, a code with several keys. The puzzlement of intuition before the need for topographic accuracy is evident in the Meigetsu-in map [94], where the buildings within a surrounding landscape, oriented to the cardinal directions as represented by the four edges of the picture, are seen as if the artist had no single viewpoint but turned left and right to record each typical view of every structure. The structures to the south are behind the observer but are nevertheless represented from the viewpoint required for the

95 Kano Shōei, *Picture-Map of Shōten Temple,* hanging scroll.

main buildings to the north. The three-storied pagoda, set on an angle to the southeast, is oriented to still another singular viewpoint. The result may be an intellectual and visual hodge-podge, but it remains a useful and effective map, locating each structure and revealing its most characteristic appearance.

Comparison of this work with one made two hundred years later, a map-view of Shōten-ji painted in 1570 by Kanō Shōei [95], reveals that adoption during the Muromachi period of Chinese landscape modes developed in the Sung, Yüan, and early Ming dynasties enabled Japanese landscapists to achieve apparent visual coherence. But this seemingly more rational and unified image is almost as ambiguous as its intuitive predecessor. The location of the distant

buildings at the right is so vague and mist-veiled as to be unreadable, while the uncertainties of scale leave one quite undecided as to the real size of the structures in relation to their landscape setting. Are these dwarf pines and miniature buildings? Are the mountains near or far? Are the figures giants? The Chinese monochrome landscape style adopted by the Muromachi Zen masters is in reality no less abstract than that of the mandalas. In Japanese hands, in fact, its abstraction was heightened, because the to-pography of these landscapes was Chinese, not Japanese, learned by most Japanese painters from the monochrome paintings imported from the mainland and used as models to produce not Japanese landscapes but Zen pictures.

These Zen exercises in pictorial meditation are

148

among the great achievements of East Asian painting, but they also served further to blunt any impulses to create pictorial images of the Japanese landscape, impulses already atrophied by the intervention of the mandala concept between the artist and the lovely land of Yamato. All of these impediments make the occasional appearance, within the Muromachi monochrome school, of real views of the Japanese landscape seem especially remarkable. Hence the signal fame and importance of Sesshū's (1420–1506) *Ama no Hashidate* [96] and *Fuji* [97]. Even the format of these two ink hanging scrolls was radically changed to accommodate the singular intention of the artist—from the usual verticality of the Chinese style hanging scroll to a broad horizontal. The *Ama no Hashidate* in particular consistently emphasizes low, rolling forms in the old *yamato-e* manner. Its ground is made up of many small rectangles of paper pasted together, unlike the continuous fabric of the *Fuji* paper, indicating that the artist considered the work a sketch, even a sketch-map. This impression is supported also by the fact that the *Ama no Hashidate* is neither signed nor sealed, the only

inscriptions being brief designations of several salient features of the scene. But the character and strength of the brushwork and masterly control of the wet washes are clearly Sesshū's, and no one doubts his authorship of the work. The *Fuji* is more staid and formal, a recollection presumably painted as a demonstration for Chinese colleagues during Sesshū's trip to the mainland in 1468. Mt. Fuji itself seems something of an intrusion into a fundamentally idealized, Chinese style landscape.

The *Ama no Hashidate* stands alone among contemporaries in its brusque notational quality, ranks of low pines, and rolling hills in a wet atmosphere. Only color is lacking for the landscape to take its place as a lovely and creative revival of the native landscape style begun in the Heian period but lost to major artists during the long period of Zen and Chinese dominance (ca. 1300–ca. 1600). The shifting points of view—low in the foreground, high in the middle distance, and declining somewhat in the far distance—probably result from Sesshū's reliance on preliminary sketches, made from nature, of small parts of the scene. They recall, but with greater

96 Sesshū, *View of Ama no Hashidate,* hanging scroll.

97 Sesshū (attrib.), *Mt. Fuji and Seiken Temple,* hanging scroll.

150

sophistication, the numerous viewpoints of earlier topographic map-landscapes. The specificity of the scene permits the painting to be dated between about 1503 and 1506. The small, single-storied pagoda of Chion-ji on the pine-covered point at the lower left was not completed until 1501, and the temple complex of Nariai-ji in the mountains at upper right was destroyed by fire in 1507, one year after Sesshū's death. The kind of realism we find in the *Ama no Hashidate* does seem reminiscent of *yamato-e* style, probably because Sesshū, working in his powerful, idiosyncratic modification of the Muromachi *suiboku-ga* (ink painting) style inherited from Shūbun, among others, was recording a Japanese scene as faithfully as he could. It does not anticipate the kinds of realism that were to become so common in the Edo period (1615–1868).

One of these later approaches to reality can appropriately be considered here, in another masterpiece of Japanese landscape painting with a cone-shaped volcanic mountain as its dominant feature. This is *Mt. Asama* [98], in central Honshū, painted about 1790 by Aōdō Denzen (1748–1822). Nothing, save a developed Western landscape of the seventeenth century, could be further in kind from Sesshū's *Fuji*. The name Aōdō, given the painter by his patron, Matsudaira Sadanobu, means "Hall of Asia and Europe" and fittingly embraces the union of two hitherto separate art styles.[5] Although the bold, monumental composition could as well have derived from the decorative *rimpa* style initiated by Sōtatsu and continued by Kōrin, other elements are indebted to Dutch engravings—the tonal treatment of broadly defined forms without emphasis on brushwork, the modelling of volumes in light and shade, the atmospheric perspective in the far distant hills, the limited "old master" palette, the skillfully indicated smoke, and the visually convincing low eye-level of the beholder. Aōdō has recorded a visual experience

98 Aōdō Denzen, *Mt. Asama*, six-fold screen.

no more striking than the panorama by Sesshū, but he has superimposed new imported conventions on inherited native ones. To our eyes, and even more to those of his contemporaries, he achieved a more realistic pictorial image than his predecessors.

By the end of the medieval period, about 1600, the Japanese artist had mastered various traditional means to achieve visually persuasive ends. The fleeting world provided mundane subject matter, to which Buddhism directed dispassionate, even melancholy, observation. The sketch had sharpened the means of transcribing moments of activity, the typical appearances of various classes, and the unique characteristics of individuals. These means, perfected in complex visual narratives, portraiture, satire, and the grotesque, were at hand when Japan once again achieved relative peace, unity, and effective rule, supported by a new level of prosperity engendered by rising mercantile activity. Increasing population, increasing mobility, and accompanying urbanization made social, cultural, and specifically artistic stimuli more numerous and more effective. Artistic diversity, including numerous essays in realism catalyzed by Western influence, was permitted by the sophisticated, exclusionary, and thoroughly policed feudalism of the Edo period, being considered no threat to established order. Though the new artistic realism was not an agent in the overthrow of Edo feudalism, the culture from which it drew inspiration, *Rangaku,* or "Dutch studies," certainly was.

1. Donald Keene, ed., *Anthology of Japanese Literature* (New York: Grove Press, 1955), p. 34.

2. The best reference for this subject is still Alexander Soper's fine essay "The Rise of Yamato-e," esp. pp. 374–77. No better discussion of the subject has yet appeared; the reader is urged to read it attentively.

3. Even the apparently pure *yamato-e* "blue-and-green" landscapes on the four doors of the Hōō-dō (1053) of the Byōdō-in at Uji are now thought to be an early essay in the increasingly prominent category "landscapes of the four seasons," not simply four individual paintings. This rational organization is inconspicuous in the paintings themselves, but its existence has been confirmed by inscriptions to that effect discovered in 1955 on the edges of the picture panels. See Terukazu Akiyama, *Japanese Painting* (Geneva: Skira, 1961), p. 69.

4. Human-headed bird imported with Buddhism from India.

5. Donald Keene, *The Japanese Discovery of Europe* (London: Routledge and Kegan Paul, 1952), p. 88.

Edo Complexities

Castle building reached near-epidemic proportions at the end of the sixteenth and beginning of the seventeenth century. The pace was set by the principal agents of reunification—Oda Nobunaga (1534–82), who subdued the heartland; Toyotomi Hideyoshi (1536–98), who completed the reunification; and Tokugawa Ieyasu (1542–1616), first of the Tokugawa shōguns who ruled Japan throughout the long Edo period. Their powerful followers and sometime competitors, the daimyō rulers of regional fiefs, were in no way behindhand. For these new men, bloodily risen to power in exceedingly precarious times, castles were not only an instrument of defense but an expression of vaunting ostentation. Decorators as well as builders were required—a veritable army of master painters, assistants, and apprentices to create the quantities of screen and wall paintings commissioned by the victors in Japan's century of civil war.

The sheer volume of work precluded a uniformly high level of excellence, but the Chinese manner of producing landscapes and bird-and-flower paintings, well learned and prevalent in the preceding century, provided a facile way to cover the new large spaces. Rapid calligraphic brushwork and areas of flat color were enlarged and made boldly decorative. The characteristic Chinese mode of the officially patronized Kanō school became in the Momoyama period (1573–1615) even more stylized and remote from the rapidly changing real world. In the masterpieces of large-scale decoration produced by the most creative Momoyama artists, Kanō Eitoku (1543–90), Hasegawa Tōhaku (1539–1610), and Kanō Sanraku (1559–1635), only a secondary place was afforded to the kinds of reality that had been staple in earlier Japanese art. Certain narra-

tive subjects—military campaigns, hunting scenes, horse races, the various classes and their occupations—crept into the general repertory and were often treated in the old *yamato-e* manner now embraced by the Tosa school and associated with the court at Kyoto.

The monolithic daimyō patronage that summoned up the decorative masterpieces of Momoyama art was replaced during the Edo period by increasingly broader and more complex sponsorship, particularly from the rising middle class of merchants, artisans, and professionals. Combined with a well-enforced peace and growing prosperity, the new patronage provided greater opportunities for diversity in artistic format, subject matter, and style.[1]

Underlying these diverse styles was one surprisingly common and consistent form—the sketch. Van Gogh's observation (see p. 1) about the Japanese artist, stimulated though it may have been by an unrealistic Japanese print, went to the heart of the matter: "He studies a single blade of grass." The Dutch artist sensed the discipline of observation behind traditional Japanese stylistic masks. Whether Kanō, Tosa, *rimpa*, Shijō, or *nanga*, all the practitioners now did sketches from nature—not a few but thousands. To the medieval tradition of impressionistic sketches, or better, notations, the Edo painter added detailed studies of flora and fauna executed with almost scientific objectivity. He examined landscape, too, more closely, sometimes with European conventions of viewpoint and perspective in mind. In addition, these studies [99, 101, 103] de-emphasize calligraphic brushwork. The demonstrative and expressionistic manipulation of the brush seems suppressed; in its place we find the more objective and imper-

sonal even line produced by the brush tip alone. Alternatively, painters sometimes adapted the Chinese "boneless" wash technique which, by omitting the arbitrary, conceptual boundary line, tends to match optical appearance.

One might expect sketches by the master academician of the official, Sinicized Kanō style, Kanō Tan'yū (1602–74), to be quite unlike those by masters of rival schools, but they are not. Only certain minor details betray the calligraphic character common to his finished work and to the numerous sketch-copies he made of Chinese and Japanese paintings. In the study of a coxcomb [99] only a trial leaf at the bottom of the sheet shows anything resembling his usual brush manner, and in other nature sketches [100] the characteristic Kanō line appears only in the branches supporting the main subject. Tan'yū is concentrating on reality, slipping into brushwork conventions only when he is, in a sense, performing a bridge passage. His study of a weasel eloquently reveals this relationship between realism and convention. The slinking animal is keenly observed; the minimal leafy setting appears conventional and unimportant, as indeed it was to the artist.

Ogata Kōrin (1658–1716) continued the decorative *rimpa* tradition of Sōtatsu; his most creative works are dazzling and daring arrangements of gold and bright color, usually in the folding-screen format—one thinks of the *Irises* of the Nezu Art Museum in Tokyo or the two-fold screen of *Waves* at the Metropolitan Museum of Art, New York. But Kōrin's sketch-scroll of birds [101] differs little from that of Tan'yū. These sketches were originally owned by the Konishi family that adopted Kōrin's illegitimate son, Juichirō, and represent early works produced under the tutelage or influence of the Kanō painter Yamamoto Soken. Still, one might have expected at least hints of an approach more decorative than that of his early mentors. A touch of playfulness may be found in the owl sketches [101a], even a decorative note in the reserved white silhouette of the leaves in front of the blinking, tufted owl; but the ducks [101b] show a straightforward, objective, and analytical rendering of tail feathers and outspread wings.

99 Tan'yū, *Sketches of Plants.*

154

100 Tan'yū, *Weasel*, hanging scroll.

101a Kōrin, *Sketches of Birds and Animals.*

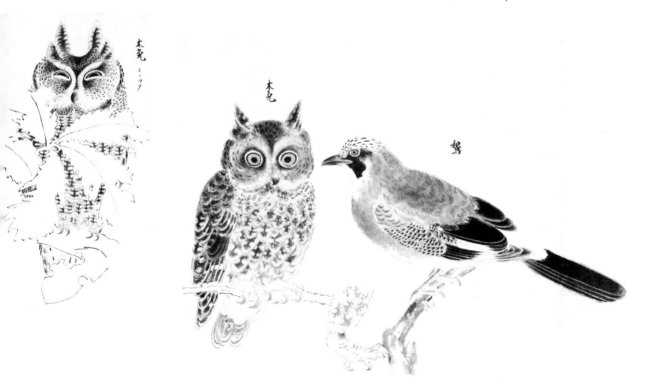

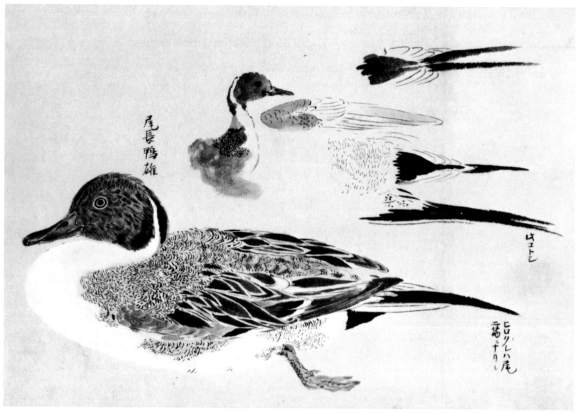

101b Kōrin, *Sketches of Birds and Animals.*

Still another Kōrin sketch [102] from the Konishi hoard shows a woman of plebeian, or at best merchant (*chōnin*), class, somewhat informally dressed. We can see Kōrin searching for a way to show the fall of the kimono over the body. He found his first effort so unsatisfactory that he covered the botched skirt with a fresh piece of paper and tried again, still with incomplete success. The completed work reveals the process: Kōrin struggling at the unfamiliar task of translating the appearance and movement of the draped human figure into a linear graphic realization, vacillating between what he saw in reality and what he remembered of Tosa and early *ukiyo-e* conventions. This conflict is the nub of the problem for any artist attempting to achieve what he conceives as objectivity, or "truth to the model." As Ernst Gombrich has shown, the solution is always a compromise, and here the struggle to attain one is evident. In this respect the bird studies are more successfully unified and consistent from a realistic viewpoint.

Kōrin's pupil Watanabe Shikō (1683–1755) also sketched birds from nature, and though his usual style is decorative, some of these studies are even more searching, more structurally analytical, than Kōrin's.[2] Kono suggests that Shikō's sketches, produced between 1718 and 1742, may have influenced those of another master more famous for his realist affinities, Maruyama Okyo (1733–95). One thing is certain, that Shikō's patron, Prince Konoe Iehiro, for whom these studies may have been painted, was an amateur of Chinese and Western science in general and of natural history in particular. (Despite the exclusionary policy of the Tokugawa government, Chinese and Western learning trickled to an eager audience through the foreign commercial enclaves at Nagasaki.) This, combined with the appearance of these sketches, suggests that Shikō may have been a more significant figure than previously accepted in the development of eighteenth-century painting.[3]

Okyo's sketches during the second half of the

156

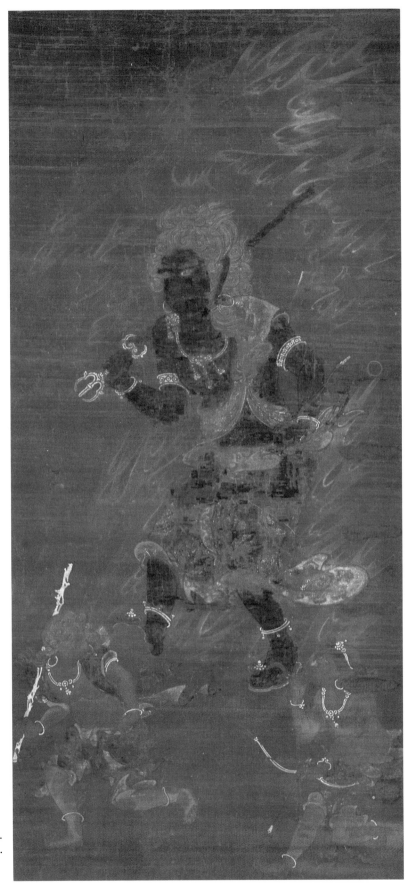

Color Plate XIII.
Running Fudō [84].

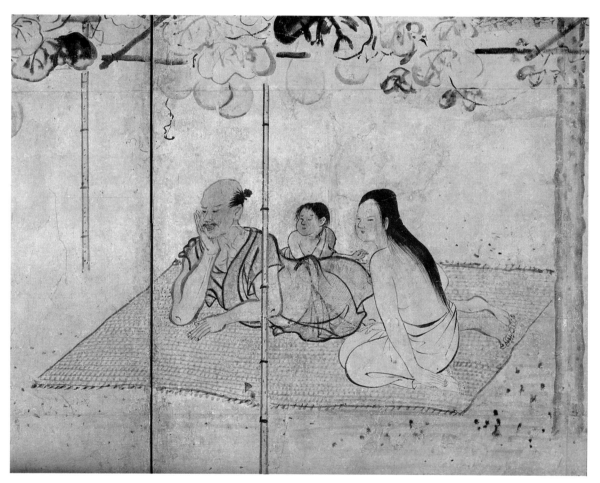

Color Plate XIV. *Enjoying the Evening Cool,* detail [109].

Color Plate XV. *Sights in and around Kyoto,* detail [115].

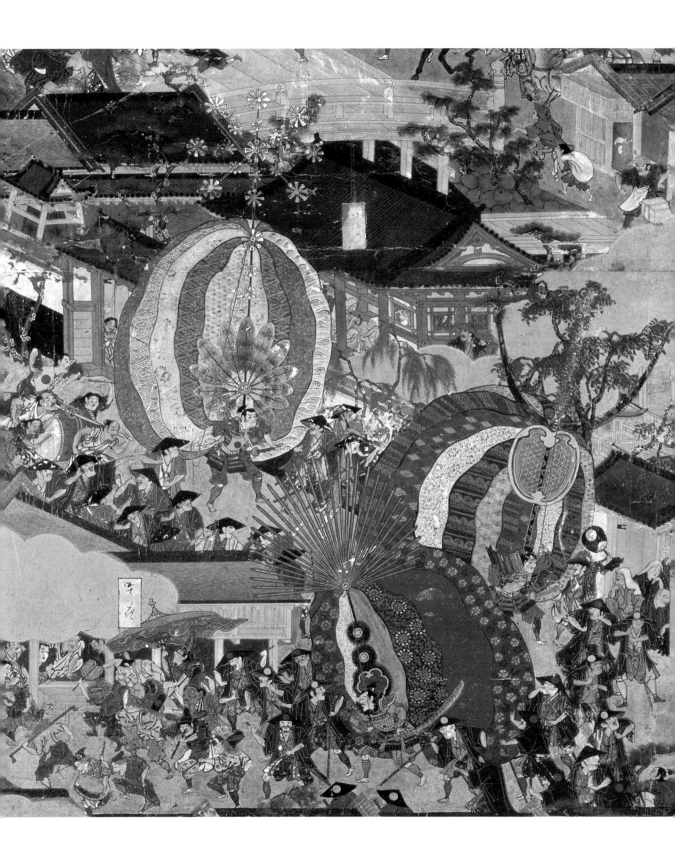

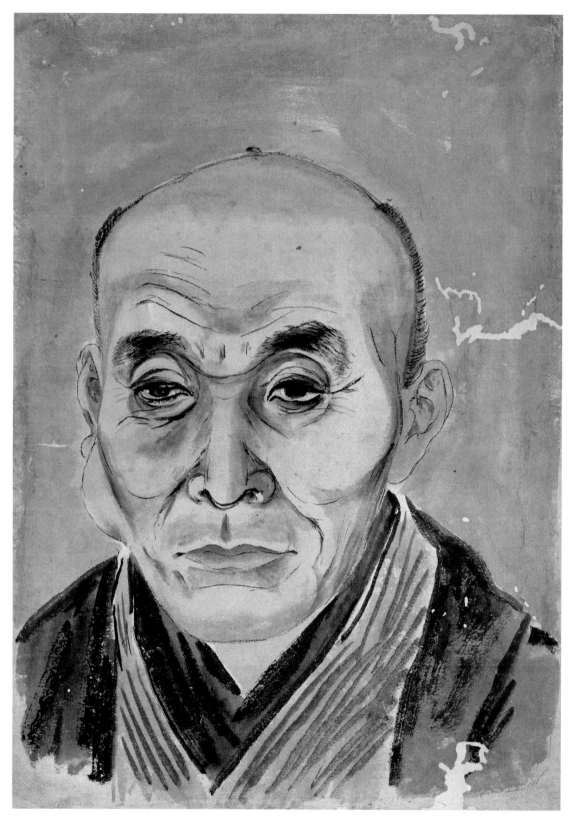

Color Plate XVI. *Study for Portrait of Ichikawa Beian* [126].

102 Kōrin, *Sketch of a Woman.*

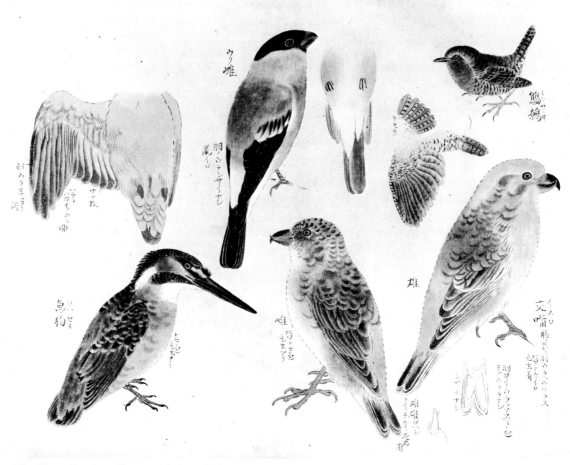

103 Okyo, *Sketches of Insects, Birds, and Plants.*

century are probably the most famous of all Edo essays in this genre. His brilliant and eclectic genius succeeded in melding any and all materials at hand into the recognizable style of the Maruyama school and its offshoot, the Shijō school. Prolific and facile, Okyo produced works in Western chiaroscuro and perspective, some in the form of woodblock prints for use in the newly imported stereoscopes; scrolls and screens that can be called Kanō; *ukiyo-e* style courtesan pictures; *e-maki* of extraordinary richness and energy [114]; and sketches of flora, fauna [103], figures, and landscape [104]. Since there are two almost identical and apparently genuine versions of the animal, bird, and flower sketches, one in the Nishimura Collection,

Kyoto, and the other in the Tokyo National Museum [103], one must assume that these sketches were much in demand, either by his students and followers or by some patron deeply interested in the new scientific natural history. The variety and intensity of the subjects—flies, bees, cicadas, grasshoppers, the whole gamut of observable birds,[4] a Yamato monkey depicted with unusual accuracy [103a]—still distinguish these works as the finest Japanese sketches of the natural science type.

Okyo's sketch-roll from the Kyoto National Museum [104] reveals other facets of his wide interests and varied techniques. It opens with a group of nine unexceptional Kanō style cranes [104a], but beneath them is a rapid and only

158

partially realized low-viewpoint sketch of boats on the water under a freshly observed cloud-streaked sky; both sky and perspective are new notes in Japanese landscape painting. Later come extremely quick notations [104b] of boatmen at work, mountain contours, a duck and duckling, a gate and fence in an overgrown garden shaded by willows, and, most unusual of all, a tiny sketch of smoke rising vertically for a bit before it catches the breezes above. The section [104c] with two fine studies from different angles of a peasant woman at a well is made almost ludicrous by the haphazard insertion of the study of a parrot with the colors of his plumage specified in writing. The most "pictorial" of the sketches is the faggot-gatherer sharpening his axe on a rock by a small stream [104d]. Later we will consider Okyo's adaptation of these visions and techniques in the extended handscroll format.

103a Okyo, *Sketches* (section).

103 Okyo, *Sketches of Insects, Birds, and Plants.*

104a Okyo, *Sketches of Lake Biwa and Uji River.*

104b Okyo, *Sketches of Lake Biwa and Uji River.*

104c Okyo, *Sketches of Lake Biwa and Uji River.*

104d Okyo, *Sketches of Lake Biwa and Uji River.*

Although the master seldom used sketch technique in finished and signed works, one characteristic work by his pupil and associate Nagasawa Rosetsu (1754–99) is a successful application of the notational sketch to the large-scale sliding-screen (*fusuma*) format [105]. *The Puppies, Sparrows, and Chrysanthemums* shows little trace of Kanō brushwork; the sharply brushed sparrows and boneless-wash chrysanthemum leaves are effective studies, while the dogs, plump and irresistible, are brushed in with a combination of lines and boneless washes that rivals the visual tonal magic in a drawing by Edouard Manet, a master of tonal realism.

The sketches we have thus far examined are by major figural artists of the Kanō, *rimpa*, and Shijō schools. Sketches by landscape artists of the new *nanga* (C. *nan-hua*), or southern painting, school were largely notational, quite unlike the careful studies of animals, plants, and people. Like the

105 Rosetsu, *Puppies, Sparrows, and Chrysanthemums,* hanging scrolls.

yamato-e, *suiboku-ga*, and Kanō schools before it, *nanga*, which came to fruition in the eighteenth century, represents the Japanese transformation of a Chinese style. This was *wen-jen-hua* (J. *bun-jinga*), the "gentlemen-scholars' painting" arbitrarily termed "southern painting" (*nan-hua*) by the influential Chinese painter-theorist who exalted it above all other modes. *Wen-jen-hua* was the antithesis of professionalism, the work of scholarly amateurs who painted for their own pleasure and that of their peers. Expressionistic brushwork was its highest desideratum, representational fidelity its least consideration. The resulting style was allusive, calligraphic, and abstract, despite the overtly representational character of its principal subject—landscape. But Tokugawa isolationism limited Japanese artists' access to this tradition. *Nanga* art was based on the work of a handful of Chinese emigré painters, none of them great masters; on a handful of late Ming and Ch'ing paintings, by no means all *wen-jen-hua*; and on woodblock-printed Chinese painting manuals in which the painting style was inevitably altered by the woodblock medium. The result was more playful and perhaps more adventurous than most of the *wen-jen-hua* of the later Ch'ing dynasty (1644–1912).

At the same time *nanga* masters were partial to local scenes, to views hallowed since the early days of *yamato-e*. They recorded their travels as a matter of habit, in brief sketches simultaneously abstract and particular—abstract because of the extreme shorthand of the recording technique, particular because of their concentration on the salient features of a given view. Ike no Taiga's (1723–76) sketches, poems, and notations [106], now mounted on both sides of a folding screen, show the *nanga* sketch at its abbreviated best. One sheet from the folding album he carried with him is a study of the same Mt. Asama painted by Aōdō Denzen [98]. Where the Western-influenced artist concentrates on the mass and surface of the mountain, admittedly in a large-scale finished work, Taiga simply outlines the shape of the mountain and its major fissures. But both masters were interested in the specificity of the object observed, its distinctive appearance.

Finally, Edo sketch practice included up-to-date variations on the old *e-maki* tradition: genre subjects, particularly figures in motion, treated to rapid, cursive, calligraphic depiction. This kind of sketch became increasingly common in the work of masters of many schools—Shijō, *ukiyo-e*, and some artists associated with the *nanga* movement.[5] The numerous genre sketches of Watanabe Kazan (1793–1841), whose name will figure prominently later in our discussion, are particularly germane. His *Issō Hyakutai* [*Sketches of Scenes from Daily Life*] [107], from the Kazan Foundation at Tawara, Aichi Prefecture, is an often riotous assemblage showing all levels of society in an infinite variety of actions. Schoolboys at their lessons, plebes at a festival, woman dyeing, men gaming, travelers, itinerant doctors, wayside food vendors, battling samurai, all these and many more are sketched by Kazan with omnivorous delight. Like the *e-maki* masters of the Kamakura period, Kazan was interested in all of the urban and village life around him, and like theirs, his simplified characterizations and shorthand references are often exaggerated into caricature or grotesquerie.[6] Although Kazan's sketches seem more sympathetic than Kamakura *e-maki*, their overtones more humorous than malicious, they do not reveal the unsentimental compassion of his later works. When Kazan had experienced tragedy and come to understand the tragic dimension of life, his open-minded curiosity about the world in both its pragmatic and theoretical aspects, so apparent in these early jottings, had already provided him with the artistic discipline necessary to convey his understanding.

One major painting of the eighteenth century can only be fully understood as a unique embodiment of the sketch tradition writ large. The painter was Kusumi Morikage (ca. 1620–90), whose patrons were the powerful Maeda daimyō of Kaga Province. His two-fold screen *Yūgao-dana Nōryō* [*Enjoying the Evening Cool*] [109; Color Plate XIV] was perhaps originally a *fusuma* decoration, but in subject and handling it is a large, masterful sketch. Even the underdrawing for the male figure is left exposed, and the brushwork throughout is extremely free, varied, and suggestive. The informality of style heightens the informality of the subject. A lightly clad peasant family reclines on a straw mat under an arbor of gourds next to their humble cottage. A preter-

106 Taiga, *Record of a Journey to Three Mountains*, eight-fold screen.

naturally large summer moon hovers above. The informality and tranquillity of the scene is sensitively observed and beautifully transcribed, creating a sense of tangible summer warmth and tired ease. These peasants are not infinitesimal figures working in a distant field or supporting players in a larger scene but *the* subject of a major painting by a major artist. The obscure information about Morikage is in harmony with the nature of his screen. He studied under Kanō Tan'yū but left his studio, perhaps under duress, and became an independent, even maverick, master. The sketch idiom must have been familiar to him, and in this work he raised it to the highest level.

If the widespread use of the sketch as a means to verisimilitude provided an underlying discipline in observation and recording, certain choices of subject matter lent themselves to the exercise of a sharpened realist vocabulary. Chinese subject matter and style, whether landscape, birds-and-flowers, or historical or Zen figures, dominated Muromachi painting but did not monopolize it. Not all patrons, whether courtiers or daimyō, followed the Chinese-Zen fashion, and works may well have been commissioned in either Chinese or Japanese manners, depending on their subject matter and intended location. Horses or hawks, for example, would seem awkward and incongruous rendered in the abbreviated Chinese ink manner. For these and other traditional subjects the old style was more appropriate, and in this connection between subject and style lay the possibilities of change and development.

Activities of the aristocratic and warrior classes remained subjects for the Tosa school artists, who continued the *yamato-e* and *e-maki* traditions, sometimes on the generous scale of the sliding or folding screen. The pair of six-fold screens in the Cleveland Museum of Art, showing stabled horses with grooms and other figures [110], demonstrates that Fujiwara and Kamakura idioms continued effective for conservative subjects in the Muromachi period. Horses often formed a major compositional element in *e-maki* with military themes, but they could also be the principal subject, as in *Bai Sōshi* [*Scroll of Horse Doctors*], a Kamakura handscroll dated to 1267 in the Tokyo National Museum. This illustration of

106a Taiga, *Record of a Journey to Three Mountains* (detail).

107 Kazan, *Sketches of Scenes from Daily Life*.

107 Kazan, *Sketches of Scenes from Daily Life.*

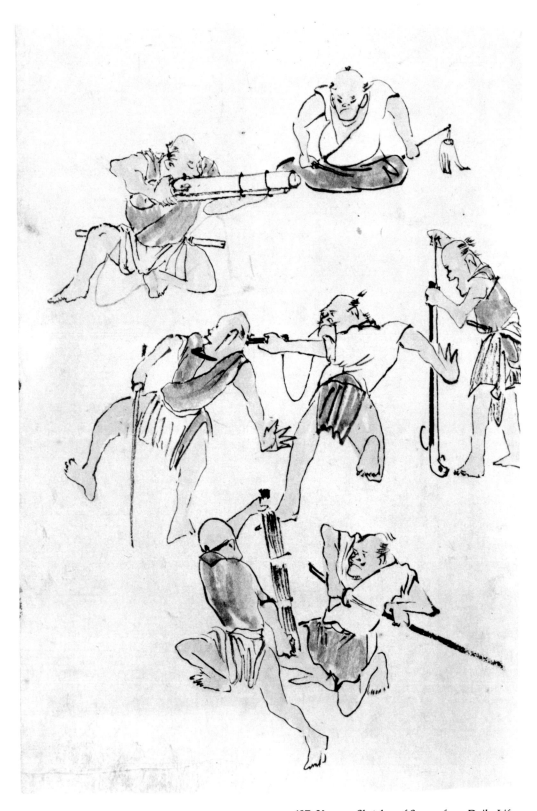

107 Kazan, *Sketches of Scenes from Daily Life.*

109 Morikage, *Enjoying the Evening Cool,* two-fold screen.

veterinary practice intersperses horses tethered in stalls with carefully rendered medicinal herbs and occasional figures of veterinarians.[7] Horses were not only useful in war and hunting but were kept at Shintō shrines as divine vehicles for the *kami*. The Cleveland Museum screens display strong decorative tendencies in the delineation of the animals and in the general composition. But direct observation is evident in the foreground nobles with their falcons and especially in the gentry and priests playing *go* [110a]. The dogs too, as in Kamakura *e-maki*, are

carefully observed and convincing. The same combination of subsidiary realism with predominant Tosa decorative style occurs in the portraits of Asakura Toshikage [76] and Takeda Shingen [78], the latter even paired with a hunting falcon like those shown on the Cleveland screens [110b].

The subject of *shokunin* (occupations) provided greater opportunities for innovation. Craftsmen were a prominent subtheme in *e-maki* of the Kamakura period [29, 31, 33] and occur, though only as vehicles of satire, in the *Tōhoku-in Shokunin Uta Awase* [88]. But the theme resur-

169

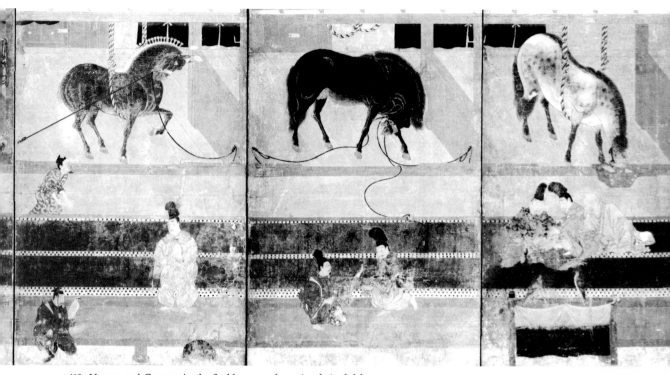

110 *Horses and Grooms in the Stable,* one of a pair of six-fold screens.

faced by the early Edo period, becoming one of the accepted categories of principal subject matter within the new, complex iconography. Anonymous artists floating among the Kanō, Tosa, and rising *ukiyo-e* schools were responsible for numerous *shokunin* pictures, usually in panel or screen form [111]. By implication this choice of subject acknowledged the modest social worth (above merchants, below everyone else) traditionally accorded craftsmen, as well as their accruing economic and social power within the Tokugawa class system. The constantly increasing interest of the newly affluent middle class in its own activities spurred a comparable increase in patronage for paintings of subjects hitherto considered beneath major notice. The lower orders moved from supporting roles within the earlier religious and military narrative scrolls to the foreground in a painted world of their own. True genre became a primary subject for painting.

The *shokunin* panels from the Bunka-chō [111] are remarkable for their uninhibited use of the various styles available to the early Edo painter, whether artisan or master. Banana trees are Kanō in flavor. Roofs are rendered in a free ink manner owing much to Kanō adaptations of Chinese brushwork. Figures recall *e-maki* renditions. The accumulation of telling detail reveals close observation of the accoutrements of the various artisans. The panel with the ironmonger anticipates the greater accomplishments of the eclectic Morikage [111a]. The tightly orga-

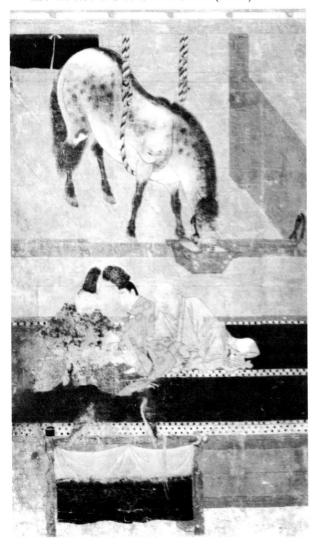

110b *Horses and Grooms in the Stable* (detail).

110a *Horses and Grooms in the Stable* (detail).

111a *Iron-Monger,* panel.

111b *Picture-Mounter,* panel.

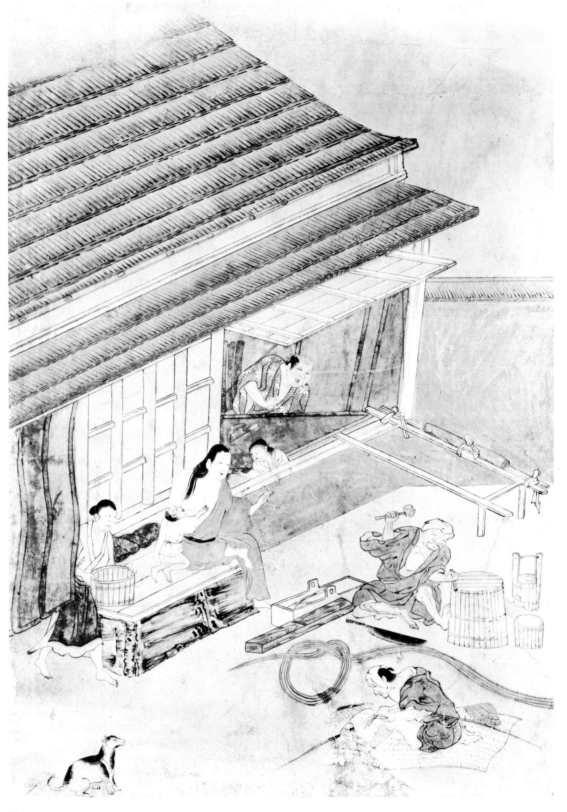

111c *Tub-Maker,* panel.

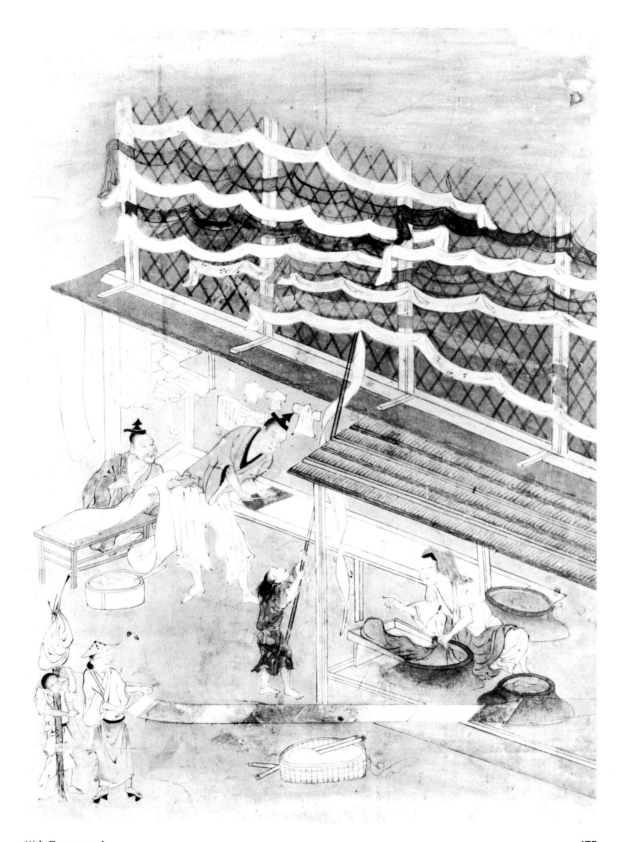

111d *Dyer,* panel.

nized representation of picture mounters at work [111b] recalls Tosa compositions. The tub maker [111c] might well be a detail from a narrative scroll. The most striking and original composition shows a dyer's family at work [111d] and uses the long strips of cloth being treated or dried as a dominant decorative feature. In the same scene the artist indulges in a very particular recording of reality at the lower left corner, where a stripling supports a heavy post by awkwardly bracing his neck and head against it [111e]. The casual rendering of the scenes supports the informality of the subject matter. In this the anonymous artist approaches the sketch methods of more sophisticated masters.

Matabei (Iwasa Katsumochi; 1578–1650), considered by many the founder of the *ukiyo-e* style, was such a master. His accepted works display strength and amplitude, while amalgamating all of the traditions existing in the early Edo period except for the imported Western manner. It is therefore significant that he essayed a major rendering of the *shokunin* theme at least once in his career. The handscroll [112a, b] in the Idemitsu Museum, Tokyo, is continuous in its representation, but in effect divides the subjects into individual components separated by areas of blank paper. The manner of drawing owes much to the Kamakura *e-maki* tradition, but the firmness of outlines and carefully planned arrangement of

111e *Dyer* (detail).

112a Matabei, *Occupations,* handscroll (section).

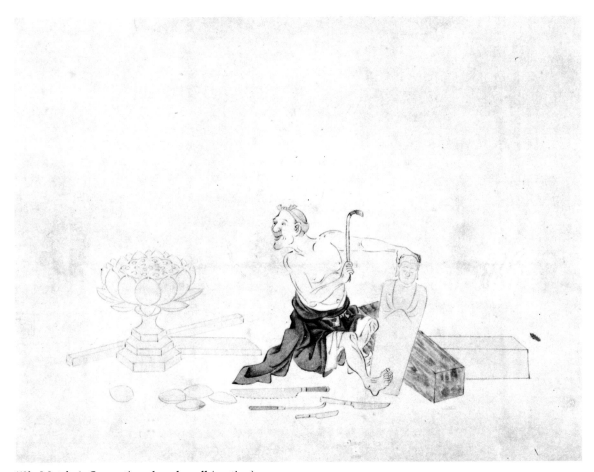

112b Matabei, *Occupations,* handscroll (section).

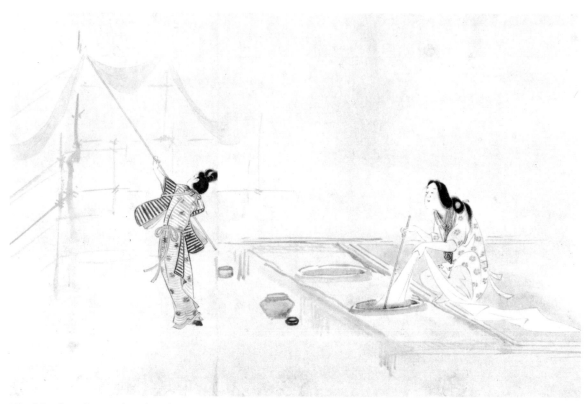

112c Matabei, *Occupations,* handscroll (section).

elements within the implied pictorial units, combined with an interest in patterned costumes and a precise delineation of the physical attitudes of the various figures, transcends the informality of previous *shokunin* depictions. A comparison of his section showing dyers at work [112c] with that by the anonymous painter of the Bunka-chō panels is revealing. The lesser artist is more direct and fresh in his observation but less disciplined in his technique. Matabei has willed the various manners at his disposal into a controlled personal style, more important for the future development of genre painting but less and less susceptible to variations on the theme of reality. The quiet, moving, but sadly damaged self-portrait by Matabei [113], one of the first such works in Japanese painting, is consistent with this evaluation. The tie-dye pattern of his undergarment clearly fascinated the artist, just as his scholar-samurai attributes—book, bronze, table, spear—did not. The gentle, elderly face is convincing until we remember the portrait of Ikkyū [79], when it seems but the outline of the man.

Another subject from the past reappeared in a masterly treatment by Maruyama Okyo.[8] His three-roll handscroll *Shichifuku Shichinan* [*Seven Fortunes and Seven Misfortunes*] [114], from the Emman-in, Shiga Prefecture, must be among the most perfect artistic recreations of the Kamakura *e-maki* tradition. *Rokudō* as subject also reappears, in the two rolls that deal with misfortunes. The old content has been transfigured to produce the most dramatic effects possible, particularly in the war, fire, and flood scenes of the first roll [114a, b, c]. But the *e-maki* style has been transformed as well, encompassing much of Okyo's study of nature and visual appearance. Compared with its predecessors, Okyo's scroll seems to be more complete, leaving less to the imagination. Representation covers almost the entire surface of the paper, and the scale of figures, architecture, and landscape is varied from scene to scene in the continuous composition to produce the greatest dramatic effect. All elements are more finished, and modelling in light and shade is introduced to increase the effect of

178

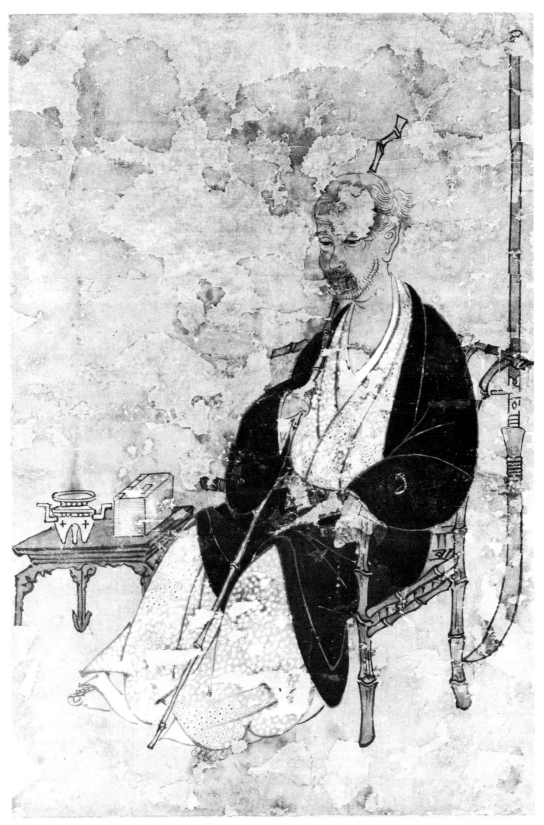

113 Matabei, *Self-Portrait,* hanging scroll.

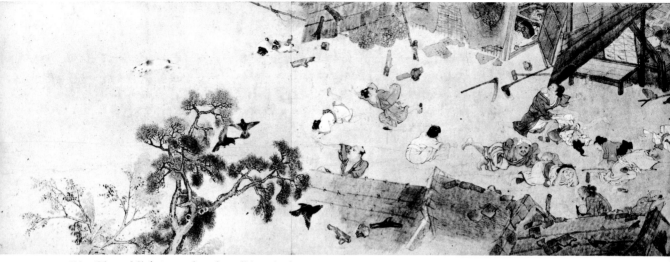

114a Okyo, *Misfortunes*, handscroll (section).

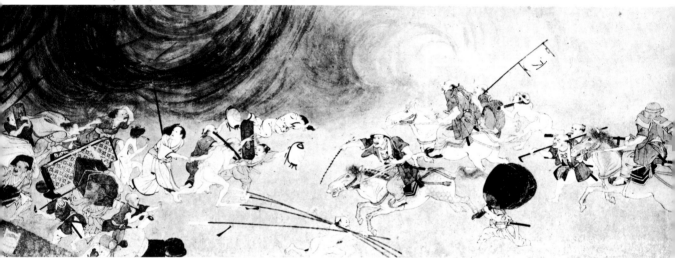

114b Okyo, *Misfortunes*, handscroll (section).

114c Okyo, *Misfortunes*, handscroll (section).

115a *Sights in and around Kyoto* (detail).

reality, whether in faces or in tile roofs. Comparison among the late twelfth-century *Kokawa-dera Engi* [24], Okyo's *Seven Misfortunes*, and Shimomura Kanzan's *Ohara Goko E-maki* [136] of 1908 reveals dramatically the difference between suggested and explicit reality and their relative adaptability to the long handscroll format. The later the scroll, the more explicit the representation. Despite Okyo's virtuoso gifts the *Seven Misfortunes* embodies the insoluble tensions between developed ways of depicting reality and the peculiarly limiting dimensions of *e-maki* with their almost limitless length but restricted height.

There were still other ways in which the subject matter of Japanese painting was expanded, sometimes in the service of aims somewhat removed from realistic depiction of the world. In the Edo period not only nobles required decorative screens but also rich though plebeian townsmen. All of these patrons were curious about the manners and mores of the emerging lower orders and interested in the new manners of representing them. The reconciliation of realism with decoration is particularly notable in a class of paintings popular in the first half of the seventeenth century, the *Rakuchū Rakugai* [*Sights in and around Kyoto*] folding screens [115; Color Plate

xv]. From a distance these screens appear all broad areas of gold and bright, opaque, contrasting colors. Moving closer, we see that the representational framework is geographic—eastern suburbs on the right screen, central city on the left—but the composition is decorative, with vignettes of people and places clustered among gold cloud bands, rows of vivid green pine trees, and the geometric pattern of architectural elements, especially roofs. Once visually within the city, however, one is plunged into a hurly-burly of people, hundreds of them from all walks of life [115a]. Street dancers, prowling samurai, prostitutes, vendors, shopkeepers, seasonal festival processions, the whole urban world of the great capital is depicted in a style here strikingly influenced by Matabei's synthesis of the past. The detailed representations, though small in scale, are carefully finished, and although an effort at individual characterization is evident, the faces are stereotyped into the Matabei mold of thick lips, wide jaws, and puffy jowls [115b], making them types not unlike those found in the Kamakura *Heiji Monogatari* rolls and related contemporary works. One other characteristic is traditional and notable: a cold objectivity in the depiction of humans at rest, at play, or in violent action.

Complex, large-scale works such as the *Rakuchū Rakugai* screens were almost certainly turned out by workshops whose employees specialized among the elements of the composition—trees, embossed gold, architecture, figures. The remarkable quality of the result speaks well for the artisans' proficiency and the effective control exercised by the artist-designer. But these workshop productions seldom reach the excellence of smaller and simpler paintings that were most likely the work of a single master. There are few of these in early *ukiyo-e* style, probably because noble and wealthy patrons preferred more traditional styles. One example is the small screen *Honda Heihachirō Sugata-e* [*Picture of Honda Heihachirō*], from the Tokugawa Art Museum, Nagoya, Aichi Prefecture. It presents a pictorial combination of fact and romance, observation and decoration, which was to be a major hallmark of later *ukiyo-e*, whether paintings or the famous and more numerous woodblock prints.

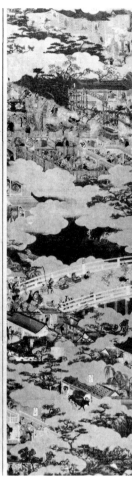

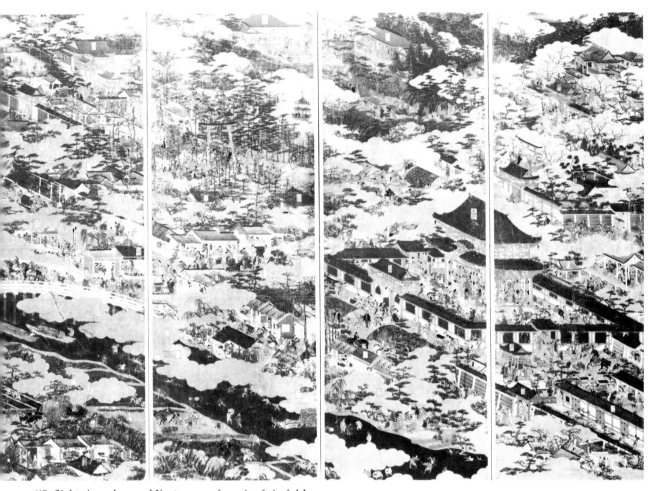

115 *Sights in and around Kyoto,* one of a pair of six-fold screens.

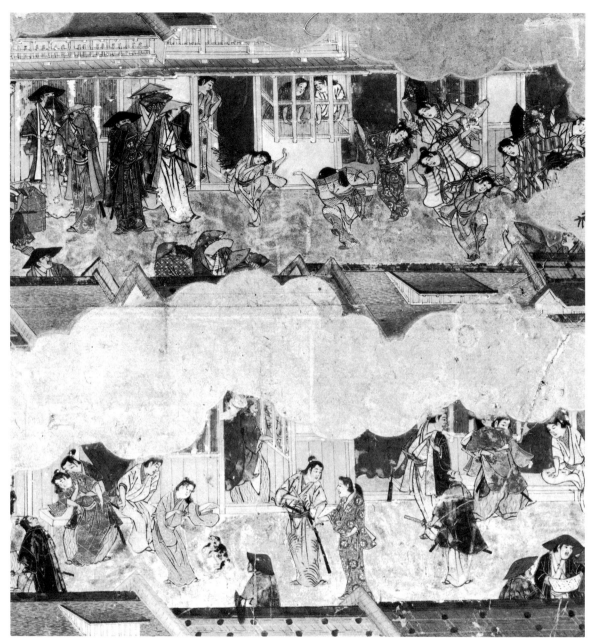

115b *Sights in and around Kyoto* (detail).

A master of this *ukiyo-e* amalgam of realism and decoration was Miyagawa Chōshun (1683–1753), whose handscroll *Fūzokozu [Scenes of Popular Entertainment]* [116a] maintains the two elements in superb balance. One's first impression is of riotous and brilliant color, but the relationships among the figures, established through carefully detailed placement and ges-

ture, accentuate the representational and narrative elements. In the narrative content of the handscroll the unities of time and place are nicely, if intuitively, observed: itinerant actors are seen first approaching the mansion where they are to play [116b], then making ready, and finally in performance. Matching this narrative coherence is Chōshun's thematic repetition and

184

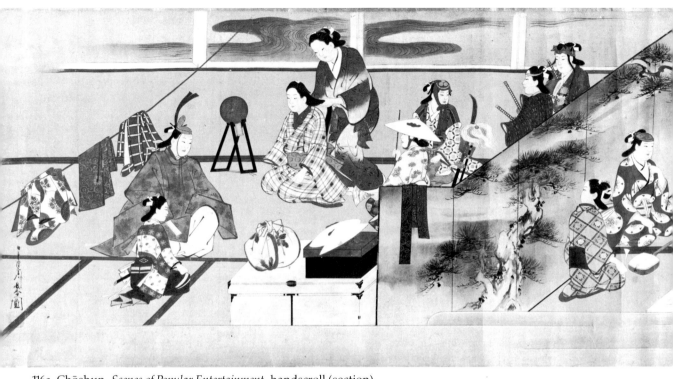

116a Chōshun, *Scenes of Popular Entertainment,* handscroll (section).

116b Chōshun, *Scenes of Popular Entertainment,* handscroll (section).

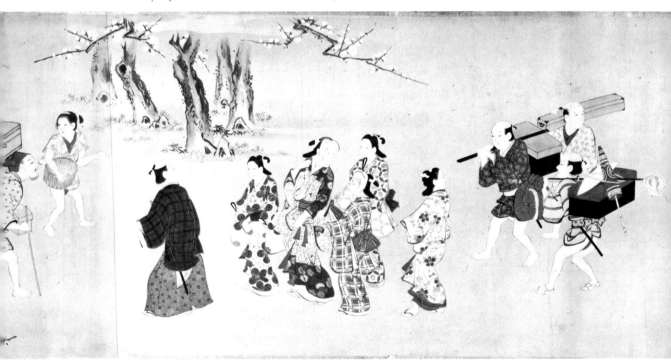

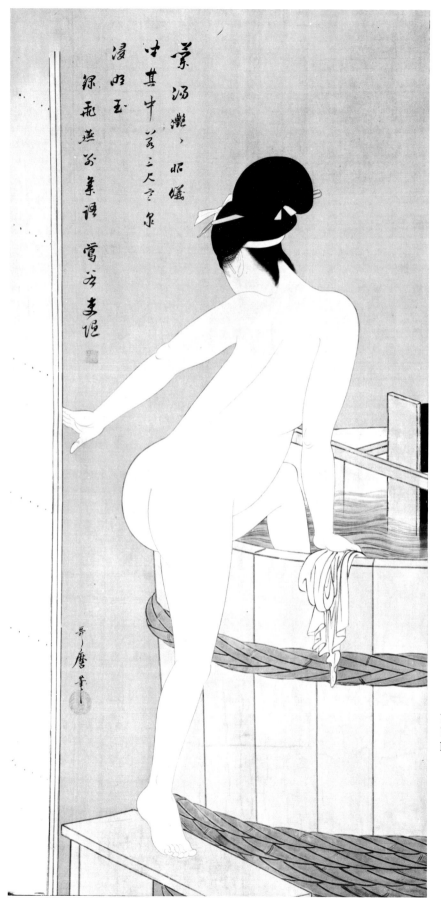

117 Utamaro,
Woman Bathing,
hanging scroll.

variation of shapes, voids, and patterns, in a measured movement closer to early *onna-e* than to the energetic surge of Kamakura and early Muromachi *e-maki*. This carefully controlled static character permits the decorative elements full scope. Here, again, we see commoners depicted as if they were aristocrats, but (unlike the *Tōhoku-in Shokunin Uta Awase*) not for satirical purposes. Precisely this levelling and mixing of styles and attitudes is what the official Kanō and Tosa schools resisted to the last.

Still another *ukiyo-e* masterpiece, the *Woman Bathing* [117] by Kitagawa Utamaro (1754–1806), one of the most famous and successful of all printmakers, expresses the binary nature of this genre tradition. Before the Edo period the nude as principal subject would have been almost unthinkable;[9] a few can be found in early erotic scrolls, the sex manuals and pornography of their day. As one might expect with a rising middle- and lower-class urban population, erotica flourished in Edo, both in painted and print form. To Western eyes, even those familiar with the considerable production of erotica and pornography by notable Western artists of the eighteenth and nineteenth centuries,[10] many of these Japanese paintings and prints verge on caricature, even the surreal.[11] But the opportunity to portray nonpornographic nudes clearly existed, and Utamaro's hanging scroll is one of the most elegant artistic achievements in this genre. Reality is served in the proportions, in the folds of flesh at the elbow points, and in the splendid balance provided by the thrust of the right leg as the left extends more gingerly into the water in the tub. And yet the rather sleek profiles, the flat body with its sharp linear boundaries, as well as the careful manipulation of voids, apertures, and intersections, proclaim the work as masterly decoration with calculated distortions worthy of Ingres' equally rhythmical nudes. Most of the realist possibilities inherent in the subject have been suppressed to achieve a consciously elegant and aesthetic goal. *Ukiyo-e*, in its original meaning, recalled to Japanese minds the grim transitoriness of *Rokudō*; but one can be pardoned for believing that Utamaro had no such idea in mind. His *Woman Bathing* is as unaware of fleshly decay as of contemporary artistic currents involving a sober and intellectually rigorous reality.

This additional element in the Edo complex was the direct result of Western art and learning. Until the Edo period foreign cultural stimuli had been exclusively Chinese, China being the sole model and inspiration for successive waves of innovation. But the seventeenth-century, exclusionary edicts notwithstanding, brought certain aspects of Western culture to Japanese notice, including a novel vision of artisitic reality. No more striking incongruity can be imagined than that between the *Daruma* (S. Bodhidharma; legendary Indian monk said to have brought Ch'an doctrine to China) in Western (*yōga*) style [118] and the same subject handled in the traditional Sino-Japanese manner (Figure 12). An abstract, symbolic image has been translated into a palpable—and abnormal—presence. Daruma's singular appearance was dictated by the legend that in penance for dozing during meditation he had cut off his eyelids so that he could close his eyes no more. The monk's iron determination and forcefulness are preserved in the Western style version, but the icon's timeless essence has become a strange, time-bound corporeality. The resulting shock to a present-day viewer familiar with the traditional image must be as nothing compared with the effect on a Japanese observer of the Edo period. One of the most notable students of *Rangaku* ("Dutch," i.e., Western, studies) was Honda Toshiaki (1744–1821), and his comments on Western artistic methods should be noted while observing the *Daruma*:

> European paintings are executed in great detail with the intention of having them resemble exactly the objects portrayed so that they will serve some useful function. There are rules of painting which enable one to achieve this effect. The Europeans observe the division of sunlight into light and shade, and also what are called the rules of perspective. For example, if one wished to draw a person's nose from the front there would be no way in Japanese art to represent the central line of the nose. In the European style, shading is used on the sides of the nose and one may thereby realize its height.[12]

It must be remembered that the influence of Western methods on Japanese painting was but a small part of the intellectual ferment generated by *Rangaku*. Nagasaki, where a few Dutch na-

118 *Daruma.*

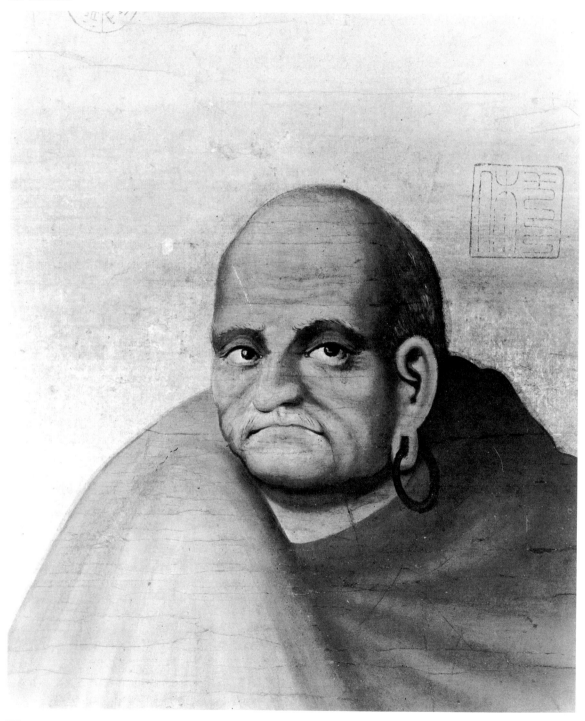

tionals were allowed to remain, under close government supervision, and even to offer instruction in politically inoffensive subjects, became a magnet for Japanese intellectuals who felt their native culture growing exhausted and sterile.[13] Curious artists and scholars seized on the new learning, assiduously studying its ramifications in many branches of science, technology, philosophy, and the arts. The breadth of these studies and their impact on the political and social thinking of well-born and well-connected Japanese occasioned suspicion and ultimate suppression by the Tokugawa authorities. The specific influence of Western practices on the visual arts did not alarm the government and was allowed to operate unhampered among artists of the Edo period. Western realism was new and different in its methods and appearance but not antithetical in its interests to the realist elements that had existed intermittently in Japanese art since earliest times. The quantity of Western-influenced artistic production was not negligible, and the large collection at the Kobe Municipal Museum of Namban Art comprises only a part of the material scattered in both Japanese and Western collections.

Perhaps the most famous single painter in *yōga* style is Shiba Kōkan (1747–1818). Originally an *ukiyo-e* artist good enough successfully to forge Harunobu's (1725–70) classic works,[14] he acquired in Nagasaki a devouring enthusiasm for Western science and mathematics as well as art. He was the first Japanese to undertake copperplate engraving and to write an essay proclaiming the superiority of Western chiaroscuro and vanishing-point perspective to Japanese and Chinese painting styles. Inevitably, such a man undertook to paint in oil. He produced a variety of *yōga* work, including representations of Daruma. But his pictures of birds in landscape settings are of particular interest because the traditional subjects rendered in Kōkan's variations on Western style exist in a kind of double matrix, with resulting tensions that sharpen the questions posed by Edo adaptations of Western art and thought.

Waterfowl and Willow Tree [119], from the Kimiko and John Powers Collection, shows in large scale in the foreground a heron perched on the trunk of a leafless willow on the right and an ibis

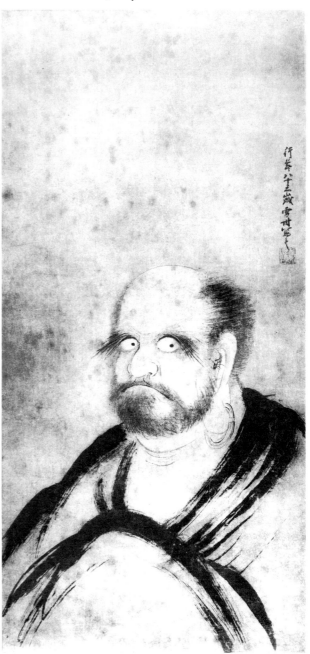

Figure 12. *Daruma.* Sesshū, Japanese, 1420–1506, Muromachi period. Hanging scroll, ink on paper. Yoshinari Collection, Tokyo.

119 Shiba Kōkan, *Waterfowl and Willow Tree,* hanging scroll.

120 Bunchō, *Sketches from an Inspection Tour of the Coast.*

standing on the ground at left. Between them, in the middle distance, a small kingfisher perches on a sparsely leaved peach or persimmon tree. All three birds are modelled in light and shade. They seem more ornithological specimens than inhabitants of the scene. In the distance, seen over water, is a European town with crenellated towers and gable roofs, most likely derived from some Dutch or Flemish engraving. The composition is striking, emphasizing a low horizon in the Western manner. The sky is modulated as if by faint passing clouds. Heavy shadows in the foreground give weight to the lower quarter of the picture. All of these elements, save for the principal subject of birds and willow, are Western. Nevertheless the picture is clearly a strange hybrid. A Japanese would be pardoned for not acknowledging it as his own. A Westerner could not accept it as a recognizable product of his artistic culture. The flat opacity of the pigments on silk adds to the incongruity of the image. Like the *Daruma*, the *Waterfowl* represents a kind of reality, one worth struggling to understand because of the light it sheds on Edo period artistic aspirations, but one without roots or issue in Japanese culture. In Kōkan's work European artistic novelties were only interpolated, not assimilated. More significant and effective for succeeding essays in realism were the ideas that

accompanied them—scientific method, pragmatism, an emphasis on immanent and societal rather than transcendental and mystical concerns. The latter two concepts, at any rate, were already much more familiar in their Confucian than in their *Rangaku* forms. But Western ideas were influential in abetting or modifying Confucian learning and in heightening a growing dissatisfaction with feudal ways and traditional beliefs.

By 1800 so many artists had produced Western style work that the method, and at least some of the ideas accompanying it, can be assumed to have been widespread. We have already noted that Okyo made woodblock prints in Western style for stereoscopic viewers.[15] Modelling in light and shade as well as modified Western perspective play a part in even his most Japanese productions. Tani Bunchō (1763–1840), a teacher of Watanabe Kazan, did a series of landscapes in 1793 [120] in a predominantly Western manner but retaining strongly Japanese brushwork. We have already seen, in the majestic representation of Mt. Asama by Aōdō Denzen [98], a successful melding of Western modelling and atmospheric perspective with characteristic Japanese compositional modes, format, and medium. Popular prints and optical devices[16] helped spread the new knowledge.

相州高麗寺

高麗山

120 Bunchō, *Sketches from an Inspection Tour of the Coast.*

The creative possibilities inherent in the artistic and intellectual movements of late Edo were most fully realized by Watanabe Kazan (1793–1841) and his circle. The portrait of Kazan [121] by his student Tsubaki Chinzan (1801–54) shows a pensive samurai-scholar-official, his Chinese-Confucian training implied by the Chinese style border of the lacquer table in front of him, and his interest in Western art by the somewhat realistic modelling of his features. Here Chinzan is following Kazan's teaching with some success, but the tangled rhythms of the draperies indicate that the pupil did not fundamentally understand the master's integration of Eastern and Western methods and therefore could not consistently achieve it.

Kazan was the son of a samurai attached to the minor fief of Tawara, on a small peninsula southeast of Nagoya in present-day Aichi Prefecture. By 1832 he had become the principal official for Tawara, responsible for its coastal defenses.

From about this time until his untimely and inevitable suicide Kazan was an advocate of *Rangaku*; he became a charter member of Shoshikai, a private society dedicated to the study of Western learning.

Painting supplemented his meagre income. He studied with Tani Bunchō and produced early works in a conservative *nanga* manner, using pale washes of transparent color with sharp, incisive brushwork. Some critics find his *nanga* works somewhat cold and calculated, but the essence of his art and the measure of his originality are to be found in his sketches and portraits, which reveal his dedication to observed reality and to the revelation of individual character.

Kazan's memorial fan painting [122] of Kō Sukoku (1730–1804), with one of Kō's poems written on the reverse by Tani Bunchō, seems to be an early work. It is executed in the Chinese manner, with emphasis on linear brushwork,

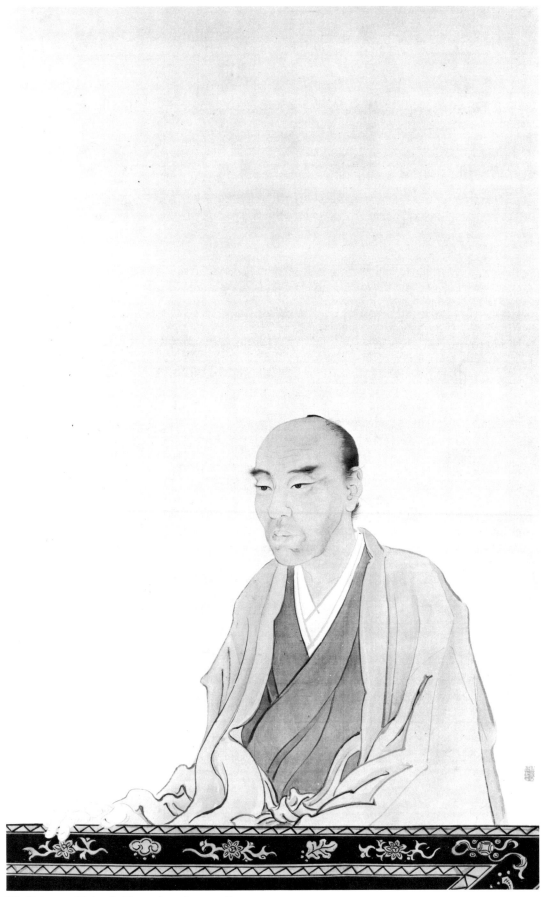

121 Chinzan, *Watanabe Kazan,* hanging scroll.

122 Kazan, *Kō Sūkoku*, fan painting.

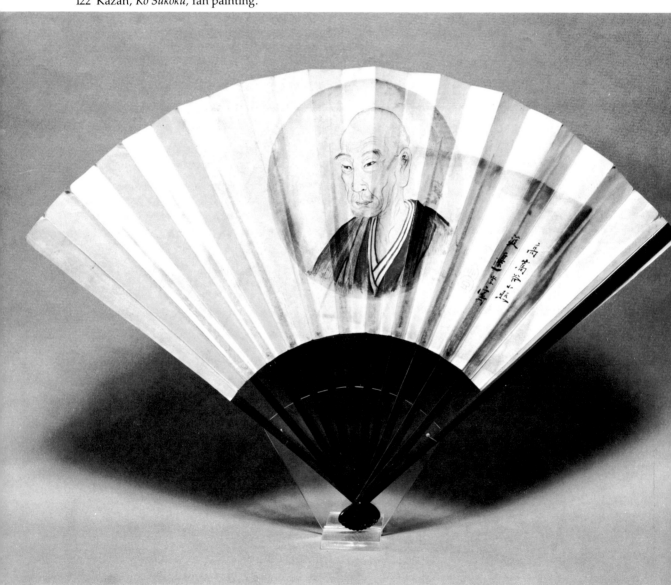

but offers a sensitive portrayal of fragile old age. The large and carefully finished hanging scroll of a Chinese subject, *Ukō Kōmon* [*Story of Count Yu Building a Great Gateway*] [123], is probably the finest of all Kazan's traditional works. Its complexity was arrived at through a series of preliminary sketches [124] concentrating on the activities of the carpenters and of the boatmen bringing materials. In the sketches the setting is left unresolved and chaotic while Kazan explores the attitudes of the workmen through repeated searching lines. The raw material of visual experience is the artist's concern. Even the dogs, which other artists usually treat as copybook repeats, seem to be freshly observed in these sketches, both in detail and placement.

This combination of sketch and *nanga* styles in a Chinese subject does little to prepare us for Kazan's major achievements in portraiture. One of his masterpieces is the justly famous *Portrait of Ichikawa Beian*, dated to 1837 [125]. To understand the master's achievement, we should compare the finished work with Chinzan's portrait of Kazan [121]. In particular, the modelling of Beian's head is consistent and artful, achieved with a knowing use of Western chiaroscuro. The psychological state of the sitter, pensive and slightly melancholic, is caught with a subtlety unknown in works by the artist's contemporaries. All of this is heightened and more explicit in the extraordinary sketch [126; Color Plate XVI] for the portrait. What is subdued or even suppressed in the finished work—the tumor on the right cheek, the deep shadows in the eye sockets, the grim set of the mouth, and above all the modelling of the underlying skull structure—leaps out from the sketch at the beholder. The sketch may be arguably closer than the painting to the artist's true intentions. Even in art there was a need, whether conscious or not, to veil one's thoughts from officialdom.

The life-sized sketch-portrait of Ozora Buzaemon [127], dated to 1827, adds yet another facet to Kazan's achievements in portraiture. The famous giant samurai-turned-sumō-wrestler Buzaemon was a curiosity of the age. Over seven feet tall, he obviously suffered from pituitary

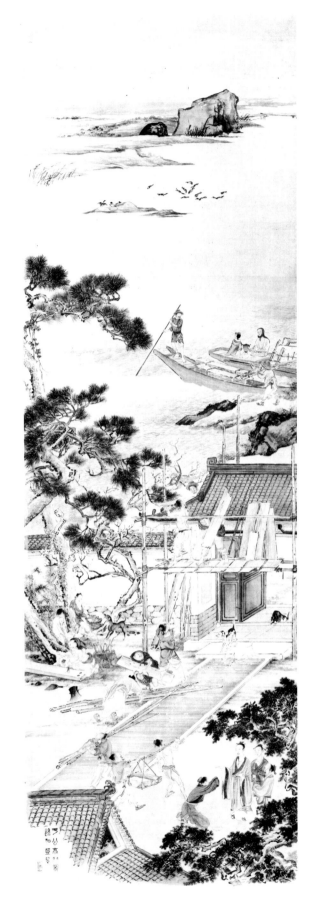

123 Kazan, *Ukō Kōmon*, hanging scroll.

Studies for Ukō Kōmon, hanging scrolls.

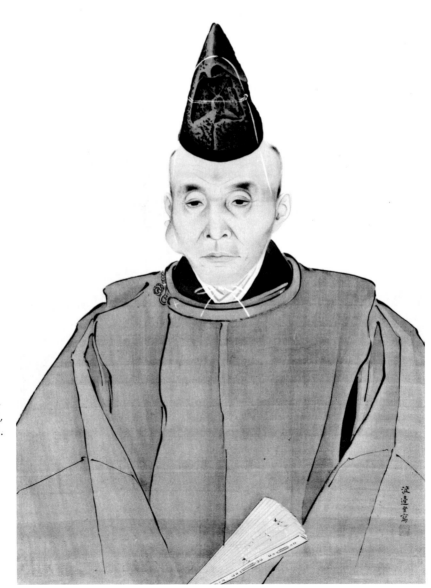

六旬誕日寫傳神鷲
見著額一老人烏帽
戴來雖似貴綿裳著
得竟應真縈名文苑
瘤相頼游手墨池龜
有因無事散閒能到
七重逢垂白畫中身
戊戌九月六日
　朱莘自題

125 Kazan,
Ichikawa Beian,
hanging scroll.

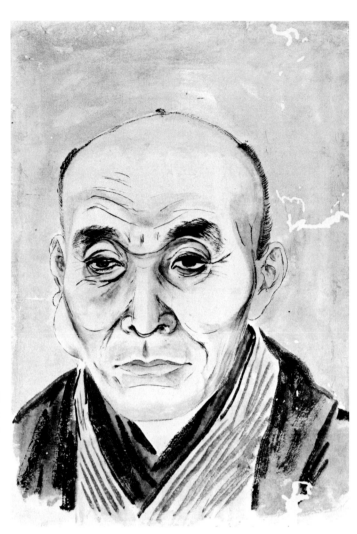

126 Kazan,
*Study for Portrait
of Ichikawa Beian*,
hanging scroll.

abnormalities. He was depicted in numerous *ukiyo-e* prints, but it is never Buzaemon that we see there, only the stereotype of a sumō wrestler as conceived by the woodblock artists. Kazan's portrait, based on the use of a camera obscura (*shashinkyō*), is painfully realistic. Buzaemon is shown with enlarged hands and feet; narrow, sloping shoulders; and a thick-lipped, heavy-jawed countenance. True giants, contrary to popular belief, are rarely strong; Buzaemon suffered the double stigma of physical abnormality and professional failure. His lifelong grief is written on his face, surely the saddest in the long history of Japanese painting. It is also the most tragic: in the depiction of this unfortunate there is no hint of malice, not even a trace of *genjitsu*,

only the most profound compassion. Kazan was careful to note Buzaemon's dimensions in the inscription on the sketch; and to make the reality of the likeness indisputable, he had the subject impress his handprint on the left side of the pieced-together paper surface of the picture. In this attestation the artist unwittingly returned to one of the earliest of all means to witness the physical presence of a person and in so doing imposed an element of prehistoric magic on the sophisticated realism of the image.

Kazan's tragic sense is often in evidence. Some of the preliminary sketches for the portrait of his father, Watanabe Hashū [128], were executed from the corpse. The artist's care in recording the true appearance of the death mask is

198

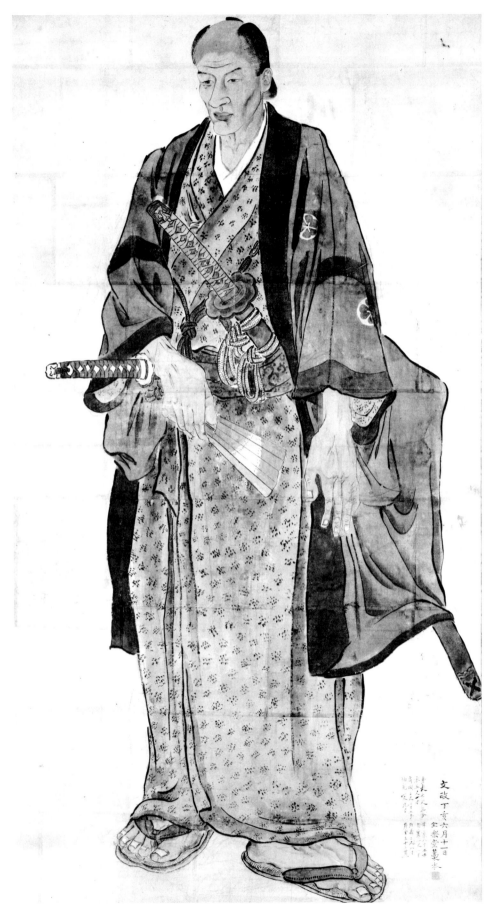

127 Kazan,
Ozora Buzaemon,
hanging scroll.

文政丁亥六月十一日
金蘭雲藝本
神夫沈香
來雲秋之多
身歸官軍亡
相視處學
旧知処學

evident, and the final memorial sketch-portrait [129] is effective and moving.

Similarly impressive is the series of sketches mounted as a handscroll [130] that retell the cruel events of Kazan's arrest and imprisonment in 1838–39, the year in which the shogunate began its systematic suppression (*bansha no goku*) of the advocates of *Rangaku*. Disaffection from the shogunate's domestic as well as isolationist policies had become sharp and widespread, especially among intellectuals, and the government no longer tolerated criticism of its exclusionary policies or considered *Rangaku* a harmless avocation. Kazan's *Shinkiron*, published in 1838, was explicit in its strictures against Tokugawa foreign policy. His prison sketches represent with unflinching honesty the bare prison enclosure, his interrogation, and especially himself being bound. The attitudes of jailers and prisoner suggest the bitterness of the the experience, as does the attached diary, which matter-of-factly records friends' visits and the simple presents they brought. Like many another critical patriot, Kazan was sentenced to death. Though the sentence was commuted to house arrest, Kazan chose suicide instead. His death sets a tragic seal on the succession of images recording its harsh and unjust prelude.

The portraits and sketches by Watanabe Kazan express of a new artistic and philosophical vision, a short-lived attempt to reconcile Japanese traditions with *Rangaku*, including its implicit recognition of individuality and concern for the human condition. Other, if lesser, works attest the new point of view, such as Gessen's *Pilgrimage of the Blind* [131]. Tani Bunchō's forty-two *Portraits of Contemporaries* [132] are finished for use as book illustrations, and their individuality is evident. One of the subjects is the hospitable Osaka *sake* merchant and art patron Kimura Kenkadō, who was portrayed again by Bunchō in a striking image of unabashed and sympathetic good humor [133]. This should be contrasted with the far more traditional rendering of Ota Shokusanjin [134] by the *ukiyo-e* master Chōbun-

128 Kazan, *Studies for a Portrait of the Artist's Father, Watanabe Hashū.*

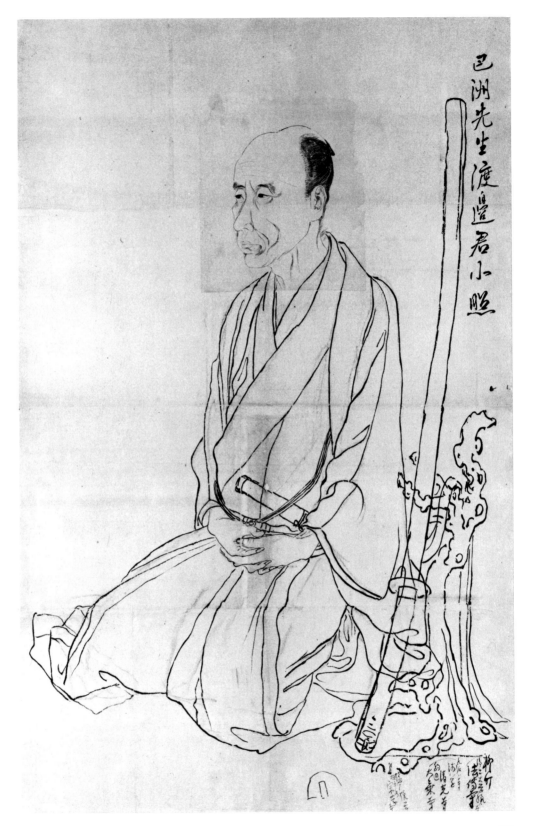

129 Kazan, *Watanabe Hashū*, hanging scroll.

130 Kazan, *Prison Sketches and Notes.*

131 Gessen, *Pilgrimage of the Blind,* handscroll (section).

131 Gessen, *Pilgrimage of the Blind,* handscroll (sections).

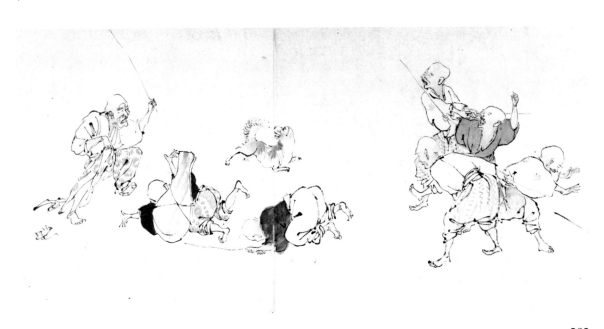

132 Bunchō, *Portraits of Contemporaries*, handscroll (section).

sai Eishi (1756–1829) to understand the more sympathetic and humane nature of the new realism. Finally, Kazan's pupil Chinzan at least once reached his teacher's level, in the portrait of the *nanga* painter Takaku Aigai (1796–1843) (Figure 13), friend of Kazan and pupil of Bunchō. In placement, informality of pose, and immediacy of expression Chinzan's portrait indicates that Kazan's accomplishments (unlike Kōkan's) could be propagated and bear fruit. But this avenue of growth was closed by the repression of 1839, only fifteen years before Commodore Perry's treaty (1854) opening Japan to American ships and but three decades before the downfall of the shogunate and restoration of imperial power (1868) conclusively changed Japan's direction. The subtle synthesis of East and West taking place in the art and thought of Kazan and other *Rangaku* scholars was cut off, and when the way to the present was suddenly reopened, it was beset with painful conflicts between old and new.

133 Bunchō, *Kimura Kenkadō*, hanging scroll.

204

享龢二秊三月廿五日社日文晁稽首拜寫

205

134 Eishi, *Ota Shokusanjin*, hanging scroll.

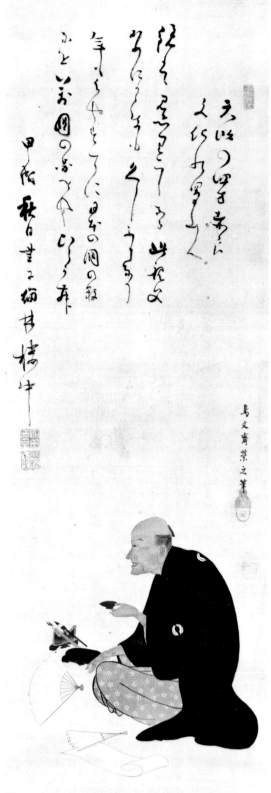

Figure 13. *Portrait of Takaku Aigai (1796–1843).* Tsubaki Chinzan, Japanese, 1801–1854, Edo period. Hanging scroll, ink and color on silk, 120.5 x 48.2 cm. Hara Meitarō, Tokyo. Important Cultural Property.

1. For Momoyama and Edo periods the standard history is George Sansom, *A History of Japan*, 3 vols. (Stanford: Stanford U. P., 1958), vol. 2: *1334–1615*, and vol. 3: *1615–1867*. The standard art histories are Paine and Soper, *Art and Architecture of Japan*, and Akiyama, *Japanese Painting*. In addition, excellent summaries of social and artistic developments in the Edo period may be found in William Watson, ed., *The Great Japan Exhibition: Art of the Edo Period 1600–1868* (London: Royal Academy of Arts, 1981).

2. See Motoaki Kono, "The Scroll of Real Forms of Birds by Shikō Watanabe," *Bijutsu Kenkyu*, no. 290 (November 1973), plates I-V and English summary.

3. Some details of the Shikō sketch-roll, particularly those representing quail, recall very strongly Sung Chinese pictures with a long history of Japanese ownership, as well as works in that style by Tosa Mitsuoki. Not all sketches were from nature; some followed studio patterns or copybooks. No artist can will away his artistic vocabulary and grammar, even should he wish to do so—and in Edo Japan he did not so wish.

4. Kono, "Real Forms of Birds," cites the collection of rare birds kept at a teahouse, the Kujaku Chaya (Peacock House), in the Gion entertainment district of Kyoto.

5. Such Shijō works by the followers of Okyo have been published by Jack R. Hillier, especially in *The Uninhibited Brush* (London: Hugh M. Moss, 1974). The *ukiyo-e* material, including the well-known drawings usually attributed to Hokusai, are to be found in more scattered sources, notably *Hokusai Manga* [*The Hokusai Sketch Books*], 12 vols. (Tokyo: Ohari Tohekido, n.d.); Theodore Bowie, *The Drawings of Hokusai* (Bloomington: Indiana U. P., 1964); and Jack R. Hillier, *Hokusai* (London: Phaidon Press, 1955).

6. Even the abbreviated, abstracted images of later Zen painting reveal keen observation in sketch form. See *The Yawning Hotei* [108] by Sengai (1750–1837), showing vibrating tonsils.

7. *E-maki Tokubetsuten*, no. 60 and p. 241.

8. See [103, 104] and earlier for a discussion of his sketches.

9. Keene, *Landscapes and Portraits*, p. 289, cites a nude of 1895 by Kuroda Seiki as the first Japanese nonpornographic nude, but others preceded, including this one by Utamaro. Most *shunga* (erotic or pornographic pictures), for all their insistent attention to genitalia, are thoroughly unrealistic—stylized, swirling arabesques of limbs and garments that form a decorative puzzle unresolvable into coherent bodies by even the most avid viewer. The element of caricature in realism is nearly always present in carefully portrayed but wishfully exaggerated genitalia.

10. See Eduard Fuchs, *Illustrierte Sittengeschichte vom Mittelalter bis zur Gegenwart* (Munich: Langer, 1909–12).

11. Richard Lane, *Images from the Floating World* (New York: Putnam, 1978), contains selected specimens from all periods of *ukiyo-e* print production.

12. Keene, *Japanese Discovery of Europe*, p. 84. This book is the best single English-language introduction to Western studies in Japan.

13. Some Chinese nationals and a tiny handful of Englishmen under Dutch aegis were also to be found at Nagasaki, but the Dutch, having earned the shogunate's particular trust by abjuring both missionary and expansionist designs, were the preponderant presence. Western learning was naturally perceived as Dutch learning and called by that name.

14. See Calvin L. French, *Through Closed Doors: Western Influence on Japanese Art 1639–1853* (Rochester, Mich.: Oakland Univ., Meadowbrook Art Gallery, 1977), no. 61, p. 143, for a Shiba Kōkan forgery of this type. This exhibition catalogue is an excellent intensive study of its subject, based on the Kobe Municipal Museum of Art collection.

15. Watson, ed., *Great Japan Exhibition*, no. 86, p. 65.

16. French, *Through Closed Doors*, pp. 99-120.

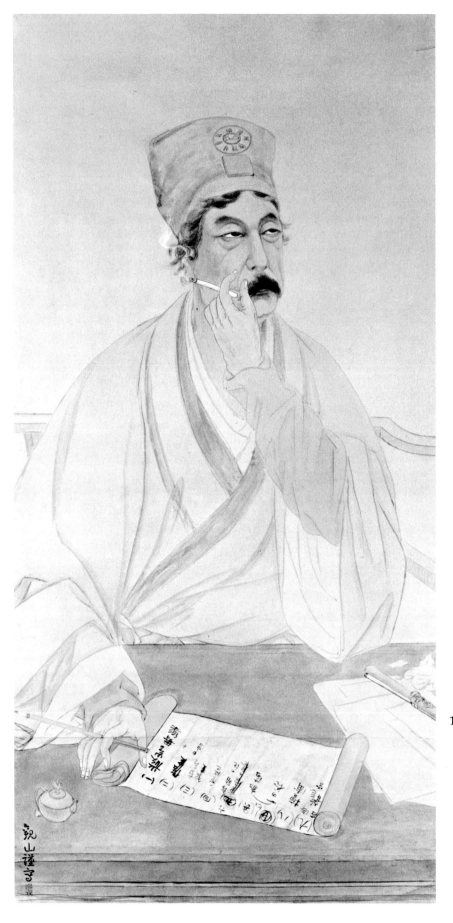

135 Shimomura Kanzan,
Okakura Tenshin,
hanging scroll.

A New Reality

The restoration of imperial authority and the creation of a representative modern state opened Japanese culture wide to Western influence. The restoration of the emperor was a conservative act, an attempt to expunge centuries of military government and powerless, even impoverished, emperors and to recreate the theoretically centralized imperium of the Nara period. But the liberalization and modernization of the government was a recognition that Japan needed to catch up to the West in military and political effectiveness. Even today the tension between tradition and modernism has not been fully relieved. The type of synthesis achieved by Kazan, however incomplete, was no longer adequate, and the direction it indicated was no longer possible, for success in the modern world required larger infusions of Western theory and practice than would have been necessary only slightly earlier. In reaction against such ardent Westernizing a vehement nationalism arose, which pervaded even scholarship and the arts. That Japan was to be made great was indisputable, but the spirit and content of its greatness became the subject of ferocious dissension. The difference between the potential impact of the West upon Japan in 1830 and its real impact by 1900 was far greater than the time span would suggest.

In the train of the Meiji Restoration came imperial, centralized encouragement of the arts, with academies organized on European models. These, notably the Imperial Fine Arts Academy, with its predecessors and affiliated schools, encouraged Japanese style painting, but for the nationalists they were not traditional enough.

Those conservative dissidents were led by Ernest Fenollosa, a young Harvard scholar who arrived in 1879 to teach at the Imperial University in Tokyo, and his colleague Okakura Kakuzō (1862–1913), later Curator of Far Eastern Art at the Museum of Fine Arts, Boston, who initiated Fenollosa into Japanese art history. The two became leaders in the fight to keep alive traditional subject matter and styles. Forced by Westernizers out of the leadership of the Tokyo School of Fine Arts, in 1898 Okakura formed the powerful Institute of Japanese Fine Art (Nihon Bijutsu-in). So fissionable was the Meiji art world that the Institute was itself shaken by dispute within two years of its founding. The passionate conflict even drove some artists to suicide. A few major paintings of the period testify that these tensions, uncertainties, and controversies were not confined to academy politics and events.

The portrait of Okakura Tenshin (Kakuzō) [135] by Shimomura Kanzan (1873–1930) was executed late in the artist's life (1922). One is struck immediately by contrasts: the carefully finished face modelled in Western style and the pale washes of the almost ethereal robe; the cigarette, carefully drawn and colored in opaque white, and the curling, structureless hand; the realism of the heavy-lidded eyes with highlighted eyeballs and the lack of any background setting for the figure other than a cursorily rendered chair. It is an elegant but decadent image; the artist seems unwilling to grapple with either the realist or decorative Japanese traditions and even less with Western traditions of realism and naturalism. This romanticism was endemic in many of the conservative movements attempting to stem Westernization—the cult of tea (*cha no yu*), the way of the warrior (*bushidō*), Buddhist and particularly Zen mysticism, and the folk-art (*mingei*) movement. Carried to extremes, it ended in rank nostalgia.

The impossibility of adapting Western forms of realism into the old Japanese formats and techniques is particularly evident in two long and complex efforts to revive the *e-maki* tradi-

209

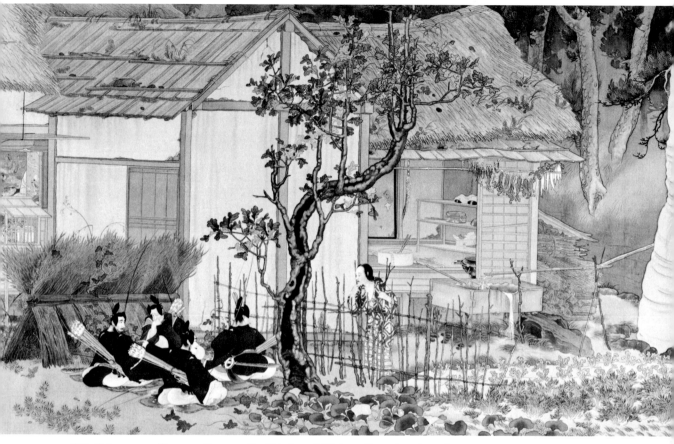

136 Shimomura Kanzan, *Emperor Go-Shirakawa's Visit to Ohara*, handscroll (section).

tion: *Ohara Gokō* [*Emperor Go-Shirakawa's Visit to Ohara*] [136], painted in 1907 by Shimomura Kanzan, and *Mikoshi-buri Zukan* [*Riotous Priests of Enryaku Temple*] [137] by Kanzan's pupil, the late Maeda Seison (1885–1977). Both handscrolls capitalize on subject matter from the stirring time of transition between the Fujiwara and Kamakura periods, and both artists carefully studied medieval costume and mores to achieve authenticity. The technical virtuosity displayed in the scrolls is extraordinary, with striking prospects—gloomy forest [136a], or the twisting trunk and luxuriant foliage of a chestnut tree subtly modelled in light and shade—coming abruptly into view as one unrolls the scrolls.

Both Shimomura and Maeda attempted greater realism than ever before achieved, but in ways that cumulatively led to defeat, however worthy the effort. Shimomura uses a low, Western viewpoint and rationally conceived, solidly built structures. Heads, rocks, and trees are modelled in chiaroscuro. Linear brushwork and implied movement are suppressed in favor of solid and brilliant local color. Maeda, on the other hand, adopts the old convention of a tilted ground plane rising to the top of the scroll, thrusting the action forward to the picture plane. There is more line and movement in his scroll than in Shimomura's, but the buildings are equally carefully and solidly constructed. The faces of Maeda's wicked monks are also in the traditional mode, more linear and with considerable satirical content. The actions and characterizations of the figures in *Mikoshi-buri Zukan* are extremely well done.

But in both works the traditional handscroll format, so well suited to showing movement and the passage of time within the flow of narrative,

137 Maeda Seison, *Riotous Priests of Enryaku Temple,* handscroll (section).

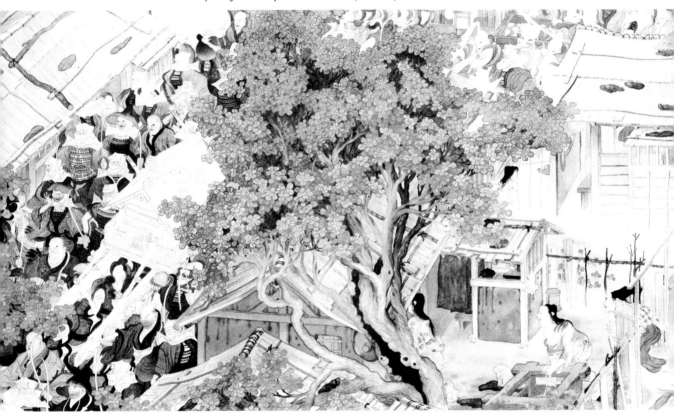

is hopelessly at odds with the apparently real and authentic details so appropriate to a Western style academic picture. The modelled world of light and dark in carefully defined space is the realm of the framed picture, the window on the world; the handscroll format compresses it like a vise. At the same time the gestures and directions implying movement, the suggestion of things rapidly passing by, the sudden glimpses of depths or voids, are lost in the attempt to depict a real world, Western style. Realism in time and movement was to be the daring new world of the cinema, and the mastery rapidly achieved by the Japanese in that medium is now a matter of record and admiration.

Still another and diametrically opposed image poses and gives one answer to the problem of realism after the Meiji restoration—*Salmon* [138], an oil painting executed in 1877 on panel by Takahashi Yuichi (1828–94). Born in feudalism, student of the Kanō school, then of minor English and Italian painters in Japan, Takahashi finally set up, in 1873, a private school first licensed by the Tokyo government in 1881. He did not study abroad and mastered oil painting largely on his own. His *Salmon* is the epitome of that kind of Western realism seen in Dutch and Flemish still life or in the massive lake trout painted by the master of French nineteenth-century realism, Gustave Courbet. Nothing is left to the imagination; the corporeal image of a particular, lifeless mass is complete. We see dry, wrinkled skin, hooked mouth, the cruel tension of the rough twine—just this and nothing more. This is not capitulation to the West but rather mastery achieved outside the realm of Japanese tradition yet with something of that tradition's integrity.

With membership in the present-day international artistic milieu come the uncertain paths and shifting allegiances of the world of modern culture. But one direction was pointed out by Takahashi's new realistic image of death, dismemberment, and decay, in which *Rokudo* and *genjitsu* combine with a new beginning of realism in Japanese art.

138 Takahashi Yūichi, *Still Life of Salmon.*

CATALOGUE

1 *Wild Boar*

Late Jōmon period, ca. 3000 BC. Earthenware. H. 9 cm. L. 20 cm. Tokoshinai site, Hirosaki, Aomori Prefecture. Hirosaki Municipal Museum, Aomori Prefecture.

In the context of its time this clay figure is particularly unusual for being immediately and unmistakably recognizable as a wild boar. Of the numerous animal *haniwa*, which date from centuries later, many are so equivocally made that we are hard put to know whether they represent pigs or dogs.

Here, however, the snout, ears, head, and body shape with hooved stubby legs and short thick tail present an indisputable pig. The body is hand molded and its surface demarcated by incised curving lines enclosing impressed cord patterns. The boar's face, legs, and tail have been scraped smooth and virtually the entire body is burnished, the body fabric ranging in color from brown to bluish black.

This small figure was discovered during recent scientific excavations at the Tokoshinai site in northern Honshū. As in earlier excavations there, several vessel types have emerged from the site that bear similar impressed and incised designs. Comparable designs appear on decorated vessels from the famous site at nearby Oyu and on Kasori and Horinouchi type vessels from the distant Kantō region. Other late Jōmon boar images, quite different in appearance, have been excavated in the northern province of Iwate and in Nara to the west. MC

Literature

Masayoshi Mizuno, *Dogū* [*Clay Images*], vol. 5 (1979) of *Nihon no Genshi Bijutsu*, color pl. 63 and p. 76.
Tadashi Saitō and Itsuji Yoshikawa, *Genshi Bijutsu* [*Primitive Art*], vol. 1 (1970) of *Genshoku Nihon no Bijutsu*, color pl. 44 and p. 54.

2 *Chicken*

Tumulus period, 6th–7th century. Earthenware. H. 56 cm. Gumma Prefecture. Yokouchi Chusaku, Tokyo. Important Cultural Property.

The *haniwa* (clay cylinders) typically found along the slopes of tumuli (burial mounds) fall into two broad categories: plain cylindrical shapes and, more germane to our purpose, cylinders with representational images attached to or emerging from them. These ceramic forms are usually low-fired, unglazed, and rather fragile. Chickens are but one member of a *haniwa* repertoire which includes animals, land and water birds, fishes, boats, houses and buildings, armored horses and warriors, and ceremonial paraphernalia.

To construct the simple cylinders, clay rings would be stacked and then smoothed with paddles and scrapers. For sculptural *haniwa* several such cylinders might be joined to approximate the shape of the figure, which would then be finished by modelling

Catalogue Authorship

Because the catalogue entries have been prepared by two authors, we have indicated authorship by initials at the end of each entry:

MC Michael Cunningham
JU James Ulak

and incising and the addition of separately formed appendages. By this ingenuous technique were produced some of the most impressive sculptural images of Japan's early history. The oldest examples are from tumuli in the Kansai (Kyoto-Nara plain) and northern Kyūshū areas. Subsequently this burial practice with its attendant funereal art spread east to the Kantō (Tokyo plain) and Tōhoku (northern provinces) regions. This *haniwa*, one of the many kinds of domesticated fowl represented, comes from a site in Gumma Prefecture in the Kantō.

Despite repairs, it is possible to see that the head, neck, trunk, and tail flange have been modelled separately and joined together. The broad wing plates, bony feet, and head features were separately made, with considerable attention to realistic representation, and added on. Drilled eyes and nostrils, comparatively rare among the many chicken *haniwa*, enhance the lifelikeness achieved by studied manipulation of the facial structure and subtly swelling body parts. They also heighten the tactile effect of the shallow incised and combed feather patterns. MC

Literature

Masanari Matsubara, *Haniwa* (Tokyo: Sogensha, 1958), pl. 14.
Fumio Miki, *Haniwa*, trans. and adapted by Gina Lee Barnes, vol. 8 (1974) of *Arts of Japan*, pl. 90 (captioned as turkey).

3 *Monkey*

> Tumulus period, 6th–7th century. Earthenware. H. 24.8 cm. Tamatsukuri site, Namegata, Ibaragi Prefecture. Nakazawa Tatsuo, Tokyo. Important Cultural Property.

This rare and haunting image of a monkey is probably more familiar to the Japanese than any other single *haniwa*. In color as well as surface quality the clay augments the extraordinary simplicity of the design.

Evidence suggesting repeated modelling can be observed in the facial area, shoulders, and flexed torso. A C-shaped ear has been lost from the side of the head, and fragments remaining on the back have traditionally been taken to signify that a baby monkey once clung to this adult's back. The lower half of the figure is missing. MC

Literature

Masanari Matsubara, *Haniwa* (Tokyo: Sogensha, 1958), pl. 12.
Fumio Miki, *Haniwa*, trans. and adapted by Gina Lee Barnes, vol. 8 (1974) of *Arts of Japan*, pl. 43 (color) and p. 51.

4 *Sketches on Pedestals for Sculptures of Taishakuten and Bonten*

> Nara period, ca. 800. Ink on wood. W. 36.6 cm. and 36.1 cm. Tōshōdai-ji, Nara Prefecture. National Treasure.

Tōshōdai-ji, a Buddhist temple built in eighth-century Nara, houses among its many impressive wood or dry lacquer sculptures two images of Bonten and Taishakuten, Buddhist interpretations of the Hindu deities Brahma and Indra. They stand on the raised platform of the main hall (*kondō*), flanking the central Vairocana Buddha which towers above them. In contrast with this central lacquer figure, Bonten and Taishakuten are each carved from a single piece of Japanese cypress (*hinoki*) wood.

Each figure stands on an elaborate wooden dais. This consists of a two-layer hexagonal section topped by a carved lotus-form pedestal supporting a flat hexagonal base upon which the sculpture stands. A wood peg from the sculpture above passes through a hole in the middle of each of these supporting members, effectively aligning and locking them in place.

Consequently the casual viewer is unaware of the extraordinary drawings concealed between the two uppermost units, on the top surface of the lotus pedestal. Bonten's pedestal in particular abounds with ink sketches of men and women; horses, rabbits, and deer; frogs; birds; low, level landscapes; decorative floral arrangements; and scattered writing. The individuals responsible for the drawings demonstrate a lively familiarity with the appearance of court attendants in profile, three-quarter, and frontal poses. These, along with several demonic and fanciful beings, intermingle with the animals in seemingly random fashion, often flowing out of one another in inventive brush play.

Artisans' ink cartoons, sometimes quite coarse in subject, have turned up in a number of temple structures in Japan, most notably perhaps at Hōryū-ji. They have also been found inside several Buddhist sculptures. The thematic content and animation of these Tōshōdai-ji drawings place them among the most visually complex examples known. MC

Literature

Hayashi Mori, ed., *Tōshōdai-ji*, vol. 13, pt. 2 (1972) of *Nara Rokudaiji Taikan*, repr. following p. 36 (both pedestals).
Shōzaburō Maruo et al., *Nihon Chōkoku-shi Kiso Shiryō Shūsei, Heian Jidai: Zōzō Meiki Hen* [*Complete Collection of Fundamental Research Materials in the History of Japanese Sculpture, Heian Period: Inscribed Images*] (Tokyo: Chūō Kōron, 1971), pt. 8, vol. 2.

5 Yuima Koji

Late Heian period, 9th–10th century. Wood with traces of color. H. 35. cm. Enryaku-ji, Shiga Prefecture. Important Cultural Property.

Said to be a contemporary of the Buddha and a diligent follower of his teachings, the Indian layman Vimalakirti, or Yuima, as he is known in Japan, attained Enlightenment but rejected the monastic life. *Koji* means "lay disciple." His understanding of Buddhist principles and his preaching and proselytizing were renowned. Indeed, Yuima is supposed to have feigned illness on occasion, in order to lure unsuspecting visitors into conversation on some point of Buddhist thought. Monju (S. Manjusri), the Bodhisattva of Wisdom, is said to have debated with Yuima under just such circumstances, an event celebrated in Buddhist legend and recorded in Japanese sculpture by early eighth-century clay figures in the pagoda at Hōryū-ji. In this representation the debate takes place in a grotto before a group of figures. Yuima sits cross-legged on a dais, supported by an arm rest, his two hands raised before his chest. He is looking straight ahead and speaking forcefully. In this early representation of the Indian sage we see a man of advanced years, bearded and bald and dressed in fine secular garments. He bears scant resemblance to the later *Yuima* from Enryaku-ji.

The Enryaku-ji *Yuima* is a Sinicized version of the layman, and unlike virtually all other Japanese representations in being neither old nor frail. His stout bodily proportions, large head, and diminished legs are characteristic of Late Heian "single-block" (*ichiboku*) construction, as is the solemn facial expression with downcast eyes. Yuima is shown lecturing, using an armrest as in the Hōryū-ji carving, but his left hand is held up palm outward, with the first two fingers raised in what seems to be a preaching *mudra* (hand gesture signifying a Buddhist divinity's intention). Among the small group of Yuima images known in Japan only the small ninth-century Ishiyama-dera figure shares this feature. Both are highly idiosyncratic interpretations of the Yuima theme, but the youthful, formally posed Enryaku-ji figure appears to be unique. This representation was formerly at Seiryō-ji, a subtemple in the western precincts of the Enryaku-ji purportedly founded by Jie Daishi (913–86), one of the Tendai sect's esteemed patriarchs.
MC

Literature

Heian Jidai no Chōkoku, Tokubetsu Ten [Sculpture of the Heian Period, Special Exhibition] (exh. cat.; Tokyo National Museum, 1971), no. 16.

Hisashi Mōri, *Japanese Portrait Sculpture*, trans. and adapted by W. Chië Ishibashi, vol. 2 (1977) of *Japanese Arts Library*, pl. 35 (color).

John M. Rosenfield, "Studies in Japanese Portraiture: The Statue of Vimalakirti at Hokke-ji," *Ars Orientalis*, vol. 6 (1966), 213-22.

6 Daikokuten

Heian period, 12th century. Camphor wood. H. 171.8 cm. Kanzeon-ji, Fukuoka Prefecture. Important Cultural Property.

An impressive number of large-scale Buddhist sculptures have survived at Kanzeon-ji, a Tendai temple founded in the mid-eighth century, close to the old administrative and military headquarters for Kyūshū, the Daizaifu. The temple has enjoyed a distinguished history, including religious and cultural ties with the continent. Although this life-sized image of Daikokuten now stands in a modern treasure hall, it was almost certainly originally installed in the refectory, now lost like most of the temple buildings.

In current popular belief Daikokuten is a deity associated with good fortune and plenty, but his iconography and appearance grow out of an older tradition in which he wore a decidedly fierce guardian aspect, characterized by black body, fiery hair, three faces, and six arms. Subsequently he became a protective deity of monastic kitchen areas, oftentimes paired with Monju.

Of the several known types of late Daikokuten figures, this Kanzeon-ji example is the oldest and the largest. Carved from a single block (*ichiboku*) of camphor wood (*kusu*), it attains a degree of three-dimensionality and an air of informality rarely seen in Japanese Buddhist sculpture. Daikokuten assumes a *contraposto* attitude, as if to help support the weight of the characteristic heavy bag of benefactions slung over his left shoulder. The turned-out right foot and forceful gesture of the clenched right hand recall the figure's genesis as a protective deity, as do the raised, knitted eyebrows and set lips.
MC

Literature

Kanzeon-ji Okagami [Reflections of Kanzeon-ji] (Tokyo: Otsuka Kōgeisha, 1934), pls. 35-38; English summary, p. 5.

Kyūshū, pt. 1: *Fukuoka [prefecture]* (1976) in *Kokuhō Jūyō Bunkazai Bukkyō Bijutsu*, no. 32, repr. p. 85; p. 209.

7, 8 *Gigaku Masks: Taikofu* [*Bearded Old Man*]

Nara period. Dated to 751. Paulownia wood with color and added hair. H. 30.2 cm. and 31.7 cm. Tōdai-ji, Nara Prefecture. Important Cultural Property.

The origins of the religious dance-drama *gigaku* can be traced back to China well before its introduction into Japan about the seventh century. Typically *gigaku* was performed at solemn temple and court ceremonies, to flute, gong, and drum accompaniment, and employed approximately twenty dancers, two of whom wore the *taikofu* masks seen here. Its high solemnity would be relieved by interludes of comic dance, which the *taikofu*, said to represent an old man of Central Asian or Persian background, performed along with other troupe members.

These two masks are carved of paulownia wood (*kiri*), with holes drilled for the eyes, nose, mouth, and implanted hair. The wood surface has been restored and repainted more than a thousand years after its manufacture. An inscription inside each mask tells us that they were made one month apart in the spring of 751. Individual in appearance, they are the oldest extant examples of this dignified *gigaku* mask type, and may have constituted the preeminent *taikofu* pair for *gigaku* performances at Tōdai-ji since the mid-eighth century. MC

Literature

Mosaku Ishida, *Shōsōin Gigaku Men no Kenkyū* [*A Study of Gigaku Masks in the Shōsōin Collection*] (Tokyo: Bijutsu Shuppan-sha, 1955).
Peter Kleinschmidt, *Die Masken der Gigaku der ältesten Theaterform Japans*, Asiatische Forschungen, 21 (Weisbaden: Harrasowitz, 1966), nos. 158 and 159.

9 *Bugaku Mask: Hare Men* [*Old Woman*]

Late Heian period, 12th century. Wood, cloth with priming, and color. H. 31.5 cm. Tamukeyama Shrine, Nara Prefecture. Important Cultural Property.

Bugaku, the official court dance of Japan which dates back to the Asuka period, includes performances in which masked dancers participate. Moving to the accompaniment of a small wind and percussion ensemble, the dancers follow a precisely choreographed routine, more stylized than narrative in content. Introduced into Japan from China and Korea, the costumes and the masks (*men*) used in *bugaku* reflect considerable diversity in foreign ancestry, type, and age.

The *hare men* was used in the *Ni no Mai*, a relatively lively two-person dance. It supplied comic relief after the slow, serious *Ama* dance which preceded *Ni no Mai* on a typical program. At the same time, however, the gross swelling and distortion of the *hare men* suggests the discomfort associated with the woman's purported affliction, leprosy. This mask is one of the finest and earliest of its type, predating the 1178 *Ni no Mai* masks at Atsuta Shrine, Nagoya. MC

Literature

Gunhild Gabbert, *Die Masken des Bugaku: Profance japanische Tanzmasken der Heian-und Kamakura-Zeit*, Sinologica Coloniensia: Ostasiatische Beiträge der Universität zu Köln (Wiesbaden: Franz Steiner Verlag GmbH, 1972), Band I, Nr. 133, pp. 450-51, Band II, Tafel 29:133.
Kyōtarō Nishikawa, *Bugaku Masks*, trans. and adapted by Monica Bethe, vol. 5 (1978) of *Japanese Arts Library*, pl. 57.

10 *Bugaku Mask: Heishitori* [*Winebearer*]

Kamakura period, early 13th century. Wood, cloth with priming, and color. H. 28.4 cm. Tamukeyama Shrine, Nara Prefecture. Important Cultural Property.

The grinning *heishitori* acted as the buffoon-servant in *Kotokuraku*, an amusing story of a winebearer who secretly steals the guests' wine. This mask may be dated to the early thirteenth century through comparison with the *emi men* (the mate to the *hare men* in the *Ni no Mai* dance) from the Masumida Shrine, which is dated to 1211. It bears a striking resemblance to the *hare men* [9]. MC

Literature

Gunhild Gabbert, *Die Masken des Bugaku: Profance japanische Tanzmasken der Heian-und Kamakura-Zeit*, Sinologica Coloniensia: Ostasiatische Berträge der Universität zu Köln (Weisbaden: Franz Steiner Verlag GmbH, 1972), Band I, Nr. 133, pp. 450-51, Band II, Tafel 29:134.
Kyōtarō Nishikawa, *Bugaku Masks*, trans. and adapted by Monica Bethe, vol. 5 (1978) of *Japanese Arts Library*, pl. 34.

11 *Nō Mask: Enmei-kaja [Man]*

Kamakura period. Dated to 1291. Katsura wood with color. H. 17.6 cm. Chūson-ji, Iwate Prefecture. Important Cultural Property.

In this *nō* mask of a young man we see a broad and relatively short head with a low forehead and flaring nose. The mouth is wide and the full lips are parted, with a hole pierced through the mask on either side of the blackened teeth to define the mouth opening. The cheeks are plump, with conspicuously large dimples. These features, together with the narrow strongly curved eyes, compose a face and an identity quite different from that of most young women (*waka onna*) masks seen in *nō* performances.

Indeed, the origin and subsequent use of this mask are noteworthy. In both the *ennen nō* dance and *dengaku nō* Okina plays there appears a young female character wearing a mask like this one. In later *sarugaka Okina* performances a similar female character is actually called Enmei-kaja. Thus this young man's mask derives from prototypes identified as female in earlier dramatic forms. In fact, the inside surface of the mask bears two inscriptions confirming this.

The first records the dedication of the mask and, except for one character, is written in ink. The second, entirely carved, dates the piece to 1291 and names it a *Nyakunyo* (Young Woman). Another interpretation of the name reads *Nyakubo* (Young Mother). Whichever reading is correct, the style of the mask confirms the carved inscription, identifying this as one of the oldest *nō* masks known.

Of the four smiling or laughing masks commonly worn in *Okina* performances, Enmei-kaja is the most recent in origin as well as the youngest-looking. Indeed, adults between the ages of sixteen and fifty-nine were only permitted to act the dance role in the play *Heron [Sagi]* after the young Enmei-kaja mask had become acceptable. The mask is further distinguished from the other *Okina* mask types by being sculpted in one piece; all the others have movable chins. This very mask was used annually for *nō* performances until approximately thirty years ago, when a copy was made. MC

Literature
Hisashi Mōri, *Nō Men Sen [Selection of Nō Masks]* (exh. cat.; Kyoto National Museum, 1965), pl. 5 (color).
Shin'ichi Nagai, ed., *Chūson-ji to Michinoku no Koji [Chūson-ji and Other Ancient Temples in Michinoku* (Tōhoku district)], vol. 16 (1980) of *Nihon Koji Bijutsu Zenshū*, pl. 19 (color) and p. 131.
Masako Shirasu, *Nō Men [Nō Masks]* (Tokyo: Kyuryūdō, 1963).

12 *Nō Mask: Okina [Old Man]*

Muromachi period, mid-15th century. Hackberry wood with color and hemp beard. H. 20.3 cm. Cleveland Museum of Art 77.33. Purchase from the J. H. Wade Fund.

The *Okina* character originated in the popular folk drama of the Heian and Kamakura periods—*sarugaku, dengaku* and *ennen nō*. Especially in the agricultural regions, the circumstances of these performances must have resembled a traditional Western country fair with quasi-religious undertones or a saint's day festival.

Okina developed from a supporting role in such folk entertainments into a principal character by the fifteenth century, when *nō* had become a more solemn and consciously aesthetic drama enjoyed by the elite of Muromachi society. As a result, the *Okina* character changed from a villager who participated in ceremonies petitioning for peace and bountiful harvests to a more potent, semicomic figure who typically opened the medieval *nō* program, welcoming the audience and invoking success on the day's plays and general harmony on the country.

Okina alone among *nō* masks possesses a moveable chin, establishing its sculptural ancestry among the earlier *gigaku* (see [7,8]) and *bugaku* (see [9,10]) traditions. The earliest *Okina* representations date from the twelfth century and were copied faithfully for centuries, making accurate dating difficult unless the mask bears an inscription. This example has traditionally been considered of mid-fifteenth-century vintage. MC

Literature
Ko Men no Bi [The Beauty of Old Masks] (exh. cat.; Kyoto National Museum, 1980).
Sherman E. Lee, Michael R. Cunningham, and Ursula Korneitchouk, *One Thousand Years of Japanese Art (650-1650) from The Cleveland Museum of Art* (exh. cat.; New York: Japan House Gallery, 1981), cat. 32.
Masako Shirasu, *Nō Men [Nō Masks]* (Tokyo: Kyuryūdō, 1963), pl. 1 (color) and pp. 102-3; English summary, p. 6.

13 *Aizen Myōō [Lord of Human Desire]*

Kōen (1207–85?). Dated to 1275. Wood with color. H. 39.7 cm. Jingo-ji, Kyoto Prefecture. Important Cultural Property.

An inscription on the pedestal of this statue records its completion by Kōen (1207–85?) in 1275. Generally thought to be the grandson of Unkei (1151–1223) and

nephew of Tankei (1173–1256), Kōen succeeded Tankei in 1256 as *dai busshi* (master sculptor of Buddhist images) and leader of the third generation of the Unkei school. Unkei's professional life had bridged the period of violent transition from aristocratic to military rule. The loss by fire of major Tempyō and Heian period sculptures in the late twelfth-century wars provided that great artist with opportunities for repair, restoration, and creative reinterpretation of Buddhist iconography, resulting in the distinctively intense and realistic style synonymous with Kamakura figural representation. Kōen, unquestionably a major artisan of the thirteenth century, might be regarded as a faithful executor rather than as an innovator within the Unkei tradition. A fair number of his sculptures survive, the *Aizen Myōō* being his last known work.

The *myōō* (king of bright wisdom) deities are fierce manifestations of the Buddha. They function iconographically as terrifying guardians of the Buddhist faith and uncompromising guides for those who choose the rigorous Esoteric path toward spiritual transformation. Fudō Myōō was the most popular of these figures. Aizen Myōō can be understood as deriving from Fudō and embodying popular Buddhism's tolerance and compassion for humanity.

Devotion to Aizen (literally, "dyed in love") Myōō existed in Japan from the Heian period. He represents the fullness of sensual passion, not burned and purged away but fused with spiritual insight into Enlightenment. Thus he suggests to believers the fundamental compatibility of natural instincts with the possibility of salvation. Six arms hold the traditional symbolism-laden *myōō* attributes: bow and arrow defend the faith, dispel ignorance, and exemplify the piercing quality of love; the five-pronged double *vajra* (thunderbolt) clutched to the breast indicates a heart sincerely open to Enlightenment; the bell warns of impermanence and calls to prayer; the lotus bud (which grows in mud) evokes notions of purity rising out of corruption, rebirth, and a nurturing maternalism which deals gently with guilt. The blood-red body color and central third "eye" are the most explicit references to the deity's acceptance of sexual passion. Aizen Myōō is a protector of marital union, of prostitutes, and of textile dyers.

Deeply carved fabric folds and a stout, fleshy body whose modelling reflects careful observation of human anatomy place this work in the Unkei tradition. The bronze jewelry is contemporary with the statue. Traces of *kirikane* (thin sheets of gold leaf cut into a fine decorative pattern) and polychrome suggest the original opulence of the figure. JU

Literature

Takeshi Kuno, ed., *Jingo-ji to Rakusei, Rakuhoku to Koji* [*Jingo-ji and Other Ancient Temples in Western and Northern Kyoto*], vol. 9 (1981) of *Nihon Koji Bijutsu Zenshū*, pl. 6 (color) and p. 125.
Tokubetsu Ten: Kamakura Jidai no Chōkoku [*Special Exhibition: Japanese Sculpture of the Kamakura Period*] (exh. cat.; Tokyo National Museum, 1975), cat. no. 35.

14 *Kūsō Zukan E-maki*
[*Scroll of the Nine Aspects of Decay*]

Kamakura period, 14th century. Handscroll; ink and light color on paper. H. 31.6 cm. L. 484.5 cm. Nakamura Hideo, Kanagawa Prefecture.

Ono no Komachi, acknowledged in Heian anthologies as one of the six poetic geniuses in the Japanese tradition, very soon became synonymous with beauty and its fickle transience. The body of legend surrounding her could only have been augmented by the appeal of her hauntingly romantic verse and by the very sparseness and vagueness of biographical data. She was portrayed as a gifted woman who, attempting to parlay her beauty into the position of imperial consort, rejected all other suitors but died destitute.

The visual meditation on mortality in the present handscroll derives from Chinese and Japanese Buddhist writings and iconography that distinguished nine degrees in the decomposition of the human corpse. The artist ingeniously integrates a somewhat earlier tradition of portraiture with the genre of decay by first depicting a robust, elaborately dressed young woman whom tradition, rather than concrete evidence, has identified as Ono no Komachi. The nine stages of decline (*kūsō*) then proceed against a stark background devoid of explanatory text. Death and dishabille, discoloration, bloating, putrefaction, infestation by maggots, and dismemberment by dogs, crows, and birds of prey follow a conventionalized pattern (see [18,19]) that is faithful to the vigorously descriptive Chinese literary versions. Japanese poetry composed to be read while viewing this or similar sequences is slightly more allusive and restrained.

Musō Kokushi (1275–1351) [72], Zen monk and arbiter of taste to the Ashikaga shogunate, is said to have drawn, at the age of fourteen, a version of "decline and decay" as an object of personal reflection. JU

Literature

E-maki [*Illustrated Handscrolls*] (exh. cat.; Tokyo National Museum, 1975), no. 52, repr. p. 134 (two sections).

Yoshinobu Tokugawa et al., *Gaki Zōshi, Jigoku Zōshi, Yamai no Sōshi* [*Scrolls of Hungry Ghosts, Scrolls of Hells, Scrolls of Diseases and Deformities*], vol. 7 (1977) of *Nihon E-maki Taisei*, color repr. pp. 110-19.

15 *An Albino*

> Late Heian period, 12th century. Detached section of the handscroll *Yamai no Sōshi* [*Scroll of Diseases and Deformities*], mounted as a hanging scroll; ink and light color on paper. H. 25.1 cm. W. 39.1 cm. Hirota Yutaka, Tokyo. Important Cultural Property.

Medieval illustrations of human disease and deformity are best comprehended as a subspecies of the Buddhist-inspired *Rokudō* paintings (see [18,19]), which catalogued the afflictions of all sentient creatures.

Central among these more medically explicit paintings is this scroll, traditionally attributed to the artist Kasuga (Tokiwa) Mitsunaga (act. ca. 1173) and the poet-calligrapher Jakuren (1139–1202) (see [24]). The paintings examine a variety of disorders. Along with such commonplace afflictions as obesity and halitosis, a light-hearted voyeurism details for the viewer the remarkable genitalia of a hermaphrodite. Equally interesting are the keenly observed dispositions of those who react to the afflictions. Along with matter-of-fact nursing of ills we are also shown mockery and cruel laughter.

An albino woman deals good-naturedly with those startled by her appearance. In the group of four figures to the left, a surprised woman looks on slack-jawed while her small child pesters for an explanation and an older boy with shaven pate emphasizes his remarks on the obvious with a pointing finger. The courtier laughs loudly and slaps his forehead, finding either the albino or the boy's comments on her hilarious. To the right another woman, burdened with cooking utensils, manages a sidelong glance. This is a sophisticated composition. Figures strain in opposite directions to assure focus on the central character. In the group of four the artist confidently overlaps figures, obscuring body parts and alluding to unseen but imaginable form.

Records from the tenth century mention several albino children living in Kii Province (Wakayama Prefecture). They are described as being white as snow and kept hidden by their parents during the daylight hours. But the albino woman of this scroll painting conveys an air of accustomed forthrightness, and the *tsuzumi* (shoulder drum) clutched in her arm suggests that she makes her way in the world as an entertainer.

In the late Edo period the scroll was owned by the Nagoya poet Odate Takakado (1766–1839). Sometime later it entered the Sekido Collection, when the separate scenes were remounted individually. Nine of these remain in the Sekido holdings, while others, including the work exhibited here, have gone to other collections. JU

Literature

Yoshinobu Tokugawa et al., *Gaki Zōshi, Jigoku Zōshi, Yamai no Sōshi* [*Scrolls of Hungry Ghosts, Scrolls of Hells, Scrolls of Diseases and Deformities*], vol. 7 (1977) of *Nihon E-maki Taisei*, color repr. pp. 78-79.

16 *Monks Punished in Hell*

> Kamakura period, ca. 1200. Detached section of the handscroll *Jigoku Zōshi* [*Scroll of Hells*]; ink and color on paper. H. 26 cm. L. 27.3 cm. Seattle Art Museum. Eugene Fuller Memorial Collection.

Hell was the lowest and most gruesome of the Six Realms of Reincarnation (see [18,19]) through which sentient beings passed on the hard journey to Enlightenment. Much Kamakura period iconography of suffering and retribution was derived from Chinese Buddhist literature of the T'ang dynasty (618–906). Late Heian and early Kamakura Japan quickly took to heart and heightened these descriptions of the underworld. The transition from civilian aristocratic to military rule was being accomplished by sword and fire, which simultaneously created ready models of hell and aroused longing for a realm, albeit supernatural, where malefactors of brute force were brought to justice.

Sutras created a multiplicity of varied hells, where the most condign punishments were meted out for even the most specialized sins. Apocryphal or "forged" sutras expanded on the subject. One such text, which sets forth the punishments awaiting evil monks and nuns, inspired the painted roll whence comes the fragment exhibited here. The roll, formerly in the Masuda Collection, depicts seven types of punishment for monks who have debauched, violated the proscriptions against abusing or taking life, or ignored dietary restrictions. The fragment, now in the Seattle Art Museum, treats of the fate of monks who have tortured animals. Stripped of their robes of

office, they stumble, awkward and defenseless, into a stylized but searing fire that burns without consuming. Before them the orange and red flames, outlined in black, leap to meet them. Close behind them, driving them forward with ungainly, ground-devouring strides, come huge horse-headed demons wielding iron clubs.

In other segments of the roll the helpless clerics are hurled by monsters, flayed and butchered, boiled in molten copper, and marched into a river fetid with human waste. The artist takes evident glee in depicting the suffering of ecclesiastical hypocrites. JU

Literature

Terukazu Akiyama, *E-makimono* [*Illustrated Hand-scrolls*], vol. 2 (1980) of *Zaigai Nihon no Shihō*, color pls. 62 and 64.

Yoshinobu Tokugawa et al., *Gaki Zōshi, Jigoku Zōshi, Yamai no Sōshi* [*Scrolls of Hungry Ghosts, Scrolls of Hells, Scrolls of Diseases and Deformities*], vol. 7 (1977) of *Nihon E-maki taisei*, color repr. pp. 68-69.

Henry Trubner, William J. Rathbun, and Catherine A. Kaputa, *Asiatic Art in the Seattle Art Museum: A Selection and Catalogue* (Seattle: Seattle Art Museum, 1973), cat. 191.

17 *Emma O and Shokō O*

Tosa Mitsunobu (1434–1525). Dated to 1489. Two of a set of ten hanging scrolls depicting the *Jū O* [*Ten Judges of Hell*]; ink and color on silk. H. 96.1 cm. W. 42.4 cm. Jōfuku-ji, Kyoto. Important Cultural Property.

The cult of the Ten Kings of Hell likely originated in China during the Six Dynasties (222– 589). Taoists construed an underworld governed by the deity T'ai-shan-fu-chün and ten attendant kings. These Taoist notions, along with Confucian and folk beliefs, were absorbed by Chinese Buddhism to produce, during the Sung dynasty (960–1279), a concept of hell which was codified in various hybrid sutras and rendered in a generally consistent iconography. In the Buddhist version, the eleven figures of the Taoist tradition became ten, with the role of presiding deity assumed by Yen-lo-wang (J. Emma O; King Yen-lo or Emma). The ten kings functioned as a tribunal over the souls of the deceased. Associated with the Ten Kings is the concept of the bodhisattva Jizō as intercessor or savior of those condemned to hell. In appearance he is a gentle, tonsured monk.

Images of the Ten Kings were prominent in funerary liturgy. During the forty-nine days following a death, memorial services were held every seventh day. The seventh observance was regarded as most critical, since at that time the fate, or stage of rebirth, of the deceased was determined. Three more services followed, marking the one hundredth day, the first year, and the third year from the date of death. Each of the Ten Kings presided over one of the memorial services.

From the late twelfth century, importation of Sung examples stimulated Japanese production of Ten Kings iconography. Concurrently Japanese Buddhists composed a sutra in which the role of the kings was further elaborated, making them retributive emanations of benign Buddhist deities. This adaptation of imagery and proliferation of correspondences whereby one deity is understood as an "aspect" of another reflects a pervasive tendency in contemporary Japanese Buddhism. The same propensity accounts for Japanese Buddhists' conscious efforts to assimilate Shintō, in a system called *honji-suijaku*, in which each Shintō *kami* became the local manifestation (*suijaku*) of a universal Buddhist deity (*honji*). Yet another system increased the Ten Kings to thirteen in order to provide presiding officers for memorial services held seven, thirteen, and thirty-three years after death.

The scrolls exhibited here, two of a set of ten executed by Tosa Mitsunobu in 1489, are faithful copies of an earlier set attributed to Tosa (Fujiwara) Yukimitsu (fourteenth century). Mitsunobu's works were commissioned for use in a *gyakushu* (reverse ritual) for the emperor Go-Tsuchimikado (r. 1465–1500). *Gyakushu* meant the performance before death of religious services normally held after death, in order to prevent posthumous suffering. It proved a prescient measure, for at Go-Tsuchimikado's demise the imperial treasury was near collapse and over a month was needed to raise funds for an appropriate funeral.

Shokō O, lord of the fourteenth day, barks commands as a sinner vainly offering a sheet of petition is dragged away with neck in pillory. Fiercely-muscled demons smash the elbows of another unfortunate with workmanlike diligence. A third tortured soul stumbles in the foreground. The stately costumes and furniture of judicial office contrast with the king's livid rage and the grotesque features of his clerk. Overhead floats Sakyamuni, of whom Shokō O is the emanation.

The reigning judge of the thirty-fifth day after death is Emma O. Before his throne, a demon grasps a bound man by the topknot and forces him to view his past sins in a magic mirror. We see reflected a warrior in a boat splitting the head of a victim who flounders in the water. A beauty clad only in red undergarment strains away from the demon's grip and from her turn before the incriminating mirror.

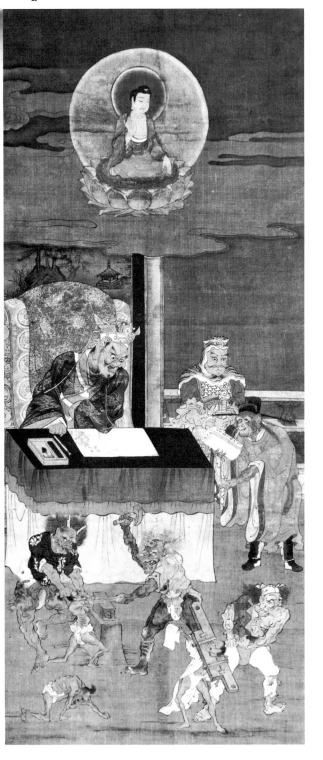
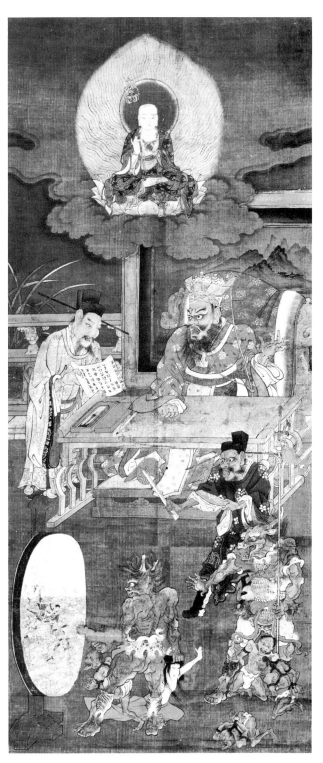

Shackled sinners wait their turn at the mirror, while gleeful attendants look on. Emma O gazes into the distance, ignoring the scene before him, and engages a lawyer in argument. From above, the bodhisattva Jizō, benign counterpart of Emma O and rescuer of the damned, looks down in compassion. JU

Literature

Jōji Okazaki, *Pure Land Buddhist Painting*, trans. and adapted by Elizabeth ten Grotenhuis, vol. 4 (1977) of *Japanese Arts Library*, 179-81.

John M. Rosenfield and Elizabeth ten Grotenhuis, *Journey of the Three Jewels: Japanese Buddhist Painting from Western Collections* (exh. cat.; New York: Asia House Gallery, 1979), cat. nos. 47, 48 (Powers collection, private collection).

Tōru Shimbo, *Jigoku-e [Pictures of Hells]* (Tokyo: Mainichi Shimbun-sha, 1976), pls. 117, 118, 124, 125.

Yūzo Yamane, ed., *Sanjūsangendō to Rakuchū, Higashiyama no Koji [Sanjūsangendō and Other Ancient Temples in Rakuchū (central Kyoto) and Higashiyama]*, vol. 25 (1981) of *Nihon Koji Bijutsu Zenshū*, pls. 74, 75 and p. 143.

18 *Chikushōdō [The Realm of Animals]*

Kamakura period. One of a set of fifteen hanging scrolls illustrating the *Ojō Yōshū*; ink and color on silk. H. 155.5 cm. W. 68 cm. Shōjuraigō-ji, Shiga Prefecture. National Treasure.

This painting shows us suffering in the world of beasts, not only the inherent misery of animal existence but the pain inflicted by humans. Emaciated, foundering horses and oxen pull plows and loads beyond their strength. A falcon brings down a pheasant and cormorants fish—not for their own food but for ours. Cocks are made to fight—for our diversion.

Even the mythical dragon, undisputed lord of the beasts, is undone, though not by men. In the lower portion of the painting the dragon is subjected to an unceasing hot, sandy wind, disrobed of his jewelled coat, and devoured by a fierce, hellish golden cock.

The scroll offers no prospect of surcease but at least a suggestion of retributive justice: as an archer takes aim at a boar, a devil looms behind him with a lance, ready to inflict the punishment that awaits those who compound the already miserable lot of dumb creatures. JU

Literature

Jōji Okazaki, *Pure Land Buddhist Painting*, trans. and adapted by Elizabeth ten Grotenhuis, vol. 4 (1977) of *Japanese Arts Library*, pl. 182 and p. 175.

Tōru Shimbo, *Rokudō-e [Pictures of Rokudo]* (Tokyo: Mainichi Shimbun-sha, 1977), color pl. 33 and p. 223.

19 *Jindō Fūjō Sō [The Realm of Humans]*

Kamakura period. One of a set of fifteen hanging scrolls illustrating the *Ojō Yōshū*; ink and color on silk. H. 155.5 cm. W. 68 cm. Shōjuraigō-ji, Shiga Prefecture. National Treasure.

In 985 the monk Genshin completed his *Ojō Yōshū [Essentials of Salvation]*. In it he distilled over 160 commentaries on Buddhist scripture in an attempt to clarify the meaning of suffering, the problems of reward and retribution, and the way to rebirth in the Western Paradise. Its tone was consolatory, its theme the hope of deliverance. Admired both in Japan and on the continent for its synthetic genius, pragmatism, and compelling descriptions of the horrors of hell and delights of paradise, this work was profoundly influential in the development of popular Buddhism and its iconography.

Two sections of the ten-part treatise vividly detail the intricate cosmology of the Six Worlds (*Rokudō*) of sentient beings. The fifteen scrolls that include this painting and [19] are later twelfth-century works directly inspired by Genshin's text. They were originally housed in Ryōsen-in, a temple in the Yokawa section of the Mt. Hiei complex (a diary of 1525 mentions fifteen scrolls, presumably these). In 1571 the conquering warlord Oda Nobunaga (1534– 82) laid waste Mt. Hiei, slaughtering the Tendai monks who had allied themselves with his enemies. The scrolls survived, finding their way to Shōjuraigō-ji in the village of Sakamoto, at the eastern base of the venerable mountain, near Lake Biwa.

Painted versions of the Six Realms date from fairly early times in India, Central Asia, and China. The Shōjuraigō-ji examples reflect acquaintance with accomplished Sung and Yüan Chinese treatments of the subject. They combine vitality and attention to movement in the *e-maki* tradition with a fuller rendering of forms and modelling that is more typically Chinese.

Four of the scrolls address the human condition; the work seen here exemplifies the inevitable corruption of the flesh in a woman's corpse lying exposed to the elements. Read from top to bottom, the painting depicts the nine stages of decay (see [14]). At the top the amenities are still in evidence: the dead woman lies on a mat wrapped in silk, a teacup on a lacquer tray at her head and blossoms drifting down from the cherry tree that curves protectively over her. By the middle of the scroll the season has turned to autumn,

her wrappings are all askew, and putrefaction has set in. Farther down, the dogs and crows have set to work, leaving, at the very bottom, a heap of tumbled bones. JU

Literature

Yasushi Inoue, *Shōjūraigō-ji*, vol. 1 (1980) of *Koji Junrei: Omi*, color pl. 40 and pp. 119-21.
Tōru Shimbo, *Rokudō-e* [*Pictures of Rokudō*] (Tokyo: Mainichi Shimbun-sha, 1977), color pl. 23 and p. 222.

20 *Senmen Kosha Kyō*
 [*Transcription of a sutra on a folding fan*]

Fujiwara period, 12th century. Fan painting mounted as a hanging scroll; ink and color on paper. H. 25 cm. W. 49.4 cm. Saikyō-ji, Shiga Prefecture. Important Cultural Property.

The *Lotus Sutra*, perhaps the single most important religious text introduced into Japan from China, is typically composed of twenty-eight chapters divided into eight rolls. It was particularly venerated during the Nara and Heian periods, when laymen as well as priests often donated copies of the sutra to temples and Shintō shrines as a means of gaining spiritual merit. The most celebrated of such donations are the thirty-three sutra rolls commissioned by the Heike family in 1164 for Itsukushima Shrine. Twenty-eight of the rolls contain a chapter each of the *Lotus Sutra* plus a decorative frontispiece illustration.

Another format for the sutra is this fan shape, on which is inscribed a fragment of text from the first chapter. Originally this leaf was bound with other fan-shaped fragments in book form. Underlying the text is a picture of two courtiers seated on either side of a pedestalled lacquer stand. The higher-ranking figure, holding a gold fan, sits near the corner of an inner courtyard. Architectural elements, matting, and the raised blinds were woodblock-printed on specially colored paper. This design was then augmented and strengthened with brush and ink, after which color was applied. The Saikyō-ji example is unusual in depicting two male aristocrats; most extant fragments show women, either commoners or ladies of status. None of the scenes bear any obvious relationship to the text inscribed over them. This fragment dates somewhat earlier than the Heike family scroll and is the work of anonymous court artists. MC

Literature

Shirō Kunimitsu, *Saikyō-ji*, vol. 5 (1980) of *Koji Junrei: Omi*, color pl. 47 and p. 135.
Nara National Museum, *Hokke-kyō no Bijutsu* [*Arts of the Lotus Sutra*] (exh. cat.; Nara National Museum, 1979), cat. 13.

21 *Niga Byakudō* [*The White Path to the Western Paradise across Two Rivers*]

Kamakura period, ca. 1300. Hanging scroll; ink, color, silver, and cut gold leaf on silk. H. 123.5 cm. W. 50.7 cm. Cleveland Museum of Art 55.44. Gift of the Norweb Foundation.

The red fiery river of anger, the blue watery river of greed, and the strait white path between them to salvation form a rectangular band that divides the composition horizontally. Above is enthroned Amida, principal deity of the Western Paradise, flanked by the bodhisattvas Kannon and Seishi and surrounded by pavilions and lotus ponds. Below is the fleeting world, by turns alluring and horrible: two courtiers in an elegant house make music on flute and *biwa*, a trainer gentles a handsome horse, while nearby a monk meditates among bodies decomposing in a graveyard (see [14,19]). All this is set within a carefully observed seasonal landscape. Above, a monk flees for his life from predatory animals, monsters, and armed bandits. On the earthly shore stands the golden figure of Sakyamuni, encouraging him to attempt the terrifyingly narrow path to salvation, and just beyond we see the monk again, now crossing the path. Just as the monk appears twice, to illustrate two points in the narrative (see *iji dōzu*, p. 57), so does the Amida trinity: their figures, shown much smaller than on the thrones above, wait to welcome the monk on the celestial side of the river. The painting serves as a visual parable for believers in Pure Land Buddhism.

Stylistically and compositionally this painting may be compared favorably with the late thirteenth-century example in the Kōmyō-ji, Kyoto. As has been remarked elsewhere, however the artist seems conspicuously more interested and skilled in representing the secular than the sacred world. The convincing figures in the lower half of the composition have been vigorously and incisively drawn; by contrast, the Amida and bodhisattvas seem a bit bland and inert. This suggests that the painter is more likely to have been a secular professional (*eshi*), experienced at narrative handscroll painting, than a member of a Buddhist temple workshop (*e-busshi*). MC

Literature

Sherman E. Lee, Michael R. Cunningham, and Ursula Korneitchouk, *One Thousand Years of Japanese Art (650-1650) from The Cleveland Museum of Art* (exh. cat.; New York: Japan House Gallery, 1981), cat. 14.

John M. Rosenfield and Elizabeth ten Grotenhuis, *Journey of the Three Jewels: Japanese Buddhist Painting from Western Collections* (exh. cat.; New York: Asia House Gallery, 1979), cat. 37.

Koji Yamamoto, *Jōdokyō Kaiga* [*The Painting of Pure Land Buddhism*] (exh. cat.; Kyoto National Museum, 1975), pl. 42 (color) and p. 252 (*Niga Byakudō* in Kōmyō-ji, Kyoto).

22 *Wooden Cylinder for Tantric Ritual*

Late Heian period, ca. 1150–75. Cedar wood with ink drawings and inscriptions. H. 23.5 cm. Diam. 5.28 cm. Kimiko and John Powers, New York.

A believer in Esoteric Buddhism might have employed this twelfth-century wooden tube, embellished with drawings of deities and Sanskrit writing, to obtain a specific wish. The ceremony, known in Japan by the ninth century, involved putting a written petition inside the cylinder and setting it before the most germane deity. A group of monks then offered incantations, to the accompaniment of ringing bells, burning incense, and a special fire.

This cylinder contains a slip of paper bearing a Kōzan-ji seal (see [23]) and stating that the cylinder was made at the request of Fujiwara Yasuie (d. 1210), who in 1175 petitioned for increased good fortune. Although this paper was written in 1205 at the Mt. Kōya temple complex, the scholars Yanagisawa Taka and John Rosenfield have convincingly shown the ink drawings to be contemporary with the original ceremony. Yanagisawa identifies the sixteen deities of protection and good fortune arranged about the surface of the cylinder and speculates that Myōe Shōnin (see [55]) may at one time have owned it.

The tube has been crafted from a single piece of fragrant cedar coated with reddish brown pigment. Its end lids are carved in low relief to resemble the Buddhist Wheel of the Law. MC

Literature

John M. Rosenfield and Shūjirō Shimada, *Traditions of Japanese Art: Selections from the Kimiko and John Powers Collection* (exh. cat., Cambridge, Mass.: Fogg Art Museum, Harvard University, 1970), cat. no. 21.

23 *Chōjū Jinbutsu Giga*
 [*Caricatures of Animals and People*]

Kamakura period, 13th century. Roll 4 of the four-roll handscroll; ink on paper. H. 31.2 cm. L. 1,130.5 cm. Kōzan-ji, Kyoto. National Treasure.

Hōryū-ji and Tōshōdai-ji bear witness to the artisans' penchant for producing playful, satirical, or scatological graffiti on inconspicuous corners of plaster and woodwork. The *Chōjū Jinbutsu Giga* is the first extant Japanese example of caricature and satire organized into scrollpainting form.

The four rolls that comprise the canonical set were produced separately, the first and second dating from about the last quarter of the twelfth century and the third and fourth from perhaps a century later.

In the first roll, surely the best known of the set, anthropomorphized frogs, hares, and monkeys engage in raucous tableaux of human activity—sports, bathing, and religious observance. The second presents domestic, wild, and mythical beasts in no particular narrative relationship. The third and fourth rolls show considerable thematic dependence on the earlier ones, with the third offering essentially realistic scenes of humans at leisure as well as a somewhat miniaturized and adapted version of the animal frolic found in the first roll.

The fourth roll, exhibited here, brings the theme to an ebullient climax. Satire and wild caricature no longer require animals as their vehicle but fasten directly on humans, who are shown in situations ranging from the humorous to the ridiculous.

The earlier rolls have long borne a traditional but dubious attribution to the monk-painter Kakuyū (1053–1140), also known as Toba Sōjō, or the Toba bishop, for his close association with the emperor Toba. Certain literary sources mention Kakuyū's skill at satirical painting, but we have no extant examples. We do know that Kakuyū and an assistant, Jōchi, collected, classified, and produced a vast quantity of Esoteric iconography. The first two rolls were owned by Kōzan-ji (as attested by the multiple red seals) by the mid-thirteenth century, and the third and fourth were probably painted there. Their authorship and meaning remain open questions, but it seems reasonable to assume that these wry works were the divertissements of artists usually engaged in the monochrome line painting of Esoteric Buddhist subjects. JU

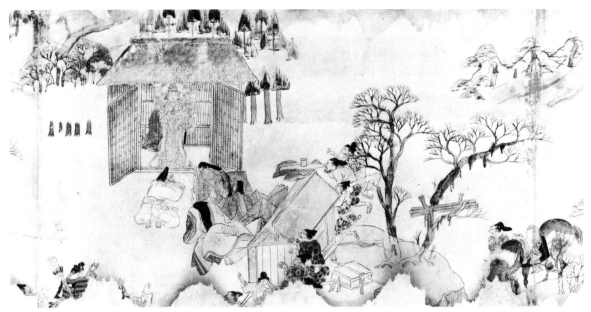

24c (section).

Literature

E-maki [Illustrated Handscrolls] (exh. cat.; Tokyo
 National Museum, 1975), cat. 81 (rolls 1-4), pp.
 158-59, bottom (roll 4).
Hideo Okudaira, Narrative Picture Scrolls, trans.
 and adapted by Elizabeth ten Grotenhuis, vol. 5
 (1973) of Arts of Japan, pls. 24-25, 56 (roll 1), and p.
 99.
Yoshinobu Tokugawa et al., Chōjū Jinbutsu Giga
 [Caricatures of Animals and People], vol. 6 (1977) of
 Nihon E-maki Taisei, repr. pp. 100-108.

24 *Kokawa-dera Engi* [*Legends of Kokawa Temple*]

Kamakura period, late 12th century. Hand-
scroll; ink and light color on paper. H. 30.6 cm.
L. 1,959 cm. Kokawa-dera, Wakayama Prefec-
ture. National Treasure.

Dated with reasonable certainty to the last quarter of
the twelfth century, the Kokawa-dera scroll, along
with the slightly earlier *Shigisan Engi E-maki*, signals a
shift in thematic interest in narrative scroll painting.
The elegantly posed tales of courtly romance are
gradually supplanted by more animated accounts of
temple foundings and miraculous manifestations,
and reflect broader political and social currents, in-
cluding the rise of Amidist Buddhism.

In the first story of this single scroll a hunter
stalking game notices a brightness in the forest. On
the numinous site he constructs a small hut, vowing
to place a Buddhist icon within it. A young boy
appears and carves a fabulous statue of the Senju
(Thousand-Armed) Kannon. The second story illus-
trates the tale of a merchant's ailing daughter. She is
cured by the visitation of a mysterious young boy
from Kokawa who accepts only a red garment and
small knife in remuneration. During a subsequent
visit to the forest her family comes upon the small hut
and discovers garment and knife in the hands of
Senju Kannon [25c]. Awed by the full implications of
the daughter's cure, the entire family requests ton-
sure and entry into monastic life. The two stories
form the legendary origin of Kokawa-dera.

Kokawa Temple was founded in the latter half of
the eight century on the Kii Peninsula near Mt. Kōya
in present-day Wakayama Prefecture. By the early
eleventh century Sei Shōnagon's *Pillow Book* [*Makura
no Sōshi*] notes the prominence of Kokawa-dera and
Ishiyama-dera (see [29]) among the thirty-three tem-
ples in central Japan dedicated to the compassionate
bodhisattva Kannon. A cycle of pious pilgrimage to
each location ensured salvation.

During the Middle Ages the Kii Peninsula wit-
nessed elaborate court pilgrimages, both to the
Kannon temples and to the Kumano shrines. The

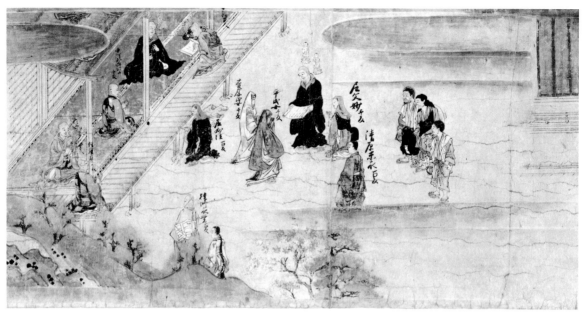

25a (section).

cloistered emperor Go-Shirakawa [61] seems a likely, though unproven, patron for this scroll. Its calligraphy has been inconclusively compared to the style of Jakuren (1139?–1202), a court poet who took Buddhist vows in 1172.

The fire damage to the handscroll probably occurred in 1585, when the warlord Toyotomi Hideyoshi defeated the militant Ikkō (Single-minded) Buddhist sectarians and burned their religious foundation, Negoro-dera, of which Kokawa-dera was a close neighbor. Written histories predating the scroll have allowed for an accurate reconstruction of the narrative. JU

Literature

E-maki [*Illustrated Handscrolls*] (exh. cat.; Tokyo
 National Museum, 1975), cat. 88.
Yoshinobu Tokugawa et al., *Kokawa-dera Engi*
 [*Legends of Kokawa Temple*], vol. 5 (1977) of *Nihon
 E-maki Taisei*.

25 *Yūzū Nembutsu Engi* [*Efficacy of Repeated
Invocations to the Amida Buddha*]

Kamakura period, 14th century. One of a pair
of handscrolls; ink, color, and gold on paper.
H. 30.5 cm. L. 1,018 cm. Art Institute of
Chicago. Kate S. Buckingham Collection.

Japanese Buddhism of the Heian period was a
melange of Esoteric doctrine and complex ritual, at
once a vehicle of political intrigue and an expression
of the studied world-weariness of an aristocracy in
decline. The monk Ryōnin (1073–1132) stands early in
a series of charismatic figures (see [52]) who broke
free from the stagnation of the religious establishment to propagate a popular salvationist Buddhism.

It was Ryōnin's genius to make the Tendai concept
of *yūzū*, the basic interrelatedness of all things, into
an instrument of social redemption by joining it with
the idea of a compassionate Amida. If "one act is all
acts," Ryōnin reasoned, then one person's invocation
of the name of Amida Buddha (*nembutsu*) could
benefit all people. Believers were enrolled in registry
books, and each pledged a number of *nembutsu*, thus
guaranteeing a continuing flow of transforming
petition.

The Chicago and Cleveland rolls constitute a set,
the former depicting Ryōnin's biography and the
latter his miraculous posthumous involvement in the
growth and good fortunes of the *Yūzū Nembutsu* sect.

The Chicago roll contains five long sections of illustration separated by explanatory texts. A thoroughly professional production, it employs varyingly muted, subtle washes and luxuriant color highlighted with gold detail. Shown first as a brilliant young Tendai monk discerning the need to leave the corruptions of Mt. Hiei, Ryōnin is subsequently seen in his hermitage at Ohara, northeast of Kyoto. After twenty-four years of prayerful seclusion there, he receives a vision of Amida, who affirms the correctness of his doctrinal insights and urges aggressive propagation of the *yūzū nembutsu*. Remaining scenes recount Ryōnin's conscription of creation (animal, heavenly, and human) into the *yūzū nembutsu* process. Deities, emperor and court, clergy, and common folk are won over to the teaching and enter their names in the all-important tally book [25a].

Ryōnin's skill in enlisting Shintō divinities reflects Buddhism's deliberate, systematic assimilation, during the Kamakura period, of native gods into the continental pantheon. Interestingly, during an almost century-and-a-half period in which it was leaderless, the *Yūzū Nembutsu* sect went so far as to place its registry books under the protection of the Shintō Hachiman Shrine at Iwashimizu, south of Kyoto. JU

Literature

Terukazu Akiyama, *E-makimono* [*Illustrated Handscrolls*], vol. 2 (1980) of *Zaigai Nihon no Shihō*, color pl. 81.

John M. Rosenfield and Elizabeth ten Grotenhuis, *Journey of the Three Jewels: Japanese Buddhist Painting from Western Collections* (exh. cat.; New York: Asia House Gallery, 1979), cat. 39.

Jack Sewell, "*Yūzū Nembutsu Engi Emaki*—Illustrated Scrolls of the History of Yuzu Nembutsu," *Bulletin of the Art Institute of Chicago*, LII, no. 2 (April 1959), 128-34.

26 *Yūzū Nembutsu Engi* [*Efficacy of Repeated Invocations to the Amida Buddha*]

Kamakura period, 14th century. One of a pair of handscrolls; ink, color, and gold on paper. H. 89.7 cm. L. 1232.4 cm. Cleveland Museum of Art 56.87. Mr. and Mrs. William H. Marlatt Fund, John L. Severance Fund, and Edward L. Whittemore Fund.

Subdued coloring and the evidence of several artistic hands are among the prominent features distinguishing the Cleveland roll from the one in Chicago. Ryōnin's death, the second scene in a series of fourteen within ten illustrated sections alternating with text, effectively initiates the movement of the Cleveland roll. The bodhisattvas Kannon and Seishi, Amida's principal attendants, lead an array of deities on descending clouds [26a]. Golden rays emanate from the unseen figure of Amida as the assemblage greets Ryōnin and escorts him to the Western Paradise. The stiff, reserved formalism that characterizes much religious painting of this and subsequent decades is nowhere apparent. Rounded, smiling celestial creatures mingle matter-of-factly with earthbound beings. This makes an interesting contrast with the somewhat earlier *Ippen* scroll [28], which deals with equally miraculous matters but shows no divinities.

Ryōnin's demise and transfiguration is followed by vignettes suggesting the universal efficacy of the *nembutsu* formula. The cloistered emperor Toba (1103–56), a court lady, and a provincial governor's daughter perform *nembutsu* to win entry into the Western Paradise. A cowherd's wife, near death from complications of childbirth, recovers through enrollment in the *nembutsu* program; we observe a monk diligently entering the sick woman's name in the registry. The cure transpires in full view of curious neighbors, passersby, and villagers engaged at the community well [26]. The everyday setting renders the miracle charmingly prosaic. The disastrous epidemic of the Shōka era (1257–58) serves as background for the tale of a squire who repelled the plague demons by enrolling his household in the *nembutsu* prayer schedule. A dream sequence has the squire confidently presenting his registry to a throng of monsters who inspect and countersign it, thus guaranteeing his family's safety. The confrontation with death is negotiated in the manner of a shrewd business transaction [26b].

Five abbots after Ryōnin administered the sect until 1182, when the incumbent died without indicating a successor. The ensuing confusion precipitated a period of decline, reversed in 1321 when Hōmyō (1279–1349), claiming divine inspiration, assumed control of the beleaguered group. A 1314 date and unreliable attributions to Abbot Kōshu and Tosa Mitsunobu are appended to this roll. It seems likely that the scroll, based on a 1314 version no longer extant, was painted during the sect's renewal in the period of Hōmyō's ascendance. JU

Literature

Terukazu Akiyama, *E-makimono* [*Illustrated Handscrolls*], vol. 2 (1980) of *Zaigai Nihon no Shihō*, color pls. 82-84.

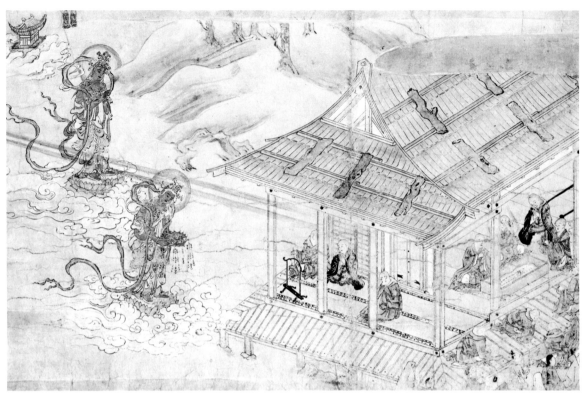

26 (sections).

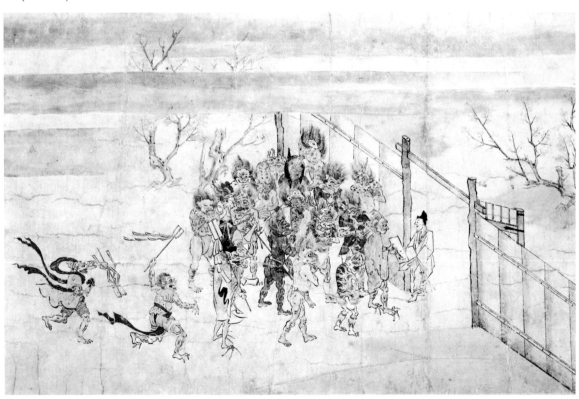

E-maki (exh. cat.; Tokyo National Museum, 1975),
 cat. 97, p. 179 (two sections).
John M. Rosenfield and Elizabeth ten Grotenhuis,
 *Journey of the Three Jewels: Japanese Buddhist Painting
 from Western Collections* (exh. cat.; New York, Asia
 House Gallery, 1979), cat. 40.

27 *Saigyō Monogatari E-kotoba*
[*Illustrated Biography of the Monk Saigyō*]

Kamakura period, 13th century. Handscroll;
ink and light color on paper. H. 30.3 cm. L.
1,178 cm. Manno Hiroaki, Osaka. Important
Cultural Property.

Less than two decades after his death the poet-monk
Saigyō (1118–90) was enshrined in the Japanese liter-
ary pantheon by the inclusion of over ninety of his
poems in the imperially commissioned anthology of
Heian and early Kamakura verse, the *Shinkokinshū*
[*New Anthology of Ancient and Modern Poems*] (1205).
His forte was the use of nature metaphors to achieve
emotive resonance. From his dual commitment to
poetic excellence and to radical purification attained
through the wandering mendicant life he forged a
profoundly influential aesthetic, most notably emu-
lated by the haiku master Matsuo Bashō (1644–94).

The earliest known visual biography of Saigyō
survives in two rolls of a painted handscroll with
accompanying text. These, produced in the second
half of the thirteenth century, are assumed to have
been part of an original four- or five-roll set.

The first roll, in the Tokugawa Art Museum,
Nagoya, depicts the young warrior-aristocrat Satō
Norikiyo disconsolate at the unexpected death of a
friend, an event that precipitates spiritual awakening
and rejection of family and worldly office in favor of
the eremitic life. Meagre biographic details of the
monk's early life are expanded and dramatized to
conform with the stages of Enlightenment tradi-
tionally ascribed to Gautama Buddha.

The Manno scroll, exhibited here, shows Norikiyo,
now tonsured and bearing the monastic name
Saigyō, progressively withdrawing from the allure-
ments of secular life, even from the more compatible
company of like-minded ascetics, and moving toward
increasingly solitary communion with nature.

The naive charm and cheerful sweetness of the
painting are tempered by blocks of text that include
selections from Saigyō's verse. Poems of loneliness
and melancholy add complementary depth and am-
biguity to the more lighthearted illustrations.

The historical Saigyō's considerable poetic talent
gave him access to major contemporary figures in
literature, politics, and religion. Awareness of his
continuing secular contacts and his erotic poetry
provides an intriguing balance to the more didactic
accounts of his spiritual ascent. JU

Literature

William R. LaFleur, "Saigyō the Priest and His Poetry
 of Reclusion: A Buddhist Valorization of Nature in
 Twelfth-Century Japan" (Ph.D. dissertation, Uni-
 versity of Chicago, 1973; microfilm, University of
 Chicago Library).
Yoshinobu Tokugawa et al., *Saigyō Monogatari
 E-maki* [*Illustrated Biography of the Monk Saigyō*], vol.
 26 (1979) of *Nihon E-maki Taisei*, repr. pp. 2-59
 (color).

28 *Ippen Shōnin E-den*
[*Illustrated Biography of the Monk Ippen*]

En-i (act. late 13th century). Dated to 1299. Roll
6 of the twelve-roll handscroll; ink and color on
silk. H. 38.2 cm. L. 979.5 cm. Kangikō-ji,
Kyoto. National Treasure.

The narrative-scroll biography of the charismatic
mendicant Ippen (1239–89), completed in 1299 on the
tenth anniversary of the monk's death, is one of the
finest extant products of the *e-maki* tradition. The
twelve-roll set shows the hands of at least three
painters and four calligraphers working under the
general direction of participant-artist En-i. The *Ippen*
scroll is the only known work bearing his signature.

Ippen's disciple Shōkai composed the text of the
scroll and was clearly instrumental in the conception
of this record of his master's achievements. Painted
on silk (among extant narrative scroll paintings only
the *Kasuga Gongen Reigen Ki* enjoys a similar distinc-
tion), both quality of material and artistry suggest
wealthy benefaction. An intriguing theory proposes
the Kujō branch of the Fujiwara family as patron and
perhaps aesthetic guide for the project. Aristocratic
support for a memorial to a wandering ecstatic is
witness to Ippen's undifferentiated social and re-
ligious message. It may reflect, as well, the attempt of
an ascendant courtly faction to align itself with Ip-
pen's reportedly huge following, which by the mid-
fourteenth century would have become the most
broadly popular and powerful of the Pure Land
Buddhist sects, the Ji (Timely) sect.

Born to wealth, Ippen entered religious life at the
age of nine. He trained in the Pure Land tradition
until his father's death in 1263, then returned to lay
life and the management of family affairs. But bicker-
ing over an inheritance reaffirmed in 1271 his

commitment to austerities, pilgrimage, and the priestly life.

The *odori nembutsu*, a dance involving rhythmic and repetitive invocation of the name of Amida Buddha, became a dominant feature of his devotional practices. In keeping with the tendency of the time and in conscious emulation of his spiritual forebear Kūya (903–72) (see [50]) Ippen fostered the amalgamation of Buddhism with indigenous religious sensibility.

The narrative begins with Ippen's 1251 journey to Kyūshū, followed in succeeding rolls by accounts of journeys to Kii Province, including visits to Kumano and Nachi Waterfall and to the famous Shingon complex at Mt. Kōya; west again to Kyūshū; then east to Shinano Province (present-day Nagano Prefecture) and to Kamakura; west again through Ise and Yamato, including a pause at ancient Taima-dera; next to western Hyōgo and Okayama prefectures; on to Itsukushima Shrine, then a journey toward the central regions and finally to the Kannon-dō Temple in Hyōgo, where he died on 23 August 1289.

The sixth roll depicts Ippen's journey in 1282 from Katase, near Kamakura, west to Kyoto. The scenes are egalitarian in proportion and in subject matter. Poor commoners, finely clad courtiers, and monks at their prayers mingle in a reliable and comprehensive visual description of the Kamakura era. The final section of the sixth roll is appended out of order and would more properly be located at the beginning of the scroll. JU

Literature

Yoshinobu Tokugawa et al., *Ippen Shōnin E-den* [*Illustrated Biography of the Monk Ippen*], vol. 27 (1978) of *Nihon E-maki Taisei*, repr. pp. 143-71 (color).

29 *Ishiyama-dera Engi E-maki* [*Legends of Ishiyama Temple*]

Attrib. Takashina Takakane (act. 1309–30). Roll 1 of the seven-roll handscroll; ink and light color on paper. H. 33.3 cm. L. 1,524 cm. Ishiyama-dera, Shiga Prefecture. Important Cultural Property.

Planned and perhaps executed between the years 1324 and 1326, this narrative scroll documents the origin and subsequent history of Ishiyama Temple, located south of Lake Biwa, a major medieval center of Kannon worship (see [25]).

The monk Rōben (689–773), while supervising the construction of Tōdai-ji in Yamato in 752, was com-

missioned by Emperor Shōmu (701–56) to search for gold to gild the statue of the Great Buddha, projected centerpiece of the new temple. Through a series of mysterious visions and encounters related in the first roll, Rōben learns that a temporary enshrinement of the emperor's personal Kannon statue at the Ishiyama site would be efficacious in the search for the precious metal. Shortly thereafter gold is indeed discovered to the north in Mutsu Province. When Rōben attempts to return the statue to the emperor, it remains miraculously immovable, further confirming Kannon's intervention. The statue becomes the numinous center around which Ishiyama Temple is constructed. Also included in the first roll are scenes of the temple's construction, of various celebrations, and of imperial visitation.

Rōben, the first abbot of Tōdai-ji, was favored by the emperor, and his name is associated with major projects of the period. Political unrest interpreted through augury encouraged the emperor to shift the location of the capital several times. Rōben's involvement with one such ill-fated venture at Shigaraki lends some credence to the suggestion that materials from that abandoned site were used in the construction of Ishiyama-dera.

Modern scholarship is in general agreement with the traditional attribution of the first three rolls to Takashina Takakane, head of the Imperial Painting Bureau (*E-dokoro*) during at least the two decades from 1309 to 1330. These rolls bear strong resemblance to Takakane's *Kasuga Gongen Reigen Ki E-maki*. Minute caricature, confident use of graded color, skilled observation and depiction of animals, as well as variety and animation in the composition of large group scenes all strengthen the Takakane attribution.

The fourth and fifth rolls were executed by the Muromachi painters Tosa Mitsunobu and Awadaguchi Takamitsu respectively, while the sixth and seventh rolls are the work of the Edo master Tani Bunchō (see [120,132,133]). JU

Literature

Nobuo Itō, ed., *Ishiyama-dera to Omi no Koji* [*Ishiyama-dera and Other Ancient Temples in Omi District*], vol. 11 (1981) of *Nihon Koji Bijutsu Zenshū*, color pl. 14, fig. 8, and p. 126.

Yoshinobu Tokugawa et al., *Ishiyama-dera Engi* [*Illustrated Legends of Ishiyama Temple*], vol. 18 (1978) of *Nihon E-maki Taisei*, repr. pp. 2-15 (color).

30 *Scene of the Voyage to Tsukushi*

Kamakura period, late 13th century. Detached section of the handscroll *Kitano Tenjin Engi* [*Illustrated Legends of Kitano Tenjin Shrine*], mounted as a hanging scroll; ink and color on paper with mica. H. 30.5 cm. W. 52.7 cm. Seattle Art Museum. Eugene Fuller Memorial Collection.

The high official Sugawara Michizane (see [31]), disgraced through machinations of political enemies, is posted to Kyūshū—in effect, exiled and demoted. This scene of his departure for Tsukushi is generally regarded as a fragment of the so-called Kōan version of the *Kitano Tenjin Engi E-maki*. An inscription from the first year of the Kōan era (1278) gives the scroll its name and a fairly precise dating. Three rolls of what was likely a six-roll work have been accounted for, mostly in the possession of Kitano Shrine. Other segments belong to the Tokyo National Museum and the Daitōkyū Memorial Library.

Comparison with the Jōkyū version (1219) in the possession of the Kitano Shrine is instructive. In this earlier work, use of color is flamboyant. As the ship puts to sea, fantastic bug-eyed monsters loom among curling, stylized waves. Their threatening presence serves to communicate the anxiety of the moment. The Kōan version, restrained and subtle in composition, conveys Michizane's internal dread and despair. Within a rectangular enclosure in the center of the boat a small group of courtiers huddle, while two women gaze dejectedly. These figures are surrounded by the purposeful activity of oarsmen and the precisely rendered detail of the craft. A dog, oblivious to the human emotions, scrounges in the bow. Delicate treatment of waves and the smooth roll of wash assist in framing the central drama.

The fragment reveals damage caused by repeated rolling and remounting. But with the exception of retouching to the figure of the dog, the color and drawing are intact. JU

Literature

Terukazu Akiyama, *E-makimono* [*Illustrated Handscrolls*], vol. 2 (1980) of *Zaigai Nihon no Shihō*, color pl. 70.
Henry Trubner, William J. Rathbun, and Catherine A. Kaputa, *Asiatic Art in the Seattle Art Museum: A Selection and Catalogue* (Seattle: Seattle Art Museum, 1973), cat. 193.

31 *Kitano Tenjin Engi* [*Illustrated Legends of Kitano Tenjin Shrine*]

Kamakura period, ca. 1300. Rolls 2 and 5 of the five-roll handscroll; ink and color on paper. Roll 2: H. 30.2 cm. L. 763.9 cm. Roll 5: H. 30.2 cm. L. 894.5 cm. Metropolitan Museum of Art. Fletcher Fund, 1925.

Legend has embellished the precocity of Sugawara Michizane (845–903), but surely he displayed early and unique promise as a scholar. In 872 his skill at composing Chinese poetry drew the praise of ambassadors from the T'ang court. Michizane advanced through a series of academic and governmental posts and was serving as governor of Sanuki Province (Shikoku) when Emperor Uda recalled him to the capital in 891. This was a maneuver to combat the Fujiwara clan's monopoly of political power. Michizane was appointed chief of the Bureau of Archivists (*Kurōdo Dokoro*), a powerful and prestigious office that managed the court calendar, issued imperial decrees, and had intimate access to the throne. In 894, on being asked to head an official mission to T'ang China, Michizane argued that the current political instability in China did not bode well for such a journey. So persuasive was he that the mission was cancelled, and although certain commercial and private intercourse continued, official relations with the continent were not resumed until the firm establishment of the Sung dynasty (960–1279).

But Fujiwara aspirations were not to be denied. Fujiwara Motosune's son Tokihira (871–909) kept pace with Michizane's rise. He gained favor with the boy-emperor Daigo and received the office of *dainagon* (great councillor), while Michizane held the lesser post of *gon no dainagon*. Still jealous of Michizane's influence, Tokihira convinced the credulous Daigo that Michizane was plotting to depose him. Michizane was banished to a post in Kyūshū, where he languished and died in 903.

His death was followed by a series of calamities. Torrential rains caused floods and lightning sparked fires that terrorized the capital. The *shishinden* (great audience hall) of the imperial palace was struck by lightning. Important personages died in alarming succession. This train of misfortunes was soon interpreted as Michizane's posthumous vengeance, and throughout the tenth century every significant disaster brought a fresh round of posthumous honors to appease the dead scholar's wrath. In 947, after a series of earthquakes, his spirit was enshrined and deified at the Kitano Shrine in the northwest of Kyoto.

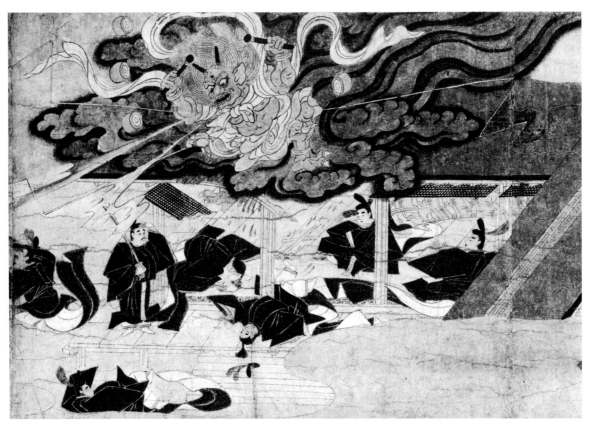

31c (section).

Michizane's history, the founding of Kitano, and the miraculous interventions associated with the shrine form the narrative content of the *Kitano Tenjin Engi* scrolls. Although texts survive from the late twelfth century, the first known illustrated account is the Jōkyū era (1219) version. From the Kamakura through the Edo periods over thirty editions, now extant in varying degrees of completeness, were produced. In 1925 the Metropolitan Museum of Art acquired three rolls depicting the tale. These have been reordered into a set of five rolls, based on the extensive research of Murase Miyeko. The second and fifth rolls are exhibited here.

The second roll records certain events directly following Michizane's death and the havoc wreaked by his irate spirit. Observed in sequence: a friend receives an anthology of the recently deceased Michizane's poems and grieves; the ox pulling the carriage bearing Michizane's body halts suddenly, indicating burial at Anraku-ji; a monk of Mt. Hiei, visited in dreams by the angry Michizane, hastens to apprise the court of the scholar's wrath, and the swollen waters of the Kamo River part to facilitate his

journey; lightning blasts the imperial palace; snakes emerge from the ears of an afflicted noble and demand revenge on Michizane's detractors; Emperor Komatsu accepts tonsure in a useless effort to pacify the angry spirit.

In the fifth roll two children, a girl of Kyoto and a boy in Omi Province (present-day Shiga Prefecture), become vehicles transmitting Michizane's wish for a shrine at Kitano; reconstruction of the burned palace is frustrated when termites attack the building lumber, chewing out a pattern of script that can be read as a poem expressing Michizane's displeasure; a young woman attending the imperial consort is suspected of stealing her mistress's clothing but vindicated after seven days of prayer at the Kitano Shrine; a monk accused of dalliance with the empress implores the spirit of Michizane, is exonerated, and receives from the emperor the gift of a horse; a monk passing the Kitano Shrine in a carriage is spilled by his ox and thereupon embarks on a life of walking pilgrimage. Michizane continues to be revered as the patron of scholars and the falsely accused. JU

232

Literature

Miyeko Murase, "Metropolitan-bon Tenjin Engi E-maki" ["The *Tenjin Engi E-maki* in the Metropolitan Museum of Art, New York"], with English summary, *Bijutsu Kenkyū*, no. 247 (July 1966), 28-31; no. 248 (September 1966), 28-42.

John M. Rosenfield and Elizabeth ten Grotenhuis, *Journey of the Three Jewels: Japanese Buddhist Paintings from Western Collections* (exh. cat.; New York: Asia House Gallery, 1979), cat. 46.

32 Battle Scene

Kamakura period, second half of 13th century. Detached section of the handscroll *Heiji Monogatari* [*History of the Heiji Insurrection*], mounted as a hanging scroll; ink and color on paper. H. 35.5 cm. W. 43.8 cm. Seattle Art Museum. Eugene Fuller Memorial Collection.

The Heiji Insurrection (1159–60) (see [33]) initiated an era of increasingly large-scale armed conflict, pitting Taira against Minamoto warriors, that would finally result in the dominance of the military class and the establishment of the Kamakura *bakufu* ("tent government," i.e., military government).

This segment of a scroll, acquired by the Seattle Art Museum in 1948, has been traditionally referred to as a fragment of the *Heiji Monogatari E-maki*, but attempts to establish its relationship with more complete extant versions of the tale have been unconvincing. Recently Akiyama has suggested a close stylistic affinity between the Seattle scroll and another, unnamed, fragment in Japan that seems to depict a typical Heiji scene of military encampment at the imperial palace. Both fragments may be part of an as-yet-unaccounted-for version of the war tale.

Fourteen armed warriors, five mounted, sprint across a stark, untreated background. Intense concentration shows in the eyes of both combatants and steeds. The descending arc of bows and *naginata* (halberds) emphasizes the direction of attack. The tautly executed scene evokes a sense of impending clash.

Some of the painting's mineral-based pigment has been lost. Close examination suggests a rich and elegant original coloring, including gold paint. Carefully modulated and sure brushwork attests to a high quality of artistry. JU

Literature

Terukazu Akiyama, *E-makimono* [*Illustrated Handscrolls*], vol. 2 (1980) of *Zaigai Nihon no Shihō*, color pl. 10.

Penelope E. Mason, *A Reconstruction of the Hōgen-Heiji Monogatari Emaki* (New York and London: Garland, 1977).

33 *Heiji Monogatari E-maki: Tokiwa Maki* [*Illustrated Handscroll of Lady Tokiwa and Her Sons*]

Kamakura period, mid-13th century. Handscroll; ink and light color on paper. H. 33.1 cm. L. 1,584 cm. Setsu Iwao, Tokyo.

By the eleventh century real power in Japan was beginning to slip from the capital to the great rural manors, from the court and the civilian Fujiwara regents to the Minamoto and Taira clan warriors. First in ascendancy were the Minamoto, invaluable to the capital in waging successful military campaigns in northern Honshū and against unruly Taira captains in the east (see [32]). In the 1156 Hōgen Insurrection, sparked by contention for the throne, alliances were complex and both candidates were able to rally support from each of the major clans. Go-Shirakawa [61] emerged victorious but keenly aware of the structural impotence of imperial office and of the sheer strength of the military clans. He soon abdicated, foisting on his successors the burdensome ceremonial role while freeing himself for political maneuver as an *insei*, or cloistered emperor. In an attempt to balance Minamoto aspirations Go-Shirakawa enlisted the aid of Kiyomori (1118–81), who had succeeded to leadership of the Taira clan in 1153. Rivalry escalated, and in the Heiji Insurrection (1159–60) Kiyomori routed a Fujiwara-Minamoto alliance and Minamoto no Yoshitomo (1123–60) was killed.

Accounts of these conflicts inspired literature, ballads, and narrative painting. In the *Tokiwa* scroll five sections of text and eight distinct illustrated scenes relate three incidents that occurred at the close of the Heiji conflict. With Yoshitomo dead, his concubine, Lady Tokiwa, flees south to Yamato with his three sons. The first scene shows Tokiwa abandoning her hiding place and preparing to return to the capital to plead with Kiyomori for her mother's life [33a]. The babe in her arms is Ushiwaka, later known as Yoshitsune (1159–89). Subsequent scenes depict Tokiwa petitioning the imperial consort, encountering her mother, and meeting Kiyomori, who in largesse inspired by her beauty spares his rival's family.

The second incident concerns discord between the cloistered emperor Go-Shirakawa and retainers of the reigning monarch. Go-Shirakawa delights in observing the thoroughfare in front of his Hachijō-Horikawa residence from the privacy of a pavilion. In the first sequence workmen dispatched by the imperial household arrive unexpectedly and proceed to board up the view from the pavilion. The enraged Go-Shirakawa, suspecting court ministers Korekata and Tsunemune, summons Kiyomori and instructs him to punish the culprits. Scenes of battle at the imperial palace and delivery of the captives to the offended Go-Shirakawa follow [33b].

A final section of text and illustration relates the capture of Yoritomo (1147–99), son of the slain Yoshitomo. Through the intercession of Kiyomori's stepmother, the nun Ike no Zenni, the youth is spared execution and exiled to Izu. Prior to his departure Yoritomo, destined to defeat the Taira and become the first shōgun, bids farewell to the nun who saved his life.

A connoisseur's note was appended by Karasumaru Mitsuhiro (1579–1638) in 1632. He attributes the painting to the Tosa school and calligraphy to the priest Hōshu (1308–91). Both painting and calligraphy have since been convincingly related to works of the mid-thirteenth century, casting doubt on the Hōshu attribution. JU

Literature

Tōru Shimbo, "Heiji Monogatari-e (Tokiwa Maki) ni tsuite" ["Newly Found Version of the Illustrated Tales of the Heiji War (Tokiwa scrolls)"], with English summary, *Bijutsu Kenkyū*, no. 307 (September 1978), 1–16.

Yoshinobu Tokugawa et al., *Heiji Monogatari E-kotoba* [*Illustrated Tales of the Heiji War*], vol. 13 (1977) of *Nihon E-maki Taisei*.

34 *Zen Kunen Kassen E-maki*
 [*Illustrated History of Zen Kunen Civil War*]

Kamakura period, 14th century. Handscroll; ink and light color on paper. H. 30.6 cm. L. 380.8 cm. Tokyo National Museum.

From the mid-seventh century the central government initiated serious attempts to extend its control to the northern stretches of the Japanese archipelago. In 658, at the request of Empress Saimei (r. 655–61), Abe no Hirafu mounted a large-scale campaign against the Ezo (Emishi) people who populated that area. Centuries of attrition and assimilation finally effected the imperial policy but also greatly increased the strength of the Abe clan, whose warriors came to operate in semiautonomous fashion, generally ignoring the direction and tax levies from the south. In the eleventh century the Kyoto court turned to the military expertise of the Minamoto clan (see [33]) to reestablish order in Mutsu Province (present-day Aomori Prefecture). Minamoto no Yoriyoshi (995–1082) and his son Yoshiie (1041–1108) emerged victorious from this protracted and bloody struggle (1055–63), referred to as the Earlier Nine Years' War. Their success secured prominence for the family and signaled a rise which would culminate in the establishment of the Kamakura shogunate.

A branch of the Fujiwara family from the Iwate area in eastern Mutsu Province assisted the Minamoto in this and other expeditions. Proud of their contributions, later generations of these northern Fujiwara commissioned Kyoto artists to produce a visual record of the exploits.

A scroll and a fragment from a thirteenth-century version are held by the Ministry of Culture and the Gotō Art Museum, respectively. A single roll from the fourteenth century is exhibited here. This version, without text, seems to depict the initiation of hostilities. The names of characters are inscribed within the illustrations. Typical developments of fourteenth-century narrative painting are evident in this work: figures are rendered in a tight or shrunken manner. The dynamic qualities found in earlier examples of the genre are now somewhat formalized.

The war-scroll genre was based primarily on diaries and memoirs. It catered to the tastes of the warrior class and its popularity paralleled the years of Kamakura rule. Always eager to curry favor with the military, Go-Shirakawa [61] is known to have commissioned such a scroll in 1171. The scroll recounting the Mongol invasions, produced in the last decade of the thirteenth century, marks the terminus of the more vigorous works of this kind. JU

Literature

E-maki [Illustrated Handscrolls] (exh. cat.; Tokyo National Museum, 1975), cat. 29.

Tsugio Miya, *Kassen-e [Paintings of War]*, no. 146 (July 1978) of *Nihon no Bijutsu*, especially 19–33: Zen Kunen Kassen E-maki" ["Illustrated History of Zen Kunen Civil War"].

35 *Fukutomi Zōshi [Story of Fukutomi]*

Nambokuchō period, 14th century. Roll 2 of the two-roll handscroll; ink and color on paper. H. 35.3 cm. L. 1,028.8 cm. Cleveland Museum of Art 53.358. John L. Severance Fund.

This animated handscroll tells the humorous story of Fukutomi, a poor man who envies his neighbor's financial success at entertaining noblemen with his ability to break wind tunefully. Tricked by this neighbor into believing himself capable of the same feat simply by eating morning-glory seeds, Fukutomi, oblivious to the laxative quality of the seeds, obtains an audience with the local nobleman and proceeds to create an embarrassing mess. He is beaten and thrown out and becomes the object of derision of his fellow townsfolk, his wife, and even the local dogs. The scroll abounds in local residents who encounter Fukutomi repeatedly throughout its length and mock his predicament. Dialogue is incorporated into the illustrations, placed next to the person speaking. These people and their surroundings set the scene for a kind of fairy tale gone awry.

Numerous versions of the *Fukutomi Zōshi* exist, some in one roll, others in two, like the set from the Shunpō-in at Myōshin-ji, Kyoto. This is executed on thin paper in a hand somwhat more deliberate than the Cleveland example and is usually dated to the fifteenth century. In both the Shunpō-in and Cleveland scrolls several scenes and bits of dialogue within scenes are misplaced. Evidently both versions were produced by a professional painter unaware of the discrepancies as he copied from an earlier model of the popular tale.

The Cleveland roll is virtually identical with the second roll of the Shunpō-in set but exhibits a more facile figurative treatment and can be dated slightly earlier. Both paintings are workshop products of the *e-maki* tradition known as *otogi zōshi* (picture scrolls of popular tales), executed by anonymous masters. This Nambokuchō–Muromachi era tradition favored popular rather than religious imagery and enjoyed the patronage of aristocratic, military, and plebeian society alike. At one time this handscroll belonged to Reizei Tamechika (1823–64), the well-known painter of traditional *yamato-e* themes. MC

Literature

Terukazu Akiyama, *E-makimono [Illustrated Hand-scrolls]*, vol. 2 (1980) of *Zaigai Nihon no Shihō*, color pls. 12, 13.

E-maki (exh. cat.; Tokyo National Museum, 1975), cat. 41.

Sherman E. Lee, Michael R. Cunningham, and Ursula Korneitchouk, *One Thousand Years of Japanese Art (650-1650) from The Cleveland Museum of Art* (exh. cat.; New York: Japan House Gallery, 1981), cat. 24.

36 *Shōtoku Taishi E-den*
[Illustrated Biography of Prince Shōtoku]

Kamakura period. Two of a set of three hanging scrolls; ink and color on silk. H. 165.1 cm. W. 61.2 cm. Tokyo National Museum.

During the middle of the sixth century, the balance of power among the small kingdoms of the Korean peninsula was threatened. Paekche in the southwest was pressured by the expansionist policies of Silla in the east and the growing strength of Koguryo to the north. Paekche rulers sought alliance with and aid from Japan. Gifts to the Japanese court accompanying an appeal from Paekche in 552 included a bronze Buddha statue, copies of sutras, and a message enthusiastically endorsing the new faith that had come from India via China.

In central Japan the powerful Mononobe and Soga clans were vying to be the power behind the throne, and their opposite attitudes toward Buddhism offered a focal point in the conflict. The Mononobe were deeply suspicious of all foreign influence, while the Soga, allied by marriage to the throne, pragmatically viewed the new faith as a useful potential vehicle of continental civilization, including political centralization. The politics of assassination placed a Soga granddaughter, Empress Suikō (554–628), on the throne in 592. Her nephew, Prince Shōtoku (574–622), son of Emperor Yōmei (r. 586–87), was appointed regent and effective administrator of the realm.

Prince Shōtoku was by all accounts a brilliant and innovative leader. As a young man he was tutored in Buddhist and Confucian thought. As regent he cautiously avoided military entanglement in Korea, turning his energies to domestic policy. Buddhism was declared the religion of state, and major temples, including Hōryū-ji and Shitennō-ji, were constructed. The scholarship and art generated by the new faith stimulated a period of cultural growth. Government was reorganized on the Confucianist model of a centrally administered bureaucracy serving a hereditary prince.

The cult of Prince Shōtoku, which began not many decades after his death, flourished in the thirteenth and fourteenth centuries. Its popularity attested the continuing search for national definition and for a founding figure within historical memory. Amidist sects revered Prince Shōtoku as a savior figure and

manifestation of the bodhisattva Kannon. The chronic instability of Japanese society in the medieval period caused him to be invoked as a patron of good government as well.

Representations of the prince, both painted and sculpted, are numerous. Many of the rapidly multiplying Buddhist sects sought legitimacy by claiming direct descent from Prince Shōtoku. The *kōshiki*, a type of lecture on the Buddhist scriptures, developed in Japan after the tenth century. One variation of this exposition was a discourse on Prince Shōtoku, usually delivered in the presence of his pictorial biography or sculpted image. The pictorial biographies tend to derive from the great screen paintings made for Hōryū-ji in the early ninth century and to present highly mythologized scenes along with his major historical accomplishments. Certain events in the life of Gautama Buddha figure as archetypes in Prince Shōtoku's biography.

Exhibited here are two of a set of three hanging scrolls recording the events of the prince's life in neatly divided horizontal registers. Precision and formalism are apparent in the composition and rendering of figures. The rambling, adventurous sweep of the Hōryū-ji panels has been codified into units more convenient for the rapid production of religious icons. JU

Literature

Terukazu Akiyama, *Heian Jidai Sezokuga no Kenkyū* [*Secular Painting of the Heian Period*] (Tokyo: Yoshikawa Kobunkan, 1965), pp. 169-203.

Minoru Mushakōji, "Shōtoku Taishi Den to Kaiga" ["Traditions and Paintings Concerning Prince Shōtoku"], *Kokka*, no. 831 (June 1961), 239-42; no. 833 (August 1961), 379-82; no. 834 (September 1961), 423-26.

John M. Rosenfield, "The Sedgwick Statue of the Infant Shōtoku Taishi," *Archives of Asian Art*, XXII (1968-69), 56-79.

37 *Seigan-ji Engi* [*Legends of Seigan Temple*]

Kamakura period. Two of a set of three hanging scrolls; ink and color on silk. H. 238.5 cm. W. 148.5 cm. Seigan-ji, Kyoto. Important Cultural Property.

Seigan-ji, traditionally dated from the mid-seventh century when its focal Amida Buddha statue was imperially commissioned, originated in Nara as a Sanron sect temple. Along with the government and some major religious foundations, Seigan-ji moved to

Kyoto in the late eighth century. There it prospered in relationships with the influential and powerful and eventually adopted the Pure Land tradition. Seigan-ji was damaged several times by fire, most severely in the Onin civil war (1467–77), and was reconstructed during the final decade of the sixteenth century under the special patronage of one of Hideyoshi's consorts.

The two scrolls displayed here reveal the elegant coloring and attention to detail characteristic of Tosa school painters of the late Kamakura period. A third scroll, attributed to Kaihō Yūshō (1533–1615), is a product of the late sixteenth or early seventeenth century. From the temple's rich history the artist has shrewdly illustrated engaging tales of miraculous conversion, titillating scandals, and glamorous construction projects. The disjointed scenes and absence of accompanying text suggest that the scrolls were used as visual aids by lecturers to the congregation.

Malachite mountains and uncolored sections of silk divide the eight incidents recorded on the two scrolls. The guided viewing proceeded from top to bottom of the first scroll and from bottom to top of the second. Notable scenes depict events leading to the carving of the Amida Buddha statue, as well as the conversions and cloisterings of Sei Shōnagon, author of the Heian classic *The Pillow Book*, and Izumi Shikibu (b. ca. 976), a poet ensconced in the popular imagination for her numerous romantic entanglements. Precise architectural sequences employ a refined version of the *fukinuki yatai* ("roofless" convention) to reveal the intricacies of Buddhist memorial liturgy and the fervent worship of a noble who eventually underwrites one of the temple's reconstructions. We see also a thief, miraculously spared execution, who becomes an artisan-monk devoted to enhancing the temple's beauty. JU

Literature

"Den Tosa Yukimitsu Hitsu, Kaiho Yūshō Hohitsu, Seigan-ji Engi E-maki" ["The *Illustrated Legends of Seigan Temple* Attributed to Tosa Yukimitsu and Supplemented by Kaihoku Yūshō"], *Kokka*, no. 160 (September 1903), 59-60, pls. 3-5.

Yūzō Yamane, ed., *Sanjūsangen-dō to Rakuchū, Higashiyama no Koji* [Sanjūsangen-dō and Other Ancient Temples in Rakuchū (central Kyoto) and Higashiyama], vol. 25 (1981) of *Nihon Koji Bijutsu Zenshū*, pl. 73 (color) and p. 144

38 *Portraits of Priests*

Heian period. Datable to 1163. Handscroll; ink on paper. H. 28 cm. L. 663 cm. Ninna-ji, Kyoto. Important Cultural Property.

From the continent to Japan, borne by travelling priests, came religious texts, images, paintings, related liturgical equipment, and also iconographical albums and handscrolls depicting Buddhist deities and the patriarchs. These modest-sized paintings were not icons in their own right but served as manuals to acquaint the Japanese clergy with the themes and styles of recent religious developments abroad. The major Heian and Kamakura era monastic institutions owned numbers of such imported drawings, as well as similar aids produced at home, which served numerous functions. Principal among these was their use as texts for the study of Buddhist history and liturgy at member temples in the outlying provinces. These sketches also served as models for the large finished portraits required at periodic formal ceremonies observed throughout the Buddhist community.

This sketch-scroll depicts thirty-six patriarchs of Indian, Chinese, and Japanese origin seated in prayer or meditation. All are identified by name and many by short biographical notes, some of which include pronunciation aids. The scroll is unusual in being datable and by a known artist: made in 1163 by a monk named Kansuke from the Ishiyama-dera near Otsu in Shiga Prefecture. This information is gleaned from another portrait-scroll now in the Daitōkyū Memorial Library in Tokyo but originally part of the Ninna-ji composition. The artist has attempted to capture solely in ink line, without color or washes, those essential physiognomic characteristics that identify each sitter. These traits were time-honored and, as might be expected, sometimes stereotyped or misplaced. One portrait in the Daitōkyū scroll bears a notation stating that it was unidentified in the scroll from which it was copied—evidence that this Ninna-ji segment also represents an effort some generations removed from the original. MC

Literature

Bunsaku Kurata, *Nihon no Bukkyō o Kizuita Hitobito: Sono Shōzo to Sho[Special Exhibition of Japanese Buddhist Portraiture: Portraits and Calligraphy]* (exh. cat.; Nara National Museum, 1981), cat. 94.

Takashi Hamada, ed., *Zuzō [Buddhist Iconographical Drawings]*, no. 55 (December 1970) of *Nihon no Bijutsu*, pl. 114.

39 *Portrait of Priest Sōō*

Kamakura period, 13th century. Hanging scroll; ink and color on silk. H. 116 cm. W. 80.5 cm. Enryaku-ji, Shiga Prefecture. Important Cultural Property.

Sōō Kashō, a native of Shiga Prefecture just east of Kyoto, studied with Ennin (794–864), the Tendai monk whose travels in China and India are recorded in an extraordinary diary that has fortunately survived. Sōō apparently met Ennin at Enryaku-ji on Mt. Hiei, the important temple that enjoyed particularly close ties with the court. He is said to have gained a reputation as a healer, but is known more substantively as Tendai Buddhism's main advocate of Shugendō (mountain-dwelling or -climbing) austerities.

Sōō sits on a raised lacquer dais of Chinese design, holding prayer beads in both hands. Beside him a lacquer stand supports two *vajra* (thunderbolts), implements used in Esoteric rituals. His straw sandals are placed in front of the dais and the corner of a black lacquered box is visible just to the right of the stand. Of special note is a three-panel undecorated screen serving as a backdrop. This portrait composition represents an orthodox approach to the subject, as does the unnaturalistic, stylized drawing of the garment patterns.

A mid-twelfth-century handscroll by a monk from Ishiyama-dera (see [29]) contains patriarch sketches, including one of Sōō. Of comparable quality and antiquity are portraits of Ryōe Shōnin in a Tokyo private collection and of Shinsai Sōjō in the Jingo-ji. MC

Literature

Tendai no Hihō Ten [Exhibition of Treasures of the Tendai Sect] (exh. cat.; Tokyo: Odakyū Dept. Store, 1969), cat. 40.

Bunsaku Kurata, *Nihon no Bukkyō o Kizuita Hitobito: Sono Shōzo to Sho [Special Exhibition of Japanese Buddhist Portraiture: Portraits and Calligraphy]* (exh. cat.; Nara National Museum, 1981), cat. 88.

40 *Mokkenren, One of Sakyamuni's Ten Disciples*

Kaikei (act. ca. 1189–23). Wood with color. H. 97.2 cm. Daihōon-ji, Kyoto. Important Cultural Property.

Among the earliest groups of Buddhist deities known to have been represented in sculpture are the ten disciples [*Jūdai Deshi*] of the historical Buddha,

Sakyamuni. The earliest remaining set, datable to 734, is the compelling group of six dry-lacquer figures once installed with a Shaka image in the western image hall (kondō) of Kōfuku-ji, Nara. Important later assemblages of the ten disciples are at Seiryō-ji, Kyoto (twelfth century); Gyokuraku-ji, Kamakura (thirteenth century); and Daihōon-ji, from which this figure of Mokkenren comes.

A short inscription painted on one foot peg identifies it as the work of "Hōgen Kaikei," a master sculptor of the Nara "Kei" school who was active in the restoration of many temple images during the years 1185–1220. For his efforts Kaikei received the honorary Buddhist rank of hōgen in 1208. The simple dais on which Mokkenren stands bears a carved inscription naming the donor, Fujiwara no Tadayuki, who held court rank from 1216 to 1219. Since sutra texts dated to 1220 were found in the body cavities of other disciples in the group, this Daihōon-ji ensemble represents one of Kaikei's late accomplishments and his last major commission.

Like the other imaginary portraits in this group, Mokkenren is composed of several pieces of wood which have been separately carved, joined, and painted. Crystal eyes were inserted from the back (gyokugan), as is typical in this joined wood (yosegi) technique. At one time the colors of the Indian style robe were rich and the cut gold leaf (kirikane) textile designs gleamed, much like those seen in Sung period lohan paintings. These, as well as imported Sung sculptures, surely influenced Kaikei, a deeply religious artist and an intimate friend of Chōgen [51], who favored incorporating contemporary Chinese style in architecture and painting as well as sculpture. The treatment of Mokkenren combines realism and ideal depiction, a trait characteristic of Kaikei's latest efforts. Both in general outline and in detailed garment configurations Mokkenren may be compared instructively with Kaikei's 1221 Amida at the Kōrin-ji, Nara. Not all of the Daihōon-ji disciples attain this measure of refinement, reflecting instead the considerable participation of Kaikei's studio assistants. MC

Literature

Yūzō Yamane, ed., *Sanjūsangen-dō to Rakuchū, Higashiyama no Koji* [*Sanjūsangen-dō and Other Ancient Temples in Rakuchū (central Kyoto) and Higashiyama*], vol. 25 (1981) of *Nihon Koji Bijutsu Zenshū*, pl. 60 (color) and p. 139.

Bunsaku Kurata, *Nihon no Bukkyō o Kizuita Hitobito: Sono Shōzo to Sho* [*Special Exhibition of Japanese Buddhist Portraiture: Portraits and Calligraphy*] (exh. cat.; Nara National Museum, 1981), cat. 5-7.

41 *Priest Keika, One of Eight Patriarchs of the Shingon Sect*

Jōshin, Kamakura period. Dated to 1327.
Wood with color. H. 87.2 cm. W. 61.4 cm.
Kongōchō-ji, Kōchi Prefecture, Shikoku.
Important Cultural Property.

The patriarchs of the Shingon sect of Esoteric Buddhism commonly include the eight high priests of Indian, Chinese, and Japanese origin who were most influential in the formulation and transmission of the sect's scriptures. Their importance in Shingon history developed out of that sect's emphasis upon direct master-pupil instruction rather than textual exegesis.

The Shingon sect placed considerable importance upon symbolic language, ritual, and iconography to convey its liturgy, the most familiar vehicles being the mandala and memorial portraits of the eight partriarchs.

The prototype for this carved relief panel, one of a set of eight, is believed to be the renowned Tō-ji paintings from which succeeding generations of sets derived. Although single paintings or sets of paintings are known in Japan, these carved panels represent a distinctive departure from the patriarch portrait tradition. The panels are installed on the interior walls of the temple pagoda, and the back of each panel bears an inscription. This states that the reliefs were executed in 1327, well after Shingon's eclipse, at the request of the temple's abbot, Ryūen. The sculptor is also cited: Daibusshi Hōgen Jōshin, who is known to have assisted in the carving of the Shaka Nyorai image at the Kamakura temple Shōmyō-ji in 1308. Keika is better known by his Chinese name, Hui-k'o. His pupil Kūkai, who brought Shingon beliefs to Japan, is the sect's most revered patriarch. MC

Literature

Takeshi Kobayashi, *Shōzō Chōkoku [Portrait Sculpture]* (Tokyo: Yoshikawa Kobunkan, 1969), 156-58.

Shikoku, pt. 2: *Ehime, Kōchi [prefectures]* (1975) in *Kokuhō Jūyō Bunkazai Bukkyō Bijutsu*, no. 42, repr. p. 106; pp. 200-203.

42 Gushōjin, Attendant in the Court of Hell

Kamakura period. Wood. H. 122.4 cm. Hōshaku-ji, Kyoto. Important Cultural Property.

The cult of the Ten Kings of Hell (see [17]) conceived an iconography, both painted and sculpted, based on the procedures and dramatis personae of Chinese law courts. Judges, scribes, and advisers considered the fate of forlorn souls who stood as plaintiffs in the ten courts. Gushōjin, exhibited here, is one of the four attendants comprising the court of Emma O at Hōshaku-ji in southwest Kyoto.

Popular religiosity of the medieval period entertained the notion that individual human acts, both commendable and erring, were recorded in precise detail by Gushōjin. His account was read in evidence while the deceased awaited judgement. Attired in boots, pantaloons, and high-collared smock, the figure sits with right leg tucked up on an animal skin. His hands are poised to hold a scroll that is sometimes displayed with the statue. Intense inset crystal eyes scan the record of virtue and vice, while his mouth is open in the act of reading. The face is broad-nosed and fleshy, and the hat with starched horizontal flaps is a copy of those worn by Sung Chinese officials.

The hollow joined-block technique (yosegi) by which this sculpture was made was widely employed in Japan from the middle of the eleventh century. This method of sculpting individual sections of the work from small pieces of wood and then assembling them permits great fluidity, expressiveness, and sense of movement, as well as economy of material and production efficiency. The transparent crystal lenses, which are held in place by small wooden blocks and pegs, have pupils painted on the unexposed sides and are backed with white paper. The effect is startling.

Relatively conservative treatment of garment folds and economy of incision combine with technical innovation to produce a fiercely animated yet unflappable bureaucrat of hell. He is usually paired with Ankoku Dōji, a figure of similar execution, who, with brush and plank, acts as court scribe. JU

Literature

Nishikawa Kyōtarō and Emily J. Sano, *The Great Age of Japanese Buddhist Sculpture* (exh. cat.; Fort Worth: Kimbell Art Museum, and New York: Japan House Gallery, 1982), cat. 26 (Ankoku Dōji from Hoshaku-ji).

43 Raijin [Thunder God]

Kamakura period, 14th century. Wood with traces of gesso and red and black pigment. H. 67.3 cm. Cleveland Museum of Art 72.64. Purchase from the J. H. Wade Fund.

The Wind (Fūjin) and Thunder (Raijin) gods appear in early Buddhist illustrated sutras and wall paintings in China and Japan, having been appropriated from popular imagery fundamentally Indian in origin. Their earliest representation in Japanese art occurs in the mid-eighth-century *Sutra of Cause and Effect* [*Kako Genzai-e Inga Kyō*], an illustrated handscroll with explanatory text relating the life of the historical Buddha, Sakyamuni. A section of the fifth roll in the Hōo-in subtemple of Daigō-ji depicts a phalanx of demon-monsters flying through the sky above the meditating Sakyamuni, trying to frighten away his concentration. Among them is Fūjin, dressed in a loincloth and holding aloft a red scarf that whips about him. Raijin, on the other side of a mountain, is moving toward Sakyamuni. He too is depicted as a muscular, seminaked demon with exaggerated features, his mouth agape, eyes bulging, hair streaming straight back. Surrounding him is a ring of small drums, each rotating on its own axis from being struck by the stick in Raijin's left hand. Thus his dash through the skies is accompanied by a thunderous commotion, an effect confirmed by other early versions of the *Inga Kyō*, in which scudding clouds generated by Raijin's charge precede him. If anything, these versions heighten his animalistic appearance, making him something akin to the horse-headed demons in the *Jigoku Zōshi* fragment [16].

The Nara revival in the very Late Heian and Kamakura periods, and especially the renewal of interest in illustrated scrolls of the *Inga Kyō*, prompted new renditions of Fūjin and Raijin in *e-maki* and in sculpture. In the thirteenth-century *Kitano Tenjin Engi* [31c] Raijin appears as an over-muscled red demon with two horns and flowing scarf amid ominous black clouds and lightning—a composite of Fūjin and Raijin. The finest sculptural image of Raijin in Japan is found at the Myōhō-in in Kyoto. It portrays the Thunder God as a terrifying animal-like figure wearing a scarf around his neck and short, flaring leggings. His pose is energetic, and he is framed by the essential iconographical feature—an arc of small rotating drums suspended from a metal ring.

A metal clasp protruding from the back of the Cleveland Museum's *Raijin* indicates that it too once possessed the ring of drums. Though drums and arms are now missing, the figure shares the general characteristics of thirteenth-century Raijin images.

Raijin became one of that small group of imported deities whose visual idiosyncracies and histories made them a focus of Shintō, Buddhist, and plebeian interest, assuring their survival and transformation into compelling religious images. This Cleveland Museum example is not as refined as the Myōhō-in sculpture, a National Treasure, but nevertheless admirably displays the talent of a major sculptural studio in Kyoto or Nara. The matching Fūjin is in the Matsunaga Collection of the Fukuoka Art Museum.

MC

Literature

Matsunaga Kinenkan Zuroku: Fukuoka-shi Bijutsukan Jōsetsu Tenji [*Catalogue of the Matsunaga Memorial Museum: Permanent Exhibition at the Fukuoka Municipal Museum*] (Fukuoka Municipal Museum, 1979), cat. 71 (Fūjin).

Yuzo Yamane, ed., *Sanjūsangen-dō to Rakuchū, Higashiyama no Koji* [*Sanjūsangen-dō and Other Ancient Temples in Rakuchū (central Kyoto) and Higashiyama*], vol. 25 (1981) of *Nihon Koji Bijutsu Zenshū*, pls. 2, 5, and p. 177.

44, 45 *Uma and Hitsuji, Two of the Jūni Shinshō* [*Twelve Heavenly Generals*]

Kamakura period. Wood with color. Uma: H. 117 cm. Hitsuji: H. 96.4 cm. Murō-ji, Nara. Important Cultural Property.

Buddhism of the sixth century AD, in its multiplicity of cults and sectarian subdivisions, reflected nearly a millennium of development on the Asian continent. Attributes of the Buddha were personified into a complex pantheon of deities, offering believers more particularized and intimate access to the transcendant. Yakushi Nyorai (the Healing Buddha) held particular appeal and in early Japanese Buddhism was given a devotional prominence previously unknown on the continent. In his so-called twelve vows, or promises, Yakushi Nyorai specified his intent to help heal the physical and mental afflictions of humanity. The twelve figures traditionally surrounding the gentle-featured Yakushi Nyorai serve as guardians and reminders of vows. Early examples are found carved in relief on the pedestal of the Yakushi Nyorai statue (ca. 692) at Yakushi-ji in Nara. Twelve demons squat beneath arches and peer menacingly at the viewer. Wiry-haired, fanged, and round-bellied, the figures recall their prototypical forms in India.

In vivid contrast are the guardians exhibited here. They are two from a phalanx of twelve protectors, fully armed and known as generals, arrayed before the five central devotional figures placed in the *kondō* (golden hall) of Murō-ji in Nara Prefecture. Their names, transliterated from Sanskrit to Japanese, are Indara and Haira. From the eleventh century, however, these figures and their ten companions were understood as corresponding to the twelve animals of the zodiac and thus became popularly known as Uma (Horse) and Hitsuji (Sheep). Small carved animals affixed to the helmets or coiffures assist in identification. Thus a small horse head on the Uma makes naming consistent with iconography. However, Ushi (Ox) is another frequently encountered appellation for this statue.In ideally consistent iconography Uma wields a sword and Hitsuji a bow and arrow. Here, however, certain liberties have been taken, and Hitsuji grasps a lance.

Works in the military or guardian genre occasionally lapse into heavy and inarticulate rendering of body extremities. But in the Murō-ji figures limbs are skillfully distinguished from the overlay of realistic-looking garment and armor. Chinese models, astute anatomical observation, and perhaps awareness of dance movements have informed and enhanced these works. The juxtaposition of personalities is instructive. The challenging, fiery-haired Uma is offset by the fetching study of Hitsuji as a bored sentry.

JU

Literature

Murō-ji no Bijutsu [*Art Treasures in Murō-ji*] (exh. cat.; Nara National Museum, 1975), cat. 11-1.

Kyōtarō Nishikawa and Emily J. Sano, *The Great Age of Japanese Buddhist Sculpture* (exh. cat.; Fort Worth: Kimbell Art Museum, and New York: Japan House Gallery, 1982), cat. 24 (two Heavenly Generals from Jōruri-ji in Tokyo National Museum).

46 *Portrait of Priest Sengan Naigu*

Kamakura period, 13th century. Wood with color. H. 69.1 cm. Atago-Nembutsu-ji, Kyoto. Important Cultural Property.

Trained in the Esoteric rites and beliefs of the Tendai sect, Sengan Naigu (d. 983) gradually turned to the Pure Land (Jōdo) teachings of Shan-tao (613–81), a Chinese patriarch whose explanations of Pure Land tenets, both written and visual, stirred great interest among early Japanese followers. Shan-tao's image has been portrayed in painting and sculpture. The most celebrated sculpture, from the Chion-in, Kyoto, depicts him standing, hands held together in prayer as he recites the *nembutsu*. His head is raised, and his open mouth shows teeth and tongue in the act of

speech. A contemporary image in the Raigō-ji, Nara, wholly dissimilar in style, nevertheless reveals these same basic gestures.

This is the only known portrait of Sengan Naigu, a native of the Kanagawa area whose translation and adaptation of difficult Esoteric ritual chants from Chinese into condensed Japanese prayers (*mida wasan*) became extremely popular. A friend of Kūya [49], he is also known affectionately as Nembutsu Shōnin, and as the man responsible for the revitalization of the Atago-Nembutsu-ji, once a Shingon establishment. In expression and appearance this sculpture, though seated, closely resembles the standing figure of Shan-tao in the Chion-in. The proportions of the high, domed head, the expansive forehead, and the prominently shaped mouth also appear in images of other Pure Land evangelists. Two sculptural images provide apt stylistic and morphological reference points: the well-known *Kūya* and *Priest* (Taira no Kiyomori) from the Rokuharamitsu-ji in Kyoto. These are stylistically distinct from the more "finished" Tōfuku-ji priest portraits and the Hossō sect patriarch portraits at Kōfuku-ji, Nara.

This image of Sengan Naigu may be dated to the latter part of the thirteenth century. Its worn surface has recently been restored, allowing the elaborate raised textile designs of the robing to be seen more clearly. These appear also in the Chion-in figure of Shan-tao, as do the light, crisp fold patterns of the drapery. MC

Literature

Tsutomu Kameda et al., *Men to Shōzō* [*Masks and Portraits*], vol. 23 (1971) of *Genshoku Nihon no Bijutsu*, pl. 32 and p. 48.

Hisashi Mōri, *Japanese Portrait Sculpture*, trans. and adapted by W. Chië Ishibashi, vol. 2 (1977) of *Japanese Arts Library*, pl. 61.

47 Heads of Niō [*Two Guardians*]: Ungyō and Agyō

Kamakura period, 13th century. Wood with traces of gesso. Ungyō: H. 75.6 cm. Agyō: H. 75 cm. Cleveland Museum of Art 70.4-.5. Andrew R. and Martha Holden Jennings Fund.

These large heads originally surmounted the muscular bodies of two guardians known collectively as *niō*. Derived from Hindu deities, they are members of a group of menacing guardian figures known as *kongō rikishi* (thunderbolt-wielding strong men). Their individual names are Ungyō and Agyō. Together these figures commonly flanked the main entrances—either the south or middle gates—of temples, where they symbolically warded off evil spirits.

Agyō, open-mouthed and snarling, symbolizes active intention and customarily stands on the west side of the gate. Scowling Ungyō, on the east side, denotes potential action. Together they personify the dual nature of conduct.

The heads are broad and rounded, in contrast with many later thirteenth-century representations. Each is carved from a single large block of wood that was roughly shaped and then split vertically into two pieces toward the back of the head. The interior was hollowed, the pieces rejoined, the detachable topknots positioned, and the fine carving completed before application of a white ground and polychromy, now mostly lost. The technique originated as early as the Heian period, but these heads are of later date, from the first half of the thirteenth century. They occupy an important historical and aesthetic position between the monumental *niō* of 1203 by Unkei and Kaikei at the main south gate of Tōdai-ji and the fine images from the Rengeo-in subtemple of the Myōhō-in, Kyoto, datable to about 1250 and ascribed to Tankei and his workshop. MC

Literature

Bunsaku Kurata, *Niō Zō* [*Niō Statues*], no. 151 (December 1978) of *Nihon no Bijutsu*.

48 En no Gyōja

Kamakura period. Wood. H. 74.9 cm. Cleveland Museum of Art 75.65. Purchase from the J. H. Wade Fund.

For the life and religious career of En no Gyōja we have no clear documentation. He is, however, considered to have been more than just a composite figure derived from Shintō and Buddhist legends. His name appears in the *Nihon Ryōiki* and the *Shoki Nihongi* (early collections of Buddhist tales). A reclusive man of the seventh century from the Nara area, En no Gyōja apparently shunned the great religious establishments there for a solitary, peripatetic life among the mountains to the south. Subsequent generations therefore came to regard him as an exemplar of the holy man living honorably in the secular world, an embodiment of the active and contemplative life commingled. Later, Kamakura era practitioners of similar religious austerities performed in the remote mountains of Japan claimed En no Gyōja as a kind of patriarch for their Shugendō sects.

Images of him were painted and sculpted, usually commissioned by provincial temples or by private believers in Shugendō. A small number of these

necessarily imaginary portraits survive, and these generally depict the patriarch delivering a lecture—an old bearded man, seated, wearing a hooded cape. He holds a small sutra scroll in one hand and a walking staff in the other and is accompanied by two small demon-like attendants.

The Cleveland Museum's sculpture departs from these basic iconographical features in showing En no Gyōja somewhat younger, clean-shaven, and more eccentric of feature. Stylistically it is closer to the work of an accomplished thirteenth-century sculptural studio of the Nara-Kyoto area than to more provincial examples such as the 1286 image by Keishun in the Yoshino area.

The dark, close-grained wood of the image was never painted. As Kuno Takeshi has pointed out, the *Nihon Ryōiki* states that wooden statues of *gyōja* (mountain ascetics, so called after En no Gyōja) were normally carved from large old trees that were considered sacred, and these images were left unadorned to retain the special character of the wood. MC

Literature

Bunsaku Kurata, *Chōkoku [Sculpture]*, vol. 8 (1980) of *Zaigai Nihon no Shihō*, color pl. 87 and p. 151.
———, *Nihon no Bukkyō o Kizuita Hitobito: Sono Shōzō to Sho [Special Exhibition of Japanese Buddhist Portraiture: Portraits and Calligraphy]* (exh. cat.; Nara National Museum, 1981), cat. 20.

49 *Portrait of Priest Kūya*

> Kamakura period, 13th century. Wood with color. H. 84 cm. Shōgon-ji, Shiga Prefecture. Important Cultural Property.

The rough and rather humble appearance of this figure belies the commonly held tradition that Kūya was born of highly aristocratic parentage. Supposedly the second son of Emperor Daigo (897–930), Japan's sixtieth sovereign, he chose a life devoted to pastoral religious work. As a young man he travelled extensively and alone through the provinces in order to strengthen his conviction. Following this, he studied Tendai doctrine at Enryaku-ji on Mt. Hiei, a temple which enjoyed a privileged relationship with the Kyoto court.

After leaving Enryaku-ji, Kūya became increasingly more absorbed in the tenets of Pure Land Buddhism as expressed in the teachings of the Chinese monk Shan-tao (613–81). Kūya's early experiences in the provinces apparently had convinced him of the need to communicate fundamental Buddhist principles to common people in a more

meaningful way than heretofore. Shan-tao had advocated the *nembutsu*—repetition of the simple phrase "Namu Amida Butsu" ("Homage to Amida Buddha") as a way of invoking Amida's blessing, and Kūya returned to the countryside to preach the *nembutsu*. He is also credited with being a kind of social worker, assisting with bridge and well building and caring for lepers and outcasts.

A small number of Kūya portrait-sculptures remain in Japan, all said to derive from the early thirteenth-century image by Kōshō in the Rokuharamitsu-ji, Kyoto. The Shōgon-ji image exhibited here differs dramatically from its supposed prototype in depicting the monk as a sturdy older man, somewhat bent and with large, craggy, features—hardly the appearance of a person of refined background and exalted ancestry. This determined, somewhat folkish image is traditionally dated to the very end of the Kamakura period. Of the four extant Kūya representations from this time, this is perhaps the most individualized by virtue of the artist's conscious effort to imbue a legendary figure with vivid, popularly recognizable attributes. MC

Literature

Bunsaku Kurata, *Nihon no Bukkyō o Kizuita Hitobito: Sono Shōzō to Sho [Special Exhibition of Japanese Buddhist Portraiture: Portraits and Calligraphy]* (exh. cat.; Nara National Museum, 1981), cat. 100.
Hisashi Mōri, *Japanese Portrait Sculpture*, trans. and adapted by W. Chië Ishibashi, vol. 2 (1977) of *Japanese Arts Library*.
Yūzo Yamane, ed., *Sanjūsangen-dō to Rakuchū, Higashiyama no Koji [Sanjūsangen-dō and Other Ancient Temples in Rakuchū (central Kyoto) and Higashiyama]*, vol. 25 (1981) of *Nihon Koji Bijutsu Zenshū*, pl. 26 (color) and p. 132 (Priest Kūya in Rokuharamitsu-ji).

50 *Shussan no Shaka [Sakyamuni Coming Down from the Mountain]*

> Muromachi period, 15th century. Wood with color. H. 96.3 cm. Nara National Museum.

Portraits of *Sakyamuni Coming Down from the Mountain* are extremely rare in Japanese Buddhist sculpture. This is due in part to the relatively late introduction of the subject into the repertoire of accepted Buddhist themes in East Asian art. It appears initially about the year 1200, among the records of Japanese monks returning from China, most notably Chōgen [51]. In China it enjoyed limited popularity among literati artists and Ch'an (Zen) Buddhist monk-painters. The theme gained quicker acceptance and wider dis-

semination in Japan, as attested by the Seattle Art Museum's hanging scroll [65] from Kōzan-ji, a Kegon sect temple, and by a number of other thirteenth- and fourteenth-century renderings still extant or recorded. Indeed, the subject came to be much sought after, first in ecclesiastical and then in emerging tea circles.

The story is a legendary one, relating Shaka's (Sakyamuni's) six-year retreat into the mountains to meditate and practice austerities as a means to Enlightenment. Realizing the futility of such extreme asceticism, he returns, reconciled to finding a more moderate path.

This sculpture of Shaka shows him returning, walking with the aid of a staff, his emaciated body exposed under a single elaborately folded robe. His head is rather large and broad, his face full despite the protruding cheekbones, which are a traditional mark of his ascetic experience. His introspective expression is seen also in paintings of the subject, by which this sculpture was surely inspired, but the paintings more often show him quietly meditating, with his hands concealed rather than holding a staff. Likewise unusual is the elegant treatment of his garment, not unlike that seen in orthodox Buddhist images. There are marked similarities here to figures by fourteenth-century Nara school sculptors such as Kōshun and Kankei. MC

Literature

Nara National Museum, *Muromachi Jidai Butsuzō Chōkoku, Zaimei Zakuhin ni Yoru* [*Buddhist Statues of the Muromachi Period, Based on Inscribed Objects*] (Tokyo: Gakugei Shorin, 1971).
Taizō Nonaka, *Tochigi Ken no Chōkoku* [*Sculpture of Tochigi Prefecture*] (Utsunomiya: Tochigi Ken Kyoiku Iinkai, 1977), 103-4.

51 *Portrait of Priest Chōgen (Shunjō Shōnin)*

Kamakura period, 13th century. Wood with color. H. 81.8 cm. Shindaibutsu-ji, Mie Prefecture. Important Cultural Property.

Among sculptural representations of Buddhist priests made during their lifetimes (*juzō*), the most renowned in Japan are the seated portraits of Ganjin (688–763) and Chōgen (1120–1206). Both images are in Nara, in Tōshōdai-ji and Tōdai-ji, respectively. Chōgen is remembered in Japanese history as the man appointed by Minamoto no Yoritomo to direct the restoration of the Tōdai-ji *daibutsu-den* (great Buddha hall) following its destruction during the late twelfth-century civil conflicts. In his travels throughout Japan to raise

funds and procure materials for the reconstruction Chōgen founded at least two temples, one of which is the Shindaibutsu-ji, established about 1202 in Mie Prefecture.

This lifelike portrait of Chōgen was placed in the founder's hall (*kaizandō*) at that temple. The custom of including a founder's hall in each temple precinct was relatively new in Kamakura Japan and undoubtedly related to practice in Sung China. Here Chōgen is shown younger than in any other surviving example, and his formidable physiognomy and character are trenchantly described, but the air of intense religious fervor that informs the Tōdai-ji image is lacking. MC

Literature

Bunsaku Kurata, *Nihon no Bukkyō o Kizuita Hitobito: Sono Shōzō to Sho* [*Special Exhibition of Japanese Buddhist Portraiture: Portraits and Calligraphy*] (exh. cat.; Nara National Museum, 1981), cat. 101, 102 (statues of Priest Chōgen, Amida-ji, Yamaguchi prefecture, and Jōdo-ji, Hyōgo prefecture).
Susumu Miyama, "Juzō to Chinsō Chōkoku" ["Life Portraits and Commemorative Portraits of Zen Masters"], *Museum*, no. 295 (October 1975), pl. 2.

52 *Portrait of Priest Ippen*

Kamakura period, 14th century. Hanging scroll; ink and color on silk. H. 57.1 cm. W. 24.2 cm. Shōjōkō-ji, Kanagawa Prefecture.

The fundamental tenet of Ippen's teachings in his later years was the efficacy of reciting the *nembutsu* during one's daily activities (see [28, 49]). He exemplified this practice while travelling and promoted it energetically in his writings, as is vividly described in the *Ippen Shōnin E-den* [28]. The prayer, which was chanted continuously, consists of six characters: *Na-mu-A-mi-da-Butsu* ("Homage to Amida Buddha").

The *Ippen Shōnin E-den* contains numerous scenes involving the writing of the invocation and its display as a hanging scroll. These include Ippen passing out slips of paper bearing the written prayer to fellow priests and laymen, and an episode at Kitano Shrine in Tokushima on Shikoku, where he inscribes a hanging scroll with a one-line dedication to the resident Shintō deity, beginning with the large characters *Na-mu*....

On the Shōjōkō-ji scroll exhibited here the *nembutsu* appears directly in front of Ippen under an elaborate canopy, written boldly in large script using gold pigment. Above Ippen a piece of colored paper with a floral underdesign is inscribed with an admo-

nition taken from an anthology of his writings. Both inscriptions indicate the singular importance of the *nembutsu* to Ji sect followers and its widespread identification with Ippen himself. The painting serves as a concentrated visual icon, identifying Ippen with the written prayer. It suggests both the actual incantation of the prayer by the figure and the equivalence of figure and *nembutsu* as efficacious religous devices. This equivalence is borne out by scenes in the *E-den* in which sounds, such as the barking of dogs, are actually indicated, one of the earliest attempts of its kind in Japanese painting.

The figure of Ippen in this painting corresponds to his portrayal as an older man in the *E-den* and in some sculptural likenesses. Also known affectionately as Yugyō Shōnin (the Wandering Priest), he is shown walking forward, praying, his skin darkened from exposure to the sun during his pilgrimages across the country. Under the coarsely woven robe and *kesa* (a sort of ecclesiastical vestment) a white underrobe is visible. His angular head and pronounced features are also characteristic of his appearance in the last chapters of the *E-den*, where he is shown just prior to his death. MC

Literature

Tsugio Miya, ed., *Hongan-ji to Chion-in* [*Hongan-ji and Chion-in*], vol. 21 (1982) of *Nihon Koji Bijutsu Zenshū*, p. 107, figs. 54, 55 (Fujita Museum).
Bunsaku Kurata, *Nihon no Bukkyō o Kizuita Hitobito: Sono Shōzō to Sho* [*Special Exhibition of Japanese Buddhist Portraiture: Portraits and Calligraphy*] (exh. cat.; Nara National Museum, 1981), cat. 131.
Michitoshi Ochi, *Ippen: Yūgyō no Ato o Tazunete* [*Priest Ippen: Tracing His Preaching Route*] (Matsuyama: Ehime Bunka Sōsho Kankokai, 1978).

53 *Portrait of Priest Seigen*

Kamakura period, 14th century. Hanging scroll; ink and color on paper. H. 25.5 cm. W. 41 cm. Cleveland Museum of Art 82.55. John L. Severance Fund.

In 804 the monk Kūkai (774–835) accompanied the official diplomatic delegation of Fujiwara no Kuzunomaro to China. Already versed in Chinese classical literature and Confucianism, Kūkai devoted his visit to the study of Esoteric Shingon (C. Chenyen) Buddhist teachings, which he subsequently introduced to Japan. The aristocratic monk Shōbō (832–909), representing the third generation of Japanese Shingon practitioners, established Daigo-ji to the southeast of Kyoto in 874. His idiosyncratic inter-

pretations of the Esoteric doctrines became the basis for the Ono branch of Shingon, a persuasion favored by the Fujiwara family. The temple flourished under court benefaction, and its administrators were usually related by blood to the imperial line.

Seigen (1162–1231), the subject of this portrait, was appointed the twenty-fourth chief priest of Daigo-ji in 1203. The inscription on the painting identifies him as abbot of the Henchi-in, a subtemple within that complex. A Fujiwara by birth and nephew of the influential priest Shōgen (1138–1196), Seigen was raised within the temple precincts. His title of Saishō Sōjō, or councillor bishop, underscores a relationship to the imperial household. A series of prestigious ecclesiastical postings, the authorship of doctrinal commentaries, and the distinguished contributions of several of his disciples suggest that Seigen brought personal competence to positions of inherited privilege. His career spanned a period of singular national upheaval. Decline in aristocratic power was reflected in the waning influence of once favored religious establishments. Seigen's record of ecclesiastical accomplishment may reflect his loss of access to the wider political sphere available to his predecessors.

This unfinished study of the priest is an amateur devotional painting based either on a completed portrait (of which several are extant) or on a monochrome version found in an iconographical copybook. Red ink, commonly used in tracing, is clearly visible under the stiff, cautious black outlines of the head and features. Color notations are written on the garment. Repeated application of pigment over a white base, the coloring technique favored by the indigenous *yamato-e* tradition, is employed awkwardly here. The face splotches seem to be a conventional description of the aftereffects of smallpox. The eyes have been rendered attentively and rather effectively.

Portraiture as a patent of succession was a Zen practice introduced from China and used increasingly from the mid-thirteenth century. Shingon, however, emphasized the iconic and devotional role of such paintings. JU

Literature

Takashi Hamada, ed., *Daigo-ji to Ninna-ji . Daikaku-ji* [*Daigo-ji and Ninna-ji . Daikaku-ji*], vol. 14 (1982) of *Nihon Koji Bijutsu Zenshū*.
Sanji Mutō, ed., *Chōshō Seikan* [*Catalogue of Ancient Chinese and Japanese Paintings in the Mutō Collection*] (Osaka: Shunko Bijutsusha, 1928), pl. 7.
Ryūken Sawa, *Daigo-ji*, vol. 1 (1976) of *Jisha Shirizu*.

54 *Portrait of Priest Shinran*

Kamakura period, 13th century. Hanging scroll; ink and color on silk. H. 120 cm. W. 81.2 cm. Nara National Museum. Important Cultural Property.

Priest Shinran (Shinran Shōnin, 1173–1262) is revered in Japan as the founder of the Shin (True) sect of Pure Land Buddhism. In his early thirties Shinran renounced Esoteric Tendai Buddhism for the Pure Land doctrine of Priest Hōnen (1133–1212), which earned him exile from the Home Provinces along with Hōnen. Returning unsilenced, he continued to preach his popular faith, eventually gaining a large following both in the capital and outlying regions.

This painting is considered by many to be a copy of another Shinran portrait in the collection of the Higashi Hongan-ji, Kyoto, known popularly as the *Anjō no Miei*. It, in turn, follows the small sketch-portrait with calligraphic inscription known as the *Kagami no Gyoei*, thought to have been executed in 1262 just before Shinran's death. The portrait exhibited here and the *Anjō no Miei* both depict Shinran in an orthodox manner and at a slightly younger age than the *Kagami no Gyoei*. They are also similar compositionally but differ stylistically. This Nara painting is traditionally attributed to the priest-painter Jōga (act. ca. 1295) of the Shin sect but is more likely the work of a slightly later follower in the thirteenth century. It is known as the *Kumakawa no Miei* (*kumakawa*, or bear's fur), since Shinran is seated on a bearskin rug. The opening section of the second roll of the *Shinran Shōnin E-den* contains a scene of Shinran seated on a *tatami* in a virtually identical pose. MC

Literature

Tsugio Miya, ed., *Hongan-ji to Chion-in* [*Hongan-ji and Chion-in*], vol. 21 (1982) of *Nihon Koji Bijutsu Zenshū*, pls. 26, 27 (paintings of Priest Shinran, Nishi Hongan-ji and Higashi Hongan-ji).

Nara National Museum, *Nara Kokuritsu Hakubut su-kan Meihin Zuroku* [*Masterpieces in the Collection of the Nara National Museum*] (Kyoto: Dōhōsha, 1980) color pl. 15.

55 *Portrait of Priest Myōe*

Attrib. Enichibō Jōnin (early 13th century). Hanging scroll; ink and color on paper. H. 145 cm. W. 59 cm. Kōzan-ji, Kyoto. National Treasure.

The inscription identifies the seated figure as Myōe Shōnin (1173–1232), who established Kōzan-ji, in the mountains just northwest of Kyoto, as an independent temple. Trained in Shingon ritual, he is known primarily for reviving Kegon beliefs and sympathizing with Zen. He is depicted meditating in a tree growing from a rocky outcropping on Mt. Ryōga, behind the temple compound. Several temple records purport to identify the site of this unusual tree and rock, but their location remains problematical. The compositional affinity between this work and *rakan* paintings of Chinese lineage is, however, evident in such elements as the canopy formed by the sheltering pine and the animals "offering service." Stylistically Myōe's portrait may be compared with the *Kegon Engi* (early thirteenth century). The record of a portrait made in Myōe's lifetime by his disciple Enichibō Jōnin has been identified as referring to this scroll, a landmark in the history of Japanese portrait and landscape painting.　MC

Literature

Kōzan-ji Ten: Tokubetsu Tenrankai, Myōe Shōnin Botsugo 750 Nen [*Treasures of Kōzan-ji Temple: A Special Exhibition in Commemoration of the 750th Anniversary of the Death of Priest Myōe*] (exh. cat.; Kyoto National Museum, 1981), cat. 84.

Shin'ichi Tani, ed., *Shōzō Senshū* [*Selected Portraits*] (Tokyo: Yoshikawa Kōbun-kan, 1966), no. 11, repr. p. 37.

Yoshiho Yonezawa, Chū Yoshizawa, and Ichimatsu Tanaka, *Nihon no Sansuiga Ten* [*Exhibition of Japanese Landscape Painting*] (exh. cat.; Tokyo National Museum, 1977), cat. 8.

56 *Portrait of the Zen Priest Hakuun Egyō*

Kamakura period, 13th century. Unmounted sketch; ink on paper. H. 13.4 cm. W. 9.3 cm. Rikkyoku-an, Kyoto. Important Cultural Property.

The Tōfuku-ji in the eastern hills of Kyoto occupies a distinguished position in the history of portraiture in Japan. Its best-known monk-painter, Kichizan Minchō (1352–1431; [77]), left an impressive group of patriarch and priest portraits in ink as well as in the orthodox color tradition of Buddhist painting. A set of fifty hanging scrolls by Minchō depicting the *Five Hundred Rakan* (disciples) of Buddha is executed in this orthodox manner, undoubtedly following Chinese prototypes. A most interesting detail shows several *rakan* gathered around one who holds a small sketch on paper, the bust-portrait of a priest. They inspect it and obviously admire its likeness.

This vignette illuminates for us the raison d'etre of the small life sketch of Hakuun, a serious man who

studied Zen in China for fifteen years before returning to Japan to become the fourth abbot of Tōfuku-ji. Executed in plain ink and in the simplest of brushstrokes, it nevertheless reveals the anonymous artist's dexterous working method. Strict attention has been paid to obtaining the precise, identifying shape of the priest's head as well as to the positioning of his features. Some of these are treated summarily, others—such as the shaggy eyebrows—in considerable detail. In this sketch the artist has captured Hakuun's pithy character more incisively, perhaps, than in the finished *chinsō* (formal portrait of a Zen master) for which it was probably a working draft. It represents one of the earliest and most important documents in the history of Japanese portraiture and especially of *nise-e* (see p. 103). MC

Literature

Hiroshi Kanazawa, *Japanese Ink Painting: Early Zen Masterpieces*, trans. and adapted by Barbara Ford, vol. 8 (1979) of *Japanese Arts Library*, pl. 9.

Yoshi Shirahata, *Shōzōga* [*Portrait Paintings*], no. 8 (December 1966) of *Nihon no Bijutsu*, pl. 92.

Zen no Bijutsu [*Arts of Zen Buddhism*] (exh. cat.; Kyoto National Museum, 1981), cat. 33.

57 *Portrait of Emperor Hanazono*

Gōshin (act. first half of 14th century). Dated to 1338. Hanging scroll; ink and light color on paper. H. 31.2 cm. W. 97.3 cm. Chōfuku-ji, Kyoto. National Treasure.

The younger brother of Emperor Go-Fushimi (r. 1298–1301), Hanazono himself assumed the throne at the age of twelve in 1308. From this position, which entailed considerable ceremonial responsibilities but little true power, he abdicated ten years later, as custom dictated. At this time in Japanese history power, influence, and even the simulacra of power had become extremely fractionated. Two imperial lines (Hanazono belonged to the senior) alternated the throne, whose power was nil and whose authority and esteem were virtually so. Such political influence, or room for intrigue, as remained to the imperial house inhered in the position of retired, or cloistered, emperor. To this position the emperor of each line graduated upon abdication, when he assumed Buddhist orders. The forms of government were still being carried out by the Kamakura *bakufu*, but real power was rapidly falling away from it into the sword-hands of the warrior clans.

Hanazono appears to have separated himself from most of the striving and machinations of this time and taken refuge in culture and scholarship. His diary and other writings note that his days were filled with ceremonial duties, poetry meetings, and the study of the classics of Chinese and Japanese history and literature. This painting portrays him at age forty-two, seated in formal monk's attire and holding prayer beads and a folding fan. He had taken the tonsure three years earlier. His inscription on the painting states that it was executed by Gōshin, a descendant of the renowned portraitist Fujiwara Takanobu (1142–1205). Gōshin's father, Fujiwara no Tamenobu, was Takanobu's successor and is best known as the artist responsible for the handscroll in the Imperial Household Agency called *Portraits of Emperors*. Two similar handscrolls in the same collection are attributed to Gōshin, the *Portraits of Regents and Advisors to Emperors* and *Portraits of Ministers*. Although all three scrolls show their subjects individually, seated, and devoid of any setting save the names identifying them, none exhibits the psychological insight of this portrait. It gives us Hanazono as he described himself: a man "of poor health" disposed towards "fits of melancholy," who "from early childhood" had been "a solitary." MC

Literature

Hideo Okudaira, *Kamakura*, vol. 4 (1970) of *Nihon Kaigakan*, color pl. 57.

Yoshi Shirahata, *Shōzōga* [*Portrait Paintings*], no. 8 (December 1966) of *Nihon no Bijutsu*, pl. 7 (color) and pl. 56.

Shin'ichi Tani, ed., *Shōzō Senshū* [*Selected Portraits*] (Tokyo: Yoshikawa Kōbun-kan, 1966), no. 32, repr. pp. 78-79.

58 *Portrait of Emperor Hanazono*

Muromachi period. Hanging scroll; ink and color on paper. H. 65 cm. W. 49 cm. Chōfuku-ji, Kyoto.

This second portrait of Hanazono is based almost wholly upon the previous painting [57]. Here, however, Hanazono is seated on a *tatami*, and his features and robe are less sensitively rendered. The *nise-e* training evident in Gōshin's brushwork is conspicuously absent from this unknown artist's portrayal, although no great interval separated the two. This portrait represents the honest efforts of an amateur monk-painter and undoubtedly served as a substitute for the Gōshin painting, which would have been displayed only infrequently. MC

59 *Portrait of the Nun Myōhō*

> Attrib. Hasegawa Tōhaku (1539–1610). Hanging scroll; ink on paper. H. 64 cm. W. 36.5 cm. Hompō-ji, Kyoto. Important Cultural Property.

This sketch-portrait records the appearance in 1598, at the age of seventy-three, of the mother of Nittsu Shōnin, abbot of Hompō-ji, Kyoto. She is depicted as a nun, seated on *tatami* with prayer beads in one hand. The many *pentimenti* in the nun's robes, her hood, and the matting are in vivid contrast to the assured, almost conventional description of the woman's facial features. The careful brushwork and graduated ink values there are accentuated by contrast with the rough, energetic lines evident elsewhere in the portrait. These lines create a kind of visual dialogue with the numerous inscriptions surrounding the seated figure, all written in the dark, thick, cursive script style of the Nichiren sect. The two inscriptions on large pieces of paper attached to the upper left and right quadrants were composed by Myōhō just prior to her death in 1598 and were added to the sketch-portrait. The other inscriptions were written by her son Nittsu and identify the subject as well as her age and day of death. They also include

two short references by Nittsu to Buddhist literature, which amplify the more worldly sentiments of his mother's poems.

The painting is neither signed nor sealed, but the eighteenth-century remounting includes a note by the thirty-eighth Hompō-ji abbot specifying the artist as Hasegawa Tōhaku, a major individualist painter of the later sixteenth century. Tōhaku, already a successful provincial artist, had come to Kyoto in the early 1570s to study Kanō painting, which was supported by the military ruling class. A devout Nichiren sect follower, he established religious ties in the capital with the Hompō-ji, a relationship that endured and strengthened over time. He executed finished, signed portraits of Hompō-ji abbots, a large *Nehan* painting (see [82]), and in all likelihood this sketch-portrait when he was at the height of his career, the finest portraitist of the time and peer of any Momoyama period artist. By this time he had broken with the Kanō school, but Nittsu continued to support his work, as did the tea connoisseur Sen no Rikyū, whom the artist also portrayed. Nittsu is best remembered for his transcriptions of conversations with Tōhaku about Chinese and Japanese painting history and customs, the *Tōhaku Gasetsu*, recorded in 1592. This portrait of Nittsu's mother is another instance of their close relationship.　　　　MC

Literature

Yoshi Shirahata, *Shōzōga* [*Portrait Paintings*], no. 8 (December 1966) of *Nihon no Bijutsu*, pl. 116.
Tsugiyoshi Doi, *Hasegawa Tōhaku* (Tokyo: Kōdansha, 1977), vol. 2, pl. 108.

60 *Portrait of Fujiwara Kanetsune*

> Kamakura period, 13th century. Hanging scroll; ink and light color on paper. H. 116.7 cm. W. 100.9 cm. Kōzan-ji, Kyoto. Important Cultural Property.

The inscription in the upper right-hand corner of this impressive preparatory drawing identifies the sitter as Okaya-dono (known in secular life as Fujiwara Kanetsune), who died 4 May 1259. It says the sketch depicts accurately the clothing he wore after he had taken the tonsure and was residing at the Sekisui-in subtemple of Kōzan-ji, to which this portrait was donated.

A prominent offical at the imperial court who rose to become chancellor and then imperial regent (*kampaku*), the personal advisor to the emperor, Kanetsune belonged to the Konoe branch of the Fujiwara family. He retired from his official responsibilities in 1257 and entered Kōzan-ji soon after. His grandfather, Konoe

58

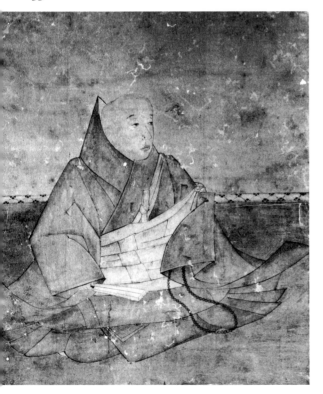

Motomichi, had been a patron and protector of that temple and a putative influence on Myōe Shōnin's thinking (see [55]). Other members of the family also maintained strong ties with Kōzan-ji, which served as their memorial temple.

Kanetsune is shown seated on a footed *tatami*-covered dais, holding prayer beads. *Pentimenti* are plainly visible in the garment folds, prayer beads, fingers, and legs of the dais. Light colors have been selectively added, and the woven patterns of the *kesa* (vestment) and *tatami* binding are indicated. The clarity and vivacity of the brushwork suggest the hand of an artist trained in Buddhist painting, perhaps at the Kōzan-ji–Jingo-ji atelier. The composition, likewise, follows thirteenth-century norms. In particular, the attitude of Kanetsune's hands and drape of his garments are closely paralleled in portraits of the priest Ryōe Shōnin and in a portrait of Emperor Go-Shirakawa in Jingo-ji.

At the temple the sketch was originally stored folded, and the paper in the area of the face, having been on the outside, darkened. The inscription identifying the sketch in the storehouse was removed from the back in the remounting process and placed on the front of the scroll. The inscription also mentions that the Tōbō subtemple of Kōzan-ji at one time owned a portrait of Kanetsune in official court dress. It probably resembled Kanetsune as he appears in the Imperial Household Agency's *Portraits of Regents and Advisors to Emperors* by Gōshin (see [57]). MC

Literature

"Fujiwara Kanetsune Zō" ["A Portrait of Fujiwara Kanetsune"], *Kokka*, no. 884 (November 1965), pl. 5 and pp. 19-20.

Kōzan-ji Ten: Tokubetsu Tenrankai, Myōe Shōnin Botsugo 750 Nen [*Treasures of Kōzan-ji Temple: A Special Exhibition in Commemoration of the 750th Anniversary of the Death of Priest Myōe*] (exh. cat.; Kyoto National Museum, 1981), cat. 70.

Yoshi Shirahata, *Shōzōga* [*Portrait Painting*], no. 8 (December 1966) of *Nihon no Bijutsu*, pl. 5 (color).

61 *Portrait of Emperor Go-Shirakawa*

Kamakura period, early 13th century. Hanging scroll; ink and color on silk. H. 134.3 cm. W. 84.7 cm. Myōhō-in, Kyoto. Important Cultural Property.

In 1158 Emperor Go-Shirakawa abdicated as emperor in favor of his son and entered Buddhist orders. From then until his death in 1192 he reigned as cloistered emperor, though he did not so much govern as maintain a fluctuating semblance of power by fomenting constant intrigue among the competing aristocratic and warrior factions. His contemporaries portray Go-Shirakawa as a genuinely religious man, but erratic, cunning rather than wise.

The badly damaged painting depicts the emperor in his retirement. Dressed in formal religious attire and seated upon raised *tatami* mats, he holds a sutra roll in his left hand and prayer beads in his right. Sliding screens behind him show large-scale bird-and-flower paintings in Sung style, an indication of prevailing court taste. Other portraits of Go-Shirakawa, such as the late Kamakura example in the Jingo-ji, depict a younger man and lack the domestic appurtenances of this painting (also see [136]). MC

Literature

Toshihide Akamatsu and Shinji Nishikawa, *Jingo-ji Jihō Tokubetsu Kōkai* [*Special Public Exhibition of Treasures from Jingo-ji*] (exh. cat.; Tokyo, Mitsukoshi Dept. Store, 1973), cat. 61.

Hiroshi Kanazawa, *Japanese Ink Painting: Early Zen Masterpieces*, trans. and adapted by Barbara Ford, vol. 8 (1979) of *Japanese Arts Library*, pl. 105.

Yoshi Shirahata, *Shōzōga* [*Portrait Paintings*], no. 8 (December 1966) of *Nihon no Bijutsu*, pl. 36.

Shin'ichi Tani, *Shōzō Senshū* [*Selected Portraits*] (Tokyo: Yoshikawa Kōbun-kan, 1966), no. 6, repr. p. 27.

62 *Portrait of Hōjō Tokiyori*

Kamakura period, 13th century. Wood with color. H. 68.8 cm. Kenchō-ji, Kanagawa Prefecture. Important Cultural Property.

Among large-scale portraits of secular figures the paintings of Fujiwara and Minamoto regents owned by Kōzan-ji, Kyoto, are especially esteemed. Only slightly less famous is a small group of sculptural portraits dating to the later thirteenth century, including this striking image of Hōjō Tokiyori (1227-63). The fifth regent (*shikken*), or chief officer, of the Kamakura military government, Tokiyori helped found Kenchō-ji by soliciting the illustrious Chinese priest Lan-ch'i Tao-lung (J. Rankei Dōryū, 1213-78) in 1246 to visit Kamakura; he became Kenchō-ji's first prelate seven years later. With Tokiyori's continued support the temple prospered, becoming not only Japan's first great Zen institution but the cultural center of Kamakura, as well as a seminary for generations of influential Zen monks. This image is traditionally dated to the year of Tokiyori's death. MC

Literature

Tatto Kan et al., ed., *Kamakura no Bijutsu* [*Art in Kamakura*] (Kamakura Kokuhō-kan, 1978), pls. 22, 23 and pp. 33-35.

Takeshi Kobayashi, *Shōzō Chōkoku* [*Portrait Sculpture*] (Tokyo: Yoshikawa Kōbunkan, 1969), pp. 111-14.

Shin'ichi Nagai, *Kamakura to Tōgoku no Koji* [*Ancient Temples of Kamakura and the Eastern Provinces*], vol. 17 (1981) of *Nihon Koji Bijutsu Zenshū*, pl. 10 (color).

63 *Attendant Shintō Deity*

Heian period, 12th century. Wood with color. H. 50 cm. Daishōgun-hachi Shrine, Kyoto. Important Cultural Property.

Over seventy sculptural images in various states of repair reside at the Daishōgun Hachi Shrine in Kyoto, a branch of the better-known Yasaka (Gion) Shrine located at the base of the Higashiyama hills. These figures, of which the majority are dressed in the military apparel associated with Buddhist guardian figures, are traditionally considered Shintō deities (*kami*). Images first came to be associated with the shrine when the capital moved from Nara to Kyoto in the last decade of the eighth century. Preparations for the move are said to have included the transfer of *kami* resident at Nara's Kasuga Shrine to the new capital site to provide spiritual protection.

Daishōgun Shrine stands guard over the northwest sector of Kyoto, much as a Buddhist guardian figure protects one of the four compass points on a temple altar. The first specific mention of the shrine dates to the late twelfth century, naming it as one of the country's forty-one official (court) establishments and noting the donation of a court building for housing images. Interestingly, an earlier, ninth-century document concerning the main Yasaka Shrine states that the resident *kami* there was Gozu Tennō, a guardian image. No longer extant, it was recorded as late as 1070, and is given attributes bearing striking resemblances to the well-known Buddhist guardian divinity Bishamonten. Although the earliest record naming Daishōgun Hachi Shrine as a branch of Yasaka dates to the mid-fourteenth century, their relationship may have been established earlier based upon these iconographical affinities.

This figure of a young servant boy squatting on one knee with both hands withdrawn into his sleeves is one of the most poignant secular portraits in Japanese art. The full, rounded modelling and decorative surface help focus attention on the child's pensive expression. Whether he represents a *kami* or

is perhaps a commemorative image of a dead child, donated to the shrine by parents, we do not know.

Like the rest of the images at Daishōgun-hachi Shrine, this figure is traditionally dated to the twelfth century, when the main worship hall was donated by the court (1178). The sheer number of figures, however, far greater than at any other Shintō shrine, makes it unlikely that they were all installed at the same time. The boy attendant, furthermore, is unique in subject, making it even more unlikely that he was part of the original installation. Finally, the image reveals a well-formed, individualized sculptural technique and style distinct from that of the military images and not unlike that of the small dog at Kōzan-ji and the boy servant at Unkei-ji in Shikoku, both of the Kamakura period. Whether it was in fact an original member of the Daishōgun-hachi sculpture group or a later addition remains undetermined. It is known that during the late nineteenth century, when large numbers of religious images were being destroyed, some were also transferred from major institutions such as Yasaka to less accessible, safer subsidiary shrines and temples. MC

Literature

Heian Jidai no Chōkoku [*Sculpture of the Heian Period*] (exh. cat.; Tokyo National Museum, 1971), cat. 82 (Shintō deity, Daishōgun-hachi Shrine, Kyoto).

Naomi Oka, ed., *Shinzō Chōkoku no Kenkyū* [*A Study of Shintō Sculpture*] (Tokyo: Kadokawa Shoten, 1966), pp. 181-206.

Kōzō Sasaki and Hideo Okumura, ed., *Shintō no Bijutsu: Kasuga, Hiyoshi, Kumano* [*Arts of Shintō: Kasuga, Hiyoshi, and Kumano Shrines*], vol. 11 (1979) of *Nihon Bijutsu Zenshū*, pl. 24 (color).

Shikoku, pt. 2: *Ehime, Kōchi* [prefectures] (1975) in *Kokuhō Jūyō Bunkazai Bukkyō Bijutsu*, no. 32, repr. p. 89 and color pl. 2 (boy attendant, Unkei-ji, Kōchi prefecture).

64 *Sumō Wrestlers and Referee*

Muromachi period, 15th century. Cypress wood with color. H. 23.9 cm. and 29.4 cm. Mikami Shrine, Shiga Prefecture.

The ninth-century introduction of Esoteric Buddhism into Japan, and its rapid expansion, had profound impact on the native religious traditions of Shintō. Both the Tendai and Shingon sects attached considerable importance to the use of visual images—painting, sculpture, and the applied arts—in propagating and explaining their beliefs. At the same time,

they reached out to incorporate Shintō belief, pairing each *kami* with a specific Buddhist deity (see [17, 92]). These twin emphases, in turn, stimulated production of syncretic Buddhist-Shintō imagery. The result was to strengthen Shintō's hold on the imagination, and hence its position in early Japanese culture, by representing its deities (*kami*) for the first time in anthropomorphic form.

Buddhism's influence is less visible in this sculptural group of a Shintō priest and two sumō wrestlers. The priest wears the tall formal hat, robes, and wooden clogs typical of his profession. His extended right hand originally held a fan, and this gesture together with the rest of his pose describes a stance assumed today by referees at sumō tournaments. These have a long history in Japan, much of which can be traced to ceremonial wrestling matches staged at Shintō shrines on local holidays. Clearly such events took place at Mikami Shrine, a modest but popular establishment at the foot of Mt. Mikami not far from Kyoto, at least as early as the thirteenth century. The shrine itself possesses a much older history and is associated with the tradition designating cone-shaped Mt. Mikami a sacred peak, like Mt. Miwa south of Nara, whose ascent was not permitted. Early legend states that when earth was dug to form Mt. Fuji the resulting hole became Lake Biwa and the surplus earth Mt. Mikami, hence its appellation, "Mt. Fuji of the Kansai."

Each wrestler has a firm grip on his opponents' waistband, and their legs are positioned to withstand the anticipated next thrust. Their heads and faces are individualized, and both in turn are distinguished from the more dignified referee by details of posture, build, and features. It is not clear whether these figures, like most Shintō sculptures, were ever considered secret images, not to be seen by common shrine visitors. MC

Literature

Haruki Kageyama, *The Arts of Shinto*, trans. and adapted by Christine Guth, vol. 4 (1973) of *Arts of Japan*, pl. 5.

———, *Shinto Arts: Nature, Gods, and Man in Japan* (exh. cat.; New York: Japan House Gallery, 1976), cat. 8.

Naomi Oka, ed., *Shinzō Chōkoku no Kenkyū* [*A Study of Shintō Sculptures*] (Tokyo: Kadokawa Shoten, 1966), pls. 87, 88.

65 *Shussan no Shaka* [*Sakyamuni Coming Down from the Mountain*]

Kamakura period, ca. 1300. Hanging scroll; ink on paper. H. 90.8 cm. W. 41.9 cm. Seattle Art Museum, 50.124. Eugene Fuller Memorial Collection.

This scroll depicting the historical Buddha, Sakyamuni (J. Shaka) is in reality a model painting, like those priest portraits discussed previously [38]. It bears the seal of Kōzan-ji (see [23]), a temple noted for collecting Chinese iconographical sketches and training monk-painters to copy them for distribution to other Esoteric temples. This activity began toward the end of the Heian period and reached its zenith under Abbot Myōe Shōnin [55]. He encouraged collection and study of the new Sung and Yüan dynasty Buddhist paintings brought back from China by Japanese priests, along with their own drawings done abroad. Of particular interest were the Zen sect paintings, normally executed in monochrome ink with rough, economical brushwork.

This depiction of Shaka is based upon such a model. The event shown is Shaka's return to the world, in a nascent state of Enlightenment, from an extended period of solitary austerities and meditation in the mountains (see also [50]). The traditional mountainous setting is suggested by only three or four dry, scrubby brushstrokes. Shaka's torso and simple robe are similarly brief in definition, combining broad, rich ink tones with thinner dry lines. The artist's attention chiefly centered on his careful, finely brushed delineation of Shaka's quiet, thoughtful expression. Similar brushwork and emphasis is evident in Chinese paintings of the same theme dating to the Southern Sung period and appears in Japanese images by the later thirteenth century. This rendition shows the distinctive stylistic technique and paper associated with the Kōzan-ji atelier. Of such Kōzan-ji type ink compositions depicting Buddhist deities, which became popular among the Kamakura period religious communities, three others survive. One, a *White-Robed Kannon*, is in the Cleveland Museum of Art; the other two remain in private Japanese collections. MC

Literature

Hiroshi Kanazawa, *Japanese Ink Painting: Early Zen Masterpieces*, trans. and adapted by Barbara Ford, vol. 8 (1979) of *Japanese Arts Library*, 84-87.

Shūjirō Shimada, *Suiboku-ga* [*Ink Monochrome Painting*], vol. 3 (1979) of *Zaigai Nihon no Shihō*, color pl. 2.

Henry Trubner, William J. Rathbun, and Catherine
A. Kaputa, *Asiatic Art in the Seattle Art Museum: A
Selection and Catalogue* (Seattle: Seattle Art Mu-
seum, 1973), cat. 192.

66 *Seitaka Dōji*

Fujiwara period. Dated to 1164. Hanging
scroll; ink on paper. H. 50.2 cm. W. 30.6 cm.
Cleveland Museum of Art 72.162. Gift in
memory of Elizabeth B. Blossom.

An inscription left intact on the lower back edge of
this iconographical sketch during a recent remount-
ing provides the date 1164. Large numbers of such
drawings, called *zuzō* (image drawings), were made in
Buddhist temple workshops, either to record ico-
nography or as preliminary sketches in the planning
of an icon. These drawings often were mock-ups
rather than the first state of a finished religious
painting. They were regularly used and collected by
such Esoteric temples as Tō-ji, Daigo-ji, Ninna-ji, and
the vast Mt. Kōya establishment.

This unusual drawing depicts Seitaka Dōji reining
in a charger and glancing the while toward the
viewer. Horse and rider are drawn in a series of
sweeping, modulated ink lines varying in tonality
and in convincing structural definition. The linear
treatment is supple and rather decorative, emphasiz-
ing successive linear patterns and flourishes of nail-
head strokes of a kind also seen in the horse-headed
demons of the Seattle Art Museum's *Scroll of Hells*
fragment (see [16]).

In painting and sculpture, Seitaka Dōji figures as
one of two principal attendants of Fudō, the central
deity of the five *myōō*, fierce Esoteric manifestations of
Buddha whose prominence dates from the ninth
century in Japan. Normally depicted seated or stand-
ing on a rocky outcropping, Seitaka is youthful in
appearance with high forehead, knitted brows, and a
generous paunch. His attributes normally include a
wooden staff and a *vajra*. The writing on the sketch
includes instructions to the painters about the
finished image, which seems not to have survived.
MC

Literature

Takashi Hamada, *Zuzō* [*Image Drawings*], no. 55
(December 1970) of *Nihon no Bijutsu*, pl. 107 (Bamei
Bosatsu in Daigo-ji).
100 Masterpieces of Japanese Art (exh. cat.; Kanazawa:
Ishikawa Prefectural Art Museum, 1971), cat. 26.

67 *Portrait of the Zen Master Hottō Kokushi*

Kamakura period, ca. 1286. Wood with traces
of lacquer. H. 91.4 cm. Cleveland Museum of
Art 70.67. Purchase, Leonard C. Hanna Jr.
Bequest.

Kakushin (1203-95), also known as Hottō Kokushi,
returned about mid-century from a second successful
period of Zen study in Sung China. He was re-
nowned in Japan for his erudition and teaching, and
also as the founder of Kōkoku-ji in Wakayama prefec-
ture, where a portrait-sculpture and painting of him
[68] are still treasured.

In his writings Kakushin noted that three sculp-
tural images of him had been made. The earliest,
dated to 1275-76 in the Ankoku-ji, Hiroshima, is also
the oldest known sculptural *chinsō* (portrait of a Zen
master) in Japan, as well as the oldest *juzō* (*chinsō* of a
living subject). Another especially revered image,
dated to 1286, resides in the Kōkoku-ji and shows
Kakushin ten years later. The Cleveland Museum's
sculpture resembles the Kōkoku-ji portrait, both in
physiognomy and in sculptural style. Although it is
not indisputably the third *juzō* mentioned by Ka-
kushin, it does antedate other images of him, such as
the one at Enmitsu-ji, Wakayama Prefecture. MC

Literature

Takeshi Kobayashi, *Shōzō Chōkoku* [*Portrait Sculpture*]
(Tokyo: Yoshikawa Kobunkan, 1969), pp. 122-31.
Bunsaku Kurata, *Nihon no Bukkyō o Kizuita Hitobito:
Sono Shōzo to Sho* [*Special Exhibition of Japanese Bud-
dhist Portraiture: Portraits and Calligraphy*] (exh. cat.;
Nara National Museum, 1981), cat. 171 (wood por-
trait of Hottō Kokushi, Ankoku-ji, Hiroshima).
Sherman E. Lee, Michael R. Cunningham, and
Ursula Korneitchouk, *One Thousand Years of Japanese
Art (650-1650) from The Cleveland Museum of Art* (exh.
cat.; New York: Japan House Gallery, 1981), cat. 20.

68 *Portrait of the Zen Master Hottō Kokushi*

Kakue (13th century). Inscription by Ichisan
Ichinei (1247–1317), dated to 1316. Hanging
scroll; ink and color on silk. H. 174.8 cm.
W. 84.2 cm. Kōkoku-ji, Wakayama Prefec-
ture. Important Cultural Property.

Although rather badly damaged, this posthumous
chinsō of Kakushin must be counted one of the most
impressive Zen portrait paintings in existence. Ka-
kushin sits cross-legged in a carved, draped chair, his
legs concealed beneath his formal surplice. His shoes

rest prominently, if awkwardly, on the footstool before him and in his hands he grasps a fly whisk instead of the thin lacquered staff (*keisaku*), often seen in formal *chinsō*, that was used to strike disciples in order to keep them alert during long periods of meditation. Both instruments are, however, emblems of religious authority.

Kakushin's distinctive appearance has been depicted in a thin yellowish underdrawing over which red ink has been applied. The sharply delineated features combine with the elaborate floral designs and heightened color scheme of the robe to produce a decidedly realistic icon. The inscription above Kakushin, an essential element of *chinsō*, is by Ichisan Ichinei (C. I-shan I-ning), the distinguished Chinese monk who had become abbot of Nanzen-ji in Kyoto four years earlier. MC

Literature

Hiroshi Kanazawa, *Japanese Ink Painting: Early Zen Masterpieces*, trans. and adapted by Barbara Ford, vol. 8 (1979) of *Japanese Arts Library*, pl. 13.
Bunsaku Kurata, *Nihon no Bukkyō o Kizuita Hitobito: Sono Shōzō to Sho* [*Special Exhibition of Japanese Buddhist Portraiture: Portraits and Calligraphy*] (exh. cat.; Nara National Museum, 1981), cat. 172, 173 (Emman-ji).
Yoshi Shirahata, *Shōzōga* [*Portrait Paintings*], no. 8 (December 1966) of *Nihon no Bijutsu*, pl. 86.
Zen no Bijutsu [*Arts of Zen Buddhism*] (exh. cat.; Kyoto National Museum, 1981), cat. 34.

69 *Portrait of the Zen Priest Buttsū Zenji*

Kamakura period. Dated to 1301. Hanging scroll; ink and color on silk. H. 111 cm. W. 53 cm. Ganjō-ji, Kyoto. Important Cultural Property.

Like Hottō Kokushi [67, 68], Priest Buttsū Zenji (1229-1312) appears older in the painted *chinsō* than in the sculpture [70]. Buttsū sits in a carved, high-backed chair (*kyokuroku*) holding a bamboo *keisaku*, his legs tucked under his priest's surplice. The lush, finely-drawn white hair of his eyebrows, cheeks, and chin stand out against the dark background and are an unusual note in painted *chinsō*. His stern, not to say truculent, expression emanates principally from the fiercely penetrating eyes; the man himself must have struck awe verging on terror in his disciples. According to the inscription this *chinsō* was executed while he was abbot of Anyō-ji in Ise. The history of its transmission to Ganjō-ji is unclear. MC

Literature

Tōru Shimbo, *Kaiga IV* [*Painting, pt. IV*], vol. 10 (1974) of *Jūyō Bunkazai*, pl. 332.
Shōzō Bijutsu no Shomondai: Kōsōzō o Chūshin ni Kenkyū Happyō to Zandankai [*Problems of Portrait Art: Concerning Portrait Sculpture and Paintings of High Priests*], Report V, Committee on Research, Ueno Memorial Foundation for the Study of Buddhist Art, Kyoto National Museum, 25 October 1977 (Kyoto: Kenkyūkai, 1978), with English summary, pl. 7 (detail reversed).

70 *Portrait of the Zen Priest Buttsū Zenji (Priest Chikotsu Daie)*

Kamakura period, 14th century. Wood with color. H. 78.3 cm. Hōkoku-ji, Ehime Prefecture. Important Cultural Property.

Buttsū Zenji trained initially in Tendai and Shingon Buddhism but turned to Zen after losing a religious debate to the Zen master Shōichi Kokushi. He completed his Zen training under Shōichi, the founder of Tōfuku-ji, and went on to become ninth abbot of that temple in the year before his death. He also founded at least two temples in the Ise area, where he had lived the greater part of his life before coming to Kyoto.

The joined-block (*yosegi*) technique used in this *chinsō* can be seen clearly in the hanging sections of the robe. The hands and the head and neck were also carved as separate units and inserted into the body cavity. The entire surface is covered with thin layers of lacquer followed by polychromy. A canister inside the body contains sutras printed in China along with fingernail and hair clippings of the priest (see chapter III). Such relics were commonly incorporated in fourteenth-century carved *chinsō* which helps date certain works. For this figure an approximate date of 1320 is reasonable. It is thought the sculpture was moved in modern times from Tōfuku-ji to Hōkoku-ji in Shikoku. MC

Literature

Jan Fontein and Money L. Hickman, *Zen Painting Et Calligraphy* (exh. cat.; Boston: Museum of Fine Arts, 1970), cat. 25.
Takeshi Kobayashi, *Shōzō Chōkoku* [*Portrait Sculpture*] (Tokyo: Yoshikawa Kobunkan, 1969), pp. 187-89.
Shikoku, pt. 2: *Ehime Kochi* [prefectures] in *Kokuhō Jūyō Bunkazai Bukkyō Bijutsu*, no. 9, repr. pp. 42-43; p. 179.

71 *Portrait of the Zen Priest Nanzan Shiun*

Inscription by Hōjō Takatoki (regent 1316–26).
Hanging scroll; ink on paper. H. 47.2 cm.
W. 26.2 cm. Setsu Iwao, Tokyo.

A native of Shizuoka Prefecture in the Kantō, Nanzan
Shiun (1254-1335) studied principally with the Zen
master Ben'en Enni (1202-81) at Tōfuku-ji in Kyoto and
later at Kenchō-ji near Kamakura. In 1298 he moved to
Shōten-ji in northern Kyūshū [95], whence he trav-
eled and proselytized extensively in the western
provinces of Honshū. By 1310, however, his peripatet-
ic career had taken him back to Tōfuku-ji and thence
to the important monastic institutions of Kamakura
where he was revered as an instructor in Zen. Evi-
dently the rigors of this life over a period of thirty
years led Nanzan into early retirement at the Sōgen-
in of the Tōfuku-ji, where he died slightly more than
a decade later, in 1335, at the age of eighty-two.

In this *chinsō* Nanzan is shown somewhat past
middle age wearing formal priestly attire. The half-
length view is unusual, as is the candid depiction
created by an economical series of thick ink
brushstrokes and thinly applied washes rather than
fine outline and bright color. The immediacy of the
subject is in large part due to these ink lines, them-
selves guided by faint, slender outlining brushstrokes
that the artist later adjusted or traced over and
heightened. This *chinsō* therefore illustrates two
stages in the preparation of a finished composition.
The unknown artist was probably an amateur monk-
painter from one of the major fourteenth-century
Kamakura temples.

The presence of an inscription by Hōjō Takatoki,
shogunal regent in Kamakura from 1316 to 1326,
suggests that the likeness, though unfinished, was
highly valued, and indeed the calligraphy and the
portrait complement one another stylistically. Tak-
atoki (1303-33), the last head of the Hōjō family,
patronized Rinzai Zen temples of the Kantō (eastern
plain) out of personal religious conviction and also as
an instrument of family political policy: to enhance
the influence of the shogunal government at Ka-
makura at the expense of the imperial court at Kyoto,
as well as the prestige of imported Chinese culture at
the expense of native tradition. He was instrumental
in bringing several venerated Chinese Zen monks
from temples in northern Kyūshū, where Nanzan
had spent a good part of his career, to Kamakura,
where he installed them as abbots at leading temples.
MC

Literature

Hiroshi Kanazawa, *Japanese Ink Painting: Early Zen
Masterpieces*, trans. and adapted by Barbara Ford,
vol. 8 (1979) of *Japanese Arts Library*.

72 *Portrait of the Zen Priest Musō Kokushi*

Mutō Shūi (14th century). Inscription by
Musō Kokushi, dated to 1349. Hanging
scroll; ink and color on silk. H. 120 cm. W.
64.5 cm. Myōchi-in, Kyoto. Important
Cultural Property.

Normally *chinsō* depict the subject seated and in full.
Less frequent are half-length or bust portraits, or
monks shown standing in an abbreviated landscape.
These interpretations represent compositional modi-
fications of Chinese prototypes, adapted the better to
illuminate their Japanese subjects. The half-length
compositions particularly lend themselves to the
broad areas of exquisitely harmonized color charac-
teristic of much of *yamato-e* and Zen thematic
material, as can be seen in this quiet portrait of Musō.
It is one of several half-length *chinsō* among a larger
number of portraits of him, all unrivalled in aesthetic
quality and characterization during the fourteenth
century. Only the later portraits of Ikkyū Sōjun offer
newer insights and keener psychological character-
ization (see [79]).

Musō achieved fame in Japan not only as a
religious activist but as a garden designer, calligra-
pher, literary scholar, and political confidante and
adviser to both emperor and shōgun. He is often
called Musō Kokushi (National Teacher), a
posthumous title conferred by the court. Trained
initially in the precepts of Esoteric Buddhism, he later
embraced Zen, ultimately becoming one of its most
effective exponents and a leader in translating conti-
nental Zen thought into Japanese ideas and form.

The artist Mutō Shūi was Musō's religious disciple
at Tenryū-ji and a painter of other *chinsō*. This portrait
is one of the most sensitively drawn *chinsō* in Jap-
anese painting history and marks him as consider-
ably more than a mere "amateur" monk-painter. MC

Literature

Jan Fontein and Money L. Hickman, *Zen Painting Et
Calligraphy* (exh. cat.; Boston: Museum of Fine
Arts, 1970), cat. 24.
Hiroshi Kanazawa, *Japanese Ink Painting: Early Zen
Masterpieces*, trans. and adapted by Barbara Ford,
vol. 9 (1979) of *Japanese Arts Library*, pl. 10 (color).
Zen no Bijutsu [*Arts of Zen Buddhism*] (exh. cat.;
Kyoto National Museum, 1981), cat. 37.

73 *Portrait of Priest Eison (Kōshō Bosatsu)*

Kamakura period, 13th century. Wood with color. H. 73.9 cm. Byakugō-ji, Nara. Important Cultural Property.

The preeminent sculpture of Eison (1201–90) in Japan is the image enshrined at Saidai-ji, Nara. Commissioned by his students and dated to ten years before his death, it commemorates a lifetime devoted to reviving Ritsu sect Buddhism, which had languished since Heian times. This smaller Byakugō-ji *chinsō* is one of several representations of Eison commissioned for installation in temples associated with the priest's activities. The fortunes of Byakugō-ji, originally a Shingon foundation of modest importance, had been languishing until Eison's donation of a Ritsu sutra imported from China and his initiation of many new temple members. Not surprisingly, Eison was venerated there beginning in the thirteenth century.

This portrait follows the Saidai-ji work in posture and drapery configuration, and so has been considered a faithful copy of that piece. But closer scrutiny reveals a lowering of the shoulders, a flattening of the chest, and a decidely older, less stylized head—all of which contribute to a singluar interpretation of the priest, which probably postdates its Saidai-ji ancestor by a decade. MC

Literature

Bunsaku Kurata, *Zōnai Nonyūhin* [*Consecrated Articles Placed Inside Buddhist Images*], no. 86 (July 1973) of *Nihon no Bijutsu.*

Takeshi Kobayashi, *Shōzō Chōkoku* [*Portrait Sculpture*] (Tokyo: Yoshikawa Kōbunkan, 1969), pp. 132-50.

Hisashi Mōri, *Japanese Portrait Sculpture*, trans. and adapted by W. Chië Ishibashi, vol. 2 (1977) of *Japanese Arts Library*, p. 87 and pl. 82 (sculpture of Eison dated to 1280 in Saidai-ji, Nara).

74 *Warrior on a Horse*

Muromachi period. Hanging scroll; ink and color on silk. H. 100.3 cm. W. 52.3 cm. Nobutaka Moriya, Kyoto. Important Cultural Property.

Portraits of samurai employ a variety of compositional formats and express a number of themes. Those of Takeda Shingen [78] and Asakura Toshikage [76], which portray their subjects at rest, represent two variations on the more orthodox tradition derived in large part from contemporary religious portraiture, especially Zen. The foundations of this tradition can be traced back to Heian period *yamato-e* representations of poets, emperors, and ranking court officials.

In the ensuing Kamakura and Muromachi periods the life of the elite became increasingly warlike, and the civilian aristocracy and its values were submerged by particularly stern military men and military ideals of prowess. Quite naturally, in this new environment painting memorialized important military events and personalities. The theme of this portrait is "going to the front" (*shutsujinei*)—a clan leader riding out from camp to battle. Together with the portraits of Ashikaga Yoshihiki (1465–89) in the Jizō-in, Nagoya, and Hosokawa Sumimoto (1489–1520) in the Eisei Bunkō, Tokyo, it occupies a celebrated place in the history of Muromachi samurai portraiture and culture in Japan. Each painting is executed on silk with the generous use of finely applied color and depicts an impressive mounted warrior in battle dress. Armor, weapons, and elaborate horse fittings are meticulously delineated and correspond to descriptions in contemporary historical chronicles.

The special attributes of this painting include the informal, vigorous attitude of horse and rider, the fine-line drawing and dark, balanced tonal harmonies, and the prominent written seal (*kao*) above the figure. The painting has been traditionally identified as a portrait of the first Ashikaga shōgun, Takauji (1305–58), on the evidence of the *kao* by his son Yoshiakira (1330–68) and of later, essentially nineteenth-century, records. But the credibility of these documents has been convincingly challenged in the last fifty years by professors Tani and Ogino, who point to the unsuitable informality of the depiction, the ambiguous nature of the historical records describing the painting and Takauji's activities, and the inordinate prominence of Yoshiakira's *kao* above his father's image, a lapse of etiquette that would not have been tolerated at the time.

Consequently the subject is no longer identified as Takauji but as an anonymous samurai. Ogino suggests that he might be Hosokawa Yoriyuki, who in the fall of 1367 came to Kyoto at the request of the ailing shōgun Yoshiakira to assume the role of "regent" for Yoshiakira's young son. Yoriyuki was thirty-nine at the time, an age compatible with the appearance of the samurai depicted in this famous scroll. MC

Literature

Minahiko Ogino, "Moriya-ke Bon Den-Ashikaga
 Takauji no Kenkyū" ["A Study of the Supposed
 Portrait of Ashmkaga Takauji Owned by the Moriya
 Family"], *Kokka*, no. 906 (September 1967),
 9-22, repr. p. 11.
Shin'ichi Tani, *Shōzō Senshū* [*Selected Portraits*]
 (Tokyo: Yoshikawa Kōbunkan, 1966), no.
 34, repr. p. 83.
Shin'ichi Tani, ed., *Muromachi Jidai Bijutsu-shi Ron*
 [*On the Art of the Muromachi Period*] (Tokyo: Tokyo-
 do, 1943), 259-306.

75 The Poet Sōgi on Horseback

Kano Motonobu (1476–1559). Hanging scroll;
ink and color on silk. H. 97.6 cm. W. 55.4 cm.
Museum of Fine Arts, Boston. Frederick L. Jack
Fund.

Before the poet Sōgi (1421–1502) died, he had travelled
virtually the entire length and breadth of Japan. An
itinerant Zen priest and master of *renga-waka* (two
traditional forms of linked verse) who chronicled
Japan's rural scenery in his verse, Sōgi is considered a
major poet of the Muromachi era. His works were
acclaimed during his lifetime by people of all classes,
and at least one anthology of his work was produced
by a court-mandated commission. Such recognition is
especially noteworthy in view of the contemporary
Japanese preoccupation with Chinese culture. In 1488
he was appointed master of linked verse at Kitano
Shrine where annual *renga* gatherings honored
Sugawara no Michizane, titular deity of the shrine
and of linked verse (see [30, 31]).

Records of the Edo period note that Sōgi painted
his own portrait and that at one time a portrait of him
by the Kanō master Masanobu also existed. Presently
four portraits are known, the most unusual being one
in the Tokuhō-ji collection and this fine example.

Here Sōgi is shown as a relatively young man
astride a horse, a rare pose for a civilian figure in
Muromachi portraiture. The written seal (*kao*) on
the painting is that of Kanō Motonobu, a son of
Masanobu, and a major figure in the establishment
of the Kanō school in the mid-sixteenth century. MC

Literature

Eiji Akazawa, "Tokuhō-ji Zō Sōgizō ni tsuite" ["The
 Portrait of Sōgi Owned by the Tokuhō-ji"], *Kokka*,
 no. 1052 (October 1982), 7-16.
Kanō-ha no Kaiga [*Painting of the Kanō School*] (exh.
 cat.; Tokyo National Museum, 1979), cat. 43.

76 Portrait of Asakura Toshikage

Muromachi–Momoyama period, 16th cen-
tury. Hanging scroll; ink and color on silk.
H. 81.5 cm. W. 44 cm. Shingetsu-ji, Fukui
Prefecture. Important Cultural Property.

One of the important regional centers of Zen culture
in the fifteenth century was located northeast of
Kyoto in Echizen Province at Ichijō no tani, the
headquarters of the Asakura daimyō Toshikage
(1428–81). Like Takeda Shingen [78], Toshikage was an
able military leader and administrator who, taking
advantage of the breakdown of central government in
the later fifteenth century, expropriated and held
against shogunal authority most of Echizen Province
(present-day Fukui Prefecture). He also promoted the
development at Ichijō no tani of *nō* mask carving and
the Soga ink painting tradition. These Soga school
painters were priestly amateurs from nearby Shinget-
su-ji, which Toshikage established, or from Daitoku-ji
in Kyoto, where Ikkyū was a monk [79, 81].

Toshikage's father, Iekage (1402–50), had made the
acquaintance of Ikkyū, who became an occasional
visitor, along with other Kyoto scholars, at the
Asakura castle near Fukui, built in 1471. The local
monk-painter Soga Bokkei painted for Ikkyū in 1465 a
stern-looking half-length *Daruma* figure, and in ensu-
ing years other Soga school artists painted for him as
well, including *chinsō* and sliding-door (*fusuma*) land-
scape compositions for rooms at the Shinju-an of
Daitoku-ji. During the later 1470s the relationship
between Ikkyū and Toshikage was further strength-
ened by the Echizen daimyō's agreeing to provide
Ikkyū with lumber for the rebuilding of Daitoku-ji, a
task given him by the emperor. The strongest tie
between the Asakura house and Ikkyū was forged
between the priest and Toshikage's nephew, who
studied Zen with the Daitoku-ji abbot, taking the
name Sōshin Etetsu (1444–1519). He became the Shin-
ju-an's fourth abbot, and the *Portrait of Ikkyū and Lady
Mori* [81] bears a dedication to him.

This formal portrait of Toshikage shows scant
similarity to paintings attributed to Soga school art-
ists. Executed on silk in finely drawn, evenly
modulated brushstokes, it depicts Toshikage in
monk's robes holding a fan and prayer beads. The
rich, balanced ink and colors of background and
clothing form a classic, muted framework for the
contemplative facial expression of the sitter. The effect
and actual delineation·are reminiscent of Hasegawa
Tōhaku's *Takeda Shingen*, as well as other portraits by
Tōhaku who, it should be noted, is recorded as
having studied with the Soga painters before going to

Kyoto. The painting, which is neither signed nor sealed, is one of the very finest sixteenth-century daimyō portraits. MC

Literature

Jūyō Bunkazai Hensan Iinkai Hen [Board of Culture, Ministry of Education], ed., *Kaisetsuban Shin-shitei Jūyō Bunkazai: Bunkazai Hogohō Shikō 30-Shūnen Kinen Shuppan* [*Descriptive Catalogue of Important Cultural Properties Appointed in the Past 30 Years*], vol. 1: *Kaiga* [*Painting*], part 1: *Butsuga, Yamato-e, Shōzō-ga* [*Buddhist Painting, Yamato-e, and Portraits*] (Tokyo: Mainichi Shimbunsha, 1981), repr. p. 302.

Takaaki Matsushita, *Muromachi*, vol. 5 (1971) of *Nihon Kaigakan*, pl. 110 (color).

Toyomune Minamoto, "Soga-ha to Asakura Bunka" ["The Soga School and the Culture of the Asakura Clan"], *Kobijutsu*, no. 38 (1972), 29-39.

77 *Portrait of the Zen Priest Daidō Ichii*

Minchō (1352–1431). Inscription by Shōkai Reigen dated to 1394. Hanging scroll; ink on paper. H. 47 cm. W. 16.4 cm. Nara National Museum. Important Cultural Property.

Priest Daidō (1292-1370) died when Minchō was but nineteen years old and just beginning his career as a Zen monk. They met initially at Ankoku-ji on Awaji Island in the Inland Sea, and both subsequently developed their most lasting affiliations with the famous Zen temple Tōfuku-ji.

Daidō Ichii became the twenty-eighth abbot of that institution, and in all likelihood influenced Minchō's decision to study there. Although Minchō remained a Tōfuku-ji monk, he became simultaneously more a professional painter than a religious amateur. He perpetuated the brightly colored, precisely drawn Buddhist portrait style inherited by Kamakura Japan from Southern Sung China, but he also pioneered the impressionistic monochrome ink landscape style, likewise derived from Southern Sung, that we see in this portrait. This was the style that would become paramount in Zen Buddhist art of the Muromachi period. MC

Literature

Jan Fontein and Money L. Hickman, *Zen Painting Et Calligraphy* (exh. cat.; Boston: Museum of Fine Arts, 1970), cat. 42.

Nara National Museum, *Nara Kokuritsu Hakubutsukan Meihin Zuroku* [*Masterpieces in the Collection of the Nara National Museum*] (Kyoto: Dōhōsha, 1980), color pl. 17.

78 *Portrait of Takeda Shingen*

Hasegawa Tōhaku (1539–1610). Hanging scroll; ink and color on silk. H. 42 cm. W. 63 cm. Jōkei-in, Wakayama Prefecture. Important Cultural Property.

The artist Hasegawa Tōhaku began painting portraits well before he arrived in Kyoto. These survive in provincial temple collections on the Japan Sea coast northeast of Kyoto, the area where he was raised. These orthodox Buddhist paintings of priests indicate that by about 1572, when he took the name Hasegawa Shinshun, portraiture already formed an important component of his oeuvre. During the ensuing Shinshun years he expanded his repertoire of Buddhist, Taoist, landscape, and bird-and-flower painting to include secular portraiture. Among these works the portraits of Nawa Nagatoshi and Takeda Shingen (1521–73) are preeminent. The vivid color and fine-line drawing of both samurai paintings are of the first order and the settings highly original.

Here the robust figure of Shingen is shown seated on a *tatami* mat, his sword on a stand beside him and his hawk perched in a nearby tree. These were recognized attributes of the Muromachi period samurai, of whom Shingen is regarded as a virtual epitome for his vigor and bellicosity. He is also credited with having been an excellent civil administrator, one who saw the relationship between economic development and political and military power. By the time he was twenty Shingen had driven his father out of their home province of Kai, northwest of Tokyo, and taken the title of daimyō for himself. Continually pressing campaigns for territory against his neighbors, Shingen became regarded as a dangerous foe and useful but not entirely reliable ally. In the 1560s he fought on the side of Oda Nobunaga, then switched allegiance to Ashikaga Yoshiaki and his attempt to restore shogunal control of the country. In 1573 the inevitable conflict between Nobunaga and Shingen began; Shingen died in the same year, and the Takeda clan, led by his son, went down to defeat in 1582 at the hands of Nobunaga's ally Tokugawa Ieyasu, the future shōgun.

Tōhaku's portrayal of Takeda Shingen confers on the subject a strident air of self-importance unusual even in samurai portraits. The precise delineation of the figure and the garment designs is reminiscent of classical *yamato-e* techniques, whereas the gnarled tree and hawk reflect Tōhaku's study of Sung and Yüan painting. The artist's identity is confirmed by a seal, and the painting can be dated to about 1573 based upon a letter of Shingen's son, who was known to Tōhaku's Zen sponsors at Daitoku-ji. MC

Literature

Tsugiyoshi Doi, *Hasegawa Tōhaku* (Tokyo: Kōdansha, 1977), vol. 2, pl. 21 (color).

Shin'ichi Tani, *Shōzō Senshū* [*Selected Portraits*] (Tokyo: Yoshikawa Kōbunkan, 1966), no. 61, repr. p. 137.

79 *Portrait of the Zen Priest Ikkyū Sōjun*

Inscription by Bokusai (act. late 15th century). Hanging scroll; ink and light color on paper. H. 43.3 cm. W. 26 cm. Tokyo National Museum. Important Cultural Property.

The most important collection of Ikkyū Sōjun's (1394–1481) portraits and writings resides at the Shin-ju-an subtemple of the Daitoku-ji, Kyoto. Ikkyū, son of an emperor, studied there as a young man under Kesō Shūdon (1352–1428), gaining a reputation for his sharp criticism of worldliness at the temple. This was expressed frequently in poetic form, as in the inscription above this *chinsō*, which derives from a poem in his *Kyōunshū* collection.

Written by his painter-follower Bokusai in Ikkyū's style, it may have been added to the painting at a later date, perhaps to replace a lost inscription. Other, more formal *chinsō* are inscribed by Ikkyū himself or by Chinese monks who recognized his Enlightenment. In addition, a few paintings by Bokusai bear inscriptions by Ikkyū. Nevertheless, its revelatory quality makes this the most significant known portrait of Ikkyū. MC

Literature

Daitoku-ji Shinju-an Meihō Ten: Ikkyū Zenji 500 Nen-ki [*Exhibition of Treasures of Shinju-an, Daitoku-ji, Commemorating the 500th Anniversary of the Death of Ikkyū Zenji*] (exh. cat.; Tokyo: Suntory Museum, 1980).

Jan Fontein and Money L. Hickman, *Zen Painting Et Calligraphy* (exh. cat.; Boston: Museum of Fine Arts, 1970), cat. 51 (portrait of Priest Ikkyū, Shūon-an, Kyoto).

Donald Keene, "The Portrait of Ikkyū," in *Landscapes and Portraits: Appreciations of Japanese Culture* (Tokyo and Palo Alto: Kōdansha, 1971), 226-41.

Toyomune Minamoto, *Soga Jasoku*, vol. 3 (1980) of *Nihon Bijutsu Kaiga Zenshū*, pl. 1 (color).

80 *Portrait of the Chinese Priest Dokuryū*

Kita Genki (act. 1664–98). Hanging scroll; ink and color on paper. H. 111.5 cm. W. 50.2 cm. Cleveland Museum of Art 65.31. Mr. and Mrs. William H. Marlatt Fund.

Dokuryū (C. Tai Li) arrived in Japan in 1653, almost ten years after the fall of Ming rule in China. In his adopted country he became a monk and ardent disciple of his fellow-countryman, the priest Ingen (C. Yin-yüan, 1592-1673), founder of the new Zen sect called Obaku (C. Huang-po). Dokuryū traveled extensively, practicing skills esteemed in Japan that he had learned as a young man in China: seal carving, calligraphy, and medicine. He attracted a small group of followers, mostly literati who emulated his scholarly accomplishments, especially his calligraphy, which is displayed on this scroll in a Zen poem of his compositon.

The fluid calligraphy provides a striking contrast to the meticulous delineation of his face and is balanced by the shapes and color values of his garments and straw mat. Almost photographic in its relentless documentation of Dokuryū's facial anatomy, the portrait's origins are to be found in such paintings as the *Portrait of Priest Seigen* [53]. It does impress the viewer as somehow "modern," even Western, and indeed the artist Kita Genki enjoyed a modest reputation in Nagasaki as a portraitist versed in Chinese and Western painting techniques. A number of fine Obaku *chinsō* survive from his hand, forming a distinctive group among the paintings of this sect. MC

Literature

Sekkō Hayashi, *Obaku Bunka* [*Culture of the Obaku Sect*] (Uji: Obakusan Mampuku-ji, 1972).

Kōbe Shiritsu Namban Bijutsukan Zuroku [*Pictorial Record of the Kōbe City Museum of Namban Art*] (Kobe, 1968), vol. 5, pls. 28-33.

Tei Nishimura, *Nihon Shoki Yōga no Kenkyū* [*A Study of Early Western-Style Painting in Japan*] (Kyoto: Zenkoku Shobō, 1945), pp. 266-321, color pl. 3.

81 *Portrait of the Zen Priest Ikkyū and Lady Mori*

Inscription by Ikkyū (1394–1481). Hanging scroll; ink and color on silk. H. 81.4 cm. W. 34.3 cm. Masaki Art Museum, Osaka.

Ikkyū's criticsm of his colleagues at Daitoku-ji, together with the imminent dangers of the Onin War (1467–77), led to his retreat to a small temple south of Kyoto, near Nara. At the Shūon-an he wrote exten-

sively and trained a small number of dedicated Zen acolytes, including Asakura Sōshin (1444–1519), nephew of the daimyō Asakura Toshikage (1428–81) [76]. When the emperor Go-Tsuchimikado in 1474 made Ikkyū the abbot of Daitoku-ji and commissioned him to supervise its reconstruction following the wars, the Asakura domains provided substantial material support.

He dedicated this unusual double portrait of himself and his mistress Lady Shin, as he called her in his poetry, to his disciple Sōshin, later abbot of the Shūon-an and Shinju-an. A blind itinerant musician said to be of imperial lineage, Lady Shin met Ikkyū about 1468 and a well-chronicled romance ensued in his later years. Ikkyū's four-line poetic inscription in Chinese characters above his bust-portrait extols Lady Shin, while the lines below in Japanese, also by Ikkyū, record her sentiments on the nature of human transience. Judging from other chinsō, Ikkyū is here portrayed rather young. Lady Mori kneels on a green tatami mat with a drum in front of her and a walking staff at her side.

The painting is attributed to Soga Jasoku (act. late fifteenth century), the best-known painter associated with the Shinju-an and an accomplished landscapist.

MC

Literature

Daitoku-ji Shinju-an Meihō Ten: Ikkyū Zenji 500 Nen-ki [*Exhibition of Treasures of Shinju-an, Daitoku-ji, Commemorating the 500th Anniversary of the Death of Ikkyū Zenji*] (exh. cat.; Tokyo: Suntory Museum, 1980).
Takayuki Masaki, *Masaki Bijutsukan Meihin Zuroku: Shoga Hen* [*Illustrated Catalogue of Masterpieces in the Masaki Art Museum: Calligraphy and Painting*] (Kyoto: Dōhō-sha, 1978), color pl. 6 (detail) and pl. 54.

82 *Nehan* [*The Death of the Buddha Sakyamuni*]

Kamakura period, 13th century. Hanging scroll; ink and color on silk. H. 163 cm. W. 169.7 cm. Kyoto National Museum. Important Cultural Property.

Depictions of the death of the historical Buddha constitute one of the universal visual images of medieval Buddhist faith in Japan. Regardless of their particular sectarian affiliation, large monastic institutions invariably owned *Nehan*, which were ceremoniously displayed on the fifteenth day of the second month each year. During the late Heian and early Kamakura periods, services commemorating

Sakyamuni's death occurred principally within monastic communities, but with the spread of Pure Land beliefs laymen were invited to attend also. The subject lent itself to historical explanation as well as direct emotional understanding, so that by the fourteenth century this annual day of mourning became a popular event throughout the country.

The painting subject possesses general appeal due to its inherent drama and because the range of beings shown mourning around Sakyamuni's bier virtually assures the interest and compassion of any viewer. Men, women, and a variety of animals, all rendered in the T'ang Chinese tradition, mournfully attend the Buddha in a grove of *sala* trees, half of which are blossoming and half of which appear dead. Behind, a river courses quietly, lit by the moon rising above a cloud bank. Sakyamuni lies on his right side, his head resting on a lotus pedestal and both arms extended at his sides. (In the earliest, textually correct depictions his right hand pillows his head.) These are features seen in a number of Kamakura *Nehan* paintings that emphasize the inherent horizontal nature of the composition and derive from an older type. Sakyamuni's mother, Maya, is not present, nor are the Buddha's staff, begging bowl, and robe shown near the bier as in other *Nehan*.

The *Nehan* subject occurs at several important pilgrimage sites across Central and East Asia. The earliest representation in Japan can be seen in the sculptural composition in the base of the Hōryū-ji pagoda, dated to the eighth century. The next important representations are the dated paintings of the Late Heian era, which already deviate from literary descriptions of the *Nehan* contained in the sutras. MC

Literature

Nehanzu no Meisaku: Tokubetsu Chinretsu [*Masterpieces of Nirvana Painting: A Special Exhibit*] (exh. cat.; Kyoto National Museum, 1978), cat. 16.

83 *Bending Shaka*

Kamakura period. Hanging scroll; ink, color, and gold on silk. H. 110.6 cm. W. 49.5 cm. Saikyō-ji, Shiga Prefecture. Important Cultural Property.

Tradition at the Saikyō-ji calls this radiant painting the *Mochihachi Shaka Nyorai* [*Shaka Nyorai Holding the Alms Bowl*]. The alms bowl is represented only infrequently in paintings of Shaka, but it does appear in Korean images of the Koryō dynasty (918-1392) and also in *Nehan* paintings (see [82]). It refers to the time

in the historical Buddha's life, after his trial of asceticism in the mountains, when he was an itinerant preacher living on alms (see [50,65]). The bending posture of this Shaka occurs in Korean and Japanese images of attendants to Amida and Shaka. In conjunction with the pious offering of the alms bowl it presents an especially appealing image. The "welcoming descent" (*raigō*) paintings of the Pure Land sect provide many examples of attendant bodhisattvas leaning forward toward the devout believer, whose spirit they have come to escort to the Western Paradise (see [26a]).

The golden halo of this painting incorporates ten angel-musicians (*apsarases*) and nine seated Buddhas into its design, whose apex is a small pagoda. The drawing of the Shaka and the robe patterns point to continental sources of the late thirteenth and early fourteenth centuries, which had an important impact on late Kamakura Buddhist imagery. Its transmutation into the Japanese vocabulary can also be examined in two novel sculptural images, both in Jōdo temples in Kyoto: the walking *Amida Nyorai* at the Anjū-in and the *Mikaeri Amida* [*Amida Who Looks over His Shoulder*] at Zenrin-ji.

The silk at the top of the painting above the top margin of the inscription was added in recent times to restore the painting to its original dimensions. The inscription, in part indecipherable, acknowledges the efficacy of the *Mochihachi Shaka's* compassion for those who "hunger" for spiritual redemption. MC

Literature

Takashi Hamada, ed., *Enryaku-ji, Onjō-ji to Saikyō-ji* [*Enryaku-ji, Onjō-ji, and Saikyō-ji*], vol. 10 (1980) of *Nihon Koji Bijutsu Zenshū*, pl. 100.

Tsugio Miya, ed., *Hongan-ji to Chion-in* [*Hongan-ji and Chion-in*], vol. 21 (1982) of *Nihon Koji Bijutsu Zenshū*, pl. 71 (Mikaeri Amida, Zenrin-ji).

Nihon Bukkyo Bijutsu no Genryū [*Sources of Japanese Buddhist Art*] (exh. cat.; Nara National Museum, 1978), Painting, no. 36 (Amida Nyorai and Attendants, with "bending" bodhisattva, private collection, Tokyo).

Hiroyuki Yoshida and Susumu Hayashi, *Kōrai Butsuga* [*Korean Buddhist Paintings of the Koryō Dynasty* (918–1392)] (exh. cat.; Nara: Yamato Bunkakan, 1978).

84 *Hashiri Fudō* [*Running Fudō*]

> Kamakura period, late 13th century. Hanging scroll; ink and color on silk. H. 128.8 cm. W. 58.5 cm. Takahashi Tarō, Tokyo. Important Cultural Property.

Fudō Myōō, a fearsome-looking Esoteric deity introduced into Japan in the ninth century, is called "the Immovable One." Shingon sectarians worshiped him as a manifestation of the potent Birushana (S. Vairocana) Buddha seen in complex painted or sculpted mandalas. As his image gained popularity during the Heian and Kamakura periods, Fudō himself became an object of worship; he was shown seated on a rock, one eye wide and the other squinting, attended by his two essential servants Kongara Dōji and Seitaka Dōji (see [66]).

This impressive painting deviates from standard iconography: "the Immovable One" is running, both eyes are wide open and glaring, and his flaming halo is not vertical but streams behind him from the speed of his passage. But, as is customary, he holds the sword of wisdom and a lasso, his hair hangs over his left shoulder, and he glowers furiously. The torso is in poor condition, but the hair, eyes, legs, and most of the arms reveal the clear, precise drawing that characterizes the figural treatment in this painting. The original dark blue color of the body has deteriorated, exposing underdrawing and simple, well-balanced ink tonal values which abut rather than cover the brushwork. The meticulous linear drawing of the hair with gold, and the application of white pigment to heighten the red flame patterns are especially noteworthy.

Two somewhat differing traditions connect this painting with the Mongol invasions of the late thirteenth century. One has it that this was the icon to which the emperor Kameyama prayed for aid against the invaders; the other, that it was executed to commemorate the defeat of the Mongols and that the artist was Fujiwara Nagataka, active at that time and associated with the *Mōko Shūrai E-kotoba*, which illustrates scenes from the Mongol invasion. Other sources mention that the Kōzan-ji painter whose name is intimately linked with the *Chōjū Jinbutsu Giga* [23], Toba Sōjō, painted a *Running Fudō*, and that the present scroll was once one of the treasures of the Kajibashi branch of the Kanō school painters of Edo. It may be reasonably dated to the late thirteenth century. MC

Literature

Genzō Nakano, *Gazō Fudō Myōō* [*The Iconography of Fudō Myōō*] (exh. cat.; Kyoto National Museum, 1980.

Hideo Okudaira, *Kamakura*, vol. 4 (1970) of *Nihon Kaigakan*, color pl. 21 (detail).

85 *Kannon*

Attrib. Shōkei (act. ca. 1478–1506). Hanging scroll; ink on silk. H. 128.5 cm. W. 51.8 cm. Kenchō-ji, Kanagawa Prefecture. Important Cultural Property.

Kenkō Shōkei is known as a priest at Kenchō-ji in Kamakura who went to Kyoto in 1478 to study painting with Geiami (1431–85). Geiami, who was a layman, enjoyed a sound reputation as a painter-connoisseur and aesthetic advisor to the shōgun Yoshimasa (1435–90) and was a friend of many important Kansai (Kyoto-Nara) area clerics. Shōkei trained under Geiami for three years before returning to Kenchō-ji. There he in turn taught painting and inspired a line of individualist ink painters who, like himself, produced Southern Sung style images that depart somewhat from the orthodox iconic subjects and brush style of Kyoto painters.

The White-Robed Kannon, a well-known subject in Buddhist art since at least the thirteenth century, personifies the Buddha's compassion. To the traditional depiction of a feminine-looking, or at least androgynous, deity sitting relaxed on a rock above lapping waves, Shōkei has added an amusing visual anecdote: this Kannon leans back on one hand and pulls up his white robes with the other so as to cool his feet under a tiny mountain waterfall. It is a gesture wonderfully familiar, slightly ungainly, and hardly godlike!

This is one scroll from a set of thirty-two representations of Kannon traditionally assigned to Shōkei. Since Shōkei surely knew the "Fumon" chapter of the Lotus Sutra [20], which describes thirty-three manifestations of Kannon, and must have painted this set with that text in mind, it is likely that one or more scrolls have been lost. Furthermore another, possibly earlier, hand can be seen in some of the scrolls. MC

Literature

Shun Etō, *Sōami/Shōkei*, vol. 6 (1979) of *Nihon Bijutsu Kaiga Zenshū*, pl. 28 (color; four scrolls from set).

Hiroshi Kanazawa, *Japanese Ink Painting: Early Zen Masterpieces*, trans. and adapted by Barbara Ford, vol. 8 (1979) of *Japanese Arts Library*, 69-84.

Tanio Nakamura, *Shōkei*, vol. 9 (1970) of *Tōyō Bijutsu Sensho*.

86 *Portrait of the Zen Priest Guchū Shūkyū (Guchūshūkyū)*

Nambokuchō period. Hanging scroll; ink and color on silk. H. 104.8 cm. W. 42 cm. Buttsū-ji, Hiroshima Prefecture. Important Cultural Property.

Guchū Shūkyū (1323–1409) studied with the Chinese Ch'an (Zen) monk Chi-hsiu Ch'i-liao (1276–1351) from 1341 until the master's death. Prior to returning to Japan, the young Japanese acolyte obtained his teacher's formal portrait, a *chinsō* showing him at age seventy-five, according to his own inscription above the portrait. Below the portrait Shūkyū in the summer of 1400 wrote a short note asking that the *chinsō* be preserved at Tennei-ji in Fukuchiyama north of Kyoto, where he had been abbot since 1365.

Chi-hsiu Ch'i-liao is portrayed sitting cross-legged, in formal attire, holding a whisk in one hand, his slippers placed on a stool in front of him. The chair in which he sits is unusual in that a round woven mat backrest is positioned directly behind the monk. A similar backrest appears in the late twelfth-century Ch'an patriarch handscroll by Chang Sheng-wen in the National Palace Museum, and in Japan in the anonymous thirteenth-century Zen patriarch sketches at Kōzan-ji. It is an iconographical feature of the earliest Ch'an patriarch portraits. But in a *chinsō* of Shūkyū in Tennei-ji bearing an inscription by the monk Reichū Zenei (1330–1410) the backrest appears again, indicating Shūkyū's close relationship with continental Ch'an tradition. Shūkyū appears somewhat diminutive, sitting in a high-backed abbot's chair of Chinese design, hands clasped in his lap. It is a subdued, careful rendering of a traditional Sung style *chinsō*.

This dramatically contrasting *chinsō* showing Shūkyū with his hand on his head comes from Buttsū-ji, a temple founded by Shūkyū before joining Tennei-ji. His face is carefully delineated, the gray and white stubble of beard and pate unusually prominent. The muted tones of outer robe and *kesa* and the sharp white of the inner robe offsetting them are also idiosyncratic. The rustic chair, shaped like a classic Ch'an priest's armchair but made of knotty tree limbs, is a modification of early Chinese bamboo examples occasionally seen in later Japanese *chinsō*. And instead of formal silk slippers, a pair of coarsely woven, straw-like ones are depicted, another refer-

ence to early Chinese patriarch portraits, in which common sandals are shown. The inscription above is by Shūkyū.　　　　　　　　　　　　　　　　　MC

Literature

Helmut Brinker, *Die Zen-Buddhistische Bildnismalerei in China und Japan*, Münchener Ostasiatische Studien, Band 10, pl. 69a (portrait of Chi-hsiu Ch'i-liao, Tennei-ji), pl. 70 (portrait of Guchū Shūkyū, Tennei-ji).

87　*The Poet Taira no Kanemori*

Kamakura period, 13th century. Detached section of the handscroll *Sanjūrokkasen* [*Thirty-six Immortal Poets*], mounted as a hanging scroll; ink and color on paper. H. 28.6 cm. W. 46.7 cm. Cleveland Museum of Art 51.397. John L. Severance Fund.

The subject of the Thirty-six Immortal Poets is associated with Kyoto culture of the later Heian period and occurs again in the early Edo era [90]. In particular, the emperors Go-Toba (1180–1239) and Go-Mizunoo (1596–1680) promoted the theme visually and in literary form as a reaction against the increasingly militaristic environments of their time. The earliest known paintings of the theme—two handscrolls, now dispersed, called the *Satake bon* and the *Agedatami bon*, date to the Kamakura period. The Satake Collection scroll (*Satake bon*) is attributed to the painter-priest Fujiwara Nobuzane (1176–1265) by literary association. The other scroll, known as the *Agedatami bon*, is traditionally dated slightly later and is also frequently attributed to Nobuzane despite stylistic dissimilarities with the *Satake bon*. Neither in fact may be the set mentioned in the diary of Fujiwara Teika (1162–1241) as a gift to the exiled Go-Toba from Fujiwara no Yoshitsune (1169–1206).

This painting is one section from the *Agedatami bon*, depicting the poet Taira no Kanemori (d. 990) in twelfth-century dress. His outer court robes are painted in deep black ink with a slightly glossier black applied over this surface to describe an intricate textile pattern of reserve designs. The lacquered gauze hat and wooden tablet held by Kanemori are standard features of paintings of court poets. Kanemori's face is simply delineated and appears slightly older looking than his likeness in the *Satake bon*.

To the poet's left a brief biography of Kanemori and melancholy poem attributed to him complement the composition. In the original handscroll, which unrolled from right to left, the text would have appeared before the portrait. The same text appears in the *Satake bon* and the *Agedatami bon*. The calligraphy here is attributed to Fujiwara no Tameie (1198–1275).　　　　　　　　　　　　　　　　　MC

Literature

Sherman E. Lee, Michael R. Cunningham, and Ursula Korneitchouk, *One Thousand Years of Japanese Art (650-1650) from The Cleveland Museum of Art* (exh. cat.; New York: Japan House Gallery, 1981), cat. 12.
Yoshi Shirahata, *Kasen-e* [*Paintings of Poets*], no. 96 (May 1974) of *Nihon no Bijutsu*, pl. 37 (ex-Satake collection), pl. 64.

88　*Tōhoku-in Shokunin Uta Awase E-maki* [*Tōhoku-in Poetry Contest Among Members of Various Professions*]

Kamakura period, 14th century. Handscroll; ink and light color on paper. H. 29.1 cm. W. 533.6 cm. Tokyo National Museum. Important Cultural Property.

The political and social instability that plagued China at the beginning of the tenth century discouraged Japanese missions to the continent. Freed for several centuries from the dominance of Chinese models, a more indigenous cultural style was allowed development. The poetic form called *waka*, based on a thirty-one-syllable verse written in Japanese, came to maturity during this era. The composition of poems (*uta*) was a pastime restricted to the aristocracy. At elegant poetry contests (*uta awase*) teams vied to produce the most appropriate verse on a designated theme. Their word play was governed by a refined aesthetic code. Winners were chosen, and both the poems and commentary offered at these events were assembled into anthology form. Later, individual authors found the *uta awase* a serviceable format, creating imaginary competitions between unlikely contestants, whether human, animal, or insect.

Relatively few of the many recorded Heian period *uta awase* were developed into illustrated scrolls. Two anthologies, *Sanjūrokuninsen* (or *Sanjūrokuninshū*) [*Anthology of the Thirty-six Immortal Poets*] compiled by Fujiwara no Kintō (966–1041) and the cloistered emperor Go-Toba's (1180–1239) *Jidai Fudō Uta Awase* [*Competition Among Poets of Different Periods*] inspired handscrolls combining imaginary portraits of the poets with calligraphy of their poems. These became prototypes for *kasen-e*, or portraits of famous poets. The *Tōhoku-in Shokunin Uta Awase E-maki*, exhibited here, derives its format, albeit in parody, from this classic tradition.

A section of text at the beginning of this scroll relates that on the thirteenth day of the ninth moon in 1214, worshippers gathered for a *nembutsu* prayer service at the Tōhoku-in in Kyoto. A particularly brilliant moon seduced the participants from pious devotion and inspired a poetry contest on the theme of "the moon and love." The competition was a delightfully ludicrous affair because the competitors were not aristocrats but *shokunin*, people from the "common" trades or occupations. The *shokunin uta awase* was yet another fiction that derived its humor from casting tradespeople in the roles of courtiers, thus allowing for a multilevelled satire on class pretensions.

The "poets," drawn with the identifying attributes of their occupations, are seated against blank background, a feature distinctive of early works of this type. In later versions ground lines and other background devices fill this space, eventually creating compositional units and conventional scenes of a kind used regularly in the genre painting of the Momoyama and Edo periods.

The texts of four major *shokunin uta awase* survive from the Kamakura and Muromachi periods. Of these the Tōhoku-in tale is oldest. Likewise, the scroll seen here is the earliest-known illustrated version of its text. Stylistic analysis suggests a dating no later than the mid-fourteenth century, a conclusion that lends credence to a colophon indicating ownership by Emperor Hanazono (1297–1348) [57]. JU

Literature

Hisatoyo Ishida, *Shokunin Zukushi-e* [*Paintings of Various Occupations*], no. 132 (May 1977) of *Nihon no Bijutsu*.

Tōru Mori, *Ise Shin Meisho-e Uta Awase, Tōhoku-in Shokunin Uta Awase E-maki, Tsurugaoka Hōjō-e Shokunin Uta Awase E-maki, Sanjūni-ban Shokunin Uta Awase E-maki* [*Poetry Competition on Newly Se-lected Spots in Ise, Tōhoku-in Poetry Competition Among Persons of Various Professions, Tsurugaoka Poetry Competition Among Persons of Various Professions on the Occasion of the Hōjō Ceremony, Poetry Competition Among Persons of Various Professions in Thirty-two Rounds*], vol. 28 (1979) of *Nihon E-makimono Zenshū*, with English summary, repr. pp. 30-36, color pls. 6-8 (sections).

89 *Haisen Gunkai* [*Gathering of Haiku Poets*]

Yosa Buson (1716–83). Hanging scroll; ink and color on silk. H. 35 cm. W. 37 cm. Kakimori Bunko, Hyōgo Prefecture.

In the early decades of the seventeenth century Tokugawa Ieyasu (1542– 1616) obliterated by force all opposition to his claim to rule Japan as shōgun. Following the precedent of the Kamakura militarists, Ieyasu separated from the effete preoccupations of Kyoto court life and established the effective center of national power to the east, in Edo (Tokyo).

During this period, in a less brutal but equally conclusive fashion, the monopoly over aesthetic norms was wrested from patrician control. Poetry had long been an aristocratic preserve. Rules of composition, knowledge of specialized vocabulary, and arcane interpretative methods were skills selectively transmitted to promising initiates who held, in addition, the prerequisite class pedigree. Yet, in a gesture that typified the increasing social fluidity of the sixteenth century, the courtier-poet and *waka* master Kujō Tanemichi (1507–97) agreed to train the precociously talented Matsunaga Teitoku (1571–1653), son of the Takatsuki daimyō, but unconnected to imperial bloodlines. Teitoku in turn instructed a generation of "commoner" disciples who disassembled traditional composition patterns and introduced unorthodox, pedestrian language to their verse. The result of this ferment of poetic experimentation was the seventeen-syllable haiku, and the acknowledged master of this jarring and evocative juxtaposition of inconsonant elements was Matsuo Bashō (1644–94).

In 1736 Yosa Buson, son of farmers from the Osaka area, travelled to Edo and there studied haiku for six years under the tutelage of Hayano Hajin (1677–1742). Hajin, also known as Yahantei, claimed descent from Bashō through his disciples Takarai Kikaku (1661–1742) and Hattori Ransetsu (1654–1707).

Exhibited here is the earliest-known irrefutably authentic painting by Buson, a remarkable historical document that underscores his dual vocation for painting and poetry. Depicted in the lower third of the scroll are figures of fourteen renowned poets whose periods of activity ranged from the fifteenth through the early eighteenth centuries. Kikaku and Ransetsu are included in this assemblage, painted in the *kasen-e* style employed by Buson to pay tribute to predecessors influential in his craft (also see [90]). Above the painting is representative poetry by these masters. The extreme upper portion of the scroll is an affixed explanatory preface written by Buson at a much later date. Buson identifies the work as his own, a product of the Genbun era (1736–41). After

self-deprecatory remarks about the embarassingly unskilled efforts of his youth, he notes that he has taken the name Yahantei and resides in the south of Kyoto. Several occasions would have offered reason for the artist to resurrect this early painting, surely executed during his years with Hajin, and to append a retrospective note: in 1770 Buson was recognized as the poet-successor to Hajin and received the name Yahantei; in the thirty-third year after Hajin's death, 1774, an anniversary accorded special significance in the Buddhist memorial cycle, Buson wrote an essay acknowledging indebtedness to Hajin and claiming spiritual links with Bashō.

The Chinese tradition of literati painting eschewed polished academic style, praising instead a studied awkwardness and brevity that skillfully conveyed the essential nature of a subject. Buson's career was largely a record of assimilation and reinterpretation of the Chinese idealism. This early work recalls for the viewer Buson's genesis from Kanō and Tosa techniques and the degree to which the haiku aesthetic continually informed his art. JU

Literature

Calvin L. French, *The Poet Painters: Buson and His Followers* (exh. cat.; Ann Arbor: University of Michigan Museum of Art, 1974).

Donald Keene, *World Within Walls: Japanese Literature of the Pre-Modern Era, 1600-1867* (London: Secker and Warburg, 1976).

Earl Miner, *Japanese Linked Poetry: An Account with Translations of Renga and Haikai Sequences* (Princeton: Princeton University Press, 1979).

Jōhei Sasaki, *Yosa Buson*, no. 109 (June 1975) of *Nihon no Bijutsu*.

Shōtarō Yasuoka and Jōhei Sasaki, *Yosa Buson*, vol. 13 (1975) of *Bunjinga Suihen*, pl. 13 and p. 153.

90 *Sanjūrokkasen [Thirty-six Immortal Poets]*

Attrib. Tatebayashi Kagei (act. first half of 18th century). Two-fold screen; ink and color on paper. H. 168.9 cm. W. 182.6 cm. Cleveland Museum of Art 60.183. Mr. and Mrs. William H. Marlatt Fund.

The subject of the *Thirty-six Immortal Poets*, never wholly eclipsed, enjoyed a strong revival beginning in the late sixteenth century. Some Edo period renditions follow the established compositional mode of the *Satake* and *Agedatami* sets [87], representing the poets formally and sequentially against a virtually blank background, in conjunction with their verses. Others introduced novel formats, among which close

grouping and the use of simple brush line and colorful ink wash proved especially popular. Many Momoyama and early Edo period artists bypassed the Tosa school representations of the recent Muromachi period for Heian and Kamakura court models, which they adapted or transformed. Prominent among these revivalists were the early *rimpa* (decorative school) artists Tawaraya Sōtatsu (?–1643?) and Ogata Kōrin (1658–1716) [101, 102] and their later followers Watanabe Shikō (1683–1755), Sakai Hōitsu (1761–1828), Suzuki Kiitsu (1796–1858), and Tatebayashi Kagei.

Kagei was, conjecturally, a physician from Ishikawa Prefecture who studied with the ceramicist-painter Ogata Kenzan (1663–1743). He painted flowers, grasses and trees, and figures. The figure paintings in particular demonstrate an intimate knowledge of compositions by Kenzan's older brother Kōrin, who lived in Kyoto. Since Kōrin died in 1716 and Kenzan only started to paint in the following decade, before he went to Edo in 1731, Kagei surely had access to Kōrin paintings firsthand.

This two-fold screen attests Kōrin's influence, since it reiterates his composition now in the Tokyo National Museum (and precedes Hōitsu's copy in the Freer Gallery). Kagei's name is associated with it by reason of a barely legible seal in the lower left-hand corner of the left panel. Far more apparent is the good-humoredly satirical and decorative interpretation the artist has given to Kōrin's parody of the Heian theme. The imaginary portraits verge on outright caricature, but the flat color harmonies and subtle ink washes are thoroughly engaging. MC

Literature

Motoaki Kōno, ed., *Kōrin-ha*, II [*Kōrin School*, pt. II], vol. 4 (1980) of *Rimpa Kaiga Zenshū*, with English summary, no. 196, repr. p. 217.

Rimpa: Sōritsu Hyakunen Kinen Tokubetsu Ten Zuroku [*Rimpa: Special Exhibition Catalogue of the Centennial Anniversary*] (exh. cat.; Tokyo National Museum, 1973), cat. 86 (Thirty-six Poets by Kōrin).

Yūzō Yamane, *Rimpa*, vol. 5 (1979) of *Zaigai Nihon no Shihō*, color pl. 98 and p. 149.

91 *Kotobiki-no-miya E-engi [Legends of Kotobiki Shrine]*

Kamakura period, 13th century. Hanging scroll; ink and color on silk. H. 102.1 cm. W. 140.3 cm. Kannon-ji, Kagawa Prefecture. Important Cultural Property.

Legend concerning the establishment of the Kotobiki Shrine states that in 703 a white cloud rose from the Usa Hachimangu Shrine on the northern coast of

Kyūshū and moved eastward through the Inland Sea, settling "like a rainbow" about a group of mountains on the western coast of Shikoku. As it floated above the waves, the sound of a *koto* (zither) being played aboard a boat could be heard. The history of the temple associated with this shrine, the Kannon-ji, is related in a separate record, which states that Kōbō Daishi (Kūkai 774-835), the venerated founder of the Shingon sect, stopped here on his return from China and founded the temple prior to continuing his journey (see [53]).

Both events are incorporated into this generously proportioned hanging scroll. The shrine precincts are visible atop the verdant central mountain capped by a long white cloud. Below and to the left a group of Shintō priests greet the legendary boat, which is being hauled in to land. Shrine tradition holds that the boat was finally installed in a special hall within the establishment, whose several outbuildings, some quite extensive, are shown here.

The buildings clustered at the foot of the mountain form the Kannon-ji, including its own Shintō shrine. Deer roam nearby, and overhead a flock of ducks fly toward the peak and the open sea. Other such vignettes dot the landscape, which displays the colors of fall and spring simultaneously in the same appealing way in which it combines Shintō and Buddhist imagery. An unreliable colophon attached to the painting assigns it to the hand of Tosa Mitsunobu (1434–1525). The bird's-eye perspective, the compression of the seasons, and the treatment of the landscape elements point to a mid-Kamakura date. This scroll is perhaps the oldest extant pictorial representation of the history of a shrine in Japan. MC

Literature

Tōru Shimbo, *Kaiga*, III [*Painting*, pt. III], vol. 9 (1974) of *Jūyō Bunkazai*, pl. 239.

Takeshi Kuno, ed., *Kanzeon-ji to Kyūshū, Shikoku no Koji* [*Kanzeon-ji and Other Ancient Temples in Kyūshū and Shikoku*], vol. 20 (1981) of *Nihon Koji Bijutsu Zenshū*, pl. 73 (color) and p. 145.

Shikoku, pt. 1: *Kagawa, Tokushima* [prefectures] (1973) in *Kokuhō Jūyō Bunkazai Bukkyō Bijutsu*, no. 47, repr. pp. 108-9; 196-99.

92 *Kumano Mandala: The Three Sacred Shrines*

Kamakura period, ca. 1300. Hanging scroll; ink and color on silk. H. 134 cm. W. 62 cm. Cleveland Museum of Art 53.16. Purchase, John L. Severance Fund.

Kumano is located in the mountainous area at the tip of the Kii Peninsula south of Osaka. This has been a major pilgrimage destination since the Heian period, when the region's association with the mythic founders of the land of Japan became increasingly popular. Beginning with the eighth-century *Nihon Shoki*, Japanese literature abounds with references to Kumano and to the three syncretic Shintō-Buddhist shrines depicted in this painting which are the focuses of its holiness. The main shrine (Hongū) located along the upper Kumano River high in the cypress-forested mountains, is shown at the bottom of the composition. Shingū Shrine, on the eastern coast of the peninsula, is in the middle, and Nachi Shrine, named after the famous waterfall, occupies the top portion of this mandala. The three shrines of Kumano are actually about eighty miles apart.

Each shrine is depicted meticulously within its own discrete landscape setting bounded by mountains, water, and mist bands. Small Buddhist deities hover over shrine buildings, emanations of the resident *kami* to whom they correspond. Within the shrine precincts pilgrims of varying social ranks pray. Outside, in the beautiful spring landscape, an array of detail both secular and religious leads the viewer on a sequential reading of the painting similar to that appropriate for the *Kotobiki no Miya E-engi* [91], the *Mandala of Pilgrimage to Mt. Fuji* [93], and handscrolls such as the *Saigyō Monogatari* [27] and *Ippen Shōnin Eden* [28]—in both of which a Kumano pilgrimage appears. En no Gyōja [48] appears with his two attendants at the upper left of the scroll, a reminder of Shugendō's influence upon the prosperity of Kumano. Above that scene *niō* [47] guard the entrance gate to a temple complex hidden in the mountains. In the lower segment of the painting woodcutters and *oni* (demons) populate the high mountain terrain overlooking the Hongū Shrine, and a group of pilgrims to the shrine has just disembarked from a riverboat.

A good number of Kumano mandalas survive from the Kamakura period and later, but these are usually geometric arrangements of the Buddhist tutelary deities of the shrine. Illustrations of the shrines themselves are uncommon. Rarer yet is a scroll such as this, which incorporates all three shrines, their settings, and their divinities into one vision. In its strong *yamato-e* character this painting closely resembles the *Ippen Shōnin E-den* and *Kasuga Gongen Reigen Ki E-maki* [*Illustrated Scroll of the Kasuga Gongen Miracles*], providing a date of about 1300. MC

Literature

Haruki Kageyama, *Kamigami no Bijutsu* [*The Arts of Japanese Gods*] (exh. cat.; Kyoto National Museum, 1974), cat. 23.

Sherman E. Lee, Michael R. Cunningham, and
Ursula Korneitchouk, *One Thousand Years of Japanese Art (650-1650) from The Cleveland Museum of Art* (exh. cat.; New York: Japan House Gallery, 1981), cat. 15.

Kōzō Sasaki and Hideo Okumura, ed., *Shintō no Bijutsu: Kasuga, Hiyoshi, Kumano* [*Arts of Shintō: Kasuga, Hiyoshi, and Kumano Shrines*], vol. 11 (1979) of *Nihon Bijutsu Zenshū*, pl. 161 (color).

93 *Mandala of Pilgrimage to Mt. Fuji*

Muromachi period. Hanging scroll; ink and color on silk. H. 109.4 cm. W. 80.3 cm. Takeuchi Setsuko, Tokyo.

Mt. Fuji has been considered a sacred mountain in Japan since well before the mid-ninth-century eruption that marked the founding of Sengen Shrine. The shrine, which provided a formal home for the principal resident mountain deity (*kami*) of Japan, Konohana no Sakuya Hime, in all likelihood resulted from the increasing production of religious imagery brought about by Buddhist influence. Initially the Shintō shrine was placed at the top of Mt. Fuji and was called by several names, including Sengen Daibosatsu and Sengen Daimyōjin, which reflect the strong Shintō-Buddhist syncretism of the time. Later the main shrine was established at Omiya near the base of the mountain and became known as Omiya Sengen Shrine, with one branch remaining on the mountain peak and another early tenth-century branch built on Mt. Shizuhata in Shizuoka Prefecture.

The shrine's development was linked in part with increased activity by Shugendō sects (see [48]), who considered the ascent of Mt. Fuji an essential lifetime goal and used the Sengen Shrine grounds as a staging area. This use intensified in the Momoyama and early Edo periods, when a new religious group in the Kantō and Tōkai (the coast south of Kamakura) regions, called Fuji-kō, promoted the ascent of the mountain as a rite of religious purification. Fuji-kō members are plainly visible in this painting, arriving at the shrine precincts at the base of the mountain by various routes and again in white robes ascending the mountain along three distinct routes above the clouds. The ascents normally took place during June and July and, as the presence of the sun and moon suggest, by night as well as by day. Above the central peak is a reduced Taizōkai (Womb World) mandala in the form of an eight-petalled lotus platform, with Dainichi Nyorai at its center presiding over the landscape as the resident Buddhist deity of the shrine.

Pilgrimage mandalas, which originated in the fifteenth century, were icon paintings subscribed by groups of believers for display at the shrine. They tended to be large and rather naive productions, showing the shrine and its environs with special emphasis on distinctive landmarks or festivals. This painting's composition is complex but accommodates sequential reading within a unified thematic plan. The Pacific Ocean with Miho no Matsubara (present-day Suruga Bay) and Seiken-ji [97] and the village of Yūhi are at the base of the painting. This part of the painting provides a variety of genre activities to supplement the more serious religious events above. A respectful dedication of the scroll to Sengen Shrine is written in the lower right-hand section of the painting, near two colorful demons (*oni*). MC

Literature

Victor and Takako Hauge, *Folk Traditions in Japanese Art* (exh. cat.; The Cleveland Museum of Art; New York: Japan House Gallery; Asian Art Museum of San Francisco, 1978-79), cat. 1 (Fuji Pilgrimage Mandala, Sengen Shrine, Fujinomiya).

Haruki Kageyama, *Kamigami no Bijutsu* [*The Arts of Japanese Gods*] (exh. cat.; Kyoto National Museum, 1974), cat. 56.

Nara National Museum, ed., *Suijaku Bijutsu* [*Buddhist-Shintō Syncretic Art*] (Tokyo: Kadokawa Shoten, 1964), pl. 93.

94 *Picture-Map of Meigetsu Temple*

Nambokuchō period. Hanging scroll; ink and slight color on paper. H. 84.2 cm. W. 127.6 cm. Meigetsu-in, Kanagawa Prefecture. Important Cultural Property.

At its founding about 1383 through the patronage of Uesugi Norikata (d. 1394) Meigetsu-in was called Meigetsu-an, a subtemple of the larger Zenkō-ji compound. Its founder, Rankei Dōryū (see [62]) received the support of the Hōjō family, but was abbot only briefly. Nevertheless Zenkō-ji was regarded as one of Kamakura's great institutions until it fell into decline during the sixteenth century.

Although the painting is called a picture-map of Meigetsu-in, the Sōyū-an subtemple occupies the central location in the composition. Its founder, Mukyū Tokuzen, who succeeded Dōryū as abbot, came to be considered a more important figure in Zenkō-ji's history. This may account for the prominence of Sōyū-an in the painting despite the fact that Meigetsu-in is the better known temple in Kamakura cultural history. The written seal (*kao*) of Ashikaga Ujimitsu (d. 1398), whose position as shogunal deputy for the Kantō area was one of major political importance, has been placed between the sutra repository and the pagoda in the right-hand section of

the painting. Since it is thought that Meigetsu-an's name changed because Uesugi Norikata's memorial name included "Meigetsu-in," the painting can be dated between 1394 and 1398. Indeed, although the Zenkō-ji declined in stature during the Muromachi period, Meigetsu-in remained sound, due principally to the continued patronage of the Uesugi and Yamanouchi families, whose memorial temple it was. Today only Meigetsu-in survives.

Some of the original color has worn off the painting. But the losses have revealed the dexterous underdrawing throughout the landscape and architectural elements. Each subtemple compound has been simply but carefully mapped, in some instances with almost geometric precision. The red line encircling the temple landscape indicates the extent of their landholdings and may reflect a survey approved by Ujimitsu. Notations along the periphery indicate adjacent temples. Although it is impossible to attribute the painting to a specific artist or artists, this is one of the most accomplished map-paintings surviving from the fourteenth century. MC

Literature

Tatto Kan et al., ed., *Kamakura no Bijutsu [Art in Kamakura]* (Kamakura: Kokuhō-kan, 1978), pl. 44 and pp. 46-47.

Shin'ichi Nagai, *Kamakura to Tōgoku no Koji [Ancient Temples of Kamakura and the Eastern Provinces]*, vol. 17 (1981) of *Nihon Koji Bijutsu Zenshū*, pl. 12 (color).

Zen no Bijutsu [Arts of Zen Buddhism] (exh. cat.; Kyoto National Museum, 1981), cat. 81.

95 *Picture-Map of Shōten Temple*

Kanō Shōei (1519–92). Dated to 1570. Inscription by Sakugen Shūryō. Hanging scroll; ink and slight color on paper. H. 53.1 cm. W. 79.1 cm. Takakura Kazuya, Fukuoka. Important Art Object.

Important centers of Zen learning and culture in the Kamakura and early Muromachi periods were located not only in Kyoto and Kamakura but also in northern Kyūshū in the vicinity of Hakata. The principal entry point for Chinese monks arriving from the mainland and for Japanese priests returning from study and travel, Hakata enjoyed in addition a healthy economic foundation for supporting religious institutions.

Shōten-ji was one of these, a Zen temple founded in 1242 by Ben'en Enni (Shōichi Kokushi, 1202–81) upon his return from China the previous year. He had studied there for four years with the renowned master Wu-chun Shi-fan (1177–1249) at the Wan-shou-ssu monastery on Mt. Ching, becoming one of Wu-

chun's ablest students. In recognition of his founding of Shōten-ji the Chinese master sent his student several pieces of calligraphy for identifying the halls of the fledgling temple. Fortunately some of these have survived in private collections and at the Tōfuku-ji. Shōichi, originally abbot at Shōten-ji, assumed the abbacy there when some conflict with the local Tendai establishments (see [69, 70]) had made his position in Hakata untenable.

This painting of the temple compound possesses a seal by Kanō Shōei, who is recorded as having visited Kyūshū in 1569 at the invitations of the monk Daiyū Sōrin. The inscription above, dated to 1570 by the monk Sakugen Shūryō, a prominent monk at the Tenryū-ji in Kyoto, strengthens the attribution to Shōei, whose father Motonobu (1476–1559) and son Eitoku (1543–90) receive more attention in Japanese painting history. This view of Shōten-ji illustrates that a flourishing Zen temple existed three hundred years after Ben'en's departure for Kyoto. An extensive, well-maintained compound is suggested by the rooftops of buildings projecting through banks of mist and the varied types of people depicted on the premises. Set against the foothills of distant mountains, this view of Shōku-ji resembles the painting of a Chinese temple.

Shōei painted another well-known composition depicting the precincts of the Kitano Shrine in Kyoto, now in the Tokiwayama Bunko (Library), Kamakura. In conception, brush manner, and figure style it corresponds directly with this painting. MC

Literature

Jan Fontein and Money L. Hickman, *Zen Painting Et Calligraphy* (exh. cat.; Boston: Museum of Fine Arts, 1970), cat. 8 (calligraphy presented to the Jōten-ji) and cat. 59 (*Tōfuku-ji Monastery* attr. Sesshū).

Hisao Sugahara, *Hibai Yokō: Selected Catalogue from the Collection of The Tokiwayama Bunko* (Kamakura: Tokiwayama Foundation, 1967), pl. 53 (View of Kitano Shrine by Kanō Shōei).

Zen no Bijutsu [Arts of Zen Buddhism] (exh. cat.; Kyoto National Museum, 1981), cat. 84.

96 *View of Ama no Hashidate*

Sesshū Tōyō (1420–1506). Hanging scroll; ink and slight color on paper. H. 89.5 cm. W. 169.5 cm. Kyoto National Museum. National Treasure.

Sesshū Tōyō, perhaps Japan's most revered artist, was a young Zen monk at the powerful Shōkoku-ji in Kyoto when he decided to leave its bureaucratic

regimen for an appointment in a western province as a kind of artist-in-residence. Shortly thereafter he realized his hope of joining a commercial embassy to China, studied painting there briefly, and returned to western Japan, away from the capital (then engulfed in the Onin War), to travel and build his studio. On one of his occasional journeys up-country he evidently spent time at Ama no Hashidate, located northwest of Kyoto on the Japan Sea coast and one of the country's most famous scenic locations.

In this unusually large sketch-painting Sesshū has not only depicted the central sandbar covered with pine trees that gives the location its name but has additionally recorded the various shrines, temples, and even village homes in the surrounding bay area. At a time when Japanese ink painters were preoccupied with depicting the imagery of China (which few had actually visited), such painting was a revelation. It was a revival of the traditional *yamato-e* absorption in the landscape and people of Japan and another instance of Sesshū's genius. MC

Literature

Takaaki Matsushita, *Sesshū*, no. 100 (September 1974) of *Nihon no Bijutsu*.

Tanio Nakamura, *Sesshū*, vol. 4 (1976) of *Nihon Bijutsu Kaiga Zenshū*, pl. 20 (color detail), pl. 54 and p. 128.

Ichimatsu Tanaka and Tanio Nakamura, *Sesshū · Sesson*, vol. 7 (1973) of *Suiboku Bijutsu Taikei*, pl. 8 (color) and pp. 175-76.

Yoshiho Yonezawa, Chū Yoshizawa, and Ichimatsu Tanaka, *Nihon no Sansuiga Ten* [*Exhibition of Japanese Landscape Painting*] (exh. cat.; Tokyo National Museum, 1977), cat. 28.

97 *Mt. Fuji and Seiken Temple*

Attrib. Sesshū Tōyō. Hanging scroll; ink on paper. H. 51.5 cm. W. 105.8 cm. Eisei Bunko, Tokyo.

Sesshū arrived in China in 1467 at the active seaport Ningpo as a member of the Ouchi family trade mission. He remained on the continent for two years, studying painting and travelling extensively, as attested by Chinese and Japanese records of the time and by a number of his paintings that document rural life, ethnic attire, the appearance of famous monastic institutions and cities, and even animals unknown in Japan. He executed commissions at the invitation of the Chinese, and brought back paintings and books for study.

Upon returning to Japan he continued to travel, particularly in Kyūshū and the western provinces, but also to famous scenic or historical areas such as Ama no Hashidate and Mt. Fuji. This scroll is one of the earliest Muromachi depictions of that mountain, seen from a southwest vantage point which permits the inclusion of Miho no Matsubara (Sugura Bay) to the right and the Zen temple Seiken-ji to the left. The Miho bay coast and Mt. Fuji are seen from a relatively low viewpoint through banks of clouds, unlike the elevated perspective of Ama no Hashidate [96]. Judging from later depictions of the subject this painting established a particular compositional standard, although its stylistic impact did not endure. Similar brushwork does appear, however, in a number of Sesshū's paintings characterized by strong Sung and Ming influence: the *Four Seasons* set in the Bridgestone Museum in Tokyo and the *Chinda Waterfall* of about 1471–72, now lost.

The painting bears an inscription by the Ningpo literati-artist Ch'en Hsi (act. ca. 1510), who befriended a number of travelling Japanese monks. One of them may have brought this painting back from China, where Sesshū had painted it for Chinese friends. Kanazawa Hiroshi has suggested that one of Sesshū's circle in Japan, perhaps the monk Ryōan Keigo (d. 1514), carried it to China after Sesshū's death, where he obtained the inscription before returning. Such uncertainties have naturally raised questions concerning the authenticity of the painting, but it is difficult to dismiss it outright or to assign it to one of the master's disciples. It is recorded as a genuine Sesshū composition in a Kanō Tsunenobu (1636–1713) sketch-scroll (*shukuzu*) owned by Tokyo University of Arts, and is specifically mentioned in Kanō Einō's (1634–1700) history of Japanese painting, the *Honchō Gashi*. It is not clear when the painting entered the Hosokawa family collection, but it is noteworthy that they enjoyed special trading privileges with China at the same time as the Ouchi. MC

Literature

Fuji no E [*Paintings of Mt. Fuji*] (exh. cat.; Nara: Yamato Bunkakan, 1980).

Shigeyasu Hasumi, *Sesshū Tōyō Shinron* [*New Study on Sesshū Tōyō*] (Tokyo and Osaka: Asahi Shimbun, 1977), with English summary, fig. 6.

Yukio Yashiro, *Nihon Bijutsu no Saikentō* [*Japanese Art Re-examined*] (Tokyo: Shinchō-sha, 1978), fig. 86.

98 Mt. Asama

Aōdō Denzen (1748–1822). Six-fold screen; ink
and color on paper. H. 149 cm. W. 342.4 cm.
Tokyo National Museum.

Aōdō Denzen figures prominently among the talented late eighteenth-early nineteenth-century artists versed in the Western painting methods which reached Japan through foreign merchants. For over two hundred years all foreign trade and traders were confined to the port of Nagasaki in southern Kyūshū by the Tokugawa government. Yet despite such stringent restrictions, elements of European culture had already begun to have an appreciable impact on the Japanese who had had intermittent contact with the English, Portuguese, Spanish, and Dutch since the mid-sixteenth century. Although the European focus was primarily on missionary and commercial ventures, Edo artists and intellectuals developed an emphatic interest in Western pictorial representation, science, and literature. Artists especially were intrigued by the naturalistic techniques so obvious in the images they saw in European books, maps, and the curious prints made by the Japanese of Nagasaki.

Whether Denzen ever actually made the pilgrimage to Nagasaki to learn Western one-point perspective drawing and oil-painting techniques eludes determination by art historians. He hailed from Iwashiro Province (present-day Fukushima Prefecture) north of Edo, but travelled south to pursue his interest in painting, meeting and studying with Gessen (see [131]) in 1785 near Ise. Of greater significance was his study with Tani Bunchō (see [120]), arranged through Matsudaira Sadanobu, whom Denzen later served as an official painter. It was Sadanobu who charged Denzen with the task of learning copperplate engraving when Shiba Kōkan (see [119]) apparently would not divulge his working method, and it is Denzen's mastery of this difficult technique that gained him the name Aōdō (Hall of Asia and Europe) and his place in the history of Western-influenced Japanese painting.

This single screen depicts Mt. Asama, the well-known volcano in the Japanese Alps that erupted in 1783 but continued to be a favorite peak to the country's mountain climbers (see [106]). The composition is fundamentally Japanese in its asymmetry and in the series of broad, interlocking landmasses, cloud bands, and sky, reminiscent of *rimpa* school paintings. Into this the artist has interjected scattered detailed vignettes focussing on the theme of woodcutting but without showing human figures. The brushwork is restrained, blunt rather than fine-line, and without outline definition. It is a haunting painting, unlike Denzen's exacting engravings but altogether in keeping with the more compelling images of such individualist Edo painters as Shōhaku and Rosetsu. It represents Denzen's finest work, inspired by Bunchō and the great screen paintings of the Momoyama era. 　　　　　　　　　　MC

Literature

Edo Bijutsu Ten Mokuroku [*Catalogue of an Exhibition of the Arts of the Edo Period*] (exh. cat.; Tokyo National Museum, 1966), cat. 192 and color cover.

Cal French, *Through Closed Doors: Western Influence on Japanese Art 1639-1853* (exh. cat.; Rochester, Michigan: Meadowbrook Art Gallery; Ann Arbor: University of Michigan Museum of Art, 1977), especially ch. 5: "The View Transformed: Scholars, Reformers, and Europhiles," 121-66.

Mitsuru Sakamoto, Tadashi Sugase, and Fujio Naruse, *Namban Bijutsu to Yōfuga* [*Namban Art and Japanese Paintings in Western Style*], vol. 25 (1970) of *Genshoku Nihon no Bijutsu*, pl. 114 (color).

99 Sketches of Plants

Kanō Tan'yū (1602-74). Handscroll; ink and
color on paper. H. 26.9 cm. L. 1,313.5 cm.
Tokyo National Museum.

Kanō Tan'yū's position in mid-seventeenth-century Edo as the principal official painter to the shogunate as well as leader of the "Kajibashi" Kanō atelier (named after his home district in the capital) has assured his place in the history of later Japanese painting. A prolific artist, his career began in Kyoto, where he studied with his father, Takanobu (1571–1618), and then Kanō Kōi (d. 1636). Having been granted an audience with two successive Tokugawa shoguns who were evidently impressed by his talent, Tan'yū was appointed to the official painting bureau (*e-dokoro*) in 1617.

Author of many temple and domestic painting cycles of major proportions, Tan'yū also acted as connoisseur-authenticator for members of Edo society who wished to have the Chinese and Japanese paintings in their possession assessed. He made thousands of rapid but precise sketches (*shukuzu*) of these paintings for his own records, adding pertinent comments concerning provenance, cost, and authorship. A virtual treasure trove for subsequent collectors and modern art historians, they reveal a personal aspect of Tan'yū frequently absent in his grander works, due in part no doubt to the formal nature of commissions and to the participation in them of his studio assistants.

But Tan'yū also sketched from nature as a way of preparing for his more colorful, finished efforts. He is

the first Edo period painter to have made this practice a fundamental part of his training, and its effect on such artists as Kōrin [101], Okyo [103], Kazan, and even Hokusai can be demonstrated. Many of these life studies were executed in the "boneless" technique, using only ink washes, while others employ simple, dry outlining strokes. Probably more than one, however, was subsequently altered or strengthened with line and color washes. Tan'yū is known to have worked on this handscroll off and on between 1661 and his death. MC

Literature

Kyoto National Museum, *Tan'yū Shukuzu* [*Sketches by Tan'yū*] (Kyoto: Dōhōsha, 1980-81), vol. 1.

Tsuneo Takeda, *Kanō Tan'yū*, vol. 15 (1978) of *Nihon Bijutsu Kaiga Zenshū*, pl. 50 (color detail) and pp. 135-36.

100 *Weasel*

Kanō Tan'yū. Hanging scroll; ink and color on paper. H. 51.5 cm. W. 105.8 cm. Fukuoka Municipal Art Museum.

Tan'yū's *shukuzu* and his numerous naturalistic compositions are generally among his latest works. One striking exception is this modest painting, probably done in his early thirties. Using a myriad of fine brush lines applied over a brown wash ground, he has composed this vivid image of a weasel moving through a landscape which is barely suggested. By contrast, the abbreviated landscape is casually brushed in simple ink tones.

The image appears to be either a life sketch which the artist progressively developed into a finished, miniature-like painting, or a painting inspired by a prior (life) sketch of the animal. One such drawing does appear among assorted animal sketches in a handscroll by Tan'yū kept at the Kyoto National Museum. Weasels were also represented in Chinese paintings of the Sung and Ming dynasties, which Tan'yū would have had ample occasion to see in his role as authenticator of paintings. MC

Literature

Jōhei Sasaki, *Okyo Shasei Gashū* [*Collection of Sketches by Okyo*] (Tokyo: Kōdansha, 1981), p. 152 (sketch of weasel, Homma Art Museum, Yamagata).

Tsuneo Takeda, *Kanō Tan'yū*, vol. 15 (1978) of *Nihon Bijutsu Kaiga Zenshū*, pl. 27 (color) and p. 132.

101 *Sketches of Birds and Animals*

Ogata Kōrin (1658–1716). Sketchbook pages mounted on a handscroll; ink and color on paper. H. 28.3 cm. W. 23.3 cm. (each page). Agency for Cultural Affairs. Important Cultural Property.

Kōrin's surviving preparatory sketches illustrate the several stages that preceded the execution of a finished composition. This handscroll shows the artist's initial examination of the subject, complete with identifications and descriptive notes. At another stage monochrome ink is used to couple recorded observation with decorative effects, forming aesthetically satisfactory compositions. This stage often combines plant life with patterned banks of clouds or water. Still later the arrangements are distilled into even more simplified shapes and color is reintroduced so as to verify its compatibility with the desired composition. These preparatory stages and more are found in the documents once owned by the Konishi family and represent the richest source material for the study of Kōrin's art.

Kōrin's own life had its share of trials. Born in Kyoto into a prosperous textile merchant's family, Kōrin's festive life-style exhausted his legacy by the time he was thirty, necessitating a career. Fortunately, he had studied painting earlier. He began collaborating with his younger brother, the potter Kenzan (1663–1743), painting decorations on Kenzan's ceramics, then went to Edo for five years at the request of a wealthy merchant. Back in Kyoto Kōrin renewed his friendship with the prominent Nijō family and was retained by the Sakai daimyō. But his prodigality apparently continued to outrun his means, for he was forced to sell his family land and shortly thereafter died at age fifty-eight, leaving no considerable assets.

The nature studies exhibited here include sketches essentially identical with examples from a late eighteenth-century Kanō notebook bearing a notation stating they were copied from an album by Kanō Tan'yū (see [99]). Kōrin might well have seen such a work during his stay in Edo and copied it or even augmented it with his own entries. But the alleged Tan'yū notebook has been lost, leaving these superb glimpses of birds and waterfowl. MC

Literature

Motoaki Kōno, *Ogata Kōrin*, vol. 17 (1976) of *Nihon Bijutsu Kaiga Zenshū*, pls. 44-47 (color) and p. 139.

Shūko Nishimoto, *Kōrin . Kenzan*, vol. 20 (1981) of *Meihō Nihon no Bijutsu* pls. 40-43 (color details).

Rimpa: Sōritsu Hyākunen Kinen Tokubetsu Ten Zuroku
[*Rimpa: Special Exhibition Catalogue of the Centennial Anniversary*] (exh. cat.; Tokyo National Museum, 1973), cat. 114.

Yūzō Yamane, ed., *Kōrin-ha*, I [*Korin School*, pt. I], vol. 3 (1979) of *Rimpa Kaiga Zenshū*, with English summary, pls. 39, 40 (color), 107-10, and essay by Shūko Nishimoto, "Kōrin hitsu 'Chōjū Shasei Zukan' ni tsuite" [" 'Birds and Animals Sketchbook' by Kōrin"], pp. 37-44.

102 *Sketch of a Woman*

> Ogata Kōrin. Unmounted sketch; ink and slight color on paper. H. 61 cm. W. 43 cm. Agency for Cultural Affairs. Important Cultural Property.

Kōrin left Kyoto for Edo in 1704 at the invitation of a prosperous merchant who supported him and in whose home he stayed while in the capital. His five years in Edo immediately followed the Genroku era (1688–1703), one of the most sumptuous cultural periods in Edo history. Genre screens and the works of the novelist Ihara Saikaku and the playwright Chikamatsu Monzaemon amply depict the attraction of the theater and famed entertainment quarters to which the wealthy townsmen of Edo flocked.

Judging from Kōrin's activities as a young man in Kyoto, he must have been attracted by the city's various diversions and by their portrayal in the popular woodblock prints of the early *ukiyo-e* artists, done in black outline with sometimes one or two colors added. The most characteristic subject was a statuesque courtesan (*bijin*), walking barefoot, her right hand lifting her robes—a motif seen in Kaigetsudō prints and somewhat later in Torii school images. We can see the artist's successive essays, drawn in faint ink lines. When the desired configurations had been established, they were traced over with a darker brush, and coiffure and *obi* were filled in. Kōrin's treatment of the beauty's face, in contrast, appears fresh and direct, and has been heightened with a red tone.

This subject is unique in the artist's oeuvre; no painting of it is known, nor is one recorded in his followers' notebooks chronicling his work. Although Kōrin is not considered to have taken an interest in genre painting, it is apparent that his superb decorative compositions emanated from observed phenomena. MC

Literature

Motoaki Kōno, *Ogata Kōrin*, vol. 17 (1976) of *Nihon Bijutsu Kaiga Zenshū*, pl. 79 and p. 142.

Shūko Nishimoto, *Kōrin . Kenzan*, vol. 20 (1981) of *Meihō Nihon no Bijutsu*, pl. 44 (color).

Takeshi Yamakawa, *Rimpa: Kōetsu/Sōtatsu/Kōrin*, vol. 21 (1979) of *Nihon Bijutsu Zenshū*, pl 72 (color) and p. 206.

103 *Sketches of Insects, Birds, and Plants*

> Maruyama Okyo (1733–95). One of a set of four sketchbooks; ink and color on paper. H. 38.5 cm. W. 44.5 cm. Tokyo National Museum.

As a young man from the country who aspired to learn the art of painting Maruyama Okyo began studying in Kyoto with Ishida Yūtei (1721–86), an artist trained in the Kanō school method. More a stylistic synthesizer than orthodox follower of the Kanō, Ishida's early guidance apparently encouraged the young artist to embark upon a career characterized by diverse stylistic influences. Tangibly these included Chinese illustrated books and prints, prints of European scenes copied from Western illustrated books, Chinese paintings of the Nagasaki school artists, *rimpa* decorative style painting, and classical *yamato-e*.

In particular the work of Watanabe Shikō (1683–1755), an artist with both Kanō and *rimpa* school training, exerted an influence on Okyo's painting, as exemplified by this sketch album. These studies were apparently copied from similar sketches by Shikō, who in turn was aware of Kōrin's efforts in this direction (see [101]). Since Okyo would have been just twenty-three when Shikō died, it is more likely to have been familiarity with the albums than with the artist that inspired these naturalistic studies. In fact the Kanō painting system also emphasized preparatory drawings, often veristic in nature (see [99, 100]), before final compositions. But whereas *rimpa* school painters tended to copy their Kanō predecessors rather faithfully, Okyo made freer use of the ideas of Kanō Tan'yū as expressed in his sketchbooks. For instance, his sketch of a weasel (in the Homma Art Museum, Yamagata Prefecture) varies significantly from Tan'yū's. It includes several close-up drawings of the weasel's head that could only have been done from direct observation of the animal.

This album is one of four sketchbooks depicting insects, birds, and plants, most of which are identified by the artist's notations. Although not dated by inscription, it has been most frequently considered a work of about 1770–72, done while he was at the Emman-in (see [114]), whose Abbot Yūjō is said to have requested the albums. Another, virtually identical, sketch-scroll is in the Nishimura Collection, Kyoto. MC

Literature

Okyo and the Maruyama-Shijō School of Japanese Painting
(exh. cat.; Saint Louis Art Museum and Seattle Art
Museum, 1980), cat. 8.
Jōhei Sasaki, *Okyo Shasei Gashū* [*Collection of Sketches
by Okyo*] (Tokyo: Kōdansha, 1981).

104 *Sketches of Lake Biwa and the Uji River*

Maruyama Okyo. Dated to 1770. Handscroll;
ink on paper. H. 22.7 cm. L. 602 cm. Kyoto
National Museum.

Okyo's interest in closely observing the human figure
as well as the natural environment occupied primarily
the first half of his working life. This sketch-scroll
records the artist's trip in late August of 1770 to Lake
Biwa, across the Higashiyama hills from Kyoto, and
to the upper region of one of its tributaries. In this
"workbook" rapids, rock shapes, and local waterfowl
are recorded in close and random juxtaposition. In
addition Okyo has included broad, sketchy views of
the lake and distant mountains; plant life; and,
significantly, figure studies.

In these he has first rendered the human form
"naked" in faint ink lines, later "clothing" it in darker
ink line as a kind of two-step lesson in anatomical
correctness. His emphasis, however, is on general
body attitude and movement rather than details of
body appearance. In contrast to the figure scrolls in
the Tenri Library south of Nara this work retains the
freshness of direct observation, perhaps revised or
added to later—as can be seen in the sketch of the
parrot inserted above the woman drawing water from
a well. The artist's notations state time of observation,
the name of the object and its component parts, and
coloration. This same information is recorded in
Okyo's only other extant notebook of this period,
dating a year after this example. MC

Literature

Nihon Keizai Shimbun-sha, *Maruyama Okyo Ten*
[*Maruyama Okyo Exhibition*] (exh. cat.; Osaka: Mit-
sukoshi Dept. Store; Nagoya: Matsuzakaya Dept.
Store, 1980), cat. 11 and cf. cat. 46 (Kyoto National
Museum).
*Okyo and the Maruyama-Shijō School of Japanese
Painting* (exh. cat.; Saint Louis Art Museum and
Seattle Art Museum, 1980), cat. 6.
Jōhei Sasaki, *Okyo Shasei Gashū* [*Collection of
Sketches by Okyo*] (Tokyo: Kōdansha, 1981), pls.
116-30 (color).
Susumu Suzuki, *Okyo to Goshun* [*Okyo and
Goshun*], no. 39 (July 1969) of *Nihon no Bijutsu*.

105 *Puppies, Sparrows, and Chrysanthemums*

Nagasawa Rosetsu (1754–99). Four sliding-
screen panels mounted as hanging scrolls;
ink and light color on paper. H. 167.6 cm. W.
91.4 cm. Cleveland Museum of Art 70.71-.74.
John L. Severance Fund.

These two hanging scrolls together with two flanking
paintings not included in the exhibition form a uni-
fied composition of chrysanthemums, puppies, and
sparrows. Circular patches in the surfaces of all four
scrolls where finger catches (*hikite*) once existed indi-
cate they have been recently converted from *fusuma*
(interior sliding-screen panels). Other sets of four
fusuma are in the Carter and Burke collections, and all
share similar stylistic traits and nearly identical di-
mensions. This suggests that Rosetsu may have been
engaged in depicting a cycle of the four seasons
across adjoining rooms. These Cleveland Museum
paintings depict a fall theme, whereas the Burke
paintings illustrate puppies cavorting alongside a
stream near young bamboo shoots, a reference to
spring. The Carter set shows a group of puppies
playing in a bamboo grove, identifiable as a summer
or fall subject.

Rosetsu's mentor Okyo painted frolicking puppies
on a number of occasions, but it is certainly Rosetsu
who became identified with the subject through his
many variations on this theme. A somewhat contro-
versial chronology largely based upon seal impres-
sions allows most of these paintings to be dated to
about 1787–92. The Cleveland Museum paintings
bear the artist's signature and seal. MC

Literature

Maruyama-ha to Mori Kansai—Okyo Kara Kansai-e
[*Maruyama School and Kansai Mori—from Okyo to
Kansai*] (exh. cat.; Yamaguchi Prefectural Museum
of Art, 1982), sect. 1, cat. 1 (Puppies by Rosetsu; no
provenance).
Robert Moes, *Rosetsu*, (exh. cat.; Denver Art
Museum, 1973), cat. 8 (Carter collection), cat. 9
(Burke collection), cat. 32 (Shinenkan Collection).
Jōhei Sasaki, *Bunjinga to Shaseiga: Taiga/Gyokudō/
Okyo* [*Literati and Realist Painting: Taiga/Gyokudō/
Okyo*], vol. 24 (1979) of *Nihon Bijutsu Zenshū*, pls.
74-77.

106 *Sangaku Kikō [Record of a Journey to Three Mountains]*

Ike no Taiga (1723–76). Eight-fold screen; ink on paper. H. 91 cm. W. 254.4 cm. Kyoto National Museum.

Ike no Taiga's epitaph, engraved on his tombstone by friends, notes that he loved to climb the mountains of Japan as much as to portray them in his landscape paintings. The subject predominates in his work, and, as might be expected, representations of the venerated Mt. Fuji abound. These are finished paintings, showing the snow-capped peak from a number of different perspectives and under varying climatic conditions. According to the epitaph Taiga climbed Mt. Fuji several times, never using the same route. His most celebrated—and only recorded—ascent is described in the travel diary on this screen (which is one of a pair).

It took place during the summer of 1760 when, according to several accounts, two of the artist's scholar-friends, the calligrapher Kan Tenju (?–1795) and the painter Kō Fuyō (1722–84) casually visited Taiga's home. Conversation turned to Mt. Fuji, whereupon the three friends decided on the spot to set out for the peak, leaving families and business affairs behind. Starting at the end of June, they first went northeast into the Hokuriku district (Toyama Prefecture), ascending Mt. Haku and Mt. Tate. Swinging southeast, they entered the Japanese Alps in Nagano Prefecture, climbing Mt. Togakushi and part way up Mt. Asama [98]. After a halt during which Taiga sold some paintings in order to meet the group's expenses, the three headed for Edo around early September. Following a brief visit there, they left for Mt. Fuji via the Tokaidō highway, climbed as far as the eighth station of the ascent, and returned to Kyoto by month's end.

The better part of this journey is recorded on the notebook pages attached to the screen and attributed to Kan Tenju. They record expenditures for food, lodging, entertainment, entrance fees to the sacred mountains, and even the cost of the white pilgrim robes used by Shugendō and Fuji-kō adherents (see [48, 93]). The rough sketches depict the terrain through which the journey took place: whole mountain ranges, individual peaks or slopes, rice fields, valleys, and buildings. Identifying notations abound. The compositions possess considerable perspectival variety but seem only rarely to have directly inspired Taiga's finished "true view" (*shinkeizu*) paintings. Even prior to this tour Taiga, an inveterate traveller and mountain climber, had used the sobriquet "traveller to the three peaks." His trips seem to have been

undertaken not only for religious purification but, like Sesshū's (see [96]), for the direct observation of nature that could be translated into painting. MC

Literature

Motoaki Kōno, *Taiga . Okyo*, vol. 24 (1981) of *Meihō Nihon no Bijutsu*, figs. 114-16.
Teizō Suganuma, "Taiga no Sangaku Kikō" ["Taiga's Journal of the Trip to the Three Mountains"], *Bijutsu Kenkyū*, no. 73 (January 1938), with English summary, pp. 9-27 and pls. VII, VIII.
Melinda Rinker Takeuchi, "Visions of a Wanderer: The True View Paintings of Ike Taiga (1723–1776)" (Ph.D. dissertation, University of Michigan, 1979; microfilm, University Microfilms Intl.)

107 *Issō Hyakutai [Sketches of Scenes from Daily Life]*

Watanabe Kazan (1793–1841). Album; ink and light color on paper. H. 26.5 cm. W. 19.7 cm. Tahara-machi, Aichi Prefecture. Important Cultural Property.

Watanabe Kazan was the son of a samurai-bureaucrat serving the Tahara (Aichi Prefecture) fief as a member of its permanent entourage in Edo. The chronically impoverished region could offer only meagre support to its representative officials. Rank and status were no protection against persistent economic hardship. The young Kazan studied painting with the goal of eventually supplementing the family income.

Straitened circumstances notwithstanding, Kazan received, in addition to fine artistic instruction, the classical Confucianist education that was prerequisite for a career in government administration. Training as a painter began informally with a relative, Hirayama Bunkyō. At sixteen (1808) Kazan studied briefly in the academy of Shirakawa Shizan (?–1857?), moving in the following year to a more compatible setting under the instruction of Kaneko Kinryō (?–1817). Kinryō, a disciple of Tani Bunchō [120, 132, 133], had, like his master, assimilated orthodox Kanō style as well as Ming literati traditions through the interpretive work of Watanabe Gentai (1749–1822). Affiliation with Kinryō brought Kazan into increasing contact with Bunchō, and at Kinryō's death Kazan was accepted into Bunchō's circle of students. Formal Confucianist study had begun earlier, in 1805, under the tutelage of the scholar Takami Seikō. In 1811, with Seikō's passing, Kazan transferred to the academy of Satō Issai (1722–1859). Thus, by late adolescence, he had established, with Bunchō and Issai, the major

relationships that would influence and sustain his artistic and intellectual development.

Confucianism, variously elaborated and interpreted over the course of several millennia, proposed an ethical system that, judiciously adhered to, would guarantee social harmony. In China the concepts of filial piety and the mutual obligations of ruler and governed were particularly stressed, in a system that provided a theoretical basis for rigid hierarchical social order. Japanese rulers in the Edo period found such principles increasingly expedient and gave broad endorsement and official recognition to the particular body of interpretation constructed by Chu Hsi (1130–1200) and introduced by immigrant Zen monks in the thirteenth century.

Kazan took Confucian precepts to heart. He wrote with high moral seriousness of his commitment to excellence in art and to progressive reform of civil institutions, and his sincerity is affirmed by contemporary accounts.

Kazan's lively collection of genre sketches, *Issō Hyakutai*, exhibited here, is all the more fascinating if considered as the young painter proposes in his introductory text to the fifty-one scenes. His text is a Confucianist convention, thoroughly didactic, suggesting the moral lessons to be learned from observation of daily life through the vehicle of genre painting. Of the fifty-one scenes, the first ten represent views of periods ranging from the thirteenth through the mid-eighteenth centuries. The remaining forty-one scenes are Kazan's marvelously rendered sketches from city life. Swift sketches relate a wide range of activity in an uncanny encyclopedia of gesture and pose. A yawn, a stretch, the adjustment of a sandal, are observed with an obvious delight that transcends moralizing intent.

Kazan tells us that this work was completed in a day and two nights. From his early twenties he had earned extra money painting paper lanterns, piece work which demands considerable speed of brush. By 1818 eight volumes of *Manga* [*Sketches*] by Hokusai (1760–1849) had been published. Kazan had close contact with Hokusai's disciple Hokuba (1771–1844), and the influence of genre sketches by the *ukiyo-e* master cannot be discounted. JU

Literature

Teizō Suganuma, *Kazan no Kenkyū* [*A Study on Kazan*] (Tokyo: Mokuji-sha, 1969).

———, *Watanabe Kazan*, no. 162 (November 1979) of *Nihon no Bijutsu*, pl. 17 (color): two leaves.

Minpei Sugiura and Teizō Suganuma, *Watanabe Kazan*, vol. 19 (1975) of *Bunjinga Suihen*, pls. 43-53 and p. 147.

Susumu Suzuki and Masaaki Ozaki, *Watanabe Kazan*, vol. 24 (1977) of *Nihon Bijutsu Kaiga Zenshū*, pls. 15-18 (color), 69-71, pp. 129-30.

Tadashi Yoshizawa, *Nihon Nanga Ronkō* [*Collected Essays on Literati Painting*].

108 *Yawning Hotei*

Sengai Gibon (1750–1837). Hanging scroll; ink on paper. H. 40.9 cm. W. 53 cm. Fukuoka Municipal Art Museum.

Sengai Gibon did not begin to paint seriously until he was sixty-one and had just retired as abbot of the Shōfuku-ji in Hakata. This is Japan's oldest Zen temple, founded in 1195, and Sengai, after his retirement continued to live at one of its subtemples until his death some twenty-five years later. He had gone to the Shōfuku-ji as its new abbot at age thirty-nine, nearly thirty years after beginning his study as a young boy. This consisted primarily of a thirteen-year apprenticeship with one master bracketed by even more years of instruction sought from various Zen prelates. The Shōfuku-ji had at one time comprised over one hundred buildings, and Sengai's lasting contribution was overseeing the revival of the institution in the late nineteenth century and, of course, his paintings.

Pictured here is Hotei, a popular Zen figure represented as early as the fourteenth century in Japan. Initially perceived as an itinerant monk who carried all his worldly possessions in a cloth sack, Hotei came to be identified as an incarnation of Maitreya, the Future Buddha. By 1600 his image had come to be viewed as a symbol of material abundance. Sengai painted Hotei many times, either showing him pointing at the moon or, as here, waking with a yawn from a nap taken leaning against his sack.

The brushwork is rough and energetic, and surprisingly descriptive of physical form. In addition the ink tonalities enhance the scrubby character of the figural delineation and the attendant inscription. It is found on all such *Yawning Hotei* scrolls by Sengai and is a play on lines from Confucius, whom the painter read avidly. Humorously, Sengai likens himself to Hotei, free alike of weighty clerical responsibilities, the need for food or money, and the intrusions of government.

108

Sakyamuni is long gone under the Twin Sala Trees;
Maitreya is still in meditation in the Tushita
 Heaven.
How aged I've grown now!
I have ceased to dream of the King of Chou!
Drawn and inscribed by Gai-tara Bodhisattva
 (Sengai).
trans. Daisetsu Suzuki MC

Literature

Kōichi Awakawa, *Sengai Bokuseki* [*Paintings
 and Calligraphy by Sengai*] (Kyoto: Ato, 1976), no. 54.
Hiroshi Kanazawa, *Japanese Ink Painting: Early Zen
 Masterpieces*, trans. and adapted by Barbara Ford,
 vol. 8 (1979) of *Japanese Arts Library*, 55-59.
Sengai: 1750-1837 (exh. cat.; Brussels: Palais des
 Beaux-Arts, 1964), cat. 57.
Daisetz T. Suzuki, *Sengai: The Zen Master* (London:
 Faber and Faber, 1971), no. 12, repr. p. 52.

109 *Yugao-dana Nōryō*
 [*Enjoying the Evening Cool*]

Kusumi Morikage (active 17th century). Two-
fold screen; ink and light color on paper. H.
150 cm. W. 167.5 cm. Tokyo National Mu-
seum. National Treasure.

When Morikage left Kanō Tan'yū's studio to pursue
an independent career in painting his choice of sub-
ject matter appears to have broadened considerably
and his brush manner matured toward an ease of
description that few seventeenth-century ink painters
have matched. Certainly the Kanō school artists re-
sponsible for such works as the genre *fusuma* at
Nagoya Castle painted about 1614 provided him with
commendable standards of figural composition. Tosa
school genre paintings such as the mid-sixteenth
century *Manners and Customs* screen in the Tokyo
National Museum illustrating rice planting and out-
door festivities lent a rich heritage of subject matter
upon which to formulate his own work.

 Morikage's paintings, characteristically done in ink
and light colors, include landscapes, classical figure
subjects—both Chinese and Japanese—hawk and
falcons, and the screens of peasant life for which he is
customarily recognized. These are usually rural agri-
cultural or fishing panoramas, sometimes in the form

of allegories on Chinese Taoist ideals. But in essence they may be construed as counterpoints to the contemporary urban settings of the Matabei [112, 113] and Kanō school artists, or the worldly activities portrayed in the emerging Edo *ukiyo-e*. Although he lived in Kyoto and later served the Kaga (present-day Ishikawa Prefecture) daimyō in Kanazawa, Morikage seems in his art to have eschewed bustling city environments in favor of country life and the last vestiges of samurai culture. In this two-fold screen a family relaxes on a woven mat beneath a trellis of gourds in the moonlight of a hot summer evening. It is signed and sealed by the artist but, like most of his works, undated.

The subject has been variously explained: as a former samurai who preferred simple country living to an urban existence that was increasingly marginal, economically and socially; or as an illustration of a poem (*waka*) by Kinoshita Chōshōshi (1569–1649), who withdrew from Kyoto with the takeover by the Tokugawa because of his close relationship to Hideyoshi. But the painting transcends both these programmatic explanations in its originality within the context of contemporary Japanese painting and its stylistic subtlety. MC

Literature

Teiji Chizawa, *Edo*, pt. I, vol. 7 (1970) of *Nihon Kaigakan*, pl. 84 (color).

Ichitarō Kondō, *Japanese Genre Painting: The Lively Art of Renaissance Japan*, trans. by Roy Andrew Miller (Rutland, Vt. and Tokyo: Tuttle, 1961), pls. 16-23, color pl. 2 (detail), and p. 135 (genre painting screen, Tokyo National Museum).

Tadashi Kobayashi and Satoru Sakakibara, *Morikage/Itchō*, vol. 16 (1978) of *Nihon Bijutsu Kaiga Zenshū*, pls. 1, 2 (color).

110 Horses and Grooms in the Stable

Muromachi period, late 15th century. Pair of six-fold screens; ink and color on paper. H. 145.7 cm. W. 348.6 cm. (each). Cleveland Museum of Art 34.373-.374. Purchase, Edward L. Whittemore Fund.

Approximately a dozen screens or pairs of screens are known in Japan and the West depicting this subject. Few of these provide such diverse imagery as the pair exhibited here, or indicate their Muromachi era origins so clearly. The similarity of the foreground figures in type and style, and the emphasis on genre activities, help associate these screens with Tosa school painting. Screens with like subjects in the

Honkoku-ji, Kyoto, and the Tokyo National Musuem provide informative reference points for examining their compositional background.

The subject of horses and grooms enjoyed its greatest popularity in the sixteenth century. Thereafter the fortunes of the Tosa school, with which the subject was so closely associated, and of *yamato-e* painting generally, waned. The appeal of this native subject became channeled into increased production of *ema* (painted votive tablets, usually depicting a horse and groom) as offerings for shrines. MC

Literature

Tanio Nakamura and Atsushi Wakisaka, *Sōjūga—Ryūko, Enkō* [*Animal Paintings—Dragons and Tigers, Gibbons*], vol. 16 (1978) of *Nihon Byōbu-e Shūsei*, plş. 63, 64 (color sections), cf. pls. 59-62, 65-68, and pp. 127-28.

Yūzō Yamane, *Momoyama Genre Painting*, trans. by John M. Shields, vol. 17 (1973) of *The Heibonsha Survey of Japanese Art*, pp. 126-27, 137-38.

111 Iron-Monger, Picture-Mounter, Tub-Maker, Dyer

Edo period, 17th century. Four of a set of twelve panels of *Shokunin* [*Occupations*]; ink and color on paper. H. 60 cm. W. 50 cm. (each panel). Agency for Cultural Affairs, Tokyo.

We find the origins of these panels in Kamakura period *e-makimono*, where craftsmen play "bit" parts, or in paintings such as the *Tōhoku-in Shokunin Uta Awase* [88], where they serve as the vehicle for satire. Genre as an appropriate subject for painting begins to appear only in the Muromachi era—especially the sixteenth century—in handscroll and screen formats (see [110, 115]). These works offer as their subjects insights into Japanese life as it was experienced by most people at that time. They are invaluable documents for understanding high and low life in Japan and the physical circumstances of ordinary people.

Entertainment and *Rakuchū Rakugai* [115] screens of the later sixteenth and early seventeenth centuries provide the most comprehensive and visually satisfying accounts of daily life, including passages describing the activities of laborers, monks, beggars, store owners, and craftsmen. Of these, the *shokunin zukushi* (occupations or professions) emerged as a favorite subject, due in part to its ancient and aristocratic literary pedigree and in part to its favorable reflection of the improving economic life of the urban middle class. Not surprisingly, relative economic and

social status are readily apparent in details of dress, housing, and simple physical appearance. Among these four craftsmen, for instance, the textile dyer enjoys the advantages of a fine workshop with a number of assistants. Also of note is the presence of women, frequently accompanied by children, in most *shokunin* scenes.

What is surprising, however, is the compositional sameness among the extant *shokunin* paintings, in contrast to the variety seen in contemporary *rakuchū rakugai* or festival compositions. Originally these panels may have numbered twenty-four, like the set in the Kita-in in Saitama Prefecture. Bearing seals of Kanō Yoshinobu (1552–1640), an artist active in Edo and in Kyoto, they offer what is now the earliest and best-known glimpse of how Kanō artists appropriated a Tosa school genre subject of the mid-sixteenth century. The anonymous Kanō painter of the panels on view here has selectively added to and deleted elements from the Kita-in set, particularly features of landscape. He also modified aspects of dress and architecture with an eye towards schematization. Other examples are known that faithfully repeat these panel scenes but without the animation of their Muromachi prototypes. The paintings are also recorded by Kanō Tan'yū in a *shukuzu* dated to 1673. The Maruyama school priest-painter Gessen [131] would later employ selective views of plebeian life as vehicles of subtle social criticism. MC

Literature

Ichitarō Kondō, *Japanese Genre Painting: The Lively Art of Renaissance Japan*, trans. by Roy Andrew Miller (Rutland, Vt. and Tokyo: Tuttle, 1961), pls. 41-44, and pl. 138 (Bunka-chō panels, formerly Okazoe coll.).
Hisatoyo Ishida, *Shokunin Zukushi-e [Paintings of Various Occupations]*, no. 132 (May 1977) of *Nihon no Bijutsu*, pls. 18, 19 (color), 212-29 (Kita-in screens).
Kanō-ha no Kaiga [Painting of the Kano School] (exh. cat.; Tokyo National Museum, 1979), cat. 113.
Kyoto National Museum, *Tan'yū Shukuzu [Sketches by Tan'yū]* (Kyoto: Dōhōsha, 1980-81), vol. 1, pp. 18-33 (Shokunin Zukushi E-maki).

112 *Shokunin [Occupations]*

Iwasa Matabei (1578–1650). Handscroll; ink and color on paper. H. 29 cm. L. 1,310 cm. Idemitsu Art Museum, Tokyo.

Traditionally Matabei has been associated with *ukiyo-e* painting and culture as it evolved in the early seventeenth century. He did participate in the general popular culture of which *ukiyo-e* painting constitutes

one phase, but his social background and obvious painting talent allowed him access to more varied artistic traditions than those patronized by the wealthy city merchants of Kyoto and Edo (see [113]). His circle of acquaintances and friends included some of the most sophisticated persons of the day, and not surprisingly the majority of his surviving work indicates that his finest accomplishments were achieved in works based upon classical court themes, such as this *shokunin* handscroll.

The theme appears initially in Heian literature, whose nonaristocratic subjects range from gamblers to sumō wrestlers, from prostitutes to diviners and priests. By the Muromachi era *shokunin* referred to people who worked with machines, not, as at present, general manual laborers. Thus the twenty-nine artisans appearing in this scroll enjoy a classical court heritage and trace pictorial ancestry to the *Tōhoku-in Shokunin Uta Awase* [88] of the Kamakura period. The subject continues popular in court-supported Tosa school painting and is seen in the copybooks used by Tosa artists. Eventually the theme found popularity among the Kanō school artists of the later sixteenth century, particularly in screen compositions.

Matabei followed their lead, sometimes quite closely, as his adaptation of Kanō Yoshinobu's (1552–1640) screen at the Nikkō Tōshōgū indicate. In fact, judging from the number of *shokunin* paintings by Matabei, he seems to have found the subject of special interest. The two known complete handscrolls by him are virtually identical and contain nearly all the figures present in the *Tōhoku-in Shokunin Uta Awase*. The men, women, and animals are depicted with scant indication of background setting. They were first sketched in using thin lines, after which washes were applied, followed by dark outlining brushstrokes. The effect is simple but deceptively rich, and the placement of the figures reminiscent of traditional Heian and Kamakura period *yamato-e* compositions such as the *Thirty-six Poets* [87, 89, 90]. MC

Literature

Nobuo Tsuji, *Iwasa Matabei*, vol. 13 (1980) of *Nihon Bijutsu Kaiga Zenshū*, pls. 46 (color), 63, and p. 138.
Sandy Kita, *Matabei as Michishū* (Ph.D. dissertation, Univ. of Chicago, 1980).

113 *Self-Portrait*

Iwasa Matabei. Hanging scroll; ink and color on paper. H. 35 cm. W. 24.9 cm. MOA Art Museum, Shizuoka Prefecture. Important Cultural Property.

When Matabei was but a year old his father, Araki Murashige, lost his territories in Settsu Province

(present-day Osaka Prefecture) to Oda Nobunaga's forces. He fled, leaving his son with a wet nurse who took the child to the Nishi Hongan-ji in Kyoto for safekeeping. Murashige went to Sakai, a prosperous city southeast of Osaka, where he reportedly studied with Sen no Rikyū and became a tea master. Apparently Matabei joined his father there, growing up in the Sakai area, where he studied painting with Tosa Mitsunori (1583–1638) and Kanō Naizen (1570–1616). Naizen moved to Kyoto in 1604 and Matabei presumably followed, subsequently meeting Karasuma Mitsuhiro (1579–1638; see [33]), Prince Sonjun (1591–1653), and Emperor Go-Mizuno-o (r. 1611– 29), all leading aesthetes of the old capital.

By 1616 Matabei had moved to Echizen, the fief of Matsudaira Tadanao, where he lived for twenty years and which he described as "a country place; twenty years or more I was in Echizen mingling with the poor, forgetting the capital, and growing old." But about 1637 Matabei was summoned by Tokugawa Iemitsu (shōgun 1623–51) to Edo. There he became a popular artist, receiving numerous commissions, the most significant of which came from Iemitsu directly: the plaques for the Tōshōgū (mausoleum of the Tokugawa family and shrine where they were venerated) at Nikkō, north of Edo, depicting the *Thirty-six Immortal Poets*. They were executed in 1650.

But as Matabei was instructed by Lord Matsudaira to maintain his household in Echizen, the prolonged stay in Edo could not have been entirely satisfactory. According to Iwasa family documents the artist painted a self-portrait when he was in Edo, ill and close to death. This was sent to his wife and children in Echizen, and it is traditionally identified with the hanging scroll exhibited here. But since a local Echizen history notes that a self-portrait burned with other family documents, the authenticity of this painting has been questioned and the suggestion put forward that it represents a faithful copy of the original.

Matabei is depicted in a Zen *chinsō* compositional format. He is seated in a cane chair holding a bamboo staff, flanked by a long halberd and a table upon which rest books and an incense burner. These accessories suggest the study of a scholar-painter. The halberd appears as an adornment to the large floats in Gion festival scenes of *Rakuchū Rakugai* screens [115] and its military equivalent, the long sword, can be seen in portraits of Ikkyū. Matabei's chosen accessories represent an intriguing blend of austere Zen culture with worldly, bourgeois interest.

Despite its poor condition, the figural treatment remains convincing as Matabei's own work or a copy from his original composition. The self-description is hardly flattering as can be seen in most portraiture of

this kind prior to Matabei's time. Like the portraits of Ikkyū [79] and Ozorabuzaemon [127], it sympathetically conveys a melancholy dignity. MC

Literature

Hokkaidō Shimbun-sha, *Kinsei no Bi no Kokoro: Kyūsei Atami Bijutsukan Meihinten* [*Essence of Beauty in Modern Japanese Art: Exhibition of Masterpieces from the Atami Art Museum*] (exh. cat.; Sapporo: Hokkaidō Modern Art Museum, 1979), cat. 8.

Nobuo Tsuji, *Iwasa Matabei*, vol. 13 (1980) of *Nihon Bijutsu Kaiga Zenshū*, pl. 53 and pp. 140-41.

Muneshige Narazaki, "Iwasa Matabei Shōi ni tsuite" ["A Study of Iwasa Matabei"] in *Kaiga Zenshū* [*Collected Articles on Japanese Painting*] (Tokyo: Kōdansha, 1977), pp. 238-309.

114 *Misfortunes*

Maruyama Okyo. Dated to 1768. One roll of the three-roll handscroll *Shichifuku Shichinan* [*Seven Fortunes and Seven Misfortunes*]; ink and color on paper. H. 32 cm. L. 1,672.5 cm. Emman-in, Shiga Prefecture. Important Cultural Property.

One of the most important periods in Okyo's life can be defined by his association with the abbot Yūjō (d. 1773) of the Emman-in in Otsu city on Lake Biwa. Beginning about 1765 and continuing for almost a decade, Okyo produced major screen compositions for the rooms of the Emman-in, hanging scrolls, and a three-roll handscroll known as the *Seven Fortunes and Seven Misfortunes*, of which this is one scroll. Work on these is known to have started in 1768 when Okyo was thirty-five, as attested by the preliminary sketches in handscroll format which remain together with the finished paintings at the temple.

The vicissitudes of life, including natural disasters, are a particularly apt theme for commission by a Buddhist monk of noble parentage. Yūjō was familiar with this traditional *yamato-e* subject from *e-makimono* of the Heian and Kamakura periods; and he collaborated with Okyo on the production of this scroll, whose theme is also included in the Ninnō sutra. On the roll exhibited Okyo has depicted storms and devastating fires; on the other *Misfortunes* scroll, fearsome animals. Together with the single roll of *Fortunes* they represent a significant departure from the colorful interpretations of Ming bird-and-flower and figure painting with which Okyo is most popularly identified. MC

Literature

Chū Yoshizawa and Takeshi Yamakawa, *Nanga to Shaseiga* [*Literati and Realist Painting*], vol. 18 (1969) of *Genshoku Nihon no Bijutsu*, pls. 109, 110 (color sections).

Hajime Watanabe, "Okyo Hitsu Shichinan Zukan Kōhon" ["Okyo's Sketch-Scroll for the Seven Misfortunes"], *Bijutsu Kenkyū*, vol. 33 (September 1934), pp. 446-48 and pls. VII, XIII (sections).

115 *Rakuchū Rakugai*
 [*Sights in and Around Kyoto*]

Momoyama-Edo period, early 17th century. Pair of six-fold screens; ink and color on gold-leafed paper. H. 138 cm. W. 341 cm. (each screen). Tokyo National Museum. Important Cultural Property.

As the Ashikaga shogunate declined into impotence, the struggle for power among the military clans escalated into the devastating Onin civil war (1467–77). The great families aligned with the chief contenders, squandering vast resources in a conflict whose battlefield was the city of Kyoto. Ashikaga Yoshihisa (1465–89) finally laid claim to a title devoid of power as his father, Ashikaga Yoshimasa (1436–90), gratefully retired to his newly constructed villa, Ginkaku-ji, in the eastern foothills of the city. Kyoto had been reduced to ashes. A century of ferocious civil strife (*sengoku jidai*, "the age of the country at war") ensued, brought to an end only when the cumulative victories of the warlords Oda Nobunaga and Toyotomi Hideyoshi had recreated national unity.

Kyoto's remarkable rebirth in the sixteenth and early seventeenth centuries owed much to an aggressive merchant class with ties to the powerful commercial center of Sakai. Cultural life received considerable stimulation from successful provincial warlords who sought legitimization through patronage of the arts. A program of castle building offered increased opportunity for experiment with the large-scale decorative formats of sliding doors (*fusuma*) and folding screen (*byōbu*). Kyoto's resilience was celebrated in a new category of screen painting, *rakuchū rakugai*, which offered panoramic views of teeming capital life. Scenes from daily life, so successfully depicted in medieval narrative scroll painting, had awaited a new vehicle after the decline of the scroll tradition. Landscape painting, based on *yamato-e* and Chinese models, provided the other major element of this new style. Whether commissioned by warlords as "views of the realm" or by wealthy merchants as proclamations of prosperity, the *rakuchū rakugai*

screens provide an intriguing window on a vibrant period of Japanese history.

The screens exhibited here, known popularly as the *Funaki bon*, after the collection of which they were long a part, are among the most distinguished examples of this genre. The two six-panel screens view Kyoto from the southwest in a rare single-perspective composition. Most screen sets follow a convention in which the right-hand screen, depicting the eastern half of the city, is viewed from the southwest, while the western half of the city rendered in the left-hand screen is seen from the southeast.

Over ninety specific sites and the activities of several thousand people have been minutely described. The diagonal of the Kamo River links the screens. Two bridges, the Sanjō above and the Gojō in the foreground, alert the viewer to the major east-west thoroughfares. The far right panels of the right-hand screen are dominated by the Hall of the Great Buddha of Hōkō-ji and the adjacent Hōkoku mausoleum, both major constructions of the Toyotomi family. In symmetric opposition in the extreme left panels of the left-hand screen is the sprawling complex of Nijō Castle, the flamboyant Kyoto residence of the Tokugawa shōguns, which was completed in 1603 for a visit from the emperor. The Great Buddha Hall was toppled by an earthquake in 1596 and eventual reconstruction was completed in 1614 under the supervision of Toyotomi Hideyoshi's son, Hideyori (1593–1615). Thus the architecture provides essential clues to the dating of this work. But we must remember that nothing prevented an artist from rendering the Great Buddha Hall from memory and imagination, as seen, for example, in a screen painting of the Hōkoku Festival dated to 1606. Nevertheless Nobuo Tsuji argues persuasively for a dating of 1616. The tension between Toyotomi and Tokugawa, exemplified in the massive buildings at opposite sides of the composition, had been resolved by a Tokugawa victory at the siege of Osaka in 1615. JU

Literature

George Elison and Bardwell L. Smith, ed., *Warriors, Artists, & Commoners: Japan in the Sixteenth Century* (Honolulu: University Press of Hawaii, 1981).

Tsuneo Takeda et al., ed., *Fūzokuga: Rakuchū-Rakugai* [*Genre Painting: Scenes in and Around Kyoto*], vol. 11 (1977) of *Nihon Byōbu-e Shūsei*; especially Nobuo Tsuji, "Funaki-ke Kyūzo Bon Rakuchū-Rakugai Zu Byōbu' no Kentō" [An Examination of the Screens Depicting Scenes in and Around Kyoto Formerly in the Funaki Collection"], 122-29.

Nobuo Tsuji, *Rakuchū-Rakugai Zu* [*Scenes in and Around Kyoto*], no. 121 (June 1976) of *Nihon no Bijutsu*.

Yūzō Yamane, *Momoyama Genre Painting*, trans. by John M. Shields, vol. 17 (1973) of *The Heibonsha Survey of Japanese Art*, 29-35.

116 *Fuzukuzu [Scenes of Popular Entertainment]*

Miyagawa Chōshun (1683-1753). Handscroll; ink and color on paper. H. 37 cm. L. 387.8 cm. Tokyo National Museum.

Miyagawa Chōshun began his career as a minor Edo official and talented avocational painter with traditional Kanō and Tosa schooling. But his work attracted favorable attention, and he became an independent artist known particularly for his handling of color. In 1751 he participated in the restoration of the Tokugawa mausoleum at Nikkō, the Tōshōgū. Unfortunately Chōshun's son, who had joined the project, quarrelled with the supervisor of the restoration, resulting in his son's compulsory suicide and Chōshun's exile to an island in Tokyo Bay.

This handscroll is among his most celebrated compositions and fairly represents his talent as a colorist and figure painter. It depicts several episodes in the working day of a kabuki troupe engaged for a private performance in a daimyō house. We see the performers, most stylishly dressed en route to their engagement, backstage, and finally on stage before their audience. Chōshun's figure style is distinctive among *ukiyo-e* artists, a blend of Moronobu (ca. 1618-94) and Kaigetsudō (act. eighteenth century) beauties tempered by his own contemporary taste. Edo art patrons evidently appreciated his talents: his commissions characteristically depict private rather than public scenarios, and he did not design woodblock prints for the mass market as was customary for *ukiyo-e* artists. MC

Literature

The Freer Gallery of Art, vol. 2: *Japan* (Tokyo: Kōdansha, n. d.), pl. 59 (color) and pp. 170-72 (Chōshun, Festivals of the Twelve Months).

Tadashi Kobayashi, *Edo Shomin no Kaiga: Fūzokuga to Ukiyo-e [Genre Painting and Floating World Pictures]*, vol. 22 (1979) of *Nihon Bijutsu Zenshū*, color pl. 22 (Chōshun, Scenes of the Yoshiwara).

Muneshige Narazaki, ed., *Edo Fūzoku [Manners and Customs of Edo]*, vol. 1, pt. 2 of *Kinsei Fūzoku Zukan*, color repr. pp. 149-87 (Chōshun, Genre Scroll, Ota coll.).

Tokyo Kokuritsu Hakubutsukan: I [Tokyo National Museum: pt. I], vol. 12 of *Sekai no Bijutsukan*, pl. 51 (color detail) and p. 165.

117 *Woman Bathing*

Kitagawa Utamaro (1753?–1806). Hanging scroll; ink and color on silk. H. 98.5 cm. W. 48.3 cm. MOA Art Museum, Shizuoka Prefecture.

The young courtesan stepping into the large wooden tub is reaching behind her to slide the wooden bath door closed. If it were already closed, we could not see the inscription, a *kyōka* (comic verse) by Ota Shokusanjin [134], a well-known poet and connoisseur of *ukiyo-e*. His verses may be found on numerous paintings by such artists as Shunman (1757–1820), Kiyonaga (1752–1815), and Eishi [134]. Based upon his signature, this painting is dated to about 1804, making it one of Utamaro's very late efforts.

Although his paintings are not rare, Utamaro is known primarily as a master printmaker, whose friendships with the writers, major publisher, and artists of Edo establish him as an important figure during the last decades of the nineteenth century. This is one of the most unusual and effective designs in his entire oeuvre. MC

Literature

Hokkaidō Shimbun-sha, *Kinsei no Bi no Kokoro: Kyūsei Atami Bijutsukan Meihinten [Essence of Beauty in Modern Japanese Art: Exhibition of Masterpieces from the Atami Art Museum]* (exh. cat.; Sapporo: Hokkaidō Modern Art Museum, 1979), cat. 36.

Muneshige Narazaki, *Utamaro*, vol. 6 (1981) of *Nikuhitsu Ukiyo-e*, pl. 72.

Martie W. Young and Robert J. Smith, *Japanese Painters of the Floating World* (exh. cat.; Ithaca: Andrew Dickson White Museum of Art, Cornell Univ.; Utica: Munson-Williams- Proctor Institute, 1966), cat. 48.

118 *Daruma (Bodhidharma)*

Momoyama period, 16th century. Oil on paper. H. 32.4 cm. W. 28.4 cm. Namban Bunka-kan, Osaka.

The patriarch of Zen Buddhism, Bodhidharma (J. Daruma), was an Indian monk said to have arrived in China in the sixth century preaching the efficacy of meditation as a means to Enlightenment. Existing practices focussed on ritual or textual study, and Daruma finally withdrew from public life to practice what he had preached. Zen in Japan embellished Daruma's stay in China with numerous legends which when pictorialized became accepted and rever-

ed visual icons: Daruma crossing the Yangtze on a reed, Daruma meditating before a cave wall, and Daruma carrying one sandal. These subjects appear in early Zen paintings of Chinese and Japanese origin. One representational type for which no clear textual or doctrinal origin has been discerned is shown here, the half-length (*hanshin*) portrait of Daruma.

It follows a later mode of Daruma portraiture, one that occurred most conspicuously in the sixteenth century and was perhaps based on an invention by Sesshū, except that Daruma's face, normally given a markedly Indian cast, is here specifically and emphatically Western. Indeed, the likeness seems more a portrait than an icon—a quite searching representation of one individual foreigner, rather than an iconographical type as is more commonly seen in Nagasaki prints or *namban* screens. A number of religious portraits by late sixteenth-century painters evidently trained by the Jesuits in Western oil painting techniques show comparable proficiency in the use of chiaroscuro, but very few achieve the degree of almost photographic verisimilitude seen here. This painting is considered to be the oldest known Western style Daruma painting in Japan. It provides yet another fascinating example of the syncretic nature of Japanese art and the purposes to which it has been put. The large seal is a later interpolation. MC

Literature

Cal French, *Through Closed Doors: Western Influence on Japanese Art 1639-1853* (exh. cat.; Rochester, Michigan: Meadowbrook Art Gallery Ann Arbor: University of Michigan Museum of Art, 1977), cat. 62 (Daruma by Shiba Kōkan).
Hiroshi Kanazawa, *Japanese Ink Painting: Early Zen Masterpieces*, trans. and adapted by Barbara Ford, vol. 8 (1979) of *Japanese Arts Library*, pp. 47-55.
Tei Nishimura, *Nihon Shoki Yōga no Kenkyū* [*A Study of Early Western Painting in Japan*], rev. ed. (Kyoto: Zenkoku Shobō, 1971), pls. 35, 36 (portrait of Nikkyō Shōnin).
Zen no Bijutsu [*Arts of Zen Buddhism*] (exh. cat.; Kyoto National Museum, 1981), cat. 15.

119 *Waterfowl and Willow Tree*

Shiba Kōkan (1747–1818). Hanging scroll; oil and color on silk. H. 139.5 cm. W. 85 cm. Kimiko and John Powers, New York.

After throwing off his early Kanō and Nagasaki school training, Shiba Kōkan devoted himself to forging Suzuki Harunobu's (1725–70) wildly popular

prints and paintings. In this as in most endeavors Kōkan succeeded splendidly, and thereafter set out to master literati and, most significantly, Western style painting, which he encountered in Western art books, principally Dutch, and through the advocacy of the *yōga* (Westernizing) painters Odano Naotake (1749–80) and Hiragi Gennai (1728–79). Kōkan's rediscovery of the technique of copperplate engraving, lost in Japan since the mid-seventeenth century, revolutionized the study of Western perspective techniques, easing the task of many later painters and illustrators. His omniverous interest in Western scientific method, maps, astronomy, and natural science resulted in several books and essays which placed him at the forefront of Edo *Rangaku* ("Dutch studies") scholarship.

Simultaneously he pursued a career as a painter, especially of landscapes in Western style, such as this one. It is a pastiche of botanical and ornithological specimens, precisely observed but rather awkwardly placed in a Dutch landscape, in the foreground of which stands a tree based upon a Chinese model apparently filtered through the work of such contemporaries as Satake Shozan (1748–85) or Naotake. The focus on near and far grounds with little convincing activity portrayed in between is not common in his landscapes, yet it lends a strange but pleasing aura to the composition. The painting is signed "Kookan Siba Zun" using Western script, in the upper left-hand corner, and has been given a date ca. 1790 based upon the signature style. MC

Literature

Calvin L. French, *Shiba Kōkan: Artist, Innovator, and Pioneer in the Westernization of Japan* (New York and Tokyo: Weatherhill, 1974), pl. 74.
Kōbe Shiritsu Namban Bijutsukan Zuroku: Pictorial Record of the Kōbe City Museum of Namban Art (Kobe, 1969), vol. 2, pls. 2-20.
Fujio Naruse, *Shiba Kōkan*, vol. 25 (1977) of *Nihon Bijutsu Kaiga Zenshū*, pl. 14 (color) and p. 132.

120 *Kōyo Tanshō-zu* [*Sketches from an Inspection Tour of the Coast*]

Tani Bunchō (1763–1840). Datable to 1793. One of two albums mounted as handscrolls; ink and color on paper. H. 23.6 cm. W. 45 cm. (each page). Tokyo National Museum. Important Cultural Property.

Although he is generally considered the founder of the Edo literati school of painters, Bunchō's oeuvre reflects an unusual visual eclecticism and a sophisti-

cated understanding of art history. Born in Edo to a family of considerable social status, by his twenties he had returned from Nagasaki, where he studied Chinese as well as Western painting techniques. Such knowledge proved not only artistically advantageous but also intellectually attractive to a society which responded to both the traditional and the novel accomplishments of this peripatetic young man. As a result Bunchō was given access to otherwise inaccessible private collections of Chinese and Japanese paintings and antiquities throughout Japan. He studied assiduously, making sketches of important older works, and wrote a history of Japanese painting, the *Honchō gasan*.

Bunchō's most prized paintings reflect his assimilation of Sung and Ming Chinese painting styles and of *yamato-e* handscrolls and screens, but he also used his painting skills in more mundane spheres. This handscroll contains numerous views of the Izu and Sagami coasts. It comprises sketches from an album he made in 1793, during an inspection tour of coastal defenses south of Edo to assess Japan's defense capabilities in the event of an attack from Russia. He went as assistant to Matsudaira Sadanobu (1758–1829), chief advisor to the shogunate from 1787 to 1793. It is mildly ironic that Bunchō, intellectually curious and artistically progressive, should have been in the employ of Matsudaira, an honest but conservative patriot who censored *ukiyo-e* and stifled the more creative movements in painting and literary circles.

MC

Literature

"Bunchō no Shakeiga" ["Bunchō's True View Paintings"], *Kokka*, no. 261 (October 1887), pp. 228-29.

Edo Bijutsu Ten Mokuroku [*Catalogue of an Exhibition of the Arts of the Edo Period*] (exh. cat.; Tokyo National Museum, 1966), cat. 83.

Tani Bunchō: Edo Nanga no Sōshi [*Tani Bunchō: Master of Edo Literati Painting*] (exh. cat.; Utsunomiya: Tochigi Prefectural Museum of Fine Arts, 1979), cat. 42.

121 *Portrait of Watanabe Kazan*

Tsubaki Chinzan (1801–54). Dated to 1853. Hanging scroll; ink and color on silk. H. 125.9 cm. W. 80.3 cm. Tahara-machi, Aichi Prefecture. Important Cultural Property.

A notation inscribed at the end of the roll on which this portrait is mounted identifies the subject as Watanabe Kazan in his forty-fifth year and the date as the eleventh day of the tenth month, 1853, the thir-

teenth anniversary of Kazan's death. It seems likely that Tsubaki Chinzan wished to depict his teacher at the height of his powers in the year when his artistic maturity was evidenced in the remarkable portraits of Ichikawa Beian [125, 126] and Takami Senseki. In 1837, too, Kazan's civil responsibilities weighed heavy, his risky political involvement accelerated, and his youngest brother, Gorō, died. Chinzan conveys, with considerable artistry but also with the advantage of retrospect, a quality of pensive resolve, perhaps fatigue, and foreboding. An 1842 portrait by Chinzan (in the Honolulu Academy of the Arts) presents Kazan within the conventional painted oval frame (see [81]), his features quite sculpted and stylized. This visage, completed less than a year after Kazan's death, is somehow abstract. Kazan's presence could only be evoked by Chinzan's considerable representational skills at a time of calmer recollection.

The development of this portrait by Kazan's outstanding disciple is well documented in a series of seven known preliminary sketches. Three of these sketches bear dates of 1843 and were likely preliminary to a third anniversary memorial portrait of Kazan. The remaining four sketches, although undated, are unmistakably essays for the completed portrait seen here.

Chinzan met Kazan in 1816 when both were students of Kaneko Kinryō. At Kinryō's death, Chinzan continued his training under Kazan. The relationship, clearly cherished by both men, was sustaining. Chinzan admirably filled the roles of advisor, correspondent, critic, editor, and advocate. Although Kazan's most faithful disciple, Chinzan was not a sycophant; he had a reputation for strength and independence of mind. Records of 1824 reveal that almost four hundred students sought his instruction, among them Kazan's brother Gorō. Chinzan's son studied under Kazan. After Kazan's death Chinzan, at considerable personal risk, looked to the welfare of the master's mother, wife, and children.

The thematic and stylistic direction of Chinzan's art was set, perhaps dominated, by Kazan. Chinzan's productions are generally lighter and more congenial compared with the probing intensity of Kazan. Still, his portraiture is convincing and his 1845 study of Takaku Aigai (Figure 13) ranks as a masterpiece of the genre.

JU

Literature

Shōbyōga, Rimpa, Bunjinga [*Sliding Door and Screen Painting, Kōrin School Painting, Literati Painting*], vol. 1, pt. 1 of *Zaigai Hihō*, p. 128 (portrait of Kazan, Honolulu Academy of Arts).

Chū Yoshizawa, "Tsubaki Chinzan Hitsu: Watanabe Kazan Shōzō Gakō" ["Sketches for the Portrait of Watanabe Kazan by Tsubaki Chinzan"], *Kokka*, no. 786 (September 1957), pp. 289-92 and pl. 6.

122 *Portrait of Kō Sūkoku*

Watanabe Kazan (1793–1841). Fan painting; ink, color, gold, and silver on paper. H. 17.8 cm. W. 45.7 cm. Cleveland Museum of Art 76.8. James Parmelee Fund.

The painted and inscribed folding fan was a most suitable gift between devotees of the literati aesthetic. It offered yet another format in which Kazan could exercise his skill in portraiture.

The subject is Kō Sūkoku (1730–1804), a prolific Edo artist, the disciple and perhaps son of Sawaki Sūshi (1707–72), who in turn was a follower of Hanabusa Itchō (1652–1724). Sūkoku's art achieved a graceful blend of Kanō and *ukiyo-e* style, admirably continuing the Itchō tradition.

The circumstance of production of this portrait is unclear. Sūkoku died when Kazan was eleven years old, making a meeting between the two improbable. On the reverse of the fan is a poem attributed to Sūkoku and sealed by Tani Bunchō:

The grave is readied
And the sake warmed.
Ah, the cold.

This is apparently Bunchō's variation on Sūkoku's final haiku:

The grave is readied,
The departed mourned.
Ah, the cold.

A death anniversary would have provided the most likely occasion for such a memorial portrait. Perhaps Kazan worked from existing sketches and Bunchō's suggestions. The depiction lacks the fluidity of many other Kazan figure studies, adding weight to the supposition that this is an imagined rather than life-drawn portrait. It is the only known portrait of Sūkoku. JU

Literature

"Kazan no Chimpin Nidai" ["A Rare Fan by Kazan"], *Geijutsu Shinchō*, 1976, no. 4, n.p.

123 *Ukō Kōmon [Story of Count Yu Building a Great Gateway]*

Watanabe Kazan. Dated to 1841. Hanging scroll; ink and color on silk. H. 157.6 cm. W. 51 cm. Yokose Fuji, Tokyo. Important Cultural Property.

124 *Studies for Ukō Kōmon*

Watanabe Kazan. One of a series of five hanging scrolls; ink and light color on paper. H. 132.2 cm. W. 50 cm. Tokyo National Museum.

At the end of the first month of 1840 Watanabe Kazan was transported from Edo to his home fief of Tahara. Prison life had aggravated health problems and the journey was strenuous. Typically, Kazan found solace in sketching views along the route. Permanent accommodations were arranged for Kazan and his family at Ike no Hara on the property recently vacated by the agronomist Okura Nagatsune (b. 1768). On the sixth day of the second month local officials duly reported to Edo that the prisoner was secured under the new conditions of house arrest.

Kazan initiated a routine of correspondence and painting. Flora, fauna, and seascape were the subjects of his repertoire, masterfully executed but hauntingly different in mood from the pre-prison works.

In the late summer of 1841, Kazan prepared the sketches and completed the painting seen here. Depicted is the Chinese tale of the construction of a great gate by the magistrate Yu. Renowned for his virtue and even-handed judgments, Yu was held in high esteem by all who dealt with him. In a gesture that simultaneously set high standards for his descendants and expressed confidence that they would live up to those standards, Yu commissioned the construction of a disproportionately huge gate before his home. He felt certain that the accumulated virtue of his life would have a beneficent impact on his descendants, and that their accomplishments would be a worthy complement to his initial construction.

The painting was to be a gift for the Edo magistrate Nakajima Kaemon, whose handling of the legal issues involved in the suppression of the Shōshikai (see [130]) was greatly admired by Kazan.

A month after completing the *Great Gateway* painting, Kazan composed a final calligraphic statement in a bold but tortuous hand: *Fuchū, fukō Watanabe Nobori* ("Unfaithful, unfilial Watanabe Nobori"). On the eleventh day of the tenth month, 1841, Kazan slipped away from his family to a small shed nearby where Okura had conducted sugar refining. There he committed suicide by disembowelment, the method required of a samurai. JU

Literature

Teizō Suganuma, *Kazan no Kenkyū* [*A Study on Kazan*] (Tokyo: Mokuji-sha, 1969).

——, *Watanabe Kazan*, no. 162 (November 1979) of *Nihon no Bijutsu*, pl. 2 (color detail), pls. 107, 108.

Minpei Sugiura and Teizō Suganuma, *Watanabe Kazan*, vol. 19 (1975) of *Bunjinga Suihen*, pls. 7, 8 (color), 9, and p. 145.

Susumu Suzuki and Masaaki Ozaki, *Watanabe Kazan*, vol. 24 (1977) of *Nihon Bijutsu Kaiga Zenshū*, pls. 25, 26 (color), and pp. 132-33.

125 *Portrait of Ichikawa Beian*

126 *Study for Portrait of Ichikawa Beian*

Watanabe Kazan. Dated to 1837. Hanging scrolls; (*Portrait*) ink and color on silk, H. 129.5 cm. W. 59 cm. (*Study*) ink and color on paper, H. 39.2 cm. W. 27.8 cm. Agency for Cultural Affairs, Tokyo. Important Cultural Property.

Ichikawa Beian (1779–1858), together with Nukina Kaioku and Maki Ryoko, formed a trinity regarded as the greatest calligraphers of the late Edo period. Beian's *Kaigyo Waiken*, a fifteen-volume examination of the evolution of script styles remains a monument of scholarship. The association between the artist and this doyen of Edo high culture was grounded in mutual interests rather than formal academic filiation.

The preliminary study and portrait are both dated to 1837. Beian added the inscription in the upper portion of the painting on the occasion of his sixtieth birthday in 1838. The portrait was likely executed in anticipation of this celebration. As a gesture of thanks, Beian presented Kazan with an album of paintings by the Chinese Ch'ing dynasty artist Cheng Tai (act. latter half of eighteenth century), a disciple of the painter Hua Yen (1682–ca. 1765).

The result of more than two decades of experiment with the human figure can be observed in the finished portrait of Beian. Kazan clearly perceived that unmodified application of European portraiture technique would be inappropriate to his subject. The flat, stark rendition inherited from the *chinsō* tradition was eminently well suited for describing the studied reserve proper to any public presentation of face. Yet a controlled use of chiaroscuro allowed a sense of tactile individuality without permitting a fully modelled figure to break the necessarily taut two-dimensionality of the portrait. The preliminary sketch is striking in its uninhibited fullness, suggesting the degree to which Kazan restrained his initial impressions of the subject. JU

Literature

Teizō Suganuma, *Kazan no Kenkyū* [*A Study on Kazan*] (Tokyo: Mokuji-sha, 1969).

——, *Watanabe Kazan*, no. 162 (November 1979) of *Nihon no Bijutsu*, pls. 8 (color), 80, 81.

Minpei Sugiura and Teizō Suganuma, *Watanabe Kazan*, vol. 19 (1975) of *Bunjinga Suihen*, pls. 64 (color), 65, and p. 148.

Susumu Suzuki and Masaaki Ozaki, *Watanabe Kazan*, vol. 24 (1977) of *Nihon Bijutsu Kaiga Zenshū*, pls. 2 (color), 3 (color), and pp. 126-27.

127 *Portrait of Ozorabuzaemon (Ozora Buzaemon)*

Watanabe Kazan. Dated to 1827. Hanging scroll; ink and color on paper. H. 221.3 cm. W. 117.6 cm. Cleveland Museum of Art 80.177. Leonard C. Hanna Jr. Bequest.

An *okugai* (reverse side inscription) signed "The Master of Ainichirō," the nom de plume of Satō Issai (1772–1859), relates the circumstances surrounding production of this portrait and offers some biographical information. Satō, a noted Confucianist scholar and intimate of Watanabe Kazan, was himself the subject of several of the artist's portrait studies. He relates that on the eleventh day, sixth month in the tenth year of Bunsei, the giant Ozorabuzaemon (Ozora Buzaemon) and the artist Watanabe Kazan visited his residence. Kazan made a detailed sketch of the giant, employing a camera obscura (*shashinkyō*). Amazed by his guest's size, Satō writes that Ozorabuzaemon could touch the *kamoi* (upper track of the sliding door) from a sitting position and when standing could easily touch the ceiling with his hand. He consumed a vast quantity of food and well over a liter of rice wine, exhibiting no ill effects. Satō lists other sundry statistics: the giant is twenty-five years old and a native of a small village in western Kyūshū; height is 214 cm.; shoulder width, 107 cm.; kimono length, 155 cm.; palm span, 25.7 cm.; sole of foot, 33.3 cm.; weight, 121.28 kg.

The inscription on the obverse of the painting confirms the date of execution and measurements listed by Satō, giving in addition the outer coat length (115.14 cm.) and the sleeve length (68 cm.). A left hand print is impressed on the left mid-section of the painting. Statistics enumerated in the various inscriptions closely approximate the measurements of the figure in the painting.

Information on Ozorabuzaemon comes from two contemporary popular publications: *Toen Shōsetsu Yoroku*, a series of miscellaneous essays by Takizawa Bakin (1767–1848), and *Kashi Yawa*, brief articles on the bizarre and unusual by various authors published in serial form during the first half of the nineteenth century. Bakin, preeminent novelist of the period, recounts the sensation caused by Ozorabuzaemon's arrival in Edo in the fifth month of 1827. A samurai in the retinue of a Kyūshū daimyō, the giant was quickly a marketing success. Street vendors hawked foot and hand prints, as well as a proliferation of paintings, none of which, says Bakin, resembled the subject. Pornographic paintings featuring Ozorabuzaemon provoked a government ban on the production of all materials related to him.

The *Kashi Yawa* relates that Ozorabuzaemon was a provincial celebrity brought to the attention of the local daimyō for his remarkable feats of strength and capacity for large amounts of food. The daimyō allegedly presented the giant with samurai attire and conscripted him. Ozorabuzaemon's days in Edo were evidently unhappy ones. He is described as a timid personality, annoyed by the constant crowds that he attracted. An attempt to become a sumō wrestler ended in failure and he returned to Kyūshū within a year of his arrival in the metropolis.

In his essays Bakin remarked that he was shown the completed portrait and was so taken by it that he requested a copy. It is not known if that is the same work now in a private collection in Japan. Over a dozen *ukiyo-e* versions, principally by Utagawa Kuniyasu (1794–1832), are in the unpublished collection of the Sumō Museum, Tokyo. JU

Literature

Seizan Matsuura, *Kasshi Yawa Zokuhen*, pt. 6, ed. Yukihiko Nakamura and Mitsutoshi Nakano, no. 342 (1979) of *Tōyō Bunko*.

Teizō Suganuma, *Kazan no Kenkyū* [*A Study on Kazan*] (Tokyo: Mokuji-sha, 1969).

Susumu Suzuki, "Watanabe Kazan no Shōzōga" ["Portraits by Watanabe Kazan"], *Museum* (Tokyo), no. 46 (January 1955), pp. 17-20.

Takahashi Suteroku Shi Iaihin [*The Collection of the Late Takahashi Suteroku*] (sale cat.; Tokyo Bijutsu Kurabu, 4-5 March 1919).

Bakin Takizawa, *Toen Shōsetsu Yoroku Daini*, in *Shin Enseki Jusshū Daiyon*, ed. Kamezō Asakura (Tokyo: Kokushokankōkai, 1913), pp. 421-24.

128 *Studies for a Portrait of the Artist's Father, Watanabe Hashū*

129 *Study for a Portrait of the Artist's Father, Watanabe Hashū*

Watanabe Kazan. Dated to 1824. Five sketches mounted on a hanging scroll; ink on paper. H. 131.9 cm. W. 51.2 cm. (overall). Hanging scroll; ink on paper. H. 92.6 cm. W. 59.7 cm. Tahara-machi, Aichi Prefecture. Important Cultural Property.

Watanabe Kazan's affectionate devotion to family is evident in both his painting and writing. Separately executed sketch-portraits of his father, mother, and youngest brother all share in a charged, unpolished quality that typifies the artist's most evocative work.

Watanabe Sadamichi (1765–1824), also known as Hashū, was the third son of Hirayama Gōuemon-naoyoshi of the Tahara (Aichi Prefecture) fief. At the age of fifteen Sadamichi was adopted by Watanabe Sadanobu of the same province. This was a practice commonly employed by families lacking a natural male heir. Untypical of the arrangement was the fact that Sadamichi's bride, Ei, was unrelated to the Watanabe clan. Thus Kazan and his seven brothers and sisters carried the Watanabe name without any blood relationship.

Shortly after his adoption, Sadamichi moved to Edo, where he represented Tahara interests to the national government. In 1792 he succeeded Sadanobu as family patriarch. Sadamichi filled administrative posts with apparent competence but was plagued by economic troubles. A man of scholarly bent, he studied Confucianism, as did his son, with Takami Seikō. Anecdotes recorded by Kazan depict a particularly warm relationship between father and son. Ill health debilitated Sadamichi in his later years and he required continuous nursing. On the occasion of his marriage in 1823 Kazan, musing on his increasing domestic and professional responsibilities, noted that his foremost duty was to his parents' welfare.

Exhibited here are the death sketches and a preliminary posthumous portrait executed by Kazan. Drawings of a ravaged face with eyes closed, muscles slack, and teeth exposed are transformed in the preliminary portraits into the mature, open countenance of the admired father. Kazan wrote of the emotional moments when he mustered the discipline to kneel beside his father's corpse with brush and paper.

The sketches and completed portrait of Satō Issai (1821) and the sketch-portrait of Kazan's youngest brother Gorō (1821) are the artist's major efforts in this

genre preceding the Sadamichi (1824) studies. The Issai portrait is an early experiment with shading and depth of field, innovations also applied to the Sadamichi portrait.

The Obaku Zen influence on *nanga* painters (see [80]), Bunchō's concern with portraiture (see [133]), and Kazan's exposure to European models and techniques in varying degrees informed his skilled pursuit of the art of portraiture. JU

Literature

Teizō Suganuma, *Kazan no Kenkyū* [*A Study on Kazan*] (Tokyo: Mokuji-sha, 1969).
———, *Watanabe Kazan*, no. 162 (November 1979) of *Nihon no Bijutsu*, pls. 47, 48.
Minpei Sugiura and Teizō Suganuma, *Watanabe Kazan*, vol. 19 (1975) of *Bunjinga Suihen*, fig. 8.
Susumu Suzuki and Masaaki Ozaki, *Watanabe Kazan*, vol. 24 (1977) of *Nihon Bijutsu Kaiga Zenshū*, pls. 41-44 and p. 137.

130 *Prison Sketches and Notes*

Watanabe Kazan. Handscroll; ink on paper. H. 23.5 cm. L. 321.5 cm. Tahara-machi, Aichi Prefecture. Important Cultural Property.

Watanabe Kazan's first exposure to "Dutch" learning took the form—seemingly politically innocuous—of experiments with perspective drawing and chiaroscuro. As a civil administrator holding positions of increasing responsibility, Kazan, along with other outstanding personalities of his generation, sought in Western models for ways to cure an ailing feudal society. Two notable periods of reform, the Kyōhō (1716–36) and Kansei (1784 1801), saw attempts to correct abuses in tax collection and revenue distribution, to increase agricultural productivity, and allay popular discontent by curbing extravagance in public and private life. In 1720 the shōgun Yoshimune, with the specific intention of introducing beneficial Western technology, relaxed the ban on the importation of Dutch books. The Tokugawa system tolerated a moderate assimilation of Western learning in such varied fields as medicine, military science, and agronomy. But the implementation of such reforms and liberalizations was sporadic and short-lived. Uncoordinated and sometimes cynically manipulated policies placed an extreme burden on the agricultural base of the economy, occasioning recurrent famine followed by peasant uprising.

In 1832 Kazan was appointed *karō* (chief retainer) for the Tahara fief. His duties included development of a defense plan for his fief's seacoast as well as a policy to alleviate the famine that oppressed Tahara and much of central Japan. During this period Kazan, in association with the scholar-activist and physician Takano Chōei (1804–50), the translator-physician Kozeki San'ei (1788–1839), and others formed a group, the Shōshikai, dedicated to Western learning. Its members were critical of the *bakufu's* inept management of domestic affairs and xenophobic foreign policy. In 1837 the neo-Confucianist scholar Oshio Heihachirō (1793–1837), moved by the disastrous famine in the Osaka area and government reluctance to initiate appropriate relief measures, led an armed uprising against the authorities and the rich. The revolt was put down and Oshio committed suicide to avoid capture, but the incident stunned the shogunate and exacerbated its suspicions that intellectual dissent spelled treason.

In 1839 the government made known its intention to expel the American ship *Morrison* on its impending entry into Japanese waters. Kazan and Chōei issued tracts deploring the government decision. Countercharges of sedition led to the suppression of the Shōshikai. On the fifteenth day of the fifth month Kazan was arrested. Chōei went into hiding but was captured in a few days. San'ei, aware that his health could not withstand the rigor of prison regimen, took his own life.

Kazan was incarcerated for six months. Tsubaki Chinzan (see [121]) organized friends in an effort to secure the release of his teacher. Matsuzaki Kōdō (1771–1844), Confucianist scholar and an intimate of Kazan, at one point offered his life as hostage for Kazan and was finally able to negotiate Kazan's release from prison to house arrest in Tahara.

These sketches, made shortly after his release, provided Kazan with an occasion for painful but perhaps cathartic recollection. With a touching attempt at objectivity he shows himself being arrested, on his knees being bound, mustering a pose of dignified formality before sparse prison fare, and the harsh linearity of the prison compound itself. Chinzan's written accounts of the imprisonment survive, but these stark sketches, so removed in spirit from the playful, fluid celebration of the *Issō Hyakutai* [107], most adequately convey the trauma of a false accusation and a life rudely transformed. JU

Literature

Teizō Suganuma, *Kazan no Kenkyū* [*A Study on Kazan*] (Tokyo: Mokuji-sha, 1969).
———, *Watanabe Kazan*, no. 162 (November 1979) of *Nihon no Bijutsu*, pl. 94 (section).
Minpei Sugiura and Teizō Suganuma, *Watanabe Kazan*, vol. 19 (1975) of *Bunjinga Suihen*, pl. 55 and p. 148.

Susumu Suzuki and Masaaki Ozaki, *Watanabe Kazan*, vol. 24 (1977) of *Nihon Bijutsu Kaiga Zenshū*, pl. 100 and p. 142.

131 *Pilgrimage of the Blind*

Sō Gessen (1721-1809). Handscroll; ink and color on paper. H. 58 cm. L. 850 cm. Chion-in, Kyoto.

The monk-painter Sō Gessen is best known as a devout Buddhist and as a teacher of such disparate artists as Aōdō Denzen [98] and Tachihara Kyōsho (1785–1840). He studied both painting and Zen from a very young age, first in Edo and later in Kyoto, despite his Zen teachers' efforts to dissuade him from art. While living in Kyoto he attracted the attention of the monk Dan'yo, of the influential Chion-in, who encouraged his painting activity and permitted Gessen to study the temple's splendid collection of Chinese paintings. Gessen also obtained lessons at Okyo's studio, establishing his artistic lineage in the standard histories as a painter of that school.

In his mid-thirties Gessen was appointed by Dan'yo abbot of the Jakushō-ji in Ise, at that time a run-down temple with few parishioners. In fact Gessen throughout his lifetime used the proceeds from the sale of his paintings to rebuild the Jakushō-ji and obtain sutras for religious services, to care for the poor in his vicinity, and even to help unfortunates outside the Ise area. His paintings are reported to have been in great demand and his output prodigious, yet relatively few works seem to have survived.

This handscroll is considered one of Gessen's major figure compositions and is one of several of his scrolls owned by the Chion-in. It depicts a theme as well known in the West as in the East: the blind leading the blind, here shown as a procession of old men on an indefinite journey. The same theme appears frequently in the works of the Zen monk-painter Hakuin Ekaku (1686–1769), both as a direct reference to a difficult river crossing near his temple on the Tōkaidō and as a visual metaphor describing the precarious path to Enlightenment. As is typical in Gessen's paintings but notably rare in Japanese art in general, his figures represent the less fortunate members of Edo period society, a predilection that earned him the name Kojiki Gessen (literally, Beggar Gessen). Seals following his inscription on this handscroll permit a dating to about 1774. MC

Literature
Chion-in (exh. cat.; Kyoto National Museum, 1974), cat. 17.

John M. Rosenfield and Elizabeth ten Grotenhuis, *Journey of the Three Jewels: Japanese Buddhist Painting from Western Collections* (exh. cat.; New York: Asia House Gallery, 1979), cat. 57 (Two Blind Men Crossing a Log Bridge by Hakuin, Gitter collection).

132 *Portraits of Contemporaries*

Tani Bunchō. Dated to 1831. Handscroll; ink and color on silk. H. 27.2 cm. L. 981.7 cm. Tokyo National Museum. Important Cultural Property.

Bunchō enjoyed extraordinary patronage throughout his career, allowing him to limit the commissions he accepted both in number and in kind. This holds true especially for his later years when his art relied less on Chinese landscape prototypes for compositional formats and themes. His brushwork became looser and more expressive, and he turned frequently to the native landscape for his inspiration. From about age fifty-five his range of subject as well as his control of brush and ink places him at the forefront of later Edo painters, a man completely versed in the classical traditions of Japan (see [29]), and at the same time comfortable with all the contemporary trends in painting: *rimpa*, *ukiyo-e*, Nagasaki, and *nanga*.

At age sixty-nine Bunchō recorded in this handscroll the portraits of more than forty well-known contemporaries. Represented are poets, including Ota Shokusanjin [132a], educators, government officials, and actors, as well as fellow painters Okyo [103, 104, 114], Goshun (1752–1811), and Kimura Kenkadō [133]. Most of the subjects came from Edo, Kyoto, and Osaka, but even Bunchō, prominent and widely travelled though he was, may not have known all of them personally. Evidently this handscroll was based on life sketches made over a period of several years. Bunchō's notations to the right of each portrait give the name, native city, and occupation, and often the age of the sitter and date of the sitting, which frequently preceded the date of the handscroll (1831) by some years.

The variety of poses, the simple but careful individualization, and the unusual framing device prompted by Western custom set this handscroll apart from comparable documents of the time. Of added interest is the artist's inclusion of his own portrait, larger than any other in the scroll, showing him at age forty. A preparatory sketch exists, and the two renditions are congruent almost line for line. The initial underdrawing for two figures at the beginning of the scroll extends to the lower edge of the handscroll, indicating that initially Bunchō did not intend to "frame" each portrait separately. MC

Literature

Tani Bunchō: Edo Nanga no Sōshi [*Tani Bunchō: Master of Edo Literati Painting*] (exh. cat.; Utsunomiya: Tochigi Prefectural Museum of Fine Arts, 1979), cat. 1.

133 *Portrait of Kimura Kenkadō*

Tani Bunchō. Hanging scroll; ink and color on silk. H. 69 cm. W. 42 cm. Osaka Prefecture. Important Cultural Property.

By occupation Kimura Kenkadō (1736–1802) was a successful Osaka *sake* brewer, by avocation a skilled painter and seal engraver who had studied first with a Kanō artist and subsequently with Yanagisawa Kien (1706–58) and Ike no Taiga [106]. His fame, however, rests on his connoisseurship and patronage: collecting rare books and coins and supporting the work of literati artists of the Kansai (Osaka-Kyoto) region. About 1790, he was forced to flee Osaka for protection in the Ise area, bankrupt and accused of having violated governmental restrictions on the production of *sake*, but after 1793 he was able to return to Osaka where he opened a stationery business.

Kenkadō's house was open to virtually every major artist of the later eighteenth century who travelled through the Kansai. Tani Bunchō visited on more than one occasion, meeting there a number of literati painters and adding a knowledge of their artistic convictions and style to the Kanō school tradition in which he had originally trained and the Western style painting he had studied in Nagasaki [120]. In the summer of 1796 Kenkadō noted in his diary that Bunchō was stopping off during a study tour of important art collections in western Japan. This is confirmed in part by Bunchō's diary sketches, one of which portrays Kenkadō in the very pose and expression we see in this portrait. MC

Literature

Nippon Keizai Shimbun-sha, *Kinsei Gonin no Kyoshō Ten: Tan'yū, Kōrin, Taiga, Okyo, Bunchō* [*Exhibition of Five Modern Masters: Tan'yū, Kōrin, Taiga, Okyo, and Bunchō*] (exh cat.; Tokyo: Matsuya Dept. Store, 1969), pl. 7 (color) and p. 107.
Tani Bunchō: Edo Nanga no Sōshi [*Tani Bunchō: Master of Edo Literati Painting*] (exh. cat.; Utsunomiya: Tochigi Prefectural Museum of Fine Arts, 1979), cat. 2.
Chū Yoshizawa and Takeshi Yamakawa, *Nanga to Shaseiga* [*Literati and Realist Painting*], vol. 18 (1969) of *Genshoku Nihon no Bijutsu*, pl. 80 (color) and p. 117.

132a (section).

134 *Portrait of Ota Shokusanjin*

Hosoda Eishi (Chōbunsai) (1756-1829). Dated to 1814. Hanging scroll; ink and color on silk. H. 87.5 cm. W. 27.3 cm. Tokyo National Museum.

Eishi first met Ota Shokusanjin (1749–1823), the renowned author of comic verse (*kyōka*), in early spring of 1813, when both were on a trip to Mitsui, stopping en route at Shirahige Shrine. The friendship proved lasting, and the poet's verse can be found on numerous Eishi paintings, as well as on those of Tani Bunchō [132, 133], Sakai Hōitsu, Kubo Shunman, Utamaro [117] and other late eighteenth-early nineteenth-century Edo artists. He was a man well known among that city's leading writers and painters, and his own oeuvre was lively, its volume prodigious.

This scroll dates to 1814 and portrays Shokusanjin seated, drinking *sake* from a small red lacquer cup. The presence of brushes, ink stone, blank fans, and a short scroll of paper suggest preparations for composing verse. Wine has been a long-honored source of poetic inspiration in China as well as Japan, and Shokusanjin's verse on this portrait was undoubtedly kindled in just this manner. It is a play on words,

comparing his age (then sixty-six) to the number of Japanese provinces (seventy-two), while looking into a mirror and contemplating how much longer he will live. The sentiment is, in its own way, startlingly reminiscent of that expressed in Hōjō Takatoki's inscription on the portrait of Nanzan [71].

Eishi enjoyed the benefits of high birth, a classical education, and painting study in the Edo studio of Kanō Eisen'in (1737–90), a court painter much favored by the shōgun Tokugawa Ieharu (1737–86). Eishi himself eventually served Ieharu and Iehari (1773–1841) as a Kanō style painter but gave up his position in his mid-thirties to further his career as a *ukiyo-e* printmaker and painter. In 1800 one of his landscape paintings was selected for the Imperial Household Collection, and this may have provided the impetus for his virtual abandonment of printmaking in favor of painting. This portrait is somewhat uncommon, as Eishi's typical subjects are lithe, beautifully dressed women set in abbreviated landscapes. As in this scroll, Eishi normally used silk and very high quality pigments with consummate skill. The fine-line drawing and elegant tonal values apparent make this portrait a somewhat understated example of his work, not too dissimilar from several "casual" paintings by Utamaro [117], who influenced Eishi's oeuvre. In comparison, Bunchō's depiction of Shokusanjin [132a] is certainly a more formal portrayal.　　MC

Literature

Klaus J. Brandt, *Hosoda Eishi, 1756–1829: Der Japanische Maler und Holzschnittmeister und Seine Schüler* (Stuttgart: K. J. Brandt, 1977).

Muneshige Narazaki, *Utamaro*, vol. 6 (1981) of *Nikuhitsu Ukiyo-e*, pl. 48 (color detail).

135　*Portrait of Okakura Tenshin (Kakuzō)*

Shimomura Kanzan (1873-1930). Hanging scroll; ink and color on paper. H. 136 cm. W. 66.4 cm. Tokyo University of Arts.

With the beginning of the Meiji period (1868-1912) Japanese artists were freely able to study Western-style painting (*yōga*). Their predecessors, such as Okyo [103], Bunchō [120], Kōkan [119], and Denzen [98], had enjoyed only limited access to Western books and illustrations. Except for Kōkan they were, after all, steeped in classical Japanese learning and painting techniques, and these predominate in their work as it is known today. But Commodore Perry's visit to Japan and the looming shadow of Russia (see [120]) forced the government to institute the study of Western learning, officially opening the door for artists such as Takahashi Yūichi [138] and his suc-

cessors to study *yōga*, oftentimes in Europe. Several independent studios and schools opened, and a government-sponsored art school offered instruction from Italian teachers in Western representational techniques. But the promotion of *yōga* set up a concurrent nationalistic reaction, which by the second decade of the era challenged the *yōga* movement and its rationale.

Okakura Tenshin (Kakuzō, 1862–1913), friend and mentor of Fenollosa (see [138]) and serious sinologist, was a principal leader in the countermovement. He encouraged the study and preservation of traditional Japanese art and in 1887 established the Tokyo School of Fine Arts (Tokyo Bijutsu Gakkō), from which *yōga* instruction was excluded until 1896. Among his students were Yokoyama Taikan (1868–1958) and Shimomura Kanzan, who also belonged to the Japanese Art Association (Nihon Bijutsu-in), founded in 1898 by a progressive group of modern Japanese-style painters many of whose works were inspired by Tenshin. Focussing on traditional historical subjects (see [136]), this young group exhibited actively at the art school before disbanding a year before the first official government salon exhibition (*Bunten*) in 1907. Nevertheless they participated individually in the troubled salon until 1914, the year following Tenshin's death, when Kanzan and Taikan joined with other progressive Japanese style painters such as Maeda Seison [137] to found the Saikō Nihon Bijutsu-in. This group of artists became the guardians of Okakura's legacy and the mainstream of modern Japanese-style painting through the 1930s, producing a number of masterpieces of modern traditional painting.

This sketch of Tenshin was executed in preparation for the final portrait, which appeared in the ninth Saikō Nihon Bijutsu-in exhibition of 1922. The portrait was unfortunately destroyed in the great Kantō earthquake the next year, but a photograph confirms the faithfulness of the sketch in all significant aspects. Tenshin is seated at a desk in the uniform of the art school, smoking a cigarette while he ponders the compositional plan for a painting of the *Heike Monogatari* [136]. Comparison with sketches for other finished paintings and the absence of significant *pentimenti* indicate that this sketch is a very late stage in the preparation of the final portrait. The sitter is best known in the West for his books *The Ideals of the East* and *The Book of Tea*, and as the man largely responsible for assembling the superb Asiatic collection of the Museum of Fine Arts, Boston. This sketch was given by Langdon Warner to Tokyo University of Arts in 1932. It is one of the monuments of Taishō painting history and may safely be dated to the same year as the lost portrait.　　MC

136a (section).

Literature

Minoru Harada, *Okakura Tenshin*, vol. 6 (1970) of *Tōyō Bijutsu Sensho*, pl. 1 (color).

Shimomura Kanzan, vol. 1, *Kanzan Gashū* [*Complete Paintings of Kanzan*] (Tokyo: Dainihonkaiga, 1981), pl. 96 (color) and pp. 306-7.

Tokyo Geijutsu Daigaku Shozō Meihin Ten—Sōritsu Kyūjū Shūnen Kinen [*Exhibition of Masterpieces from the Tokyo University of Arts in Commemoration of its Ninetieth Anniversary*] (exh. cat.; Tokyo National Museum, 1977), cat. 28.

136 *Ohara Gokō E-maki*
[*Emperor Gō-Shirakawa's Visit to Ohara*]

Shimomura Kanzan. Handscroll; ink and color on silk. H. 52.3 cm. L. 790.3 cm. Tokyo National Museum of Modern Art.

Born in Wakayama Prefecture, Kanzan entered Tokyo Bijutsu Gakkō at seventeen, having already studied with Kanō Hōgai (1828–88) and Hashimoto Gahō (1835–1908). A talented and successful painter by the time he graduated, Kanzan became an instructor at the institution, travelled with Okakura Tenshin and other artists through Japan on several occasions, and went to Europe in 1903 for over a year and a half.

Upon returning, Kanzan began to exhibit more actively than ever. Following a trip to Hokkaidō with his friend the painter Yokoyama Taikan (1868–1958), he painted this impressive handscroll, datable to 1908. Kanzan's early works comprise almost exclusively Japanese historical themes, landscapes, figure paintings, a few copies of Chinese paintings and of Western paintings seen in Europe. But the nucleus of his early oeuvre consists of reinterpretations of traditional painting subjects—especially *rimpa*, *suiboku-ga*, and, as can be seen here, Kamakura *e-makimono*. He worked sparingly in the handscroll format, preferring to paint excerpts from traditional *e-maki* themes as hanging scrolls.

This handscroll illustrates a well-known event in Japanese history, immortalized as a chapter of the *Heike Monogatari* and depicted also on several folding screens (*byōbu*): the visit of the retired emperor Gō-Shirakawa [61] to his daughter-in-law, the nun Kenreimon-in (d. 1213) at her residence in Ohara, north of Kyoto, in 1186. A daughter of Taira Kiyomori, she was at sixteen married to Gō-Shirakawa's favorite son, Takakura, then eleven, and in 1178 bore a son, Antoku. But Taira defeats in the civil war with the Minamoto clan forced her to flee Kyoto with her son. At the decisive naval battle of Dan no Ura in the spring of 1185 Kenreimon-in saw her mother leap into the sea with the child Antoku in her arms to avoid capture, but she herself was taken by the victorious Minamoto warriors. Escorted back to Kyoto, Kenreimon-in became a nun at age twenty-nine. She chose to live at the Jakkō-in, at that time a most unpretentious country retreat, in the circumstances of isolation and near-poverty described in this painting. The obligation to pray for her dead Taira kindred

289

compelled her to live, enduring a desolate condition and harrowing memories. She has been remembered in Japanese literature and drama as an especially poignant, heroic figure.

Kanzan painted this subject on at least two earlier occasions, first in 1899 and again the following year as a hanging scroll depicting Kenreimon-in with another nun gathering wood—as she also does in this composition. This handscroll shows the retired emperor's progress through the spring woods with his entourage, observed only by a country family of the valley. Kanzan carefully describes the physical condition of the Jakkō-in with its open kitchen and modest garden. During the imperial visit the housekeeper-cook eagerly pokes her head through the brushwood fence to hear news of the capital from four seated guards. In these sections of the *e-maki* Kanzan's drawing and use of ink wash are characteristically assured; the final scene in the forest is executed in superb *rimpa* technique. This scene differs more than the previous sections from his preparatory sketch for the handscroll, also signed and sealed by Kanzan, which is in the Eisei Bunko.　　　　　　　　　　　　MC

Literature

Kindai Nihon-ga no Nagare [*The Development of Japanese-Style Painting in Modern Japan*] (exh. cat.; Tokyo National Museum of Modern Art, 1961), pl. 2 (section).

Shimomura Kanzan, vol. 1, *Kanzan Gashū* [*Complete Paintings of Kanzan*] (Tokyo: Dainihonkaiga, 1981), pls. 23, 24, and pp. 282-84.

137　*Mikoshi-buri Zukan*
　　　[*Riotous Priests of Enryaku Temple*]

Maeda Seison (1885–1977). Dated to 1912.
Handscroll; ink and color on silk. H. 49.3 cm.
L. 909.9 cm. Tokyo National Museum.

During the eleventh and twelfth centuries the major Japanese Buddhist monastic establishments maintained private armies of soldier-monks. Distinguished neither by military prowess nor spiritual motivation, their existence underscored the secularization of Buddhism (see [25, 27]) at the close of the Heian period. Employed to intimidate and terrorize in the intramural squabbles of the monasteries, these monks also made occasional forays into the capital to press demands upon the court. They wound through the streets in armed and rowdy procession, usually bearing a *mikoshi*, a sacred palanquin believed to house the central spiritual presence of a neighboring Shintō shrine. Although these incursions posed no serious military threat, they intimidated the populace

and occasioned awkward moments for the court. Any opposition to their vandalism was greeted with threats of divine retribution emanating from within the *mikoshi*. They were generally dealt with in a gingerly but effective manner by court military squadrons. Especially bellicose and proximate to Kyoto were the Tendai monks from Enryaku-ji on Mt. Hiei.

An Enryaku-ji incursion of 1167, recorded in the *Heike Monogatari*, was illustrated in six scenes by Maeda Seison. Under the title of *Mikoshi-buri* [*Portable Shrine*] this handscroll received third-place honors in an important exhibition of 1912 and effectively launched Seison's career. Seison's works, representative of early twentieth-century reinterpretations of traditional mythic and historical materials, were enthusiastically endorsed by Okakura Kakuzō (see [135]). With considerable skill Seison distills the artistic insight of ensuing centuries into the essentially medieval format. *Rimpa* techniques and the occasional flavor of *nanga* style enhance the work. The flat diagonal compositional planes, the convention long employed to lead the viewer through the narrative, exist in an unresolved tension with the bursting visual opulence of the riotous assemblage.　　JU

Literature

E-maki [*Illustrated Handscrolls*] (exh. cat.; Tokyo National Museum, 1975), no. 122, repr. pp. 222-23 (section).

Zauhō Kankōkai, ed., *Gendai Nihon Bijutsu Zenshū* [*Collection of Modern Japanese Art*] (Tokyo: Kadokawa Shoten, 1955), pp. 16-21.

138　*Still Life of Salmon*

Takahashi Yūichi (1828–94). Oil on paper.
H. 140 cm. W. 46.5 cm. Tokyo University of Arts. Important Cultural Property.

Takahashi Yūichi was brought up in Edo by his grandfather, after the early death of his parents, as an instructor in the martial arts. But by the time he was twenty-seven Takahashi had persuaded his family that he wished to be a painter and could support himself as such although he possessed no formal training. He painted for a decade, without instruction but with the knowledge that some European lithographs he had seen represented the kinds of images he wished to make.

He was subsequently accepted as a student at the Bansho Shirabesho, a government institution for study of Western learning. There, in the department which taught precision drawing and industrial measurement, he got the opportunity in 1862 to study

Western painting with Kawakami Tōgai. Although technically unrewarding, this study did introduce Takahashi to theoretical questions and to Kōkan's (see [119]) essay on Western painting, *Seiyōga Dan*, which Takahashi extolled in his own treatises. A few years later Takahashi met Charles Wirgman (1835–94) a painter and illustrator for the *Illustrated London News* living in Yokohama. This was Takahashi's first meeting with a Western artist schooled in oil-painting techniques, and although they did not form a teacher-student relationship, Wirgman encouraged Takahashi's desire to master three-dimensional representation and lighting effects.

Following the Meiji Restoration the artist found himself with barely enough patronage to continue on and a family to support. Wirgman provided oil paints occasionally, and friends interested in photography were also particularly sympathetic. His petitions to government officials for permission to open his own school and to hold exhibitions were at first denied. Finally, in 1873, he opened Tenkai-sha, which became the most important art school in Tokyo and which held monthly exhibitions. Unfortunately pressure from nationalist political factions forced Takahashi to close the school in 1884. Nevertheless he had established a modest career for himself. He continued to study privately, most importantly with the Italian artist Antonio Fontanesi (1818–82), who had been invited by the Japanese government to teach at its art school, the predecessor to Tokyo University of Arts. From this study Takahashi learned anatomy and the use of chiaroscuro, as well as canvas and oil paint preparation.

The Tenkai-sha period marked the beginning of Takahashi's mature painting and prepared him for this famous *Salmon* painting of 1877. The finest of seven such efforts, it was praised at the time as being "photographically real." It raised still lifes of commonplace objects to a new level of respectability, and it is this contribution, rather than his landscapes, for which Takahashi is revered. He also executed lithographs, history paintings, and some fine portraits. His writings are numerous and essential to an understanding of Meiji Western style painting history, despite the fact that the traditionalist views of Okakura Kakuzō [135] and Ernest Fenollosa dominated the Japanese art world after Takahashi's death at age sixty-six. MC

Literature

Shigeru Aoki, *Takahashi Yuichi*, vol. 24 (September 1974) of *Kindai no Bijutsu*, pl. 11 (color).

Minoru Harada, *Meiji Western Painting*, trans. by Akiko Murakata, adapted by Bonnie F. Akibo, vol. 6 (1974) of *Arts of Japan*, pl. 12 and pp. 21-27.

Shuji Takashina, *Kindai no Yōga* [*Modern Western Paintings*], vol. 27 (1971) of *Genshoku Nihon no Bijutsu*, pls. 1, 2 (color).

Tokyo Geijutsu Daigaku Shozō Meihin Ten—Sōritsu Kyūjū Shūnen Kinen [*Exhibition of Masterpieces from the Tokyo University of Arts in Commemoration of its Ninetieth Anniversary*] (exh. cat.; Tokyo National Museum, 1977), cat. 35.

Japanese Art Series

Arts of Japan. Rosenfield, John M., supervising ed.; Cort, Louise Allison, general ed. New York: Weatherhill and Tokyo: Shibundō, 1973–76. Trans. and adapted from *Nihon no Bijutsu*.

Bunjinga Suihen [The Essence of Literati Painting]. Ishikawa Jun et al., ed. Tokyo: Chūōkōronsha, 1975–79. 20 vols. and supplements.

Genshoku Nihon no Bijutsu [Japanese Art in Full Color]. Akiyama Terukazu, ed. Tokyo: Shōgakkan, 1966–72. 30 vols.

The Heibonsha Survey of Japanese Art. Kamei Katsuichiro, Takahashi Seiichiro, and Tanaka Ichimatsu, consulting eds. New York: Weatherhill and Tokyo: Heibonsha, 1976–80. 31 vols. with index.

Japanese Arts Library. Rosenfield, John M., general ed., under editorial supervision of the Agency for Cultural Affairs (Bunka-chō), Tokyo National Museum, Kyoto National Museum, and Nara National Museum. Tokyo, New York, and San Francisco: Kōdansha and Shibundō, 1977–. Trans. and adapted from the series *Nihon no Bijutsu*.

Jisha Shirizu [Series on Temples and Shrines]. Kyoto: Tōyō Bunkasha, 1976–.

Jūyō Bunkazai [Important Cultural Properties]. Agency for Cultural Affairs (Bunka-chō), ed. Tokyo and Osaka: Mainichi Shimbunsha, 1972–78. 32 vols. in 40.

Kindai no Bijutsu [Modern Japanese Art]. Tokyo National Museum of Modern Art, Kyoto National Museum of Modern Art, and National Museum of Western Art, eds., with cooperation of the Agency for Cultural Affairs (Bunka-chō). Tokyo: Shibundō, 1970–.

Kinsei Fūzoku Zukan [Modern Genre Scroll Painting]. Narazaki Muneshige, ed. Tokyo: Mainichi Shimbunsha, 1973–.

Koji Junrei: Omi [Pilgrimage to Old Temples: Omi (Province)]. Inoue Yasushi and Tsukamoto Zenryū, eds. Kyoto: Tankōsha, c. 1980. 8 vols.

Kokuhō Jūyō Bunkazai Bukkyō Bijutsu [Complete Catalogue of Buddhist Art Designated as National Treasures and Important Cultural Properties]. Nara National Museum, ed. Tokyo: Shōgakkan, 1972–.

Meihō Nihon no Bijutsu [Treasures of Japanese Art]. Ota Hirotarō, Yamane Yūzō, and Yonezawa Yoshiho, eds. Tokyo: Shōgakkan, 1980–.

Nara Rokudaiji Taikan [General View of the Six Great Temples of Nara]. Tokyo: Iwanami Shoten, 1968–73. 14 vols.

Nihon Bijutsu Kaiga Zenshū [Complete Collection of Japanese Painting]. Tanaka Ichimatsu, Matsushita Takaaki, and Minamoto Toyomune, supervising eds; Zauhō Kankōkai, ed. Tokyo: Shūeisha, 1976–.

Nihon Bijutsu Zenshū [Complete Collection of Japanese Art]. Tanaka Ichimatsu and Fukuyama Toshio, consulting eds. Tokyo: Gakushū Kenkyūsha, 1977–80. 25 vols.

Nihon Byōbu-e Shūsei [Complete Collection of Japanese Screen Paintings]. Takeda Tsuneo, ed. Tokyo: Kōdansha, 1977–81. 18 vols.

Nihon E-maki Taisei [Compendium of Japanese Scroll Paintings]. Komatsu Shigemi, ed. Tokyo: Chūōkōronsha, 1977–79. 27 vols.

Nihon E-makimono Zenshū [Complete Collection of Japanese Scroll Paintings]. Tanaka Ichimatsu, ed. Tokyo: Kadokawa, 1958–81. 32 vols.

Nihon Kaigakan [Collection of Japanese Paintings]. Tanaka Ichimatsu, ed. Tokyo: Kōdansha, 1969–71. 12 vols.

Nihon Koji Bijutsu Zenshū [Art Collections at Old Japanese Temples]. Zauhō Kankōkai, ed. Tokyo: Shūeisha, 1979–.

Nihon no Bijutsu [Arts of Japan]. Tokyo National Museum, Kyoto National Museum, and Nara National Museum, eds., with cooperation of the Agency for Cultural Affairs (Bunka-chō). Tokyo: Shibundō, 1970–.

Nihon no Genshi Bijutsu [Primitive Art of Japan]. Tsuboi Kiyotari, ed. Tokyo: Kōdansha, 1977–79. 10 vols.

Nikuhitsu Ukiyo-e [Ukiyo-e Painting]. Narazaki Muneshige, ed. Tokyo: Shūeisha, 1980–.

Rimpa Kaiga Zenshū [Complete Collection of Rimpa Paintings]. Yamane Yūzō, ed. Tokyo: Nihon Keizai Shimbunsha, 1977–80. 5 vols.

Sekai no Bijutsukan [Art Museums of the World]. Okada Jō, ed. Tokyo: Kōdansha, 1965–71. 36 vols.

Suiboku Bijutsu Taikei [Compendium of Ink Painting]. Tanaka Ichimatsu and Yonezawa Yoshiho, eds. Tokyo: Kōdansha, 1973–75. 15 vols.

Tōyō Bijutsu Sensho [Selected Themes in Oriental Art]. Tokyo: Fujimoto, 1969–.

Tōyō Bunko [Oriental Books]. Tokyo: Heibonsha, 1963–.

Zaigai Hihō: Obei Shūzō Nihon Kaiga Shūsei [Foreign Treasures: Japanese Paintings in Western Collections]. Shimada Shujiro, ed. Tokyo: Gakken, 1969. 6 vols.

Zaigai Nihon no Shihō [Treasures of Japanese Art in Western Collections]. Shimada Shūjirō, ed. Tokyo: Mainichi Shimbunsha, 1978–81. 11 vols.

Periodicals

Bijutsu Kenkyū. Tokyo: Institute for Art Research, National Institute for the Study of Cultural Properties, 1932–.

Geijutsu Shinchō. Tokyo: Shinchōsha, 1950–.

Kobijutsu. Tokyo: Sansaisha, 1963–.

Kokka. Tokyo: Kokkasha, 1889–.

Museum. Tokyo National Museum, 1951–.

Index

Errata

Chapter Three

Color Plate III: *for* section of a handscroll *read* mounted as a hanging scroll.

Chapter Four

Page 33, paragraph 5, line 1: *for* the *inga* read *inga*.

Chapter Five

Page 63, paragraph 3, line 7: for *Honen* read *Hōnen*.
Page 65, paragraph 3, line 2: *for* scrolls *read* rolls.
Page 71, caption 32: for *Tales of Heike* read *History of the Heiji*.
Page 82, note 27, lines 3–4: *for* equation of excrement *read* equation of gold with excrement.

Chapter Six

Page 84, caption 39: for *Sō-ō* read *Sōō*.
Page 85, paragraph 2, line 22: *for* five founders *read* eight founders; paragraph 3, line 4, *for* Kongōcho-ji *read* Kongōchō-ji.
Page 96, paragraph 1, line 1: *for* Kimpu *read* Mt. Kimpu.
Page 103, paragraph 2, line 22: *for* Tōfuku-ji *read* the Rikkyoku-an subtemple of Tōfuku-ji; paragraph 2, line 28, *for* Kyoto National Musuem *read* Hompō-ji, Kyoto.
Page 105, caption 59: *for* Tohaku *read* Tōhaku.
Page 114, caption 68: *for* Kaku-e *read* Kakue.
Page 117, paragraph 3, line 5: *for* (dated to 1315) *read* (inscription dated to 1316).
Page 122, caption 75: *for* Kano *read* Kanō.
Page 124, paragraph 3, line 5: *for* Jokei-in *read* Jōkei-in.

Chapter Seven

Page 130, paragraph 3, line 5: *for* surround *read* surround-.
Page 133, paragraph 2, line 4: *for* Buttsu-ji *read* Buttsū-ji; paragraph 2, line 5, *for* Guchushukyu *read* Guchū Shūkyū.
Page 134, caption 86: for *Guchūshūkyū* read *Guchū Shūkyū*.
Page 137, paragraph 1, line 8: *for* 1215 *read* 1214.

Chapter Eight

Page 143, paragraph 3, lines 20-21: for *Kotobiki Miya Engi* read *Kotobiki no Miya E-engi*.
Page 148, caption 95: *for* Kano *read* Kanō.

Chapter Nine

Page 163, paragraph 3, line 11: *for* Tawara *read* Tahara; paragraph 3, line 14, *for* woman *read* women.
Page 181, paragraph 1, line 4: for *Goko* read *Gokō*.
Page 187, paragraph 2, line 2: *for* 1754 *read* 1753?; paragraph 3, line 6, *for* seventeenth-century *read* seventeenth century; paragraph 3, line 9: *for* artisitic *read* artistic.
Page 192, paragraph 2, lines 2 and 5: *for* Tawara *read* Tahara; paragraph 2, line 9, *for* Shoshikai *read* Shōshikai; paragraph 4, line 2, *for* Sukoku *read* Sūkoku.
Page 200, paragraph 3, line 2: *for* express of a new *read* express a new.

Postscript

Page 210, paragraph 1, line 2: *for* painted in 1907 *read* datable to 1908.
Page 212, paragraph 2, line 4: *for* panel *read* paper; paragraph 2, line 5, *for* Yuichi *read* Yūichi; paragraph 3, line 6, for *Rokudo* read *Rokudō*.

Catalogue Entries

[1] Page 213, line 1 below title: *for* Late Jōmon *read* Early-middle Jōmon; paragraph 3, lines 8–9, *for* Other late Jōmon *read* Other Jōmon.

[2] Page 213, line 1 below title: *for* Tumulus *read* Tumulus-Asuka.

[3] Page 214, line 1 below title: *for* Tumulus *read* Tumulus-Asuka.

[6] Page 215, paragraph 1, line 5: *for* Daizaifu *read* Dazaifu.

[9] Page 216, *Literature,* line 1: for *Profance* read *Profane.*

[10] Page 216, *Literature,* line 1: for *Profance* read *Profane; Literature,* line 4, *for* Weisbaden *read* Wiesbaden.

[17] Page 220, paragraph 1, line 3: *for* construed *read* constructed.

[19] Page 222, paragraph 2, line 4: *for* [19] *read* [18].

[24] Page 225, paragraph 3, line 2: *for* eight *read* eighth.

[26] Page 227, line 3 below title: *for* H. 89.7 cm. *read* H. 29.7 cm.; page 228, caption 26, *for* 26 (sections). *read* 26a (above) and 26b (below).

[31] Page 231, paragraph 2, line 2: *for* Motosune's *read* Mototsune's.

[33] Page 234, *Literature,* line 4: for *Kenkyuū* read *Kenkyū.*

[35] Page 235, paragraph 2, line 4: *for* somwhat *read* somewhat.

[36] Page 236, *Literature,* line 1: *for* Kaiho *read* Kaihō.

[40] Page 237, line 1 under title: *for* 1189–23 *read* 1189–1223.

[42] Page 239, *Literature,* lines 4–5: *for* Hoshaku-ji *read* Hōshaku-ji.

[43] Page 239, paragraph 1, line 10: *for* Daigō-ji *read* Daigo-ji.

[44,45] Page 240, line below title: *for* H. 117 cm. *read* H. 123.4 cm.; *for* H. 96.4 cm. *read* H. 106.6 cm.

[70] Page 252, *Literature,* line 1: for *Et* read *&* [Note: this correction applies to all references to this title.]

[72] Page 253, paragraph 2, line 1: *for* Musō *read* Musō Soseki.

[72] Page 253, *Literature,* line 6: *for* vol. 9 *read* vol. 8.

[74] Page 254, line 3 below title: *for* Nobutaka Moriya *read* Moriya Nobutaka.

[74] Page 255, *Literature,* line 3: *for* Ashmkaga *read* Ashikaga.

[75] Page 255, line 1 below title: *for* Kano *read* Kanō.

[91] Page 263, title: for *Kotobiki-no-miya E-engi* read *Kotobiki no Miya E-engi.*

[92] Page 264, paragraph 2, line 13: for *Eden* read *E-den;* page 265, line 6, for *Hiyoshi* read *Hie.*

[95] Page 266, paragraph 2, line 5: *for* Shi-fan *read* Shih-fan; paragraph 3, line 16, *for* Shōku-ji *read* Shōten-ji.

[97] Page 267, paragraph 2, line 3: *for* historical *read* historic.

[107] Page 272, paragraph 2, line 20: *for* 1722 *read* 1772.

[109] Page 274, paragraph 2, line 3: *for* hawk *read* hawks; page 275, paragraph 2, line 2, *for* samurai *read* samurai family.

[112] Page 276, paragraph 3, line 3: *for* indicate *read* indicates; *Literature,* line 3, for *Michishū* read *Machishū.*

[116] Page 279, title: for *Fuzukuzu* read *Fūzokuzu.*

[117] Page 279, paragraph 2, line 3: *for* publisher *read* publishers.

[119] Page 280, paragraph 1, line 15: *for* omniverous *read* omnivorous.

[127] Page 283, paragraph 1, line 1: for *okugai* read *okugaki.*

[130] Page 285, paragraph 1, line 9: *for* 1784 1801 *read* 1784–1801.

[136] Page 289, title: for *Gō-Shirakawa's* read *Go-Shirakawa's;* paragraph 3, lines 4–5, *for* Gō-Shirakawa *read* Go-Shirakawa; paragraph 3, line 8, *for* Gō-Shirakawa's *read* Go-Shirakawa's.